Photoshop[®] Elements 2025

by Barbara Obermeier and Ted Padova

Photoshop® Elements 2025 For Dummies®

Published by: John Wiley & Sons, Inc., 111 River Street, Hoboken, NJ 07030-5774, www.wiley.com

Copyright © 2025 by John Wiley & Sons, Inc. All rights reserved, including rights for text and data mining and training of artificial technologies or similar technologies.

Media and software compilation copyright © 2025 by John Wiley & Sons, Inc. All rights reserved, including rights for text and data mining and training of artificial technologies or similar technologies.

Published simultaneously in Canada

No part of this publication may be reproduced, stored in a retrieval system or transmitted in any form or by any means, electronic, mechanical, photocopying, recording, scanning or otherwise, except as permitted under Sections 107 or 108 of the 1976 United States Copyright Act, without the prior written permission of the Publisher. Requests to the Publisher for permission should be addressed to the Permissions Department, John Wiley & Sons, Inc., 111 River Street, Hoboken, NJ 07030, (201) 748-6011, fax (201) 748-6008, or online at http://www.wiley.com/go/permissions.

Trademarks: Wiley, For Dummies, the Dummies Man logo, Dummies.com, Making Everything Easier, and related trade dress are trademarks or registered trademarks of John Wiley & Sons, Inc. and may not be used without written permission. Photoshop is a registered trademark of Adobe in the United States and/or other countries. All other trademarks are the property of their respective owners. John Wiley & Sons, Inc. is not associated with any product or vendor mentioned in this book.

LIMIT OF LIABILITY/DISCLAIMER OF WARRANTY: THE PUBLISHER AND THE AUTHOR MAKE NO REPRESENTATIONS OR WARRANTIES WITH RESPECT TO THE ACCURACY OR COMPLETENESS OF THE CONTENTS OF THIS WORK AND SPECIFICALLY DISCLAIM ALL WARRANTIES, INCLUDING WITHOUT LIMITATION WARRANTIES OF FITNESS FOR A PARTICULAR PURPOSE. NO WARRANTY MAY BE CREATED OR EXTENDED BY SALES OR PROMOTIONAL MATERIALS. THE ADVICE AND STRATEGIES CONTAINED HEREIN MAY NOT BE SUITABLE FOR EVERY SITUATION. THIS WORK IS SOLD WITH THE UNDERSTANDING THAT THE PUBLISHER IS NOT ENGAGED IN RENDERING LEGAL, ACCOUNTING, OR OTHER PROFESSIONAL SERVICES. IF PROFESSIONAL ASSISTANCE IS REQUIRED, THE SERVICES OF A COMPETENT PROFESSIONAL PERSON SHOULD BE SOUGHT. NEITHER THE PUBLISHER NOR THE AUTHOR SHALL BE LIABLE FOR DAMAGES ARISING HEREFROM. THE FACT THAT AN ORGANIZATION OR WEBSITE IS REFERRED TO IN THIS WORK AS A CITATION AND/OR A POTENTIAL SOURCE OF FURTHER INFORMATION DOES NOT MEAN THAT THE AUTHOR OR THE PUBLISHER ENDORSES THE INFORMATION THE ORGANIZATION OR WEBSITE MAY PROVIDE OR RECOMMENDATIONS IT MAY MAKE. FURTHER, READERS SHOULD BE AWARE THAT INTERNET WEBSITES LISTED IN THIS WORK MAY HAVE CHANGED OR DISAPPEARED BETWEEN WHEN THIS WORK WAS WRITTEN AND WHEN IT IS READ.

For general information on our other products and services, please contact our Customer Care Department within the U.S. at 877-762-2974, outside the U.S. at 317-572-3993, or fax 317-572-4002. For technical support, please visit https://hub.wiley.com/community/support/dummies.

Wiley publishes in a variety of print and electronic formats and by print-on-demand. Some material included with standard print versions of this book may not be included in e-books or in print-on-demand. If this book refers to media that is not included in the version you purchased, you may download this material at http://booksupport.wiley.com. For more information about Wiley products, visit www.wiley.com.

Library of Congress Control Number: 2024948062

ISBN 978-1-394-29631-6 (pbk); ISBN 978-1-394-29632-3 (ebk); ISBN 978-1-394-29633-0 (ebk)

Printed and bound by CPI Group (UK) Ltd, Croydon, CRo 4YY

C9781394296316 140325

The manufacturer's authorized representative according to the EU General Product Safety Regulation is Wiley-VCH GmbH, Boschstr. 12, 69469 Weinheim, Germany, e-mail: Product_Safety@wiley.com.

Contents at a Glance

Introd	ntroduction 1		
Part 1:	Getting Started with Photoshop Elements 2025 5		
	Exploring the Photo Editor		
CHAPTER 2:	Getting Familiar with the Organizer33		
CHAPTER 3:	Organizing Your Pictures		
CHAPTER 4:	Viewing and Finding Your Images57		
Part 2:	Selecting and Correcting Photos71		
CHAPTER 5:	Editing Camera Raw Images		
	Making and Modifying Selections		
	Working with Layers		
	Simple Image Makeovers145		
CHAPTER 9:	Correcting Contrast, Color, and Clarity		
Part 3:	Exploring Your Inner Artist223		
	Playing with Filters, Effects, Styles, and More225		
CHAPTER 11	Drawing, Painting, and Typing255		
Part 4:	Printing, Creating, and Sharing287		
CHAPTER 12	Getting It on Paper		
	Sharing Your Work		
CHAPTER 14	Making Creations303		
Part 5:	The Part of Tens 315		
CHAPTER 15	The Ten Best Guided Edits317		
CHAPTER 16	Ten (or So) More Project Ideas		
Index.	341		

Table of Contents

DUCTION Adobe Photoshop Elements 2025 New Features	1
Icons Used in This Book	4
: GETTING STARTED WITH PHOTOSHOP NTS 2025	5
Exploring the Photo Editor Examining the Photo Editor Examining the image window Uncovering the contextual menus Selecting the tools Selecting from the Tool Options Playing with panels Using the Photo Bin Creating different views of an image Viewing filenames Using Photo Bin Actions Using Some Creative Features. Using Guided Edits Working with Adobe Stock images Searching Guided Edits. Controlling the Editing Environment Launching and navigating Preferences Checking out all the Preferences panes. Perusing preset libraries	7 .111 .15 .17 .19 .21 .22 .23 .23 .24 .26 .26
Getting Familiar with the Organizer Touring the Organizer	. 33 .34 .37 .38 .39 .40
Navigating the Media Browser	

CHAPTER 3:	Organizing Your Pictures	47
	Organizing Groups of Images with Tags	47
	Rating Images with Stars	
	Adding Images to an Album	
	Creating an album	
	Editing an album	53
	Adding People in the Media Browser	54
CHAPTER 4:	Viewing and Finding Your Images	57
	Cataloging Files	
	Using the Catalog Manager	
	Working with catalogs	59
	Backing up your catalog	60
	Switching to a Different View	62
	Viewing Photos in Memories (Slideshow)	
	Searching for Photos	
	Using Search	
	Searching by history	
	Searching metadata	
	Searching similarities	68
PART :	2: SELECTING AND CORRECTING PHOTOS	74
I AIXI a	2. SELECTING AND CORRECTING PHOTOS	/1
	Editing Camera Raw Images	
		73
	Editing Camera Raw Images	73 73
	Editing Camera Raw Images	73 74
	Editing Camera Raw Images Launching the Camera Raw Editor	73 74 75
	Editing Camera Raw Images Launching the Camera Raw Editor Understanding Camera Raw Learning Raw file format attributes Opening images in the Camera Raw Editor Getting Familiar with the Raw Editor	73 74 75 76
	Editing Camera Raw Images Launching the Camera Raw Editor Understanding Camera Raw Learning Raw file format attributes Opening images in the Camera Raw Editor. Getting Familiar with the Raw Editor Getting Familiar with the Panels	73 74 75 76 77
	Editing Camera Raw Images Launching the Camera Raw Editor Understanding Camera Raw Learning Raw file format attributes Opening images in the Camera Raw Editor Getting Familiar with the Raw Editor Getting Familiar with the Panels Using the Basic panel	73 74 75 76 77
	Editing Camera Raw Images Launching the Camera Raw Editor Understanding Camera Raw Learning Raw file format attributes Opening images in the Camera Raw Editor Getting Familiar with the Raw Editor Getting Familiar with the Panels Using the Basic panel Sharpening and reducing noise.	73 74 75 76 81 81
	Editing Camera Raw Images Launching the Camera Raw Editor Understanding Camera Raw Learning Raw file format attributes Opening images in the Camera Raw Editor Getting Familiar with the Raw Editor Getting Familiar with the Panels Using the Basic panel Sharpening and reducing noise. Using the Calibration panel	73 74 75 76 81 81 85
	Editing Camera Raw Images Launching the Camera Raw Editor Understanding Camera Raw Learning Raw file format attributes Opening images in the Camera Raw Editor Getting Familiar with the Raw Editor Getting Familiar with the Panels Using the Basic panel Sharpening and reducing noise. Using the Calibration panel Working with Filmstrips	73 74 75 76 81 85 85
	Editing Camera Raw Images Launching the Camera Raw Editor Understanding Camera Raw Learning Raw file format attributes Opening images in the Camera Raw Editor Getting Familiar with the Raw Editor Getting Familiar with the Panels Using the Basic panel Sharpening and reducing noise. Using the Calibration panel Working with Filmstrips Working with Profiles	73 74 75 76 81 85 85 87
	Editing Camera Raw Images Launching the Camera Raw Editor Understanding Camera Raw Learning Raw file format attributes Opening images in the Camera Raw Editor Getting Familiar with the Raw Editor Getting Familiar with the Panels Using the Basic panel Sharpening and reducing noise. Using the Calibration panel Working with Filmstrips Working with Profiles Looking at the Adobe Camera Raw profiles	73 74 75 76 81 85 85 87
	Editing Camera Raw Images Launching the Camera Raw Editor Understanding Camera Raw Learning Raw file format attributes Opening images in the Camera Raw Editor Getting Familiar with the Raw Editor Getting Familiar with the Panels Using the Basic panel Sharpening and reducing noise. Using the Calibration panel Working with Filmstrips Working with Profiles Looking at the Adobe Camera Raw profiles Managing profiles	73 74 75 81 85 85 87 89
	Editing Camera Raw Images Launching the Camera Raw Editor Understanding Camera Raw Learning Raw file format attributes Opening images in the Camera Raw Editor Getting Familiar with the Raw Editor Getting Familiar with the Panels Using the Basic panel Sharpening and reducing noise. Using the Calibration panel Working with Filmstrips Working with Profiles Looking at the Adobe Camera Raw profiles Managing profiles Creating a Favorites list	73 74 75 81 85 85 87 89
	Editing Camera Raw Images Launching the Camera Raw Editor Understanding Camera Raw Learning Raw file format attributes Opening images in the Camera Raw Editor Getting Familiar with the Raw Editor Getting Familiar with the Panels Using the Basic panel Sharpening and reducing noise. Using the Calibration panel Working with Filmstrips Working with Profiles Looking at the Adobe Camera Raw profiles Managing profiles Creating a Favorites list Opening Non-Raw Images in the Camera Raw Editor	73 74 75 76 81 85 87 87 89 90
	Editing Camera Raw Images Launching the Camera Raw Editor Understanding Camera Raw Learning Raw file format attributes Opening images in the Camera Raw Editor Getting Familiar with the Raw Editor Getting Familiar with the Panels Using the Basic panel Sharpening and reducing noise. Using the Calibration panel Working with Filmstrips Working with Profiles Looking at the Adobe Camera Raw profiles Managing profiles Creating a Favorites list Opening Non-Raw Images in the Camera Raw Editor Changing Image Defaults	73 74 75 76 81 85 87 87 89 90
	Editing Camera Raw Images Launching the Camera Raw Editor Understanding Camera Raw Learning Raw file format attributes Opening images in the Camera Raw Editor Getting Familiar with the Raw Editor Getting Familiar with the Panels Using the Basic panel Sharpening and reducing noise. Using the Calibration panel Working with Filmstrips Working with Profiles Looking at the Adobe Camera Raw profiles Managing profiles Creating a Favorites list Opening Non-Raw Images in the Camera Raw Editor Changing Image Defaults Working with XML Files and Preferences.	7374757681858787899191
	Editing Camera Raw Images Launching the Camera Raw Editor Understanding Camera Raw Learning Raw file format attributes Opening images in the Camera Raw Editor Getting Familiar with the Raw Editor Getting Familiar with the Panels Using the Basic panel Sharpening and reducing noise. Using the Calibration panel Working with Filmstrips Working with Profiles Looking at the Adobe Camera Raw profiles Managing profiles Creating a Favorites list Opening Non-Raw Images in the Camera Raw Editor Changing Image Defaults	73747581858789909191

CHAPTER 6:	Making and Modifying Selections	97
	Defining Selections	97
	Creating Rectangular and Elliptical Selections	98
	Perfecting squares and circles with Shift and Alt	
	(Option on the Mac)	
	Applying Marquee options	
	Making Freeform Selections with the Lasso Tools	
	Selecting with the Lasso tool	
	Getting straight with the Polygonal Lasso tool	
	Working Wizardry with the Magic Wand	
	Talking about Tolerance	
	Wielding the Wand to select	
	Modifying Your Selections	
	Adding to, subtracting from, and intersecting a selection.	
	Avoiding key collisions	
	Painting with the Selection Brush	
	Painting with the Quick Selection Tool	
	Selecting with the Auto Selection Tool	115
	Selecting Your Subject, Background, or Sky with One-Click Selecting	117
	Fine-Tuning with the Refine Selection Brush	
	Working with the Cookie Cutter Tool	
	Eliminating with the Eraser Tools	
	The Eraser tool	
	The Background Eraser tool	
	The Magic Eraser tool	
	Using the Select Menu	
	Selecting all or nothing	
	Refining the edges of a selection	
	Mayling with Lavous	
CHAPTER 7:	Working with Layers	
	Getting to Know Layers	129
	Converting a background to a layer	
	Anatomy of the Layers panel	
	Using the Layer and Select menus	
	Tackling Layer Basics	
	Creating a new layer from scratch	
	Using Layer via Copy and Layer via Cut	
	Duplicating layers	
	Dragging and dropping layers	
	Moving a Layer's Content	
	Transforming Layers	
	Flattening and Merging Layers Flattening layers	
	• .	
	Merging layers	142

CHAPTER 8:	Simple Image Makeovers	145
	Cropping and Straightening Images	145
	Cutting away with the Crop tool	146
	Fixing distortion with the Perspective Crop tool	148
	Cropping with a selection border	150
	Straightening images	150
	Recomposing Images	151
	Employing One-Step Auto Fixes	154
	Auto Smart Fix	
	Auto Smart Tone	
	Auto Levels	
	Auto Contrast	
	Auto Haze Removal	157
	Auto Color Correction	
	Auto Sharpen	
	Auto Red Eye Fix	
	Editing in Quick Mode	
	Fixing Small Imperfections with Tools	
	Cloning with the Clone Stamp tool	
	Retouching with the Healing Brush	
	Zeroing in with the Spot Healing Brush	
	Eliminating objects with the new Remove tool	
	Repositioning with the Content-Aware Move tool	
	Lightening and darkening with Dodge and Burn tools	
	Smudging away rough spots	
	Softening with the Blur tool	
	Focusing with the Sharpen tool	
	Sponging color on and off	179
CHAPTER 9:	Correcting Contrast, Color, and Clarity	181
	Editing Your Photos Using a Logical Workflow	182
	Adjusting Lighting	182
	Fixing lighting with Shadows/Highlights	
	Using Brightness/Contrast	184
	Pinpointing proper contrast with Levels	185
	Adjusting Color	187
	Removing color casts automatically	188
	Adjusting with Hue/Saturation	189
	Eliminating color with Remove Color	190
	Switching colors with Replace Color	191
	Changing an object's color	193
	Correcting with Color Curves	195
	Adjusting skin tones	197
	Defringing layers	198

Eliminating haze	
Adjusting color temperature with photo filters	.200
Mapping your colors	.201
Adjusting Clarity	.202
Removing noise, artifacts, dust, and scratches	.203
Blurring when you need to	.204
Sharpening for better focus	.207
Opening closed eyes	.209
Colorizing a photo	.211
Smoothing skin	.213
Adjusting facial features	.214
Moving Overlays	.214
Moving Photos	.217
Moving Elements	.217
Working Intelligently with the Smart Brush Tools	.219
PART 3: EXPLORING YOUR INNER ARTIST	. 223
CHAPTER 10: Playing with Filters, Effects, Styles, and More	225
Having Fun with Filters	
Applying filters	
Corrective or destructive filters	
One-step or multistep filters	
Working in the Filter Gallery	
Distorting with the Liquify filter	
Correcting Camera Distortion	
Exploring Elements' Unique Filters	
Creating a comic	
Getting graphic	
Using the Pen and Ink filter	
Dressing Up with Photo and Text Effects	
Adding Shadows, Glows, and More	
Applying styles	
Working with styles	
Using the Graphics panel	
Mixing It Up with Blending Modes	
General blending modes	
Darken blending modes	
Lighten blending modes	
Lighting blending modes	
Inverter blending modes	
HSL blending modes	
Using Photomerge	
Photomerge Panorama	
Combine Photos	253

CHAPTER 11: Drawing, Painting, and Typing	255
Choosing Color	255
Working with the Color Picker	
Dipping into the Color Swatches panel	257
Sampling with the Eyedropper tool	259
Getting Artsy with the Pencil and Brush Tools	260
Drawing with the Pencil tool	260
Painting with the Brush tool	262
Using the Impressionist Brush	
Filling and Outlining Selections	266
Fill 'er up	
Outlining with the Stroke command	
Splashing on Color with the Paint Bucket Tool	
Working with Gradients and Patterns	
Applying a preset gradient	
Applying a preset pattern	
Creating Shapes of All Sorts	
Drawing a shape	
Editing shapes	
Creating Type	
Specifying Type Options	
Editing Text	
Enhancing Type	
Adjusting type opacity	
Applying filters to your type	
Painting your type with color and gradients	
Warping your type	
Using Text Overlay Templates	285
PART 4: PRINTING, CREATING, AND SHARING	287
CHAPTER 12: Getting It on Paper	
Getting Pictures Ready for Printing	
Working with Color Printer Profiles	
Printing a photo with the printer managing color	
Printing a photo with Elements managing color	
Printing a picture package or contact sheet	
Getting Familiar with the Print Dialog Box	
Using the Prints options	295
CHAPTER 13: Sharing Your Work	297
Using the Share Panel	
Emailing photos	
Working with Adobe Premiere Elements	
Sharing your photos on social networks	

CHAPTER 14: Making Creations	303
Checking Out the Create Panel	
Grasping Creation-Assembly Basics	
Creating a Quote Graphic	
Creating a Memories video	
Making Additional Creations	
PART 5: THE PART OF TENS	315
CHAPTER 15: The Ten Best Guided Edits	317
Correct Skin Tone	
Sharpen	
Object Removal	
Perfect Portrait	
Remove a Color Cast	
Levels	
Resize Your Photo	
Recompose	
Move & Scale Object	333
CHAPTER 16: Ten (or So) More Project Ideas	335
Screen Savers	335
Flyers, Ads, and Online Auctions	
Clothes, Hats, and More	
Posters Household and Business Inventories	
Project Documentation.	
School Reports and Projects	
Blogs	
Wait — There's More	339
INDEX	341

Introduction

his book is about Photoshop Elements 2025. Quite a few of the past Photoshop Elements upgrades dealt with improvements in performance and modifications to the user interface. This new upgrade to Photoshop Elements focuses more on robust new features and much less on performance and interface changes.

Another big change in terms of *Photoshop Elements 2025 For Dummies* is our modification of the material in this book. We decided to offer you fewer printed pages to help reduce the cost of the book. Rather than rehash a lot of old material in printed form, we point you to the Elements Help menu when you need more information on a given topic. When you need additional information, open the Help Menu and choose Photoshop Elements Help.

Adobe Photoshop Elements 2025 New Features

If you are an experienced user of Photoshop Elements and have upgraded the program through several recent versions, you no doubt know many of Adobe's additions for AI features. Adobe calls its version of artificial intelligence Adobe Sensei. We've seen some enhancements over the past several years for implementing Adobe Sensei features with tools and menu commands. In this new upgrade, you'll find some extraordinary and very welcome new AI features that include the following:

- >> ChatBot: When you choose Help \(\sime\) Photoshop Elements Help, click the chat symbol in the lower-right corner of the window. This command opens an Al-generated chat window where you can interact with Adobe Virtual Assistant to get help.
- >> Change Object Color: Users often seek to change the color of objects in photos using editing applications, for various purposes. The new Change Object Color feature helps users select an object and change its color.

- >> Quick Actions: Quick Actions have been useful in exposing and giving the flavor of some powerful but hidden features in Photoshop Elements. Adobe continues to leverage a highly discoverable Quick Action panel to surface the suite of motion-in-photos related features. Four new Quick Actions have been added in Elements 2025.
- >> Updated content: In Photoshop Elements 2025, you will find many updated and new textures and graphics.
- >> Remove tool: You can use the new Al Remove tool to remove distracting objects in the photo.
- **>> Elements Organizer: GIF Playback:** Double-click a GIF image in the Organizer to preview the GIF animation.
- **Elements Organizer: Filter using Media Types:** Four new icons appear at the top of the Organizer Media Browser. Click one of the icons to filter media types associated with the selected icon.
- >> Elements Organizer: Sync Sorting Order: You can now sync the sorting order in Albums to the same sorting order you select in the Organizer.
- >> Combine Photos: The new Combine Photos feature helps users extract objects from multiple sources and apply them to the destination to create an output.
- >> Depth of Field filter: The new Al-based Depth of Field filter helps users add realistic depth using a depth map and helps simulate the background blur or depth-of-field effect that a user gets from using a lens with a fast aperture.

About This Book

Throughout this book, especially in step lists, we point you to menus for keyboard commands. For accessing a menu command, you may see something like this:

Choose File

Get Photos

From Files and Folders.

In this case, the command means to click the File menu to open its drop-down menu, click the menu command labeled Get Photos, and then choose the command From Files and Folders from the submenu that appears. It's that simple.

We also refer to *context menus*, which jump up at your cursor position and show you a menu of options related to whatever you're doing at the time. To open a context menu, just right-click the mouse, or Ctrl+click on a Mac if you don't have a two-button mouse.

When we mention that keys need to be pressed on your keyboard, the text looks like this:

Press Alt+Shift+Ctrl+S (Option+Shift+第 +S on the Mac).

In this case, this command means to hold down the Alt key on Windows or the Option key on the Mac, and then the Shift key, and then the Ctrl key on Windows or the \Re key on the Mac; then press the S key. You then release all the keys at the same time.

Icons Used in This Book

In the margins throughout this book, you see icons indicating that something is important, as follows:

This icon informs you that this item is a new feature in Photoshop Elements 2025.

Pay particular attention when you see the Warning icon. This icon indicates possible side effects or damage to your image that you might encounter when performing certain operations in Elements.

This icon is a heads-up for some information you may want to commit to memory. Usually, it tells you about a shortcut for a repetitive task that can save you time.

A Tip tells you about an alternative method for a procedure, giving you a shortcut, a work-around, or some other type of helpful information.

Elements is a computer program, after all. No matter how hard we try to simplify our explanation of features, we can't entirely avoid some technical information. If a topic is a little on the technical side, we use this icon to alert you that we're moving into a complex subject. You won't see many of these icons in the book because we try our best to give you the details in nontechnical terms.

Beyond the Book

In addition to what you're reading right now, this product also comes with a free, online Cheat Sheet that includes a detailed look at the Elements photo-editing workspace, Tool Panel shortcuts, tricks for selecting objects, and more. To get this Cheat Sheet, simply go to www.dummies.com and type Photoshop Elements 2025 For Dummies Cheat Sheet in the Search box.

Where to Go from Here

Try to spend a little time reading through Chapter 1, Exploring the Photo Editor. After you know how to edit and save photos, feel free to jump around and pay special attention to the cross-referenced chapters, in case you get stuck on a concept. Look over Chapter 3, where we talk about organizing and searching photos. When it comes to editing photos, look over Chapter 5 carefully. Everything begins with adjusting photos for brightness, contrast, and color. In Chapter 5, you learn that using the Camera Raw Editor is your first stop when editing a photo for any kind of output. If you're ready to jump into more advanced tasks, check out Parts 2 and 3, where you find out how to make selections; layer images and effects together; add filters and type; and much, much more.

We hope you have much success and enjoyment in using Adobe Photoshop Elements 2025, and it's our sincere wish that the pages ahead provide you with an informative and helpful view of the program.

Getting Started with Photoshop Elements 2025

IN THIS PART . . .

Tour the Photo Editor interface so that you know how to switch among images and navigate the many panels and options.

Discover the basic features of the Organizer interface.

Import images from your computer, camera, or scanner into the Organizer.

Tag images with keywords, faces, places, or events so that you can easily find images.

View your pictures in the Media Browser and change views.

Use the Organizer's search features to pinpoint the images you need.

- » Examining the Editor workspace
- » Using the Photo Bin
- » Using Creative Effects
- » Launching Preferences
- » Customizing the presets

Chapter **1 Exploring the Photo Editor**

hotoshop Elements has two workspaces: the Organizer, which we discuss in Chapter 2, and the Photo Editor, introduced in this chapter. You manage and arrange your photos in the Organizer, and you edit photos in the Photo Editor.

In this chapter, you look at the Photo Editor, where you can refine your photoediting skills. You discover the Photo Editor's workspace in depth as well as how to access the Photo Editor's three editing modes: Quick, Guided, and Advanced. You access these three workspaces by clicking the tabs above the image window.

Examining the Photo Editor

Before you begin editing photos, you'll find it helpful to look over the Photo Editor and figure out how to move around the workspace. When the Photo Editor is in Advanced mode, you find the following (as labeled in Figure 1-1):

(A) Menu bar: As does just about every other program you launch, Elements supports drop-down lists. The menus are logically constructed and identified to provide commands for working with your pictures (including many

commands that you don't find supported in tools and on panels). A quick glimpse at the menu names gives you a hint of what might be contained in a given menu list. Throughout this book, we point you to the menu bar whenever it's helpful. Most of the menu commands you find in Elements 2025 are the same as those found in earlier versions of Elements.

- (B) Create panel: When you open the Create panel and choose an option, you leave the current editing mode. For example, when in Advanced mode, choose Create

 → Photo Collage, and all the options that were available in the Photo Editor temporarily disappear when the Creation Wizard opens. To return to the Photo Editor, complete the creation or cancel the wizard. Chapter 14 guides you through the options in the Create panel.
- (C) Photo Editor modes: The Photo Editor has three modes. The Advanced mode is shown in Figure 1-1. You find a detailed look at Quick mode in Chapter 8. An introduction to Guided mode appears later in this chapter, in the "Using Some Creative Features" section. Part 2 and 3 of the book covers all the different features of Advanced mode, including making selections, creating composites from several images, drawing, adding text, and exploring creative flourishes with filters and effects.
- (D) Features buttons: On Windows, you find three buttons in the top-right corner. These buttons are used to (1) minimize the window; (2) maximize/minimize the window; and (3) close the application. On Apple Macintosh, the same three buttons appear, but they are placed in the top-left corner of the window.
- **(E) Share menu:** The Share menu works similarly to the Create menu and offers options for sharing your images. Chapter 13 focuses on the Share menu.
- **(F) Panel Bin:** Figure 1-1 shows the Layers panel. You change panels by clicking the icons at the bottom of the Panel Bin. (The icons are described in item S.) *Creations* (things you make) are also contained in the Panel Bin when you click the Create button (item E).
- (G) Open menu: When you have several files open in the Photo Editor, the Open menu is one way to switch among these files. To use this menu, click the down-pointing arrow adjacent to the Open button and, from the drop-down list, choose the image you want to move to the foreground. Note: The Open menu also offers you an option to create a new, blank file.

In Figure 1-1, several files are open, as indicated by the tabs at the top of the image window. You can also place an open file in the foreground in the image window in these other ways:

- Click a tab at the top of the image window to move the image to the foreground.
- Click a photo in the Photo Bin (see item K).
- Open the Window menu and choose a photo listed at the bottom of the menu.

(H) File tabs: Multiple photos opened in the Photo Editor appear in different tabs at the top of the window by default.

In technical-speak, this is a *docked* position, meaning that the photos are docked in the image window. You can click a tab and drag it down to *undock* the photo. To undock photos, you must change a preference setting in the General Preferences by checking Allow Floating Windows in Advanced mode. (See "Controlling the Editing Environment," later in this chapter, for more on changing preferences.) Doing so makes the photo appear as a *floating window*. You might want to float windows when copying and pasting image data between two or more photos. You can also view all open files in a floating window without choosing All Floating from the Layout pop-up menu (item M). To use this menu command, you must first enable the Preferences to allow floating windows.

- (I) Tools panel: Here you find the Photo Editor toolbox, where you click a tool and apply an edit to the photo. See "Selecting the tools" and "Selecting from the Tool Options," later in this chapter.
- (J) **Document Information Pop-up Menu:** Click to open a pop-up menu displaying document information.
- (K) Photo Bin/Tool Options: Figure 1-1 shows the Photo Bin open. Click the Tool Options button, and a set of Tool Options replaces the Photo Bin. You can also open the Tool Options by clicking a tool in the Tools panel.

Tool Options enable you to specify how the selected tool works. For example, the Tool Options for the Brush tool, as shown in Figure 1-2, enable you to select from a few different brush styles, set the size of your brush, and much more. (You discover how the specific tools work in the relevant chapters later in this book. For example, you find out how the Brush tool works in Chapter 11, which covers drawing, painting, and typing.)

Each tool in the Tools panel supports various tool options. To return to the Photo Bin, click the Photo Bin button at the bottom left of the window.

- (L) Undo/Redo: These commands are so useful that they have an extra-prominent place in the Photo Editor interface. You can also press Ctrl+Z (策+Z on the Mac) for Undo and Ctrl+Y (策+Y) for Redo.
- (M) Rotate: Click the Rotate left tool to rotate counterclockwise 90 degrees. Click the down-pointing arrow on the Rotate tool and choose the Rotate Right tool to rotate a photo 90 degrees clockwise.
- (N) Layout: When you have multiple photos open in the Photo Editor, the Layout pop-up menu enables you to choose how the photos display in the image window (such as rows, columns, as a grid, and so on). To return to the tabbed view, choose Default from the Layout pop-up menu.

- (O) Organizer: Click the Organizer button to open the Organizer, which we cover in detail in Chapter 2. Elements makes it very easy for you to toggle back and forth between the Organizer and the Photo Editor by clicking their respective buttons at the bottom of the windows.
- (P) Home Screen: Opens the Elements Home Screen window.
- (Q) Media Window: The active document is shown in this window.
- (R) Panels: Click the icons to open the panels that include Layers, Effects, Filters, Styles, Graphics, and a category named More that's a collection of other, different panels.
- (S) More menu: To open additional panels, click the three dots to open a pop-up menu of choices. The panels you open from the Panel Options menu appear as floating windows and can't be docked in the Panel Bin.

The description of the Photo Editor workspace is brief in this chapter. Most of the options you have for using tools, panels, and menu commands are discussed in later chapters. For now, try to get a feel for what the Photo Editor provides and how to move among many of the Photo Editor features.

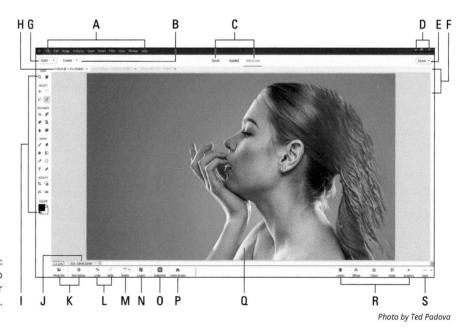

The Photo Editor workspace. Tool Options provide more editing features for tools selected in the Tools panel.

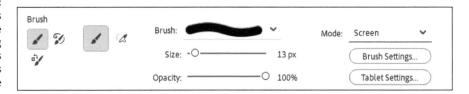

Examining the image window

Not surprisingly, the image window's tools and features are most useful when an image is open in the window. To open an image in the image window, shown in Figure 1–3, follow these steps:

1. Choose File ○ Open.

The standard Open dialog box appears; it works like any ordinary Open dialog box that you find in other applications.

You can always click one or more photos in the Organizer and click the Editor button to open the selected photos in the Photo Editor.

2. Navigate your hard drive (by using methods you know to open folders) and then select a picture.

If you haven't yet downloaded digital camera images or acquired scanned photos and want an image to experiment with, you can use a sample image. Both your operating system and Photoshop Elements typically provide sample images:

- On your operating system, sample images are typically found in your Pictures folder, which is one of the default folders in both Windows and macOS installations.
- In Elements, you can store photos anywhere on your hard drive and access them in your Organizer.

3. Select a picture and click Open.

The photo opens in a new image window in Elements.

You can open as many image windows in Elements as your computer memory can handle. When each new file is opened, a thumbnail image is added to the Photo Bin at the bottom of the workspace (refer to Figure 1–1).

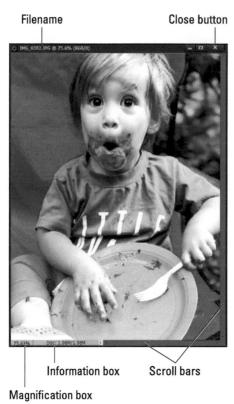

FIGURE 1-3:
The image window displays an open file undocked within the Elements workspace.

Photo: Courtany Jensen; Model: Hudson Jensen

Notice that in Figure 1–1, filenames appear as tabs above the image window when the windows are docked and not appearing as floating windows. Additionally, photo thumbnails appear in the Photo Bin. To bring a photo forward, click the filename in a tab or simply click a thumbnail in the Photo Bin. To close a photo, click the *X* adjacent to the filename or choose File r Close.

TIP

To close a photo in the image window but keep it open in the Panel Bin, click the Minimize button on a floating document window in the top-right corner (Windows) or the center button in the top-left corner (Mac). Note that in order to minimize the photo and keep it in the Photo Bin, you must set the General Preferences (Ctrl/ \Re + K) to Allow Floating Documents in Advanced Mode. Make sure the documents are in floating windows and then you can minimize them individually.

By default, all document windows are attached within the Elements document window. You can change the document windows to *floating windows* (meaning that they are free floating and unattached to the document window) by choosing Preferences and, in the General Preferences, selecting the Allow Floating Documents in Advanced Mode check box. Floating windows are available only when you are using the Advanced mode in the Photo Editor.

Here's a look at important items in the image window, as shown in Figure 1-3:

- >> Filename: Appears above the image window for each file open in the Photo Editor.
- >> Close button: Click the *X* to the right of the filename (Windows) or the left of the filename (Mac) to close the file.
- >> Scroll bars: These become active when you zoom in on an image. You can click the scroll arrows, move the scroll bar, or grab the Hand tool in the Tools panel and drag within the window to move the image.
- >> Magnification box: See at a glance how much you've zoomed in or out.
- >> Information box: You can choose what information this readout displays by choosing one of the options from the pop-up menu, which we discuss in more detail later in this section.

When you're working on an image in Elements, you always want to know the physical image size, the image resolution, and the color mode. (Size is the physical size of the image. Image resolution is the number of pixels in your image. Color mode is a mode such as RGB for red, green, and blue, grayscale for black and white, and so on.) Regardless of which menu option you select from the status bar, you can quickly glimpse these essential stats by clicking the Information box (not the right-pointing arrow but the box itself), which displays a pop-up menu like the

>> Sizing the Window:

one shown in Figure 1-4.

You can also resize the window by dragging any corner in or out when the image is undocked and not viewed as a tab.

Width: 6720 pixels (22.4 Inches) Height: 4480 pixels (14.933 Inches)

Channels: 3 (RGB Color, 8bpc) Resolution: 3 (RGB Color, 8bpc)

FIGURE 1-4:

Click the readout on the status bar to see file information.

To undock windows, press Ctrl/# +K to open the Photo Editor Preferences. Click General in the Left pane and select the box where you see Allow Floating Documents in Advanced Mode. You must be in Advanced mode to view documents undocked.

TIP

Now that you're familiar with the overall image window, we want to introduce you to the Information box's pop-up menu, which enables you to choose what details appear in the Information box. Click the right-pointing arrow to open the menu, shown in Figure 1-5.

Here's the lowdown on the options you find on the pop-up menu:

- >> Document Sizes: Shows you the saved file size.
- >> Document Profile: Shows you the color profile used with the file. Understanding color profiles is important when printing files. Turn to Chapter 12 for more information on using color profiles.
- ✓ Document Sizes

 Document Profile

 Document Dimensions

 Current Selected Layer

 Scratch Sizes

 Efficiency

 Timing

 Current Tool

FIGURE 1-5:

From the pop-up menu on the status bar, choose commands to show more information about your file.

- **>> Document Dimensions:** When selected, this option shows you the physical size in your default unit of measure, such as inches.
- >> Current Selected Layer: When you click a layer in the Layers panel and choose Current Selected Layer, the layer name appears as the readout.
- >> Scratch Sizes: Displays the amount of memory on your hard drive that's consumed by all documents open in Elements. For example, 20M/200M indicates that the open documents consume 20 megabytes and that a total of 200 megabytes is available for Elements to edit your images. When you add more content to a file, such as new layers, the first figure grows while the second figure remains static. If you find that Elements runs slowly, check your scratch sizes to see whether the complexity of your file is part of the problem. If so, you might clear some of your history or merge a few layers (see Chapter 7) to free space.
- **Efficiency:** Indicates how many operations you're performing in RAM, as opposed to using your *scratch disk* (space on your hard drive). When the number is 100 percent, you're working in RAM. When the number drops below 100 percent, you're using the scratch disk.

- If you continually work below 100 percent, it's a good indication that you need to buy more RAM to increase your efficiency. If you have multiple applications open, quit all other programs to conserve RAM.
- >> Timing: Indicates the time it took to complete the last operation.
- >> Current Tool: Shows the name of the tool selected from the Tools panel.

Why is the information in this pop-up menu important? Suppose you have a great photo you want to add to your Facebook account and you examine the photo to find the physical size of 8 x 10 inches at 300 pixels per inch (ppi). You also find that the saved file size is more than 20MB. At a quick glance, you know you want to resize or crop the photo to perhaps 4 x 6 inches at 72 ppi. (Doing so drops the file size from more than 20MB to around 365K.) Changing the resolution dramatically reduces the file size. For now, realize that the pop-up menu shows you information that can be helpful when preparing files for print and display.

Don't worry about trying to understand all these terms. The important thing to know is that you can visit the pop-up menu and change the items at will during your editing sessions.

Uncovering the contextual menus

Contextual menus are common to many programs, and Photoshop Elements is no exception. They're those little menus that appear when you right-click, offering commands and tools related to whatever area or tool you right-clicked. If you have a one-button mouse on the Mac, press Ctrl+click to open a context menu.

The contextual menus are your solution when you're in doubt about where to find a command on a menu. You just right-click an item and a pop-up menu opens.

TIP

Because contextual menus provide commands related to the tool you're using or the object or location you're clicking, the menu commands change according to the tool or feature you're using and where you click at the moment you open a contextual menu. For example, in Figure 1-6, you can see the contextual menu that appears after we create a selection marquee using the Rectangular Marquee Selection tool and right-click anywhere in the image window. Notice that the commands are all related to selections. Other selection tools, like the Quick Selection tool and Magic Wand, offer you different menu choices from a contextual menu.

Selecting the tools

More often than not, clicking a tool on the Tools panel is your first step in editing operations. (If you're not familiar with the Tools panel, refer to the upcoming

FIGURE 1-6: A contextual menu for a Rectangular Marquee selection.

Figure 1–8.) In panel hierarchy terms, you typically first click a tool on the Tools panel and then use another panel to fine-tune how the tool works.

Sometimes when you select a tool in the Tools panel, you find additional tools in the Tool Options area. For example, you may click the Rectangular Marquee tool in order to access the Elliptical Marquee tool in the Tool Options, directly below the image window. The Brush tool, Impressionist Brush, and Color Replacement tool, plus the Brush Mode and Airbrush Mode, are all shown in Figure 1–7 and are all in the Tools panel; and the Rectangular Marquee tool and Elliptical Marquee tool appear in the Tool Options panel when one of those tools is selected. See the following section for more about the Tool Options area.

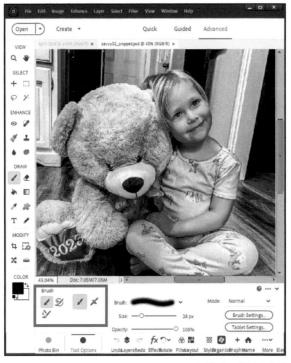

Additional tools within a tool group are available in the Tool Options.

Ted Padova (Book Author)

An additional tool introduced in this version of Photoshop Elements is the Remove tool. The tool appears in the same area as the Spot Healing Brush. Click the Spot Healing Brush and, in the Tool Options, select the Remove tool. To remove an object in a photo, draw with the Remove tool around the item you want to remove. When you release the mouse button, click the check mark, and the Photo Editor does its best to fill the removed area with the background.

Keep in mind that if you don't find a tool in the Tools panel, look in the Tool Options for additional tools within a tool group.

You can easily access tools in Elements by pressing shortcut keys on your keyboard. For a quick glance at the key that selects each tool in the Tools panel, look over Figure 1–8.

The following tips can help you find your way around the Tools panel with keyboard shortcuts:

>> To select tools within a tool group by using keystrokes, press the respective key to access the tool. For example, press the L key to select the Lasso tool. Press L again to select the Magnetic Lasso tool — the next tool in

the group. Press L again and you select the Polygon Lasso tool.

- >> Whether you have to press the Shift key to select tools is controlled by a preference setting. To change the default setting so that you need to press Shift, choose Edit ❖ Preferences ❖ General or press Ctrl+K. (Choose Adobe Photoshop Elements Editor ❖ Preferences ❖ General or press ※ +K on the Mac.) Then, in General Preferences, deselect the Use Shift Key for Tool Switch check box.
- >> The shortcuts work for you at all times, except when you're typing text with the cursor active inside a text block. Be certain to click the Tools panel to select a tool when you finish editing text, or select the Commit blue check mark to end using the Text tool.

The tools are varied, and you may find that you don't use all the tools in the Tools panel in your workflow. Rather than describe the tool functions here, we address the tools in the rest of this book as they pertain to their respective Elements tasks.

Selecting from the Tool Options

When you click a tool on the Tools panel, the Tool Options box appears at the bottom of the workspace and offers you choices specific to the selected tool. (Refer to Figure 1-7, which shows the Marquee Selection tool options.) In addition to providing you with choices for selecting tools within a tool group, you can adjust settings for a selected tool.

You can find many of these fine-tuning adjustments in the Tool Options for most of the tools you select in the Tools panel.

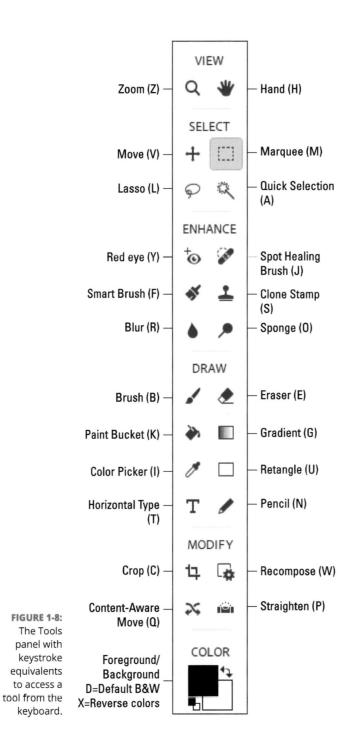

Playing with panels

The panels are where you control features such as layers, effects, and more. In the Photo Editor, you open these panels in the Panel Bin:

>> Layers: The Layers panel displays all the layers you've added to a photo. We talk much more about layers in Chapter 7. For now, look at how the different panels are designed. In the Layers panel, you find various tools at the top left and an icon with horizontal lines in the top-right corner, to the right of the Trash icon (as shown in Figure 1-9).

You can select multiple layers and click the folder icon at the top of the Layers panel to create a new layer group. All the grouped layers are nested in a folder.

When you click the icon at the top right, a pop-up menu appears (see Figure 1-10), which shows menu items supporting the tasks you perform in the Layers panel.

- >> Effects: At the bottom of the Panel Bin, click the fx button to open the Effects panel. The Effects panel contains tabs offering a number of choices for applying a number of different effects to your pictures. You simply click an effect thumbnail you want when you edit the photo. We cover applying effects in Chapter 10.
- >> Filters: Click Filters to open the panel where you can apply a number of different filter effects to the open image. For more on using Filters, see Chapter 10.
- >> Styles: Click Styles, and you find a drop-down menu listing numerous styles. Open a category and click a style to apply to an image. In some respects, this panel behaves similarly to Filters. For more on Styles, see Chapter 10.

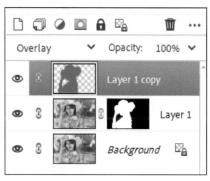

FIGURE 1-9:
The Layers panel with a Background and three layers.

FIGURE 1-10: The Layers panel pop-up menu.

- >> Graphics: The Graphics panel contains several menus where you can choose among a huge assortment of graphic illustrations that can also be added to your photos. For more information on using the Graphics panel, see Chapter 10.
- >> More: Click the down-pointing arrow at the bottom of the Panel Bin to the right of the More button, and a pop-up menu opens, allowing you to choose additional panels. The Layers, Effects, Filters, Styles, Graphics, and Favorites panels are docked in the Panel Bin and can't be removed.

The panels you open from the pop-up menu shown in Figure 1-11 open as floating panels. These are your options:

 Actions: Actions enable you to automate a series of edits to your pictures. In Figure 1-11, you can see the Actions that are supported when you open the More menu and select the Actions tab. As with other panels, a pop-up menu is supported, and it offers Load, Replace, Reset, and Clear options so that you can modify Actions.

Elements still doesn't support recording your own series of editing steps and capturing the steps as an Action. However, most of the Actions that are created in Adobe Photoshop can be loaded in Elements.

FIGURE 1-11:
Actions panel opened in a group of floating windows.

You can find a number of free downloadable Actions on the internet. Just search for *Photoshop Actions* and explore the many downloads available to you.

- Adjustments: The Adjustments panel works only when you have an Adjustment layer. For details about using the Adjustments panel and Adjustment layers, see Chapter 7.
- Color Swatches: This panel displays color swatches you might use for coloring and painting that we cover in Chapter 11.

- Favorites: Opens the Favorites panel where you find a list of items you
 designated as a favorite edit.
- Histogram: Open this panel to display a histogram of the photo in the foreground. We talk more about histograms in Chapter 9.
- History: Choose this item to display the History panel. You can go back multiple steps to, for example, undo edits from many previous steps.
- **Info:** The Info panel provides readouts for different color values and physical dimensions of your photos.
- Navigator: The Navigator panel helps you zoom in and move around on a photo in the image window.
- Custom Workspace: When you choose Custom Workspace, you can dock and undock panels. This option enables you to configure a custom workspace to your liking.
- >> Create/Share panel: These panels also exist in the Organizer. Click Create at the top right of the Panel Bin to open the Create panel in the Photo Editor. In both the Photo Editor and the Organizer, the Create panel is used for making a number of creations such as calendars, photo books, greeting cards, photo collages, and more. The Share panel contains many options for sharing your photos. We talk more about making creations in Chapter 14, and we cover using the Share panel in Chapter 13.

When you open the additional panels as floating windows, the panels are docked in a common floating window. You can drag a panel out of the docked position and view it as a separate panel or move it to the docked panels.

When you open a panel in either the Organizer or the Photo Editor, you find other options available from tools, drop-down lists, and a menu you open by clicking the icon with horizontal lines in the top-right corner of the panel.

Using the Photo Bin

The Photo Bin displays thumbnail views of all your open images (see Figure 1-12). You can immediately see a small image of all the pictures you have open at one time (refer to Figure 1-12). You can also see thumbnail views of all the different views you create for a single picture. Find out all the details in the following sections.

PIGURE 1-12:
Open the
Photo Bin
Options
pop-up menu
to display
various
actions you
can perform
on pictures
open in the
Photo Bin.

If you want to rearrange the order of the thumbnails in the Photo Bin, you can click and drag any thumbnail to the left or right.

Creating different views of an image

What? Different views of the same picture, you say? Yes, indeed. You might create a new view when you want to zoom in on an area for some precise editing and then want to switch back to a wider view. Here's how you do it:

1. Click a thumbnail image in the Photo Bin.

You must have a photo open in the Photo Editor Image window. The photo you click in the Photo Bin appears in the image window as the active document.

2. Choose View New Window for <filename>.

Note that <filename> is the name of the file in the image window.

3. Zoom to the new view.

Note that to see both windows, you need to undock the windows from the docked position. Open Preferences by pressing Ctrl/# + K. In General Preferences, select the box for Allow Floating Documents in Advanced Mode. Drag the windows down and away from the docked position to create a floating window. You can now position the windows side by side and view one at actual size and the other in a zoomed view.

A new view appears for the active document, and you see another thumbnail image added to the Photo Bin.

To zoom quickly, click the Zoom tool in the Tools panel and then click a few times on the picture in the image window to zoom in to the photo.

Viewing filenames

By default, photos open and are displayed in the Photo Bin without the associated filenames. However, if you mouse over a photo in the Photo Bin, a tooltip opens that displays the name of the file. If you want the name of each file shown in the Photo Bin without having to mouse over the files, open a contextual menu on a photo in the Photo Bin and choose Show Filenames.

Using Photo Bin Actions

On the Photo Bin Actions menu, you find handy tasks that you can perform on photos open in the Photo Editor. Click the Photo Bin Options drop-down menu (refer to Figure 1-12) to display the menu commands.

Here's what each Photo Bin command does:

- >> Print Bin Files: Select the files in the Photo Bin that you want to print and then choose Print Bin Files. The selected files open in the Print dialog box, where you can make photo prints of the selected images.
- >> Save Bin as an Album: You can add photos to an existing album, or you can create a new album. You can do many wonderful things with Photo Albums.
- **Show Grid:** By default, no divider lines appear between photos in the Photo Bin. When you choose Show Grid, divider lines appear between the photos.

Using Some Creative Features

Adding some creative effects to your photos has long been a stellar aspect of Elements. Quite often, users explore many interesting edits in the Guided Edit panel. Guided Edits not only provide you with many interesting effects to apply to your photos but also offer you easy step-by-step instructions on how to use each effect.

Using Guided Edits

Click the Guided tab at the top of the Image window in the Photo Editor, and the Guided Edit panel opens, as shown in Figure 1–13.

FIGURE 1-13: Click the Guided tab to open the Guided Edit panel.

When you click an editing option, a panel opens on the right side of the window. In the panel is a sequence of steps. Follow the steps, and you end up with a result similar to the example shown in the panel. At the top of the panel is a list of categories beginning with Basic on the left and ending with Search on the right. The Search option lets you search for a particular Guided Edit. When you click one of the other options for a given category, the panel changes and displays all the individual edits you find in the respective category.

Guided Edits walk you through various steps to apply a given edit to the open image. The best way to discover what results you can achieve is to open photos and apply various edits using the Guided panel. Some of the more complicated options, such as creating Out of Bounds effects, offer you a link to online video tutorials to help you further simplify the process.

Working with Adobe Stock images

Photoshop Elements offers you access to millions of free photos in the Adobe Stock photos library. You can use stock photo images as stand-alone photos, applied as backgrounds, and use the photos in documents much as you use graphic images from the Graphics Panel.

You have three methods for accessing the Adobe Stock photos library. One way is to choose the File ⇒ Search on Adobe Stock menu command. This command lets you search for photos in the library and open them directly in the Advanced editing mode in the Photo Editor. You can also replace a background using the Replace Background Guided Edit and use a stock photo for your new background. The third option is to click Adobe Stock in the Graphics panel. You access the Graphics panel by clicking the + symbol at the bottom of the panels column. When you click Adobe Stock in the Graphics panel, the Adobe Stock dialog opens. Type search criterion and the panel displays returned results. (To find out how to replace a background, see Chapter 15; to add images to the Graphics panel, see Chapter 10.)

Figure 1-14 shows the results of entering Model A Ford in the Search field.

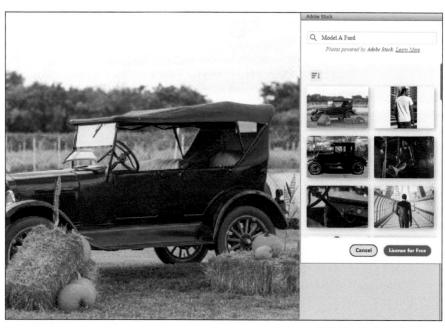

Images for a Model A Ford found on Adobe Stock.

Felix Mizioznikov/Adobe Stock Photos

To import a photo after finding the one you want, select it in the Search window and click the License for Free button. Elements adds the photo as a new document in the Advanced mode in the Photo Editor.

Photos in Adobe Stock are now becoming a foundation for many artificial intelligence (AI) tasks in Adobe applications. There are also web-based applications that you can use for free to enhance your photos and create some stunning results. Although these applications aren't part of Photoshop Elements, you can use some

creations made in certain free Adobe applications and import your results into Photoshop Elements documents.

One such application is Adobe Firefly (www.adobe.com/ph_en/products/firefly.html). You need to sign up for access, and you may need to wait a few days before Adobe grants you access to the website. If you're accepted, you can log on to Adobe Firefly to arrive at the default web page shown in Figure 1-15.

Searching Guided Edits

Click Search as shown in Figure 1-13 and you can search through Guided Edits to find the one you want to use.

Controlling the Editing Environment

Opening Elements for the first time is like moving into a new office. Before you begin work, you need to organize the office. At minimum, you need to set up the desk and computer before you can do anything. In Elements terms, the office organization consists of specifying preference settings. Preferences are settings that provide a means to customize your work in Elements and to fine-tune the program according to your personal work habits.

In the following sections, we explain the preference options that you most likely want to adjust.

Elements has two Preferences dialog boxes: one in the Photo Editor workspace and another in the Organizer workspace. The following sections cover the Preferences dialog box that you open when in the Photo Editor, whether you're using Windows or the Mac. See Chapter 2 for details about Organizer preferences.

Launching and navigating Preferences

The Photo Editor's Preferences dialog box organizes all the options into several panes. By default, when you open the Preferences dialog box, you see the General pane.

To open the Preferences dialog box, choose Edit ♣ Preferences ♣ General (or Photoshop Elements Editor ♣ Preferences ♣ General on the Mac). Alternatively, press Ctrl+K (ૠ +K on the Mac). Using either method opens the Preferences dialog box to the General pane, as shown in Figure 1–15.

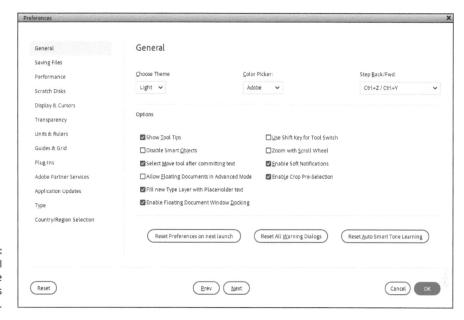

The General pane in the Preferences dialog box.

In Figure 1-15, you see items on both the left and right sides of the dialog box that are common to all preferences panes. Here's a quick introduction to what these items are and how they work:

- >> Panes list: Elements lists all the different panes along the left side of the Preferences dialog box. Click an item in the list to make the respective pane open on the right side of the dialog box.
- >> OK: Click OK to accept any changes made in any pane and dismiss the Preferences dialog box.
- >> Cancel: Click Cancel to return to the same settings as when you opened a pane and to dismiss the dialog box.
- >> Reset Preferences on Next Launch: Clicking the Restore Default Settings button returns the dialog box to the same settings as when you opened the dialog box. The dialog box stays open for you to set new settings.

Of particular importance in the General tab are the items you see for Allow Floating Documents in Advanced Mode and Enable Floating Document Window Docking. As we discuss earlier in this chapter (see "Examining the image window"), select these check boxes if you want to undock the document windows from the tabs.

Checking out all the Preferences panes

The settings in the Preferences dialog box are organized into different panes that reflect key categories of preferences. The following list briefly describes the types of settings you can adjust in each preferences pane:

- **>> General preferences:** As the name implies, these apply to general settings you adjust for your editing environment.
- >> Saving Files preferences: These relate to options available for saving files. You can change the case of existing filenames; save a file with layers or flatten layers (as we explain in Chapter 7); save files with image previews that appear when you're viewing files as icons on your desktop (Windows); and save with some compatibility options. On the Mac, the Finder generates thumbnails automatically, so you don't need to specify thumbnails in a Save dialog box.
- >> Performance preferences: This pane is where you find history states and memory settings, such as allocating memory to Elements. Be certain to not allocate all memory to Elements. You need to have sufficient memory for your operating system, and any other applications you may use in tandem with Elements.
- >> Scratch Disks preferences: Below Performance, you find scratch disk options. (See the nearby sidebar "What's a scratch disk?" for more on scratch disks.) You can monitor how your scratch preferences are working in the image window. See the earlier section, "Examining the image window," for details.
- >> Display & Cursors preferences: This pane offers options for how certain tool cursors are displayed and how you view the Crop tool when you're cropping images. Chapter 8 explains how cropping works.
- >> Transparency preferences: These require an understanding of how Elements represents transparency. Imagine painting a portrait on a piece of clear acetate. The area you paint is opaque, and the area surrounding the portrait is transparent. To display transparency in Elements, you need some method to represent transparent areas. Open the Transparency preferences and make choices for how transparency appears in Elements.
- >> Units & Rulers preferences: Here you can specify settings for ruler units, column guides, and document preset resolutions.
- >> Guides & Grid preferences: This pane offers options for gridline color, divisions, and subdivisions. A grid shows you nonprinting horizontal and vertical lines. You use a grid to align objects, type, and other elements. You can snap items to the gridlines to make aligning objects much easier. You can drag guides (sometimes called guidelines) from the ruler and position them between gridlines.

- >> Plug-Ins preferences: These preferences include options for selecting an additional Plug-Ins folder. Plug-ins are third-party utilities that work with Elements. For example, you can find plug-ins that offer editing features not found in Elements, enable many different adjustments for brightness/contrast and color correction, and provide some nifty special effects. You can find many free plug-ins on the internet by searching for *Photoshop Elements Plug-Ins*.
- Adobe Partner Services: Here you can control whether Elements automatically checks for new services, clears the online stored data, and resets your account information for all services.
- >> Application Updates: You can choose to automatically update Elements or receive a notification that an update is available.
- >> Type preferences: This pane provides options for setting text attributes. You have options for using different quotation marks, showing Asian characters, showing font names in English, and previewing font sizes.
- >> Country/Region Selection: You can select your country or region from the drop-down menu.

WHAT'S A SCRATCH DISK?

Assume that you have 1GB of free RAM (your internal computer memory) and you want to work on a picture that consumes 1.25GB of hard drive space. Elements needs to load all 1.25GB of the file into RAM. Therefore, an auxiliary source of RAM is needed for you to work on the image. Elements uses your hard drive. When a hard drive is used as an extension of RAM, this source is a *scratch disk*.

If you have more than one hard drive connected to your computer, you can instruct Elements to use all hard drives, and you can select the order of the hard drives that Elements uses for your extension of RAM. All disks and media sources appear in a list as 1, 2, 3, 4, and so on.

Warning: Don't use USB 1.1 external hard drives or other drives that have connections slower than USB 2.0, Thunderbolt, or FireWire. Using slower drives slows Elements' performance. USB 2.0 drives are being phased out and giving way to the newer, faster USB 3.0 drives.

Perusing preset libraries

Part of the fun of image editing is choosing brush tips, swatch colors, gradient colors, and patterns to create the look you want. To get you started, Elements provides you with a number of preset libraries that you can load and use when you want. For example, you can load a Brushes library to acquire different brush tips that you can use with the Brush tool and the Eraser tool. But you're likely to want to customize the preset libraries at least a little bit, too.

You can change libraries individually in respective panels where the items are used. For example, you can change color swatch libraries on the Color Swatches panel or choose brush-tip libraries in the Tool Options. Another way you can change libraries is to use the Preset Manager dialog box, as shown in Figure 1-16.

FIGURE 1-16:
The Preset
Manager dialog
box provides
a central area
where you
can change
libraries.

We cover using the presets in Chapter 10, which is where you can find out how to use the many presets that Elements provides. The important thing to note here is that you can change the presets according to your editing needs.

To open the Preset Manager dialog box, choose Edit \Rightarrow Preset Manager. The available options in the dialog box are

Learn More About: The Preset Manager: Click the blue Preset Manager hyperlinked text to open the Help document and find out more about managing presets.

- **Done:** Any changes you make in the Preset Manager are recorded and saved when you click Done.
- >> Preset Type: Open the drop-down list to choose from Brushes, Swatches, Gradients, Styles, Patterns, and Effects.
- **Append:** Click the Append button to append a library to the existing library open in the Preset Manager.
- >> Add: Click this button to open another library. Elements allows you to choose from several libraries for each preset type. When you choose Add, the open library closes as a new library opens. If you added a new item, such as a brush, it's lost when you click Add unless you saved the new brush. For more on brushes, see Chapter 11.
- >> Save Set: You can save any changes you make in the Preset Manager as a new library. If you make a change, use this option so that you don't disturb the original presets.
- >>> Rename: Each item in a library has a unique name. If you want to rename an item, click the thumbnail in the Preview pane, click Rename, and then type a new name in the dialog box that appears.
- >> Delete: Click an item in the Preview window and click Delete to remove the item from the library.

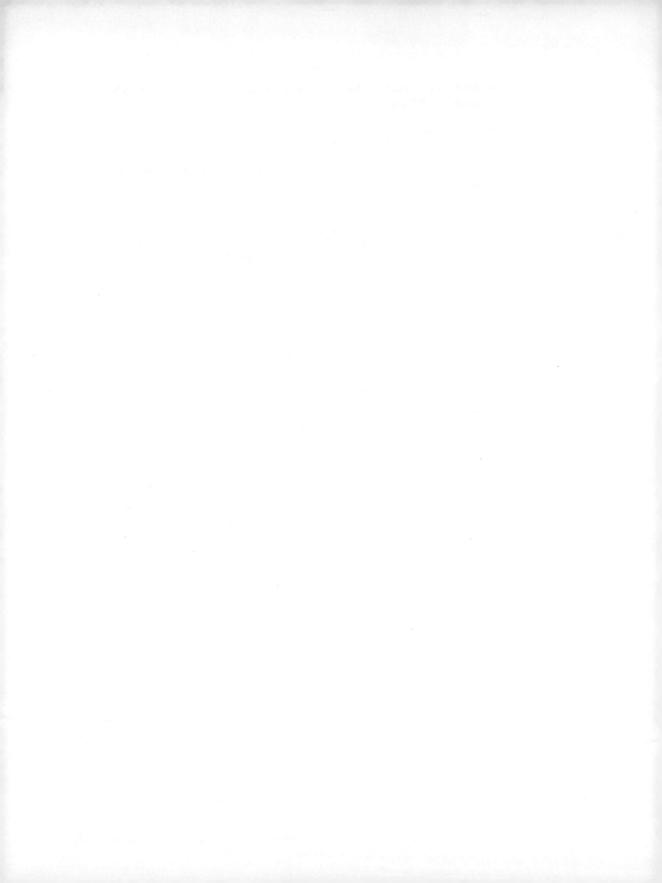

- » Organizing your photos on your computer
- » Importing photos into the Organizer
- » Exploring the Media Browser
- » Scanning photos and artwork
- » Acquiring photos from cellphones and tablets
- » Using Preferences

Chapter 2

Getting Familiar with the Organizer

o you treasure your color-coded filing system and own a special sock drawer organizer? Or are you more inclined to hand your accountant a plastic grocery sack of statements and receipts to sort out for you when tax-filing season comes around?

We're not here to judge. Whatever your organizational style, you'll like the Elements Organizer. The Organizer gives you myriad ways to tag and rate your images, but it also provides tools that automate some of the work.

Before you get started with all the organizational tools, you need to import images into the Elements Organizer. That's what this chapter is all about.

You have many ways to import a picture into Elements. We walk you through an easy method for importing images from cameras and card readers into the Organizer. We also help you import images from CDs, DVDs, a scanner, or your phone and tablet.

Touring the Organizer

To help you start using the Organizer's photo-management tools, we begin this chapter with more information about Organizer tasks by first offering a glimpse at the Organizer workspace.

Figure 2-1 shows you an Organizer view. The various items in the Organizer include the following:

- (A) Menu bar: The Organizer menus appear in the top-left section of the menu bar. In Windows, the menus belong to the application. On the Mac, the menu bar is part of the operating system's menus.
- (B) Sort By: The Sort By drop-down list is where you can sort the thumbnails in the Media Browser according to Newest, Oldest, and Batches of photos that you imported.
- (C) Media/People/Places/Events: At the top of the Organizer window, you find four tabs:
 - Media: The first tab is Media. Click the Media tab to display thumbnails of photos either in a folder or in the entire catalog. (See Chapter 4 for more on catalogs.)
 - People: Click this tab to display photos where you have tagged faces, as we discuss later in this chapter.
 - Places: Click this tab, and a Google map appears in the Panel Bin. You can
 tag photos according to map coordinates by using Google Maps. Click the
 Add Location button (item Q) to tag an image with a place on the map. See
 Chapter 4 for more on adding places.
 - **Events:** Click this tab to display photos that have been tagged as Events. To tag a photo with an Event, click the Add Event button (item R).

We talk more about tagging photos in Chapter 3.

(D) Search: Click this button to open the Search pane.

When you click the Search button, a window opens, from which you can choose from a number of different search options. We cover the new Search features in Chapter 4.

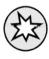

NEW

(E) Media Filter buttons: The four buttons in this area are part of a new feature in Elements 2025, The four buttons enable you to filter content in the Media Browser by Photos, Videos, Music, and Projects. Click one of the buttons and the Media Browser displays only those items corresponding to the button(s) you select. If you want more than one filter applied, such as videos and music, click the Video button and the Music button; both items are shown in the Media Browser.

- **(F) Features buttons:** In Windows, you find Maximize, Minimize, and Close buttons in the top-right corner of the Organizer. On the Mac, in the top-left corner, you find Close, Minimize to Dock, and Maximize.
- (G) Import: From the drop-down list, you can choose to import photos from Files and Folders, Camera or Card Reader, or Scanner. Another option enables you to search your hard drive. On the Mac, you have an additional option. Choose File

 Get Photos and Videos

 in Bulk. A dialog box opens and lets you import files from folders.
- (H) Share: This drop-down menu offers several options for sharing your images to Twitter, Facebook, by email, and more. For more information on sharing photos, see Chapter 13.
 - (1) Create: This drop-down menu offers options for making a variety of creations in Elements. You can make slideshows, calendars, photos, books, and more. For more information on making creations, see Chapter 14.
 - (J) Ratings: Ratings are denoted by one to five stars. Click a star, and images identified with a given rating are displayed in the Media Browser. Select the Auto Curate check box to choose to auto analyze photos for visual similarities.
- (K) Albums/Folders tabs: Click Albums to view any Photo Albums you have created. Click Folders to display a folder view, as shown in Figure 2-1.
- (L) Auto Curate: Select this box to quickly select your best images in the Media Browser. The Organizer automatically curates your photos based on image quality, people, Smart Tags, and more.
- (M) Folders view: Click a Folder name to display just the photos within the respective folder. In Figure 2-1, you see the Puerto Vallarta folder selected in the My Folders panel.
- (N) **Hide Panel:** Click this button to hide the left panel. Doing so provides you with a maximum viewing area for the photo thumbnails.
- (O) Undo: This item and (P), Rotate, go hand in hand. When you rotate an image using the Rotate tool, you can Undo by clicking this tool.
- (P) Rotate: When you click the arrow, you can choose to rotate a photo clockwise or counterclockwise. To use either tool, you must first select a thumbnail in the Media Browser.
- (Q) Add Location: When you select a photo and click Add Locations, a window opens atop the Organizer. Type a location name (as it appears on a map), and the new location is added to the Places panel.
- (R) Add Event: Add Event is yet another item that helps you organize your photos. You can add tags for people, places, and then events to help narrow down a large collection of photos. Each of these items can be sorted by clicking the respective tab at the top of the Organizer.

- (S) Instant Fix: Click this button to apply Quick Edit fixes to your photographs. You can crop, adjust lighting, fix red-eye problems, and apply some smart fixes to your photographs without opening them in the Photo Editor.
- (T) Editor: Click to return to the Photo Editor. If you have Premiere Elements installed you can choose it from the menu as well as Photoshop.
- (U) Slideshow: Click this button to begin a new project called Memories. Memories displays selected images as a video. For more on Memories, see Chapter 14.
- (V) Home Screen: Open the Home Screen that opens by default when you launch Photoshop Elements.
- (W) Adobe Elements (Beta): This button links to Elements Web. Elements Web is a web application you can use for making a variety of creations. For more information search https://elements.adobe.com in your web Browser.
- (X) Media Browser: The Media Browser shows thumbnails of your images.
- (Y) **Zoom:** Adjust the slider to make thumbnails larger or smaller.
- (Z) Catalog Info. The readout shows you the name of the current calendar in use.
- (AA) Tags panel. This panel offers many options for tagging your content. For more information on tagging items, see Chapter 3.

FIGURE 2-1: The Organizer workspace.

Photo by Ted Padova

This overall description of the Organizer can be helpful when you perform tasks related to the Organizer. Earmark this page and use it as a reference to quickly identify items contained in the Organizer.

Organizing Photos and Media on a Hard Drive

Photos and media hog most of the available storage space on the average consumer's computer. If you're anything like us, you grab a ton of photos and videos with your digital camera, smartphone, and maybe a tablet, too. Even if you faithfully transfer images from all these different sources to your computer, you can end up with a real mess of photos — all with inscrutable filenames such as DS603_Azb42.jpg.

If all the photos on your hard drive are organized into folders, you'll have an easier time managing those photos in the Elements Organizer. We recommend that you organize your image files in folders before you start working with Elements.

How you label your folders is a personal choice. You may want to name the folders by year and use subfolders for organizing photos by events, locations, photo content, and so on. In Figure 2–2, you can see just one example of how you might organize your photos on a hard drive.

After you organize your photos into folders, you can use the Organizer to import files from folders, as we explain later, in the section "Adding files from folders and removable media."

FIGURE 2-2:
Organize photos and media in folders and subfolders on your hard drive.

TIP

If your image files gobble up too much space on your computer's hard drive, we recommend storing all your photos on an external drive instead. Fortunately, the price of large-capacity drives is well within the reach of most people who own a computer, digital camera, or smartphone. Depending on how many photos you take (or image files you create), look for a 1TB to 4TB USB drive that attaches to your computer. Use the drive only for your photos, videos, and other media, and don't copy other data files to it. When all your image and media files are in one place, keeping them organized on that drive becomes much easier. If your photos are very precious to you, consider backing them up on a second hard drive in case the backup drive fails.

Adding Images to the Organizer

To use the Elements Organizer, you need to import the images into the Organizer.

You have several options for downloading photos from your camera and other devices to your computer:

- >> Using AutoPlay Wizards for Windows and Assistants on the Mac
- >> Importing photos directly from Photos (formerly iPhoto) if you use a Mac
- >> Using the Photoshop Elements Downloader

The built-in downloaders from your operating system attempt to make your life easier, but in reality, it may be more difficult to struggle with a downloader application and later organize files in folders (as we recommend earlier in this chapter).

TIP

Perhaps the easiest method for transferring photos from a camera or card reader is to quit the operating system's downloader application or any camera-specific applications and just stay with the tools that Photoshop Elements provides.

The following sections introduce you to the tools available for adding images to the Organizer. If you've already organized images on your hard drive or other media into folders, the Get Files from Folders command can help. If images are still on your camera, the Elements Downloader enables you to download images from your camera into the folder where you want to keep the images, using whatever folder organization system you've created; the Elements Downloader also imports the images into the Organizer at the same time.

Adding files from folders and removable media

Most people have photos on their computer's hard drive, as well as on removable media, such as external hard drives, media cards, or maybe even a USB flash drive. Adding images from your hard drive to the Organizer is easy. If you have a source, such as a USB flash drive, media card, or external hard drive, you copy files from the source to the drive where you store photos. Or you can copy files into the Organizer directly from the removable media.

The following steps explain how to import images from your hard drive into the Organizer Media Browser:

Click the Import button in the top-left corner of the Organizer to open the drop-down list and choose From Files and Folders.

Alternatively, you can choose File $\ \ \, \Box$ Get Photos and Videos $\ \ \, \Box$ From Files and Folders.

The Get Photos and Videos from Files and Folders dialog box opens. The dialog appears different between Windows and the Mac. In Figure 2-3, you see the Get Photos and Videos from Files and Folders on Windows on the left and the Mac version on the right.

When you first click the Import button or choose File ❖ Get Photos and Videos ❖ From Files and Folders, the dialog box appears, showing you some information regarding importing photos. Click the Start Importing button or the Skip button to continue importing photos. After you click the Start Importing button, another dialog box appears, prompting you to use the Auto Tagging feature.

2. Browse your hard drive for the photos you want to add.

You can navigate your computer and any connected external drives or media devices in the left-hand pane. (For example, if you've connected a USB drive of photos or loaded a CD of images into your CD drive, you can navigate to those photos here.) The contents of the selected drive or folder appear in the middle pane of the dialog box.

TIP

If you're importing photos directly from the external device, by default, the Get Photos and Videos from Files and Folders dialog box copies your media to your hard drive when you click the Get Media button. You can deselect the Copy Files on Import check box so that only thumbnail images will appear in the Media Browser. To edit a photo, you have to reconnect the drive, CD, or DVD to your computer. If you elect to copy the images, the photos are available for editing each time you start a new Elements session.

You can keep photos and videos on external drives and don't need to copy the images to your internal hard drive. Create a catalog specifically for a particular drive and open that catalog when you connect the drive. In this regard, you can have several external drives, each with its own catalog. For information on creating a new catalog, see Chapter 4.

3. Select the files or a folder that you want to import.

You can import individual images, a single folder of photos, or a folder and all its subfolders.

4. Click the Get Media button.

FIGURE 2-3: The Get Photos and Videos from Files and Folders dialog box (Windows, left; Mac, right).

When you add files to the Organizer, the image thumbnails are links to the files stored on your drive. They don't contain the complete image data.

If you want to import a single photo and you want to know the file attributes of the targeted photo, place the cursor over a photo; a tooltip displays file attribute information.

Downloading camera images with the Elements Downloader

Import photos from your camera to the Organizer as follows:

 Insert a media card from a camera or attach a camera to your computer via a USB port.

We recommend using a media card instead of attaching your camera, in case the battery is low on your camera. (If the battery runs out, the import stops.) If you have a media card for your camera, take it out and insert it into a card reader that you attach to your computer via a USB port or a built-in card reader in your computer.

- If, after you insert a media card, you see an Autoplay Wizard on Windows
 or a dialog box for importing photos into Photos on the Mac, cancel out
 of the dialog box and let Elements control your import. Otherwise, skip
 to Step 3.
- 3. In Elements, open the Organizer workspace and choose Import

 From Files and Folders. Or choose File

 Get Photos From Camera or Card Reader.

The Elements Organizer – Photo Downloader opens, as shown in Figure 2-3.

- 4. From the Get Photos From drop-down list at the top of the dialog box, choose your media card.
- Click the Browse button (Choose on Mac) and locate the folder on your drive to which you want to copy the photos.

If you don't click the Browse button and select a folder, all files copied to your hard drive are copied to the User Pictures folder. This is the default for Photoshop Elements. If you use an external hard drive to store your photos, you'll want to copy photos to the external drive. When you select a folder, select the one that fits the overall folder organizational structure for your images so that your image files stay organized.

You can also create a new folder and add files from your media to the new folder. Click Advanced Dialog in the lower-left corner. Another dialog box opens. Click Browse and create a new folder in the Browse dialog box.

You can leave the rest of the settings at the defaults or rename the photos here. You can also take care of file renaming in the Organizer later. Don't delete the photos from your card just in case you delete some photos in the Organizer and want to retrieve them. After you're certain everything in Elements is to your liking, you can later delete photos by reformatting your media card.

When renaming images, try to use a system that you easily comprehend. Use descriptive names such as family_2.20, Spain_3.19, photoshoot_Kelley, and so on, including dates or other descriptors such as the kind of event or the people photographed.

The Downloader has an Advanced dialog box that you access by clicking the Advanced Dialog button. In the Advanced settings, you can make choices for things like correcting for red eye, creating photo stacks, and editing photo data that we call metadata. (We explain metadata in Chapter 4.) Because you can handle all these tasks in Elements, just leave the Advanced settings at their defaults.

TIP

Import photos by clicking the Get Media button in the Photo Downloader dialog box.

Elements adds the photos to the Organizer, and you eventually see thumbnail images in the Organizer's Media Browser after the upload completes (see Figure 2-4). Give Elements some time to finish. If the Auto-Analyzer is on in your Preferences, Elements will run through facial recognition and add similar faces to different clusters.

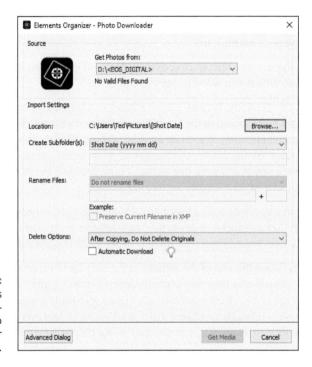

FIGURE 2-4: The Elements Organizer – Photo Downloader opens.

When you import images in the Organizer, by default the images are auto analyzed for visual similarity in addition to the facial recognition analysis. When these items are enabled in the Preferences, it can take some time to complete the import if you have a lot of files.

Importing additional photos from folders

Suppose you have your folders organized and photos copied to various folders. You take some more pictures of the same location and want to add these photos to a folder you already have labeled as a location name. To add pictures to a folder on your hard drive or external drive, follow these steps:

1. Copy photos from a media card to your hard drive or external drive.

In this example, we want to copy photos to a folder we have labeled Portraits.

2. In the Organizer, choose File

Get Photos and Videos

From Files and Folders.

The Get Photos and Videos from Files and Folders dialog box opens.

3. Select the folder on your hard drive where you copied the new photos.

In this case, we select the folder containing the files we want to import.

4. Click the Get Media button.

The Getting Media dialog box appears, and the photos are added to the Organizer (see Figure 2-5).

5. Click OK in the Getting Media dialog box.

Photoshop Elements is smart enough to import only new images into the Organizer. Any images you previously imported from a given folder are listed in the Getting Media dialog box, and you're informed that the old images will not be imported.

FIGURE 2-5: Folder names appear in the Import panel.

Navigating the Media Browser

When you add photos to the Organizer, the photos and any additional media appear as thumbnails in the central portion of the Organizer — known as the Media Browser.

After files are imported into the Organizer, you see just those photos you imported in the Media Browser. Similarly, when you click a folder in the Import panel, only the photos within the selected folder display in the Media Browser. To see all the photos in your catalog, click the All Media button at the top of the Media Browser.

The Import panel is the list of folders on the left. You can collapse the panel to provide more viewing area in the Media Browser. Just click the Hide Panel button in the lower-left corner of the Organizer workspace (see Figure 2-6).

PHOTOS are displayed in a Tree view in the Import panel. The Hide Panel appears in the lower-left corner of the window.

The Import panel offers two different views:

>> List view: By default, you see the folder List view that shows all folders imported in alphabetical order. If you have photos in subfolders, the Folder List view doesn't reflect the hierarchy for how your photos are organized on your hard drive.

TID

>> Tree view: To see a different view in the Organizer, click the drop-down list and choose View as Tree, and you change the Import panel view to the hierarchy view, as shown in Figure 2-6.

To toggle views, click the down arrow adjacent to My Folders in the left panel and choose View as Tree or View as List.

If you have a touchscreen monitor or device, you can swipe photos to view them one at a time.

If you don't see the details below the photos, or the photos don't appear in grid view, press Ctrl+D (策+D) to change the Media Browser view.

Setting Organizer Preferences

Throughout this book, we often refer to making some choices in the application Preferences. The Organizer and the Photo Editor have a set of preferences that you open by choosing Edit ⇔ Preferences (Windows) or Photoshop Elements Organizer ⇔ Preferences (Mac), or by pressing Ctrl/★ +K. Each set of preferences has several panels. When you click an item in a panel's left pane, options for the respective item appear in the right pane. After making your choices, click OK, and the preferences remain for all subsequent sessions in the Organizer.

If your computer has only 8G or less of RAM, you may find Elements performing very slowly. One of the items that slows down a computer running Elements with less than 16G of RAM is Media-Analysis. By default, Face Recognition and Media-Analysis are turned on. To turn off the auto analysis operations, be in the Organizer and press $Ctrl/\Re$ +K to open the Organizer Preferences panel. Click Media-Analysis and deselect all the check boxes, as shown in Figure 2-7. Click OK, and the auto run operations of Media-Analysis will stop.

Many preference items are self-explanatory. When you need some detail on making a preference choice, refer to the Adobe Help file, which you can find by choosing Help

⇒ Elements Organizer Help.

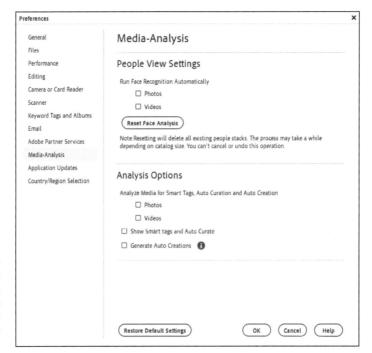

FIGURE 2-7:
Open the
Organizer's
Preferences
and deselect
all the MediaAnalysis items.

- » Creating tags
- » Using the Auto Curator and Auto Creations
- » Rating your images and placing them on maps
- » Working with albums
- » Working with Events

Chapter **3**

Organizing Your Pictures

ownloading a bunch of media cards filled with photos and leaving them in folders distributed all over your hard drive is like having a messy office with papers stacked haphazardly all on your desk. Trying to find a file, even with all the great search capabilities we cover in Chapter 4, can take you as much time as sorting through piles of papers. What you need is a good filemanagement system.

In this chapter, we talk about tagging photos, organizing and annotating files, creating versions and stacks, creating photo albums, and performing other tasks so that you can quickly sort through large collections of photos. Be certain to take some time to understand the organizational methods that Elements offers, and keep your files organized when you copy them to your hard drive. Sharpening your photo-management skills enables you to easily find photos you want to edit, add photos to a new creation, or share photos with friends and family.

Organizing Groups of Images with Tags

Tags are a great way to organize your files. After you acquire your images in the Organizer, as we discuss in Chapter 2, you can tag images according to the dates when you took the pictures, the subject matter, or some other categorical arrangement so that the images are easy to sort.

The Organizer's Tags panel helps you tag your photos and gives you the flexibility to customize your tags.

The Tags panel is divided into four categories: Keywords, People Tags, Places Tags, and Events Tags (see Figure 3-1).

The Organizer helps you organize your photos into these four main categories, and each category has a drop-down list that you can use to create new tags and add new sub-categories. In the following sections, you can find out how to create and manage tags.

FIGURE 3-1: The Tags panel in the Organizer.

To create a new tag and add tags to photos, follow these steps:

 $oldsymbol{1}$. Open the Media Browser and select photos you want to tag.

See Chapter 2 for details about opening images in the Organizer.

- To create a new tag, choose which category you want to use (Keywords, People Tags, Places Tags, or Events Tags) and then click the down arrow adjacent to the plus (+) icon next to that category to open a drop-down list.
- 3. From the Tags panel, choose the type of tag you want:
 - Keywords: Choose New Keyword Tag.
 - People Tags: Choose New Person.
 - Places Tags: Choose Add a New Place.
 - Events Tags: Choose Add an Event.

When you add a new Keyword tag, the Create Keyword Tag dialog box opens, as shown in Figure 3-2, where you can add information about the tag attributes.

Depending on what category you choose, the information you fill into the dialog box varies. For example, when you add a new tag in the Keywords category, the Create Keyword Tag dialog box provides options for editing the tag icon, specifying a category, typing a name, and adding comments. If you add a People tag, you type a person's name and choose a group such as family, friends, and so on. If you add a Places tag, you can choose to map the location. If you add an Events tag, you type the tags for the event, choose dates, and add a description. Hence, the attributes change according to the type of tag you create.

In our example, we add a new tag to the Keywords category.

4. Specify a category.

Click the Category drop-down list and choose one of the preset categories listed in the menu. In our example, we chose Other for the Category.

Type a name for the tag in the Name text box and add a note to describe the tag.

> You might use the location where you took the photos, the subject matter, or other descriptive information for the note. In our example, we chose Statue.

Click OK.

You return to the Organizer.

In the Organizer, select the photos to which you want to add tags.

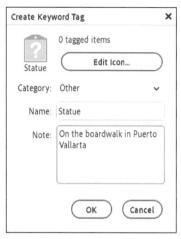

FIGURE 3-2: The Create Keyword Tag dialog box.

Click a photo and Shift-click another photo to select photos in a group. Click a photo and Ctrl+click (策 +click) different photos scattered around the Organizer to select nonsequential photos.

8. To add a new tag to a photo, first click the plus (+) symbol in the Tags panel to name a new tag, as shown in Figure 3-3. After a tag has been created, drag photos to the tag to tag them.

Alternatively, you can drag a tag to the selected photos.

When you release the mouse button, the photos are tagged.

The check box adjacent to the tag name is used to display all photos with the respective tag in the Media Browser.

Repeat Steps 2-8 to create tags for all the images you want to organize.

The Tags panel after adding a tag in the Keywords category.

Multiple keyword tags can be added to the same image.

Tags help you in many ways, as we explain later in this chapter, including the ways described in "Creating an album," later in this chapter. The more you become familiar with tagging photos, the more opportunities you have for sorting and finding photos and adding found photos to albums. We encourage you to play

with the Tags panel and explore creating tags and tagging photos in each of the different categories.

There are many more edits you can make with tags. You can add icons, create custom tags, create sub-categories, and add tags to people, places, and events. To learn more about working with additional tag features, use the Adobe Help file, which you can access by opening the Help menu and choosing Photoshop Elements Help, or by pressing F1.

Rating Images with Stars

You can rate photos in the Organizer by assigning images a number of stars, from one to five. You might have some photos that are exceptional, which you want to give five-star ratings, whereas poor photos with lighting and focus problems might be rated with one star.

To assign a star rating to a photo, select a photo in the Media Browser and click a star below the selected photo. Note that you must choose Details in the Organizer Find menu or press Ctrl/光 +D to show star options in the Media Browser. After you rate images according to stars, the star rating is shown in the Tags panel, as shown in Figure 3-4. One star is the lowest rating, and five stars is the highest.

Photos can be rated with stars by clicking a star below a photo in the Media Browser. To see the stars below photos, you must be viewing your photos with Details. If the stars are not currently visible in the Media Browser, choose View Details or press $Ctrl/\mathcal{H}+D$.

You can rate multiple photos by showing Details, select photos you want rated with the same start rating, and click the star you want to use for the rating. All photos take on the same rating.

TIP

Some DSLR and mirrorless cameras enable you to rate images with stars in-camera. You can quickly select images you think are some of the better photos of a given shoot. When you import the photos in Elements, the metadata for the files are also imported, including your star ratings.

After assigning star ratings to photos, you can sort photos according to their ratings. For example, click a star that appears in the Ratings at the top of the Media Browser (refer to Figure 3–4). If you click the third star, all photos rated with three, four, and five stars appear in the Media Browser. If you click the fifth star, only those photos rated with five stars appear in the Media Browser.

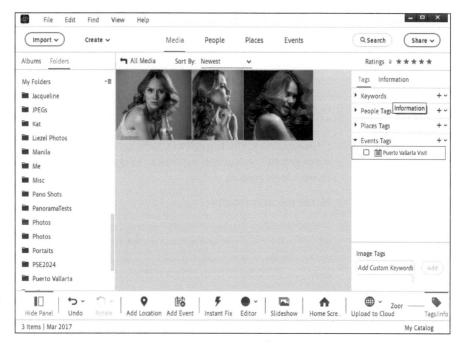

FIGURE 3-4: Photos rated with stars.

Be certain to click the star value in the Information panel when rating a photo with a star rating. If you click a star next to the Ratings label at the top of the Media Browser, Elements thinks you want to sort photos in the Media Browser according to the star rating.

Adding Images to an Album

Albums offer another way to organize your images. You can use albums to store photos that meet a specific set of criteria. For example, you might use your tags and star ratings to easily find all the five-star photos of your family. Or use your Events and Places tags to find all the photos you took at a conference in Paris. However, the photos you put in an album don't need to be tagged or starred. When you need a folder for a special stash of digital photos, the Organizer's albums feature is there for you.

Creating an album

With albums and star ratings, you can further break down a collection into groups that you might want to mark for printing, sharing, or onscreen slideshows.

To create an album, follow these steps:

1. Sort photos in the Media Browser to determine what photos you want to include in a new album.

In our example, we clicked the third star to sort photos ranked with three or more stars.

- Click Albums at the top left of the Organizer and then click the plus (+)
 icon next to My Albums, as shown in Figure 3-5. From the drop-down list,
 choose New Album.
- Name the new album.

In the Panel Bin, you see the Add New Album panel. Type a name for the album in the Album Name text box in the New Album panel on the right side of the Organizer window and click OK. The new album is added to the Albums panel on the left side of the Organizer window, as shown in Figure 3-6.

If you didn't sort files in Step 1, you can do so now, or simply pick and choose which photos to add to the new album from photos appearing in your catalog.

4. By default, any photos selected in the Media Browser are added to the new Album. To add more photos, drag photos from the Media Browser to the Content tab in the Edit Album panel, as shown in Figure 3-6.

If photos are sorted and you want to include all photos in the Media Browser, press Ctrl+A/光 +A to select all the photos, or choose Edit 🗘 Select All. After the files are selected, drag them to the Content pane in the Edit Album panel. (See Figure 3-6.)

If you don't have files sorted, click one or more photos and drag them to the Content pane. Repeat dragging photos until you have all photos you want to include in your new album.

5. Click OK at the bottom of the panel.

Your new album now appears listed in the Albums category on the Import panel.

That's it! Your new album is created, and the photos you dragged to the album are added to it. You can display all the photos within a given album in the Media Browser by clicking the album name in the Albums panel.

Creating multiple albums uses only a fraction of the computer memory that would be required if you wanted to duplicate photos for multiple purposes, such as printing, web hosting, sharing, and so on.

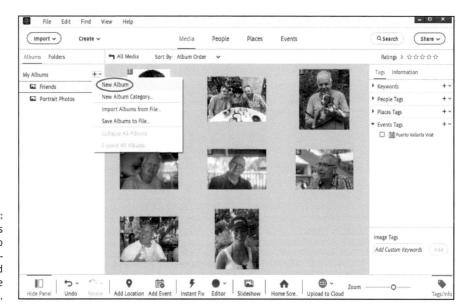

FIGURE 3-5:
Click the plus
(+) icon to
open the dropdown list and
then choose
New Album.

Editing an album

After creating an album, you may want to change the album name, add more photos to an album, delete some photos from an album, change the album category, or make some other kind of edit.

Your first step in performing any kind of edit to an album is to look at the left side of the Organizer. In the Import panel, you see a list of albums under the Albums category like those shown in Figure 3-6, in the previous section. To edit an album, right-click the album name and choose Edit. After clicking Edit, the album appears in the Panel Bin on the right side of the Organizer. Drag images from the Media Browser to the album. You can also drag images from the Media Browser to an album name to add photos to an album.

To delete photos from an album, right-click an album name and choose Edit from a context menu. When the album opens as a panel on the right, select a photo and click the Trash icon at the bottom of the panel. Note that you cannot drag a photo to the Trash icon. You must select a photo and click the Trash icon.

The other command that is available in the context menu that you open from an album name in the Import panel is Rename. Select this option to change the name of your album.

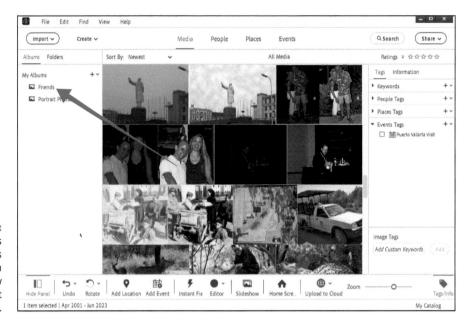

FIGURE 3-6: Drag photos to the items window in the Add New Album Content panel.

If you want to use the context menu commands, you must close the Add New Album panel in the Panel Bin. While this panel is open, you cannot open a context menu on an album name. Click either Done or Cancel to close the Add New Album panel in the Panel Bin.

Adding People in the Media Browser

For most people, the most enjoyable pictures are those of family and friends. You may take photos of landscapes and wonderful places, but quite often you'll ask someone to stand in front of the Colosseum, Louvre, Grand Canyon, or other notable landmark.

For just that reason, Photoshop Elements makes it easy for you to identify, sort, and view pictures with people.

Elements groups photos of the same person into clusters, even before you start adding names to faces in the Media Browser. What this means for you is a much easier time tagging people when you import pictures of your family and friends.

You know that you can add folders of pictures to the Organizer to help manage photos. After you add new pictures to the Organizer, you can select a folder in the Import panel and label all the people in the photos. Elements makes it easy to label people's faces:

- 1. Open Preferences (Ctrl/ \Re +K) and click Media-Analysis.
- 2. Be sure the Run Face Recognition Automatically check box is selected.
- 3. Import photos into the Organizer.
- 4. After you import photos, click the People tab.

Elements shows you several clusters of photos.

5. Click Add Name.

Type a name and click the check mark to accept the name, as shown in Figure 3-7.

Continue adding names.

This process is manual, and you may have to continue adding names even when photos appear the same as others you've named.

7. When you're finished, click Named at the top of the panel to see all the clusters you've named, as shown in Figure 3-8.

The number adjacent to the name indicates the number of photos tagged with the same name.

8. Click a cluster to show all the photos within the group.

That's it! After you label the photos, you can easily search, sort, and locate photos of specific people. You can even download your Facebook friends list to the Organizer to help simplify labeling people.

When you click the People Tab at the top of the Organizer window, you see Named and Unnamed below the tabs. When a photo has not been tagged with a name, it appears in the Unnamed group. After you add a name to a photo with a person, click the Named tab; the individual is displayed in the People window.

In addition to using the Media-Analysis preferences and running face recognition, you can open a context menu on any photo with a subject and choose Add a Person. A dialog box opens in which you type a name, and the person is shown in the People tab when you slick Named.

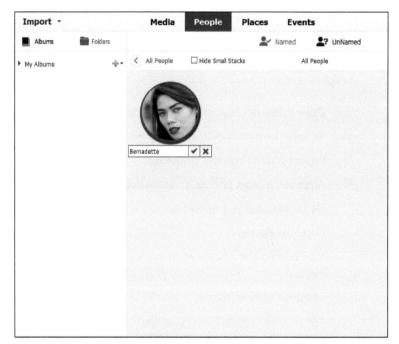

FIGURE 3-7: Click Add Name and type a name.

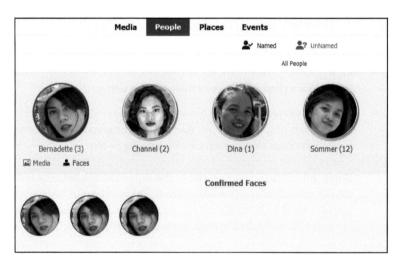

FIGURE 3-8: Photos tagged with names.

- » Working with catalogs
- » Switching to different views
- » Viewing Memories
- » Searching for your photos
- » Grouping your files in stacks

Chapter 4

Viewing and Finding Your Images

hoto organization begins with adding images to a catalog. By default, the Organizer creates a new catalog for you (so you might not even notice the presence of your catalog without reading this book). As your catalog grows with the addition of more files, you'll want to discover ways to search and use a given set of images for a project.

In this chapter, we begin by talking about catalogs and then look at how to view and organize your pictures in the Organizer and the Media Browser. We show how the many options help speed up your work in Photoshop Elements.

Cataloging Files

When you import files in the Organizer, all your files are saved automatically to a catalog. The files themselves aren't really saved to the catalog; rather, links from the catalog to the individual files are saved. In Elements, *links* are like pointers that tell the catalog where to look for a file. When you add and delete files within the Organizer, the catalog is updated continually.

After you import files in the Organizer, the Organizer maintains a link to the media. If you move the media on your hard drive, the link is broken. You need to reestablish the link by opening the file in the Photo Editor. The Find Offline Drives – Edit dialog box opens so that you can reconnect the file by browsing for its new location.

Your default catalog is titled *My Catalog* by the Organizer. As you add photos in the Organizer, your default catalog grows and may eventually store thousands of photos. At some point, you may want to create one or more additional catalogs to store photos. You may want to use one catalog for your family's and friends' photos and another for business or recreational activities. You may want to create separate catalogs for special purposes such as business, family, social networking, or other kinds of logical divisions. To further segregate images, you might create a number of different albums from a given catalog.

Using the Catalog Manager

Catalogs are created, deleted, and managed in the Catalog Manager. To access the Catalog Manager, choose File

Manage Catalogs. The Catalog Manager opens, as shown in Figure 4-1.

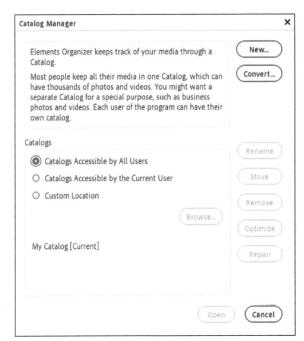

The Catalog Manager dialog box. To keep your photos organized and your catalog files small, you can start a completely new catalog before you import photos. Follow these steps:

- 1. Choose File ➡ Manage Catalogs and click the New button in the Catalog Manager dialog box, as shown in Figure 4-1.
- When the Enter a Name for the new catalog dialog box opens, type a name for the new catalog in the File Name text box.
- (Optional) If you want to add the free music files that installed with Elements, select the Import Free Music into All New Catalogs check box.

We recommend selecting the Import Free Music into All New Catalogs and Import Music Files check box. The Organizer ships with free music files that you can use in a variety of creations. See Chapter 14 for more on making creations.

- 4. Click OK to create the new catalog. You can import files in a new dialog that opens or dismiss the dialog box and then move to Step 5.
- 5. Choose File

 Get Photos and Videos

 From Files and Folders to add files to the new catalog. Alternatively, you can click the Import button above Albums and Folders in the left panel.

The Get Photos and Videos from Files and Folders dialog box opens.

6. Navigate your hard drive and select the photos you want to add. After you identify all the files, click Get Media.

The selected photos are added to your new collection of media contained in the catalog.

Working with catalogs

After you create different catalogs for your images, the following tips for working with catalogs will come in handy:

- >> Understanding how you want to organize your photos before creating your first catalog: Unfortunately, Elements doesn't provide you with a command to split large catalogs into smaller ones. However, if you've created a large catalog and want to split it into two or more separate catalogs, you can manually add new photos to a new catalog and delete photos from the older catalog.
- >> Switching to a different catalog: When you need to open a different catalog file, choose File \(\sigma\) Manage Catalogs and select the name of the catalog you want to open. Click Open at the bottom of the dialog box to open the selected catalog. The Organizer window changes to reflect files contained in that catalog.

- >> Fixing a corrupted catalog: Notice the Repair button in Figure 4-1. This button appears on Windows. On the Mac, try to use the Optimize button if you need a catalog repaired. If you can't see thumbnail previews of images or open them in one of the editing modes, your catalog file might be corrupted. Click the Repair button to try to fix the problem.
- >> Improving catalog performance: When catalogs get sluggish, you might need to optimize a catalog to gain better performance. You should regularly optimize your catalog (by clicking the Optimize button in the Catalog Manager) to keep your catalog operating at optimum performance.

Backing up your catalog

Computer users often learn the hard way about the importance of backing up a hard drive and the precious data they spent time creating and editing. We can save you that aggravation right now, before you spend any more time editing your photos in Elements.

We authors are so paranoid when we're writing a book that we back up our chapters on multiple drives when we finish them. The standard rule is that if you spend sufficient time working on a project and it gets to the point where redoing your work would be a major aggravation, it's time to back up files.

When organizing your files, adding keyword tags, creating albums, and creating stacks and version sets, you want to back up the catalog file in case it becomes corrupted. Fortunately, backing up catalogs is available to both Windows and Mac users. For optimum performance, backing up to a 1TB USB drive will serve you best.

Here's how you can use Elements to create a backup of your catalog:

1. Close an open Catalog and then choose File

Backup Catalog to open the Backup Catalog Wizard.

This wizard, shown in Figure 4-2, has several choices for backing up catalogs.

Select the source to back up.

The first pane in the Backup Catalog to Hard Drive Wizard offers three options:

 Backup Catalog Structure: When you choose this option, you back up the structure of the catalog that contains tags, people, places, events, and so on. No photos or videos are backed up when you make this choice.

- Full Backup: Use this choice when you want to back up everything, including your photos and videos.
- Incremental Backup: Select this radio button if you've already performed at least one backup and you want to update the backed-up files.

3. Click Next and select a target location for your backed-up files.

Active drives, external hard drives attached to your computer, or mounted network drives available to your computer appear in the Select Destination Drive list. Select a drive, and Elements automatically assesses the write speed and identifies a previous backup file if one was created.

The total size of the files to copy is reported in the wizard. This information is helpful so that you know whether more than one drive is needed to complete the backup (on Windows) or a backup drive has enough space to complete the backup.

- If you intend to copy files to your hard drive or to another hard drive attached to your computer, click the Browse button and identify the path.
- 5. Click Save Backup.

The backup commences. Be certain not to interrupt the backup. It might take some time, so just let Elements work away until you're notified that the backup is complete.

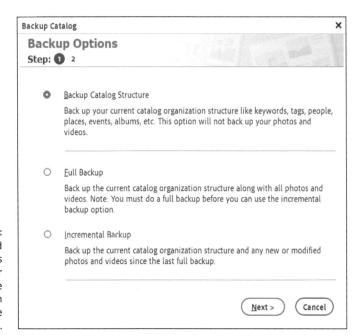

FIGURE 4-2: The wizard provides options for selecting the destination media for the backup.

Switching to a Different View

The Organizer provides you with several different viewing options. In Chapter 2, you find out about viewing files in the Media Browser and look at viewing recent imports and all files. You can also view files according to a timeline, certain media types such as those media types listed in the View ➡ Media Types menu, and places and events. Here you find a quick tour of the View menu.

On the View menu, you have choices for sorting files that are displayed in the Media Browser. Some of the menu choices you have are

- ➤ Media Types: Choose View ➡ Media Types and look over the submenu. You can eliminate video, audio, and projects by selecting the respective items if you want to view just photos in the Media Browser. Likewise, you can eliminate photos and explore the other choices by selecting or deselecting the submenu items.
- ➤ Hidden Files: If files are hidden, you can view all files by choosing View ➡ Hidden Files, and then you can choose (in the submenu) to view All Files, view Hidden Files, or (if files are in view) to hide Files.
- >> **Details:** By default, file details, such as file creation dates and star ratings, are hidden. You can show file details by choosing View ♥ Details or pressing Ctrl+D/贵+D.
- >> File Names: By default, the filenames of the photos appearing in the Media Browser are hidden. You can show filenames by choosing View
 □
 File Names.
- >> Timeline: Choose View ➡ Timeline, and a horizontal bar opens at the top of the Organizer. A slider appears on the bar that you can drag left and right to select a time when your photos were taken.

NEW

You can also filter different media types with the new icons introduced in Elements 2025. At the top of the Media Browser, you find icons for filtering images, videos, music, and projects. See Chapter 2 for more information on filtering media types.

Viewing Photos in Memories (Slideshow)

Elements offers essentially three different slideshow-type viewing options:

- >> In the Media Browser, you'll notice a button called Slideshow (after the slideshow is created, it's known as Memories) where Elements creates a video of selected photos in the Media Browser. You also find a Slideshow option in the Create panel. Both options are used to create animated videos of your cherished photos that you can export as a movie file and share with friends and family. We cover creating Memories videos in Chapter 14, where we discuss many different creation options.
- >> The other slideshow option you have is to view selected photos as a slideshow on your computer. Naturally, you find this option as a menu command in the View menu. However, the command you want is not called Slideshow. Elements provides you with a Full Screen command, which you use to view your pictures in Full Screen view as a slideshow.

Here's how you create a slideshow using Full Screen view from the View menu:

1. Select photos in the Organizer and choose View ⇒ Full Screen (or press F11 on Windows or #+F11 on Mac).

The first photo appears with a Tools panel and two panels with various editing options. You can organize, edit, transform, tag, and add metadata to your photos while in Full Screen view. Click Organize and then click Edit to open panels with editing options, as shown in Figure 4-3.

Click the Film Strip button on the lower-left side in the horizontal tools strip and click Organize to expand the panel (see Figure 4-3).

The Full Screen viewer appears, as shown in Figure 4-4. Your photos are displayed as thumbnails at the bottom of the window. Click a photo to jump to the respective image.

Keep in mind that Elements provides you with view options when you use various menu commands in the View menu. When you view photos in Full Screen view, you don't have any export or saving opportunities. Once again, to save a slideshow, turn to Chapter 14.

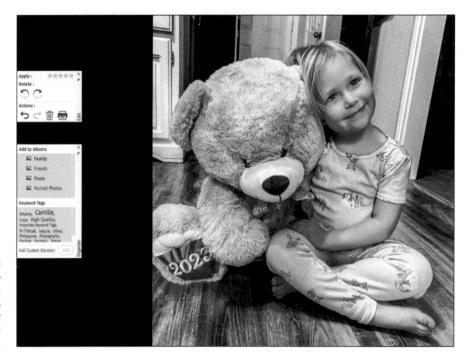

FIGURE 4-3: The first photo in Full Screen view opens with a number of tool and panel options.

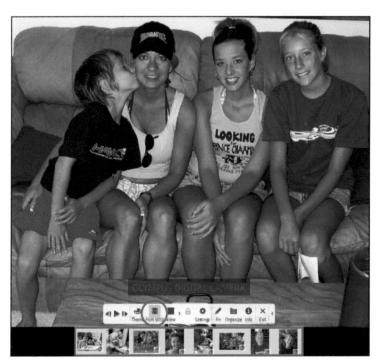

FIGURE 4-4: Click Film Strip to see mini thumbnails of the photos in the slideshow.

Ted Padova (Book Author)

Searching for Photos

When you're looking for a photo but aren't quite sure how you filed it away, the Elements search options are a great tool. You probably remember some detail that can help you find the photo or photos you're looking for. In Elements, you'll likely find a search tool that can look for that specific detail or details so that you locate your photo in no time.

Using Search

Before we explore the many options you have from menu commands on the Find menu, look at the Media Browser. At the top, you find the word Search and a magnifying glass.

When you click Search at the top of the Media Browser window, the interface changes to an overlay with a series of buttons along the left side of the window. and the thumbnails in the Media Browser are dimmed, as shown in Figure 4-5.

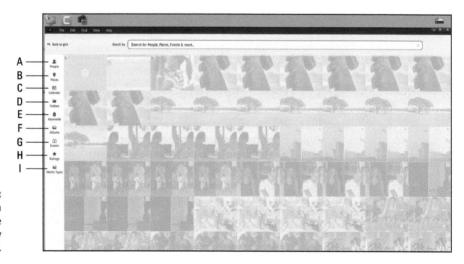

FIGURE 4-5: Click Search to display the Search overlay window.

Before we go too far, you should know that you can exit the overlay window at any time by clicking Grid in the upper-left corner or pressing the Esc key. You're then returned to the normal Media Browser window.

You can explore the various options by mousing over the icons at the left side of the window, such as the Smart Tags (top), shown in Figure 4–5. The search options available to you include the following:

- (A) People: All the people you've tagged are shown in people clusters.
- (B) Places: Photos you have tagged with locations are shown according to geographic location.
- (C) Calendar: Search by the date when the photo was taken.
- (D) Folders: You can restrict searching to photos from given folders in your catalog by clicking the Folders icon.
- (E) **Keywords:** Any photos you've tagged with Keyword tags are shown.
- (F) Albums: Click this icon and all the albums you've created are shown.
- (G) Events: All events tagged with Event tags are shown.
- (H) Ratings: You can search for photos you've tagged with star ratings.
- (I) Media Types: Mouse over Media Types, and you find options for searching photos, audio files, videos, and projects.

When you click an item in any of the search categories, only those items with the respective tags are displayed in the Media Browser. To return to a full catalog view, click Grid at the upper-left side of the Media Browser window.

Searching by history

Searching *history* is searching for chronologically ordered information about operations performed on your media, such as printing, emailing, sharing, and so on. Elements keeps track of what you do with your photos when you perform a number of different tasks. You can search for files based on their file history by choosing Find \Leftrightarrow By History. Select the options you want on the By History submenu, and Elements reports files found on date searches that meet your history criteria.

Searching metadata

Metadata includes information about your images that's supplied by digital cameras, as well as custom data you add to a file. Metadata contains descriptions of the image, such as your camera name, the camera settings you used to take a picture, copyright information, and much more.

Metadata also includes some of the information you add in Elements, such as keyword tags, albums, People tags, and so on. You can combine various metadata items in your search, such as keyword tags, camera make and model, f-stop, ISO setting, and so on. Searching for metadata might be particularly helpful when you have photos taken during an event by several family members and friends. In this example, you might want to isolate only those photos taken with a particular camera model.

To search metadata, follow these steps:

1. Choose Find

By Details (Metadata) in the Organizer.

The Find by Details (Metadata) dialog box, shown in Figure 4-6, opens.

2. Choose to search for one criterion or all your criteria by selecting a radio button.

The first two radio buttons in the dialog box offer choices for Boolean OR and Boolean AND. In other words, do you want to search for one item *or* another, or to search for one item *and* another. The results can be quite different depending on the criteria you identify in the menus below the radio buttons.

Choose an item from the first menu (we used Filename in Figure 4-6) and then choose to include or exclude the item. Next fill in the third column.

How you fill in the third column depends on your selections in the first two columns.

Items are listed as menus in horizontal rows. The third column can be a menu or a text box, as shown in Figure 4-6.

 (Optional) To add criteria (in our example, we use two items for our search), click the plus (+) symbol.

Another row is added to the dialog box, and you select your choices, as explained in Step 3.

- If you want to save the Search attributes, select Save this Search Criteria as Saved Search.
- 6. After identifying your search criteria, click Search.

The media matching the criteria are shown in the Media Browser.

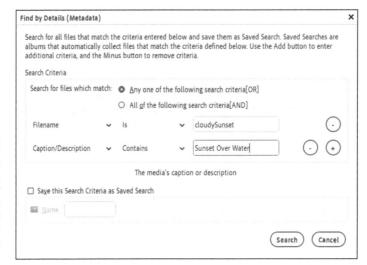

FIGURE 4-6:
Choose Find ©
By Details
(Metadata) in
the Organizer
to open the
dialog box
in which
metadata are
specified.

Searching similarities

We discuss tagging people in Chapter 3. When you have people tagged, you can easily click the People tab at the top of the Organizer and locate all the people you have tagged. Not all the search options are perfect. You may find that some photos are missed; however, the search features offer you a more than reasonable effort at finding the photos you want to use.

Searching visually similar photos

Elements also lets you search photos for visual similarities. You may have group shots, architecture, animal life, and so on and want to search for photos containing objects that are visually similar.

To search for photos with visual similarities, choose Find ⇔ By Visual Searches, Visually Similar Photos and Videos, Objects appearing in Photos, and Duplicate Photos.

Searching duplicates

You may have a number of photos that are duplicates or are very close to being duplicate images. You may want to locate duplicates or near-duplicate images and delete some from your catalog or stack the photos. To find duplicate photos, choose Find \Rightarrow By Visual Searches menu and choose Duplicate Photos.

Photos that are visually similar appear in horizontal rows. Click Stack, and the photos are stacked.

If you want to delete photos, click a photo and then click the Remove from Catalog button at the bottom of the window.

Searching objects

You may want to stack or delete photos that contain similar objects, such as buildings, automobiles, trees, groups of people, and so on. To search for objects, follow these steps:

- 1. Choose Find

 By Visual Searches

 Objects Appearing in Photo.
- 2. Double-click a photo containing the desired object.

A rectangle appears for selecting a photo that contains the object you want to search.

- 3. Move the rectangle and resize it so that it surrounds the object you're looking for, as shown in Figure 4-7.
- 4. Click the Search Object button.

Elements displays its search results.

FIGURE 4-7:
Mark the
object you
want to search
and then click
the Search
Object button.

Photo: Ted Padova

Selecting and Correcting Photos

IN THIS PART . . .

Work with the Camera Raw Editor.

Change, optimize, perfect, and combine images into composite designs.

Select image content and then alter that content for a variety of purposes, such as correcting the color, changing the appearance, and extracting the content so that you can add it to other photos.

Use quick one-step auto fixes.

Correct an image's contrast, brightness, and color irregularity.

- » Getting familiar with Camera Raw
- » Understanding panels and profiles
- » Editing non-Raw Images
- » Examining default settings
- » Using sidecar files and preferences

Chapter **5**Editing Camera Raw Images

he forthcoming chapters (6 through 9) deal with making tonal adjustments, correcting brightness and contrast, and working with color. You should look at these chapters as using techniques to tweak your photos or add special effects. Your first stop, however, when it comes to improving your photos' overall brightness and contrast is the Camera Raw Editor.

You may often hear people refer to this separate application, included with your purchase of Photoshop Elements, as the Camera Raw Converter, the Camera Raw Dialog, the Raw Editor, the Raw Converter, and other such names. For our purposes here, we refer to the application as the Camera Raw Editor or simply the Raw Editor.

Launching the Camera Raw Editor

You have several ways to launch the Camera Raw Editor. From your desktop, double-click a file that has been saved as Camera Raw. Most digital cameras and many cellphones offer you options to save your photos in a Camera Raw format. The file opens in the Camera Raw Editor. Likewise, you can also open the Elements Photo Editor and choose File \hookrightarrow Open. In either Quick or Expert mode, when you select a file saved as Camera Raw, the file opens in the Camera Raw Editor.

One more method available to you for launching the Camera Raw Editor is to open any file (JPEG, TIFF, PSD, and so on) in Camera Raw even when the file was not saved as a RAW file. From the file menu, choose Open in Camera Raw and select a file saved in any format compatible with Photoshop Elements. The file opens in the Camera Raw Editor.

Regardless of the method you use to launch the Camera Raw editor, Adobe Camera Raw opens on top of your Photoshop Elements window and the interface changes to what you see in Figure 5-1.

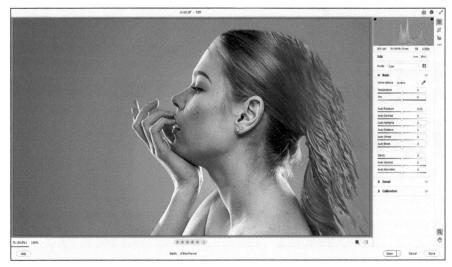

FIGURE 5-1: The Camera Raw Editor user interface.

Photo by Ted Padova

Understanding Camera Raw

First and foremost, a Camera Raw file is a file format. Most DSLRs, many mid- to high-end mirrorless cameras, and more than 20 different cellphone cameras can save data in the Camera Raw format. Unfortunately almost all developers use their own unique file extension when saving files. For example, Canon raw files are saved as .crw or .cr2, Sony's files are saved as .arw, Nikon's files are saved as .nef, and Fuji files are saved with an .raf extension. Likewise, other developers use unique naming conventions.

Dealing with myriad different Raw file formats has been a challenge for Adobe. With each release of the Camera Raw Editor, Adobe needs to ensure compatibility with all the developers supporting Camera Raw.

One solution provided by Adobe is Adobe's own Raw file format, which uses a .dng extension (Digital Negative). In the event that you acquire an update to Lightroom, Photoshop, or Photoshop Elements and your camera's Raw format is not supported, you can download the free DNG converter from Adobe at https://helpx.adobe.com/photoshop/using/adobe-dng-converter.html. You may be able to convert to DNG until Adobe supports your camera's Raw files. In the section "Changing program defaults," later in this chapter, we talk a little bit more about Adobe DNG.

Learning Raw file format attributes

There are several reasons you should make all your first attempts at improving your images in the Raw Editor. These include:

- >> Working with non destructive editing. When you open a Camera Raw image in the Raw Editor, all the edits you make for everything, including brightness/contrast, color corrections, tonal corrections, cropping, straightening, sharpening, and so on, are nondestructive. This means that you can always return to the original raw image, dismiss all previous edits, and start over. You don't need to save a copy. Moreover, you can share the Raw file with another user, who can work with your edited image or also dismiss all the edits and start with a fresh unedited version.
- >> Working with higher bit depths. Inasmuch as you can also use some editing features in the Elements Photo Editor on 16-bit images, in the Raw Editor, all the edits you make can be made on either 8-bit or 16-bit images. To understand more about bit depth, you first need to understand dynamic range.

Dynamic range is the range of *f*-stops between the brightest areas of a photo (the highlights) and the darkest areas (the shadows) where you can detect detail. The human eye can detect roughly 18 different *f*-stops. Translated into practical terms, this means that we can see some detail in the lightest areas of things like cloud formations, and we can see some detail in some dark shadows, as in a tunnel.

Higher-end DSLR and mirrorless cameras capture an average of 10–12 *f*-stops. One camera that captures 15 stops is the Sony A7RIV. The Canon 5D Mark IV captures 12 stops; the Nikon D810 captures 14.8 stops. Smartphone cameras are becoming increasingly better, capturing images at higher dynamic ranges as well. For example, some iPhone, Google, and Samsung devices capture respectable dynamic ranges. Improvements in technology are bringing cameras closer to capturing detail in highlights and shadows that approach the ability of the human eye — but they're not there yet.

When you take a picture in Raw format, your camera captures all the data the sensor can handle. You open the higher bit image in the Raw Editor and

decide on the compromises you're willing to make, such as more detail in shadows or more detail in highlights. Your final images need to be reduced to 8-bit for printing or sharing on social media websites, so you must make some decisions about where to clip the image. In other words, you decide what parts of the data you will cut off.

Because Raw editing is a post-processing task, you start with all the original data and decide what data remains and what data are tossed. Sixteen-bit images offer you much more data to work with than 8-bit images do. JPEG images, on the other hand, are processed by the camera, and many of those decisions are made for you. You have more limited control over the data with JPEG files than with Raw files. Furthermore JPEG files are only 8-bit and hold much less data than the Raw files do.

>> All editing is accessible in a single dialog box. If, for the moment, you consider the Raw Editor as a dialog box, all image editing is handled within the editor. In the Elements Editor in Expert mode, you need to address several different menu commands to perform edits in different dialog boxes. The Raw Editor offers you a panel with sliders, where you can make changes to white balance, contrast, exposure, highlights, shadows, saturation, vibrance, and more, all from within a single panel and without the need to open multiple dialog boxes.

Opening images in the Camera Raw Editor

From the desktop, you can open Camera Raw images by double-clicking the mouse button on a Raw image. The image opens in the Raw Editor. If you see a dialog box indicating that the image can't be opened, it means that Adobe has not yet included support for your camera. This is sometimes the case with new Camera Raw Editor releases. If your camera isn't supported, you can convert the image to a DNG file and open the DNG in the Raw Editor. For more information on Adobe Digital Negative (DNG), see the section "Changing program defaults," at the end of this chapter.

You can also open the Elements Photo Editor and choose File \triangleleft Open or press Ctrl/ \Re + O, select a Raw image, and click OK, and the image opens in the Raw Editor.

You also have a File ⇔ Open in Camera Raw menu command. You can open JPEGs, TIFFs, and PSD files in the Camera Raw Editor. Files saved as TIFF and PSD as 16-bit images can be edited in 16-bit. JPEG files are always 8-bit.

You may see some YouTube videos or read articles in which authors claim that the difference between JPEG and Raw is that Raw files are not compressed and JPEG files are compressed. This is not true. Today, Raw files can be compressed with lossless or lossy compression. The distinguishing factor between JPEG and Raw

is that Raw holds all data captured from the image sensor, and the camera does not process the file. JPEG files are processed by the camera, and data are clipped. When the files are saved, they are always saved with lossy compression, meaning that additional data loss occurs.

Getting Familiar with the Raw Editor

When you open a file (or multiple files) in the Raw Editor, you find a number of tools and buttons as well as several panels. You also notice that the Raw Editor has no menu. All tasks are performed within the Editor workspace.

This section familiarizes you with the tools and buttons available to you in the Raw Editor. In Figure 5–2, you can see the tools appearing at the top-right side of the Editor window and various buttons around the interface. For the moment, we skip the Panel Bin on the right and address it later, in the section "Getting Familiar with the Panels."

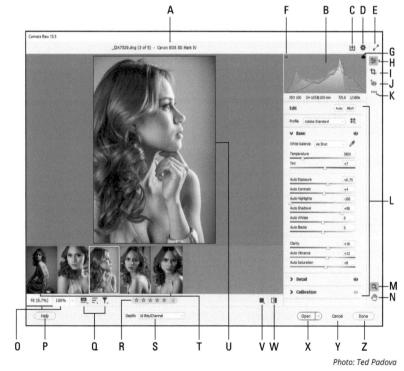

FIGURE 5-2: The Camera Raw Editor tools. Beginning with the tools at the top right of the window, you find:

- (A) Camera Data Readout
- (B) Histogram: The Histogram displays data in your image. In the three RGB channels, you can see how the data falls across a measure of grays from 0 to 255. You can also see whether clipping (cutting off data) occurs if there is a spike (high column) on either side of the Histogram.
- (C) Convert and save image: Clicking this icon opens the Save Options dialog box. For more on Save Options, see the section "Using Save Options," later in this chapter.
- (D) Open Preferences (Ctrl/亲 + K): Rather than describe the Raw Editor Preferences here, we take a look at the preference choices later in the chapter, in the section "Using sidecar files."
- (E) Toggle full screen mode (F): Press the F key or click this button to expand the Raw Editor workspace to full-screen view. Press F again and you return to the default view.
- **(F) Shadow clipping warning (U):** When you click this button, you see clipping in an image for shadows, represented by blue areas. *Clipping* means that no detail is shown in that area of the image.
- (G) Highlight clipping warning (O): Click this button, and you see clipping of highlights, represented as red areas.
- (H) Edit: If you click the Crop tool (item H) or the Red Eye Removal tool (item I) and you want to return to the default edit mode, click this tool.
- (I) Crop & Rotate tool (C): You can crop images in the Camera Raw Editor much the same as you crop in the Elements Photo Editor. If you click the Crop tool, another panel opens in the Panel Bin (item K), as shown in Figure 5-3. Settings you have available in the Crop panel include:
 - Aspect Ratio: Click the default size and a drop-down list opens, where you
 can choose from a number of different crop ratios.
 - **Angle:** Move the slider to change the angle for the crop.
 - Straighten tool (A): The Straighten tool functions the same in the Raw Editor as in the Elements Photo Editor. For more on straightening images, see Chapter 8.
 - **Rotate Left (L):** Click the tool button or press the L key to rotate the image 90° left. Keep pressing L to rotate the image at 90° movements.
 - Rotate Right (R): Click the tool button or press the R key to rotate the image 90° right.

- **Flip Horizontal:** Click the button adjacent to the Rotate Right button, and the image flips horizontal.
- **Flip Vertical:** Click the last button in the Rotate & Flip category to flip the image vertically.
- Crop Adjustments: In Figure 5-3, you can see some marks at the corners and along the horizontal and vertical centers at the edges of the photo. Click and drag a corner or center item to shape the crop. If you move the cursor outside the marks, you see a semicircle with two arrowheads. Click and drag to rotate the image. If you place the cursor at the corners, you see a diagonal line with two arrowheads. Click and drag to crop down or up.

To return to the default editing mode, click the Edit button (item F). For more on using the Crop tool, see Chapter 8.

- (J) Red Eye Removal tool (Shift+E): Removes red eye from a subject's eyes. For more on Red Eye Removal, see Chapter 8.
- (K) More image settings: The flyout menu offers options for changing default settings for the open image.
- (L) Panel Bin: By default, the Basic panel is open. For more on using the panels, see the section "Getting Familiar with the Panels," later in this chapter.
- (M) **Zoom tool:** Click the tool, move it to the document, and click to zoom in. Press Ctrl/器 and click and drag to zoom into an area.
- (N) Hand tool (H): Press the H key on your keyboard or click the Hand icon in the toolbar to access the Hand tool. Alternatively, you can press the spacebar to access the tool. Click and drag around an image to move it within the editor workspace.
- (O) Zoom options: If you move the cursor into the document window, the cursor changes to a Zoom tool. Press the Alt/Option key and click and you can zoom out. You also have fixed zoom option choices in the pop-up menu. Click to open the menu and make choices for the zoom level you want. You can also zoom in and out of an image by pressing Ctrl/光 + (minus sign) to zoom out, and Ctrl/光 ++ (plus sign) to zoom in.

TIP

- Choose 100% views or greater when you make adjustments to sharpness and noise reduction.
- (P) Help: Click this button to open Adobe's web pages, where help information related to the Raw Editor is provided.
- (Q) Change Views: These three items appear only when you have more than one image open in the raw editor. You click the first icon to toggle the filmstrip on and off. Click the middle icon to open a menu where you choose to sort

- according to Date, File Name, Star Rating, and Color Label. Click the third icon to open a menu to filter views according to Star rating, Color Label, and files marked for deletion and rejection.
- (R) Stars: Click a star to rate the photo. When you open the file in the Organizer, you can sort photos by star ratings. For more on rating photos with stars, see Chapter 3.
- (S) **Depth:** For 16-bit images, choose 16Bits/Channel. The alternative choice is editing in 8-bit mode.
- (T) Image Thumbnails: When you open multiple images, a thumbnail is displayed horizontally across the bottom of the Editor window.
- (U) Image Window: The current active document appears here.
- (V) Before/After (Q): Click this button to cycle through before-and-after views displayed adjacent to each other vertically, horizontally, and on split screen.
- **(W) Toggle between current settings and defaults:** Click this button to see your image at the defaults. Click again and you see the image with the edits you made.

Defaults are not necessarily the original image captured by your camera. You can, for example, choose to open images with some auto corrections applied. When you toggle this button, you see the defaults after auto corrections were applied.

To learn more about changing defaults, see the section "Changing Image Defaults," later in this chapter.

(X) Open: Click Open, and the image opens in the Elements Photo Editor with the edits you applied.

Alt/Option+Open: When you press Alt/Option, the button changes to Open Copy. When you press Alt/Option and click Open Copy, a copy of the edited Raw image opens in the Elements Photo Editor. The original Raw image remains unaffected and is closed as the copy is opened.

(Y) Cancel: Click Cancel, and the image closes with no edits applied.

Alt/Option+Cancel: The Cancel button changes to Reset. When you press Alt/Option and click Reset, all edits from the time you opened the image are returned to defaults.

(Z) Done: Click Done, and all your edits are applied and the image is closed. When you open the image, it is shown in the Raw Editor with the last edits you made.

The Crop panel.

Photo: Ted Padova

Getting Familiar with the Panels

On the right side of the Raw Editor below the Histogram, you see, by default, the Basic panel. If you don't see the Basic panel open, you may see a list of the available panels, as shown in Figure 5-4.

Below the Profile drop-down list you see three items with right-pointing chevrons. At the top of the list is the Basic panel, followed by the Detail panel and finally the Calibration panel. Click one of the chevrons and the respective panel opens in the Panel Bin.

The next section takes a look at each of these panels individually.

Using the Basic panel

The Basic panel is the center of your Camera Raw Editor world. The lion's share of the edits you make are handled in the Basic

FIGURE 5-4: The Panel Bin showing a list of panels.

panel. Adobe logically positions tools and panels across an application interface. In normal workflows, you begin on the left and work toward the right or at the top and work down through tools and settings.

In the Basic panel, you make edits starting at the top of the panel and working down. Furthermore, many settings need to be finessed by toggling between different adjustments. For example, you can adjust Contrast and then later, when you get to Clarity, you can make an adjustment and see that Clarity also adds some contrast. Therefore, you may need to return to the Contrast slider and tweak the contrast a bit. This back-and-forth editing is common for many adjustments. Start at the top of the panel and realize that you may need to return to previous adjustments to fine-tune your editing.

Figure 5-5 shows the Basic panel with all the sliders set to default values.

Here's a description of each of the different settings for the Basic panel, as identified in the figure:

- (A) Histogram: When you open an image in the Raw Editor, first take a look at the Histogram. You want to see whether the image is skewed to the left (where more shadows appear) or to the right (where more highlights exist). The ideal image will have no clipping on either side of the Histogram and more data appearing in the center (something like a bell curve). As a start, click the clipping warning buttons to show clipping in highlights and shadows. In Figure 5-6, the clipping indicators are selected. When the indicators are selected, you see a visual for areas of a photo that's clipped. In Figure 5-6, the red overlay on the photo shows highlights clipped.
- (B) Auto/B&W: If you want the Raw Editor to make its best guess for all the adjustments, click the Auto button. Click B&W to convert from RGB Color to Grayscale.

Generally speaking, it's a good idea to begin your edits by clicking Auto and then working your way down the panel to fine-tune the settings.

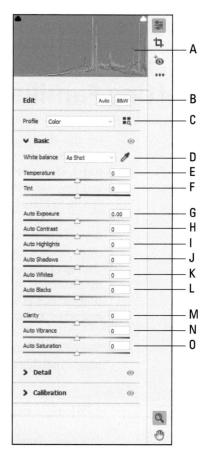

FIGURE 5-5: The Basic panel with the sliders at defaults.

- (C) Profile: The drop-down menu displays choices for a number of profiles from which you can choose to begin your editing tasks. To the right of the menu is a grid icon that displays thumbnail views of each profile. The default profile is Adobe Color. We stay with the default in this section and look at working with profiles in the section "Working with Profiles," later in this chapter.
- (D) White Balance: The default white balance is As Shot, meaning that the white balance you chose in your camera settings is used as the default here in the editor. You can change the white balance in several ways. Click the Eyedropper tool in the toolbar and locate a white, medium gray, or black area in the photo and click with the Eyedropper tool. Clicking with the Eyedropper tool sets a custom white balance. If you click several times, you can scroll back through your edits using the Undo command by pressing Ctrl/贵+Z to undo each edit. Each successive Undo takes you back one step. Hence you can, for example, click with the Eyedropper tool 10 times and undo 10 times to return to the original setting.

The other means for changing white balance is to adjust the Temperature and Tint sliders.

- (E) Temperature: As you move the Temperature slider to the left, your image appears with more blue, resulting in a cooler image. Conversely, moving the slider to the right adds more yellow, resulting in a warmer image.
- (F) Tint: You move this slider to the left to add more green. Move to the right to add more magenta.

To return to the defaults, you can choose As Shot from the White Balance menu, or you can double-click a slider to return its setting to the default. For example, if you move the Temperature slider from its default value of 5500 to 7000, double-clicking the slider returns you to the default 5500 value.

- (G) Exposure: Move the slider left to darken the image. Move the slider right to lighten the image. Press Alt/Option and drag a slider to see any clipping as you make the adjustments. Clipping will appear as white when you depress the Alt/Option key and move the slider.
- (H) Contrast: Move the slider left to decrease contrast. Move the slider right to increase contrast.
- (I) Highlights: This slider enables you to adjust highlights. In some cases where highlights are blown out (that is, no data appears in the white areas of the image), you may be able to recover some detail. Press the Alt/Option key and move left to see any clipping warnings as you add more highlight data or right to decrease highlights. When you see clipping, move the slider to the point where the clipping first begins to appear. Be sure to press the Alt/Option key down as you drag a slider to see clipping.
- (J) Shadows: This features works in the opposite way to the Highlight slider.

 To increase detail in shadows, move the slider right. To decrease detail, move

- the slider left. Holding the Alt/Option key down displays clipping if it occurs in the image.
- **(K) Whites:** This slider brightens whites in the image. Press Alt/Option and move the slider to detect clipping. When you see clipping occur, make the final adjustment just before you see the clipping.
- **(L) Blacks:** This slider helps add richer blacks in an image. Press Alt/Option to detect clipping. When you see clipping occur, make the final adjustment just before you see the clipping.
- (M) Clarity: Move this slider to the right to adjust midtones and add more contrast to the midtones.
- (N) **Vibrance:** Adjusting Vibrance can add some snap to your photos by brightening colors.
- (O) Saturation: Moving the Saturation slider left desaturates the image. Moving the slider right increases saturation. You can convert the image to grayscale by moving the Saturation slider all the way to the left, thus eliminating all color.

Note: Double-clicking a slider reverts to the default.

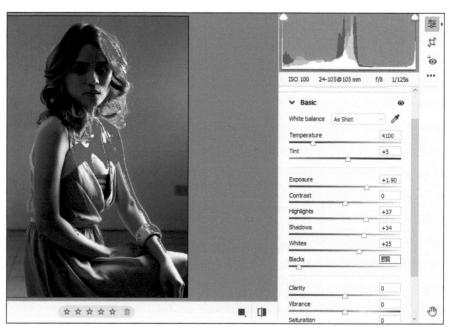

FIGURE 5-6: The red overlay shows clipping.

Photo: Ted Padova

Sharpening and reducing noise

The second panel in the Panel Bin is the Detail panel. Click Detail to open the Detail panel. This panel has three sections, as you can see in Figure 5–7. At the top you find adjustments for Sharpening. Below Sharpening is Noise Reduction and the final group is Color Noise Reduction.

Sharpening images

By default, some sharpening is applied to images when you open them. Figure 5-8 shows you default slider adjustments when an image is opened in the Raw Editor. If you want to eliminate the default amount of sharpening, move the sliders to zero.

Before making any adjustments in this panel, you should view your image at a 1:1 ratio. Open the zoom menu from the lower-left corner of the editor window and choose 100%. This adjustment zooms the image to an actual size. In an actual-size view, you can see more clearly any artifacts that might appear if

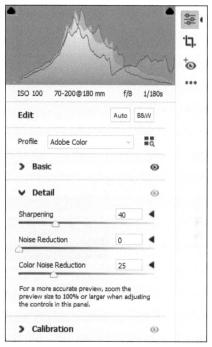

FIGURE 5-7: Click the Detail text in the Panel Bin to open the Detail panel.

you sharpen too much. Use the Hand tool to move the image around and locate an area such as a subject's eye or contrasting colors in images. Sharpening actually increases contrast along edges of subjects and the background, or along edges of contrasting colors.

The sliders provide you adjustments for:

- >> Sharpening: The Sharpening slider increases contrast between colors and at the edges of color transitions. As a general rule, keep the Sharpening slider between 70 and 90. If you're sharpening portraits or shots with people, keep the Amount to 50 or less.
- >> Radius: Radius is the number of pixels the editor looks at on either side of the line of contrast between two contrasting colors or along the edges of subjects. Increasing radius will show strong contrast along lines of contrasting pixels. It's best to keep this adjustment low, such as at values between .8 and 1.2.

- >> Detail: This adjustment increases sharpness in detail. Although it increases sharpness, it may also result in adding more noise to images shot at higher ISOs. In many cases, you want to keep this setting off or at least keep it to 20 or below.
- Masking: Masking looks at the solid colors in the image where no contrasting values exist. To use this slider, press the Alt/Option key. The image area turns white. As you move the Masking slider to the right while keeping the Alt/Option key depressed, you begin to see solid colors appear as black (refer to Figure 5-8). Black areas are where no sharpening is applied. The white areas are where sharpening occurs. Move this slider to the right as far as needed to eliminate sharpening in solid colors.

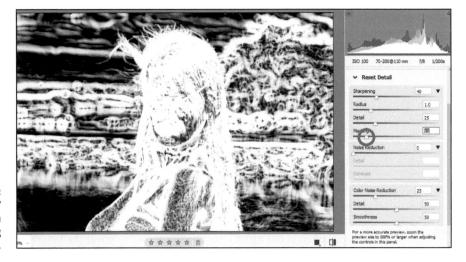

Press Alt/ Option when adjusting Masking.

Adjusting noise

By default, adjustments are made to reduce color noise. You see noise in color areas represented by varying colors of different pixels. As you reduce the noise, the colors disappear in solid color areas.

- >> Noise Reduction: Move this slider to reduce overall noise.
- >> Detail: This item represents how much detail remains in the color noise area. As you increase the adjustment, you regain some detail. Keep this adjustment low to avoid emphasizing the color noise.
- >> Contrast: Zoom in to an 800–1600 percent view to see the results of moving this slider. You can make some adjustments for the contrast in the noise areas. Move the slider to around 50 to bring back some detail in the highlights.

Noise often shows up in images shot at high ISOs as well as when you expand the dynamic range to capture more detail in highlights and shadows. For example, when you move the Highlight and Shadow sliders in the Basic panel to the far edges, you usually see some noise.

When you make adjustments on images with a lot of noise, first set all the sharpening sliders to zero and start your editing in this section. You don't want to sharpen the noise. Doing so introduces more noise in your image. First make all noise adjustments and then go to the sharpening sliders and make those adjustments.

Slider adjustments you can make to reduce color noise include:

- >> Color Noise Reduction: Move this slider to adjust overall color noise.
- >> Detail: Move this slider up to regain some detail that was lost after reducing color noise. Whereas the Color Noise Reduction adjustment blurs the image, this adjustment results in sharpening the softness introduced with the Color Noise Reduction adjustment.
- >> Smoothness: This adjustment blurs the color noise so that it appears as if the color noise disappears. Add a little bit of color smoothness to further reduce the color noise.

Using the Calibration panel

There's not much to do in the Calibration panel. Your only adjustment is to choose a version of the Raw Editor. Most of the time you leave this menu command at the default, which is the current version of the Raw Editor. If you have legacy files edited in earlier versions of the Raw Editor, you might choose a menu option equivalent to the version from which the file was edited.

Working with Filmstrips

When you select multiple Raw files in the Organizer, or you select multiple Raw files in the Open dialog box and click Open, the files are all opened in the Raw Editor and are seen in the Raw Editor filmstrip. You can select photos in a contiguous or noncontiguous order in the filmstrip. To select photos in a noncontiguous order, click a photo in the filmstrip and press Ctrl/# +. Click and select additional photos. In Figure 5-9, you can see photos selected in a noncontiguous order.

FIGURE 5-9:
To make a noncontiguous selection, press Ctrl/鍛 and click each image to add to the selection.

Photo: Ted Padova

The files appear in a filmstrip. By default, the filmstrip is across the bottom of the ACR window. If you want to view the files vertically on the left side of the ACR window, you can open a context menu on an image thumbnail and choose Filmstrip Orientation 中 Vertical, as shown in Figure 5-10. You can also press Shift + Ctrl/光+F and toggle back and forth between vertical and horizontal filmstrips.

As you can see in Figure 5-10, the context menu offers a number of options, as follows:

- >> Select All: Click the menu command or press Ctrl/光 +A to select all photos in the filmstrip.
- >> Set Rating: From the submenu, you can choose a star rating the same way you can at the bottom of the ACR window. Star ratings are the same as the star ratings you can use in the Organizer. For more on star ratings, see Chapter 3.

FIGURE 5-10: Right-click a thumbnail to open a context menu.

- >> Set Label: Mark images with a color label.
- >> Set Reject: This choice places a check mark in the context menu. If you open the menu again, a check mark is shown, indicating that you rejected the image.
- >> Mark for Deletion: If you have a photo in the group that you don't want to use, click this command, and the photo is moved to the Recycle Bin/Trash Can. Be careful. If you click Mark for Deletion, the photo is moved out of its folder and to the trash. If you empty the Recycle Bin (Windows) or Trash Can (Mac) the file is deleted.
- >> Filmstrip Orientation: Choose the orientation in the submenu.
- **>> Show Filename:** Click this command to display the filenames of the photos below each thumbnail.
- >> Show Ratings & Color Labels: Displays star ratings and color labels.
- >> Filter By: You can select only those images containing items you marked, such as Star Rating values, Color Labels, Marked or Not Marked for Deletion, Rejected, or Not Rejected. For example, if you mark three out of seven images as Rejected, and you filter the files, you see only the four nonrejected files in the film strip.
- >> Sort by: Images in the filmstrip are sorted by Star Rating, Color Label, and all the other options you have available similar to filtering.

Working with Profiles

Earlier in this chapter, in the "Using the Basic panel" section, we look at choosing settings using the default Adobe Color profile. When you open a Raw image, the Adobe Color profile is selected by default. There are, however, many other profiles you can use. You can install custom profiles created by third parties; you can set up a number of favorites to access the profiles you use more frequently; and you can create your own custom profiles.

There's quite a bit to understand with regard to Camera Raw profiles. You can start by looking at the panels that Adobe provides you with when you first install Elements.

Looking at the Adobe Camera Raw profiles

When you install Photoshop Elements, Adobe installs many different profiles. As stated elsewhere in this chapter, Adobe Color is the default profile. If you click the down-pointing arrow adjacent to the Adobe Color text, the dropdown menu opens and reveals five additional profiles. The menu shows a list of additional profiles that you can use. You can also click the Browse Profiles icon adjacent to the dropdown list, or you can choose Browse from the drop-down list to see thumbnail images displayed for the profiles. Mousing over a thumbnail reveals a dynamic preview for how your photo would look if you use the respective profile. Figure 5-11 shows some of the thumbnails for the Adobe Color group along with other groups that are shown as collapsed.

The default Adobe Color group profiles include:

- >> Adobe Color: This profile is Adobe's default profile intended for general use.
- Adobe Monochrome: This profile renders an image as black and white with optimized sensitivity for how RGB values render as different tones. It also increases contrast.
- Adobe Landscape: This profile adds enhancements to sky hues (blues) and foliage hues (greens).
- **>> Adobe Portrait:** This profile provides optimum protection and enhancements for skin tones.
- >> Adobe Standard: Adobe Standard adds subtle tonal and color adjustments to the image. Like Adobe Color, this is generally a good starting point for many images.
- >> Adobe Vivid: Adobe Vivid adds an increased level of contrast and saturation.

Additionally, you'll notice items such as Camera Matching, Artistic, B&W, Modern, and Vintage. To get familiar with these other choices, open some images and poke around by applying different profile settings to different images.

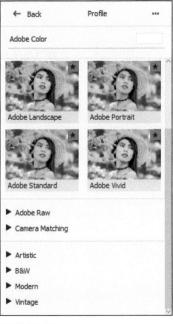

FIGURE 5-11: Profile thumbnails displayed after clicking the Browse icon.

Managing profiles

If you right-click a profile (or Ctrl+click on a Mac with a one-button mouse), a context menu opens. The menu shown in Figure 5-12 offers some options for managing profiles. These include:

- >> Profile Info: Clicking this item in the menu opens a dialog box that provides a very brief description of the profile.
- >> Remove from Favorites: If you added a profile to your Favorites list, this menu command enables you to delete the item from the Favorites. To learn more about Favorites, see "Creating a Favorites list," later in this chapter.
- Manage Profiles: Choose Manage Profiles to open the Manage Profiles dialog box which lists all profile groups. To hide or display a group, select the check box. If a check mark is already in a check box, you click it to hide the profile. Any profiles you select are visible in the Basic panel.
- >> Reset Favorite Profiles: If you add a number of profiles and want to return to defaults, click this item.
- >> Reset Hidden Profiles: If you hide any profiles, clicking this menu item brings them back and unhides them.
- >> Import Profiles & Presets: Choose this menu command to open the Import Profile & Presets dialog box. You can load custom profiles by selecting a profile and clicking the Open button. If you click the Browse icon and show thumbnails but then want to return to the List option, click the Back button at the top of the Basic panel. The Back button appears after you click Browse in the Profile area of the Basic panel.

Creating a Favorites list

By default, the installed profiles appear in a Favorites list. You can open the list by clicking the down-pointing arrow adjacent to Favorites at the top of the Profile Browser panel. As you view different profiles notice the star icon in the top-right corner of each profile thumbnail. Clicking the star adds that profile to your Favorites list. To eliminate a profile from your Favorites list, click the star icon in the Favorites panel.

Open a context menu on a profile

FIGURE 5-12:

Adding profiles to a Favorites list enables you to quickly access those profiles that you use most often. As shown in Figure 5-13, we added a number of different profiles to our Favorites list, including a custom profile we created.

Opening Non-Raw Images in the Camera Raw Editor

The Camera Raw adjustments are not limited to Raw files. Any JPEG, TIF, or PSD file can also be opened in the Raw Editor, and all the adjustments are available to all these image formats.

FIGURE 5-13: A number of profiles added to the Favorites list.

Camera Raw offers you images with all the data captured by the image sensor in the camera. Uncompressed Raw files have all the original camera sensor data. There are cameras that can save Raw files compressed with lossy compression or lossless compression. If a Raw file is compressed with lossy compression, some data is tossed during compression.

With other formats, some processing is performed, and no image format matches optimum data as Camera Raw uncompressed files do. However, you may not have images that were available in Raw format, or you may not have a camera or cellphone that can save in a Raw format. If JPEG or one of the other formats is your only option, you can easily open the images in the Camera Raw Editor.

In the Photoshop Elements Photo Editor, choose File $rackrel{r$

Changing Image Defaults

Suppose you make some adjustments to a Raw image and then want to return to the original, unedited file. You have several ways to accomplish this task. From the Panel Bin, which is available when viewing all three panels, you can click the three bullet icons to open the menu (refer to Figure 5–13).

The choices you have for this menu include:

- >> Reset to Open: Resets to the last time the file was opened.
- Reset to Default: Returns the settings to the original file captured by the camera.
- >> Previous Conversion: Uses the same settings as those previously used when file was edited.
- >> Clear Imported Settings: Clears settings that you may have imported.

Working with XML Files and Preferences

There are a few things you should understand when it comes to sharing edited Raw images and changing default settings. You can start by examining the Preferences dialog box in the next section.

Changing program defaults

You can apply some default settings in the Camera Raw Editor Preferences dialog box. To open the Preferences dialog box, you must open an image in the Raw Editor. You can't launch the Editor without opening an image first. Any settings you make in the Preferences dialog box won't affect the open image. Preference settings take effect only when you quit and reopen the Raw Editor.

With the Raw Editor open, click the Open Preferences tool in the toolbar or press Ctrl/光 +K. The Preferences dialog box opens, as shown in Figure 5-14.

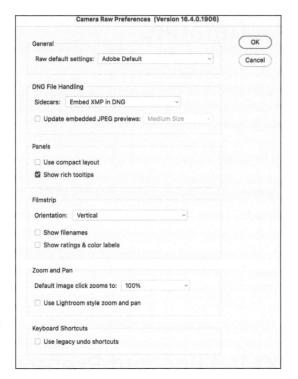

FIGURE 5-14: Press Ctrl/第+K to open the Preferences dialog box.

There are three individual areas in the Preferences dialog box with different settings. These include:

- >> General: In the General area, you make choices for Raw default settings.

 Choose from Adobe Default or Camera Settings. If you prefer your Camera
 Raw settings, open the drop-down list and choose Camera Settings.
- >> DNG File Handling: This section covers working with Adobe Digital Negative (DNG) files.
 - Embed XMP in DNG: When you make edits in the Raw Editor, by default a text file called an XMP file known as a sidecar file is created that holds all your edit information. The Raw file itself is not edited. The XMP file holds the edit information apart from the photo itself. Choose this item if you want to embed the XMP file inside the DNG file.
 - Always Use Sidecar XMP File: As the name implies, sidecar XMP files are always used.
 - **Ignore Sidecar XMP Files:** The sidecar XMP file data are ignored.
 - Update Embedded JPEG Previews: Updates thumbnails to updated images.

>> Panels:

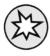

- **Show Rich Tooltips:** A Rich Tooltip is like a pop-up mini tutorial where you see an image and a more detailed explanation for what the tool does when you use it. Sometimes it can be annoying when you move the cursor to a tool and see a pop-up display that hides the area close to the tool. If you find the Rich Tooltip annoying, open the Preferences (CTRL/黑 + K) and disable this check box. If you want to see a Rich Tool Tip, be certain that this check box is enabled and move the cursor over the Red Eye tool on the right side of the Camera Raw window; then wait a moment. The pop-up window will soon open.
- >> Orientation: The default is Horizontal. The filmstrip appears horizontally at the bottom of the ACR window. Choose Vertical from the menu to view the thumbnails vertically along the left side of the image window.
 - **Show Filenames:** Filenames appear below the thumbnails in the filmstrip.
 - Show Ratings & Color Labels: Star ratings appear below the thumbnails in the filmstrip, and the stars appear with any assigned color specified when adding Color Labels.
- >> Zoom and Pan: You have an option to set the zoom level by editing the text box.
 - When enabled, you can click and drag to pan around an image that's zoomed in. If this preference is not enabled, you can press the spacebar or use the Hand tool to pan around a zoomed in image.
- >> Keyboard shortcuts: This section has a single setting. Using legacy shortcuts literally has no effect. You can use Ctrl/第 +Z or Ctrl/第 +Alt/Option+Z to step back through edits in the panels. Legacy files are treated identically when the shortcuts work the same.

Using Save Options

At the top of the ACR window, the first icon at the top-right corner of the ACR window is the Convert and Save Image icon. When you click this item, the Save Options dialog box opens, as shown in Figure 5-15. In this dialog box, you have choices for the location where you want to save photos, file naming conventions, file extension choices, and some specifics related to the Adobe Digital Negative format. Most of these options are self-explanatory.

95

FIGURE 5-15: Click the first icon in the topright corner to open the Save Options dialog box.

Using sidecar files

In the Preferences dialog box, you have some choices for handling sidecar files. Sidecar files are text files written in XML, and they contain all the data related to editing a Raw file. You can actually examine an XMP file by opening it in a text editor.

XMP files are like tape recordings. All the edits are reordered and documented for each edit you make. When you click Done or Open Image in the Raw Editor, the sidecar file is written. In a desktop view, you can see the sidecar file adjacent to the Raw image.

If you delete the sidecar file, all edits are deleted and the original Raw image remains in an unedited version. It's the same file you copied from your memory card to your computer.

It's important to understand that the sidecar file needs to accompany your original Raw image when you copy the image to another computer or share the image with another user. It's important, that is, if you want to retain all the edits you made in the Raw file.

- » Creating selections with the Lasso tools, Magic Wand, and more
- » Using the Cookie Cutter tool
- » Rubbing away pixels with the Eraser tools
- » Saving and loading your selections

Chapter **6**

Making and Modifying Selections

f all you want to do is use your photos in all their unedited glory, feel free to skip this chapter and move on to other topics. But if you want to occasionally pluck an element out of its environment and stick it in another or apply an adjustment to just a portion of your image, this chapter's for you.

Finding out how to make accurate selections is one of those skills that's well worth the time you invest. In this chapter, we cover all the various selection tools and techniques. We also give you tips on which tools are better for which kinds of selections. But remember that you usually have several ways to achieve the same result. Which road you choose is ultimately up to you.

Defining Selections

Before you dig in and get serious about selecting, let us clarify for the record what we mean by "defining a selection." When you *define* a selection, you specify which part of an image you want to work with. Everything within a selection is considered selected. Everything outside the selection is unselected. After you

have a selection, you can then adjust only that portion, and the unselected portion remains unchanged. Or you can copy the selected area into another image altogether. Want to transport yourself out of your background and onto a white, sandy beach? Select yourself out of that backyard BBQ photo, get a stock photo of the tropical paradise of your choice, and drag and drop yourself onto your tropics photo with the Move tool. It's that easy.

When you make a selection, a dotted outline — dubbed a selection border, an outline, or a marquee — appears around the selected area. Elements, sophisticated imaging program that it is, also allows you to partially select pixels, which allows for soft-edged selections. You create soft-edged selections by feathering the selection or by using a mask. Don't worry: We cover these techniques in the section "Applying Marquee options," later in this chapter.

For all the selection techniques described in this chapter, be sure that your image is in Advanced mode in the Photo Editor and not in Quick or Guided mode or in the Organizer.

Creating Rectangular and Elliptical Selections

If you can drag a mouse, you can master the Rectangular and Elliptical Marquee tools. These are the easiest selection tools to use, so if your desired element is rectangular or elliptical, by all means, grab one of these tools.

The Rectangular Marquee tool, as its moniker implies, is designed to define rectangular (including square) selections. This tool is great to use if you want to home in on the pertinent portion of your photo and eliminate unnecessary background.

Here's how to make a selection with this tool:

1. Select the Rectangular Marquee tool from the Tools panel.

The tool looks like a dotted square. You can also press M to access the tool. If the tool isn't visible, press M again.

2. Drag from one corner of the area you want to select to the opposite corner.

While you drag, the selection border appears. The marquee follows the movement of your mouse cursor.

3. Release your mouse button.

You have a completed rectangular selection, as shown in Figure 6-1.

The Elliptical Marquee tool is designed for elliptical (including circular) selections. This tool is perfect for selecting balloons, clocks, and other rotund elements.

Here's how to use the Elliptical Marquee:

1. Select the Elliptical Marquee tool from the Tools panel.

The tool looks like a dotted ellipse. You can also press M to access this tool if it's visible; if it isn't, press M again.

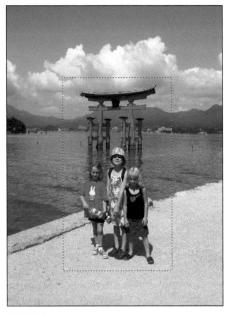

FIGURE 6-1:Use the Rectangular Marquee tool to create rectangular selections.

If pressing the keyboard shortcut doesn't cycle through the tools, choose Preferences

General and make sure Use Shift Key for Tool Switch is deselected.

Position the crosshair near the area you want to select and then drag around your desired element.

With this tool, you drag from a given point on the ellipse. While you drag, the selection border appears.

3. When you're satisfied with your selection, release the mouse button.

Your elliptical selection is created, as shown in Figure 6-2. If your selection isn't quite centered around your element, simply move the selection border by dragging inside the border.

You can move a selection while you're making it with either of the Marquee tools by holding down the spacebar while you're dragging.

TIP

The Elliptical
Marquee tool
is perfect for
selecting round
objects.

happymay/Shutterstock

Perfecting squares and circles with Shift and Alt (Option on the Mac)

Sometimes you need to create a perfectly square or circular selection. To do so, simply press the Shift key after you begin dragging. After you make your selection, release the mouse button and then release the Shift key. You can also set the aspect ratio to 1:1 in the Tool Options.

TIP

When you're making an elliptical selection, making the selection from the center outward is often easier. To draw from the center, first click the mouse button where you want to position the center, press Alt (Option on the Mac), and then drag. After making your selection, release the mouse button and then release the Alt (Option on the Mac) key.

If you want to draw from the center outward *and* create a perfect circle or square, press the Shift key as well. After you make your selection, release the mouse button and then release the Shift+Alt (Shift+Option on the Mac) keys.

Applying Marquee options

The Marquee tools offer additional options when you need to make precise selections at specific measurements. You also find options for making your selections soft around the edges.

The only thing to remember is that you must select the options in the Tool Options, as shown in Figure 6-3, before you make your selection with the Marquee tools. Options can't be applied after the selection has already been made. The exception is that you can feather a selection after the fact by choosing Select ⇔ Feather.

FIGURE 6-3: Apply Marquee settings in the Tool Options.

Here are the various Marquee options available to you:

>>> Feather: Feathering creates soft edges around your selection. The amount of softness depends on the value, from 0 to 250 pixels, that you enter by adjusting the slider. The higher the value, the softer the edges, as shown in Figure 6-4. Very small amounts of feathering can be used to create subtle transitions between selected elements in a collage or for blending an element into an existing background. Larger amounts are often used when you're combining multiple layers so that one image gradually fades into another. If you want a selected element to have just a soft edge without the background, simply choose Select □ Inverse and delete the background. See more on inversing selections in the "Modifying Your Selections" section, later in this chapter. For more on layers, see Chapter 7.

Don't forget that those soft edges represent partially selected pixels.

- >> Anti-aliasing: Anti-aliasing barely softens the edge of an elliptical or irregularly shaped selection so that the jagged edges aren't quite so obvious. An anti-aliased edge is always only 1 pixel wide. We recommend leaving this option chosen for your selections. Doing so can help to create natural transitions between multiple selections when you're creating collages.
- >> Aspect: The Aspect drop-down list contains three settings:
 - Normal: The default setting, which allows you to freely drag a selection of any size.
 - **Fixed Ratio:** Lets you specify a fixed ratio of width to height. For example, if you enter **3** for width and **1** for height, you get a selection that's three times as wide as it is high, no matter what the size.
 - Fixed Size: Lets you specify desired values for the width and height. This
 setting can be useful when you need to make several selections that must
 be the same size.

- >> Width (W) and Height (H): When you choose Fixed Ratio or Fixed Size from the Aspect drop-down list, you must also enter your desired values in the Width and Height text boxes. To swap the Width and Height values, click the double-headed arrow button between the two measurements.
- >> Refine Edge: For details on this great option, see "Refining the edges of a selection," later in this chapter.

The default unit of measurement in the Width and Height text boxes is pixels (px), but that doesn't mean that you're stuck with it. You can enter any unit of measurement that Elements recognizes: pixels, inches (in), centimeters (cm), millimeters (mm), points (pt), picas (pica), or percentages (%). Type your value and then type the word or abbreviation of your unit of measurement.

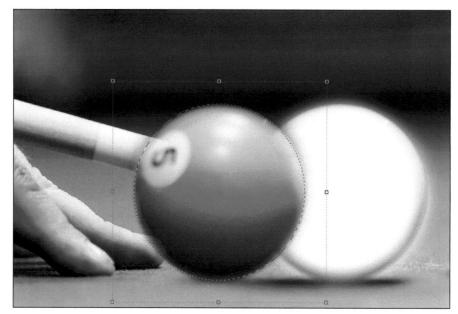

Feathering creates soft-edged selections.

Mikadun/Shutterstock

Making Freeform Selections with the Lasso Tools

You can't select everything with a rectangle or an ellipse. Life is just way too freeform for that. Most animate, and many inanimate, objects have undulations of varying sorts. Luckily, Elements anticipated the need to capture these shapes and provided the Lasso tools.

The Lasso tools enable you to make any freehand selection you can think of. Elements generously provides three types of Lasso tools:

- >> Lasso
- >> Polygonal
- >> Magnetic

Although all three tools are designed to make freeform selections, they differ slightly in their methodology.

To use these tools, all that's really required is a steady hand. You'll find that the more you use the Lasso tools, the better you become at your tracing technique. Don't worry if your initial lasso selection isn't super accurate. You can always go back and make corrections by adding and deleting from your selection. To find out how, see the section "Modifying Your Selections," later in this chapter.

If you find that you really love the Lasso tools, you may want to invest in a digital drawing tablet and stylus. This device makes tracing (and also drawing and painting) on the computer more comfortable. It better mimics pen and paper, and after trying it, many users swear that they'll never go back to a mouse. This is especially handy for laptop users. Attempting to draw accurately on a trackpad can make you downright cranky.

Selecting with the Lasso tool

Using the Lasso tool is the digital version of tracing an outline around an object on a piece of paper. It's that easy. And you have only three choices in the Tool Options — Feather, Anti-aliasing, and Refine Edge. To find out more about the Feather and Anti-aliasing tools, see the section "Applying Marquee options," earlier in this chapter. For the scoop on Refine Edge, see the section "Refining the edges of a selection," later in this chapter.

Here's how to make a selection with the Lasso tool:

1. Select the Lasso tool from the Tools panel.

It's the tool that looks like a rope. You can also just press the L key. If the Lasso tool isn't visible, press L to cycle through the various Lasso flavors. Note that you can also access any of the Lasso tools in the Tool options located under the image.

2. Position the cursor anywhere along the edge of the object you want to select.

The leading point of the cursor is the protruding end of the rope, as shown in Figure 6-5. Don't be afraid to zoom in to your object, using the Zoom tool — or,

more conveniently, pressing Control++ (\Re ++ on the Mac) — if you need to see the edge more distinctly. In this figure, we started at the top of the sunflower.

Hold down the mouse button and trace around your desired object.

Try to include only what you want to select. While you trace around your object, an outline follows the mouse cursor.

Try not to release the mouse button until you return to your starting point. When you release the mouse button, Elements assumes that you're done and closes the selection from wherever you released the mouse button to your starting point; if you release the button too early, Elements creates a straight line across your image.

4. Continue tracing around the object and return to your starting point; release the mouse button to close the selection.

You see a selection border that matches your lasso line. Look for a small circle that appears next to your lasso cursor when you return to your starting point. This icon indicates that you're closing the selection at the proper spot.

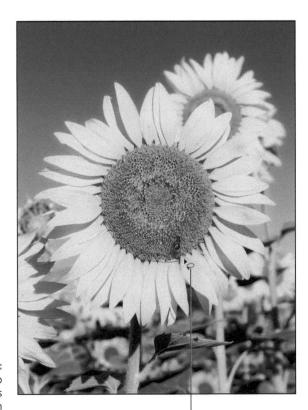

The Lasso tool makes freeform selections.

Lasso Cursor

Aleksey Stemmer/Shutterstock.com

Getting straight with the Polygonal Lasso tool

The Polygonal Lasso tool has a specific mission in life: to select any element whose sides are straight. Think pyramids, stairways, skyscrapers, barns — you get the idea. It also works a tad differently from the Lasso tool. You don't drag around the element with the Polygonal Lasso. Instead, you click and release the mouse button at the corners of the element you're selecting. The Polygonal Lasso tool acts like a stretchy rubber band.

Follow these steps to select with the Polygonal Lasso tool:

1. Select the Polygonal Lasso tool from the Tools panel.

You can also press the L key to cycle through the various Lasso tools. The tool looks like a straight-sided lasso rope.

2. Click and release at any point to start the Polygonal Lasso selection line.

We usually start at a corner.

Move (don't drag) the mouse and click at the next corner of the object.
 Continue clicking and moving to each corner of your element.

Notice how the line stretches out from each point you click.

4. Return to your starting point and click to close the selection.

Be on the lookout for a small circle that appears next to your lasso cursor when you return to your starting point. This circle is an indication that you're indeed closing the selection at the right spot.

Note: You can also double-click at any point, and Elements closes the selection from that point to the starting point.

After you close the polygonal lasso line, a selection border appears, as shown in Figure 6-6.

TIP

The third member of the Lasso team is the Magnetic Lasso. We aren't huge fans of this Lasso tool, which can sometimes be hard to work with. The Magnetic Lasso tool works by defining the areas of the most contrast in an image and then snapping to the edge between those areas, as though the edge has a magnetic pull. If you want to give it a try, simply click the edge of the object you want to select to drop a fastening point, and then move your cursor around the object without clicking. Return to your starting point to close the selection.

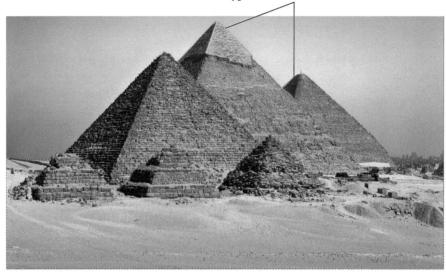

FIGURE 6-6:
After you close
the polygonal
lasso line,
Elements
creates a
selection
border.

WitR/Shutterstock.com

Working Wizardry with the Magic Wand

The Magic Wand tool is one of the oldest tools in the world of digital imaging. This beloved tool has been around since Photoshop was in its infancy and Elements was not yet a twinkle in Adobe's eye. It's extremely easy to use, but you'll have a somewhat harder time predicting what selection results it will present.

Here's how the Magic Wand tool works: You click inside the image, and the Magic Wand tool makes a selection. This selection is based on the color of the pixel you clicked. If other pixels are similar in color to your target pixel, Elements includes them in the selection. What's sometimes hard to predict, however, is how to determine *how* similar the color has to be to get the Magic Wand tool to select it. Fortunately, that's where the Tolerance setting comes in. In the sections that follow, we first introduce you to this setting and then explain how to put the Magic Wand to work.

Talking about Tolerance

The Tolerance setting determines the range of color that the Magic Wand tool selects. The range of color is based on brightness levels, ranging from 0 to 255:

- >> Setting the Tolerance to 0 selects one color only.
- >>> Setting the Tolerance to 255 selects all colors, or the whole image.

The default setting is 32, so whenever you click a pixel, Elements analyzes the value of that base color and then selects all pixels whose brightness levels are between 16 levels lighter and 16 levels darker.

What if an image contains a few shades of the same color? It's not a huge problem. You can click the Magic Wand multiple times to pick up additional pixels that you want to include in the selection. You can find out how in the section "Modifying Your Selections," later in this chapter. Or you can try a higher Tolerance setting. Conversely, if your wand selects too much, you can lower your Tolerance setting.

So you can see by our talk on tolerance that the Magic Wand tool works best when you have high-contrast images or images with a limited number of colors. For example, the optimum image for the Wand would be a solid black object on a white background. Skip the wand if the image has a ton of colors and no real definitive contrast between your desired element and the background.

Wielding the Wand to select

To use the Magic Wand tool and adjust its Tolerance settings, follow these steps:

1. Select the Magic Wand tool from the Tools panel.

It looks like a wand with a starburst on the end. You can also just press A to cycle through the Magic Wand, Quick Selection, and Selection Brush tools. Or you can choose any of the tools and then select your desired tool in the Tool Options.

Click anywhere on your desired element, using the default Tolerance setting of 32.

The pixel you click determines the base color.

If the Pixel Gods are with you and you selected everything you want on the first click, you're done. If your selection needs further tweaking, like the top image shown in Figure 6-7, continue to Step 3.

3. Specify a new Tolerance setting in the Tool Options.

If the Magic Wand selects more than you want, lower the Tolerance setting. If the wand didn't select enough, increase the value. While you're poking around in the Tool Options, here are a couple more options to get familiar with:

 Sample All Layers: If you have multiple layers and enable this option, the Magic Wand selects pixels from all visible layers. Without this option, the tool selects pixels from the active layer only. For more on layers, see Chapter 7.

Tolerance 32

Tolerance 90

FIGURE 6-7: The Magic Wand selects pixels based on a specified Tolerance setting.

Brocreative/Shutterstock.com

- Contiguous: Forces the Magic Wand to select only pixels that are adjacent to each other. Without this option, the tool selects all pixels within the range of tolerance, whether or not they're adjacent to each other.
- Anti-aliasing: Softens the edge of the selection by one row of pixels. See the section "Applying Marquee options," earlier in this chapter, for details.
- Refine Edge: Click the Refine Edge button. In the Refine Edge dialog box, clean up your selection by moving the Smooth slider to reduce the amount of jagginess in your edges. Feather works like the Feather option discussed in the "Applying Marquee options" section, earlier in the chapter. Move the Shift Edge slider to the left or right to decrease or increase the selected area, respectively. For even more details, see the section "Refining the edges of a selection," later in this chapter. Finally, see how to use the Select Subject option, later in this chapter, in "Selecting Your Subject, Background, or Sky with One-Click Selecting."

4. Click your desired element again.

Unfortunately, the Magic Wand tool isn't magical enough to modify your first selection automatically. Instead, it deselects the current selection and makes a new selection based on your new Tolerance setting. If it still isn't right, you can adjust the Tolerance setting again. Try, try again.

Modifying Your Selections

It's time for a seventh-inning stretch in this chapter on selection tools. In this section, you find out how to refine that Marquee, Lasso, or Magic Wand selection to perfection.

TIP

You're not limited to the manual methods described in the following sections, or even to keyboard shortcuts. You can also use the four selection option buttons on the left side of the Tool Options to create a new selection (the default), add to a selection, subtract from a selection, or intersect one selection with another. Just choose your desired selection tool, click the selection option button you want, and drag (or click if you're using the Magic Wand or Polygonal Lasso tool).

Adding to, subtracting from, and intersecting a selection

Although the Marquee, Lasso, and Magic Wand tools do an okay job of capturing the bulk of your selection, if you take the time to add or subtract a bit from your selection border, you can ensure that you get only what you really want:

>> Add: If your selection doesn't quite contain all the elements you want to capture, you need to add those portions to your current selection border.

To add to a current Marquee selection, simply press the Shift key and drag around the area you want to include. If you're using the Polygonal Lasso, click around the area. And if you're wielding the Magic Wand, just press the Shift key and click the area you want.

You don't have to use the same tool to add to your selection that you used to create the original selection. Feel free to use whatever selection tool you think can get the job done. For example, it's very common to start off with the Magic Wand and fine-tune with the Lasso tool.

- >> Subtract: Got too much? To subtract from a current selection, press the Alt (Option on the Mac) key and drag the marquee around the pixels you want to subtract. With the Alt (Option on the Mac) key, use the same method for the Magic Wand and Polygonal Lasso as you do for adding to a selection.
- >> Intersect two selections: Get your fingers in shape. To intersect your existing selection with a second selection, press Shift+Alt (Shift+Option on the Mac) and drag with the Lasso or Marquee tools. Or, if you're using the Magic Wand or Polygonal Lasso, press those keys and click rather than drag. Your selection now includes only the area common to both selections.

Avoiding key collisions

If you read the beginning of this chapter, you found out that by pressing the Shift key, you get a perfectly square or circular selection. We tell you in the preceding section, "Adding to, subtracting from, and intersecting a selection," that if you want to add to a selection, you press the Shift key. What if you want to create a perfect square while adding to the selection? Or what if you want to delete part of a selection while also drawing from the center outward? Both require the use of the Alt (Option on the Mac) key. How in the heck does Elements know what you want? Here are two tips to avoid keyboard collisions — grab your desired Marquee tool:

>> To add a square or circular selection, press Shift and drag. While you drag, keep the mouse button pressed, release the Shift key for just a second, and then press it again. Your added selection area suddenly snaps into a square or

circle. You must then release the mouse button and then release the Shift key. Make sure your Aspect option is set to Normal.

>> To delete from an existing selection while drawing from the center outward, press Alt (Option on the Mac) and drag. While you drag, keep the mouse button pressed, release the Alt (Option on the Mac) key for just a second, and then press it down again. You're now drawing from the center outward. Again, release the mouse button first and then release the Alt (Option on the Mac) key.

You can also use the selection option buttons in the Tool Options.

Painting with the Selection Brush

If you like the organic feel of painting on a canvas, you'll appreciate the Selection Brush. Using two different modes, you can either paint over areas of an image that you want to select or paint over areas you don't want to select. This great tool also lets you first make a basic selection with another tool, such as the Lasso, and then fine-tune the selection by brushing additional pixels into or out of the selection.

Here's the step-by-step process of selecting with the Selection Brush:

1. Select the Selection Brush from the Tools panel.

It looks like a paintbrush with a dotted oval around the tip. Or simply press the A key to cycle through the Selection Brush, Quick Selection, and Magic Wand tools. You can also select any of these tools and then choose your desired tool in the Tool Options.

This tool works in either Advanced or Quick mode.

2. Specify your Selection Brush options in the Tool Options.

Here's the rundown on each option:

Mode: Choose Selection if you want to paint over what you want to select
or Mask if you want to paint over what you don't want.

If you choose Mask mode, you must choose some additional overlay options. An overlay is a layer of color (that shows onscreen only) that hovers over your image, indicating protected or unselected areas. You must also choose an overlay opacity between 1 and 100 percent (which we describe in the Tip at the end of these steps). You can change the overlay color from the default red to another color. This option can be helpful if your image contains a lot of red.

- Brush Presets Picker: Choose a brush from the presets drop-down list.
 To load additional brushes, click the downward-pointing arrow to the right of Default Brushes and choose the preset library of your choice. You can select the Load Brushes command from the panel menu (top-right down-pointing arrow).
- Size: Specify a brush size, from 1 to 2,500 pixels. Enter the value or drag the slider.
- Hardness: Set the hardness of the brush tip, from 1 to 100 percent.
 A harder tip creates a crisper, more defined stroke.

3. Paint the appropriate areas:

• If your mode is set to Selection: Paint over the areas you want to select.

You see a selection border. Each stroke adds to the selection. (The Add to Selection button in the Tool Options is selected automatically.) If you inadvertently add something you don't want, simply press the Alt (Option on the Mac) key and paint over the undesired area. You can also click the Subtract from Selection button in the Tool Options. After you finish painting what you want, your selection is ready to go.

 If your mode is set to Mask: Paint over the areas that you don't want to select.

When you're done painting your mask, choose Selection from the Selection/Mask drop-down list or simply choose another tool from the Tool Options, in order to convert your mask into a selection border. Remember that your selection is what you *don't* want.

While you paint, you see the color of your overlay. Each stroke adds more to the overlay area, as shown in Figure 6-8. In the example, the sky is masked (with a red overlay) to replace it with a different sky. When working in Mask mode, you're essentially covering up, or *masking*, the areas you want to protect from manipulation. That manipulation can be selecting, adjusting color, or performing any other Elements command. Again, if you want to remove parts of the masked area, press Alt (Option on the Mac) and paint.

REMEMBER

TIP

If you painted your selection in Mask mode, your selection border is around what you *don't* want. To switch to what you do want, choose Select ➪ Inverse.

Which mode should you choose? Well, it's up to you. But one advantage to working in Mask mode is that you can partially select areas. By painting with soft brushes, you create soft-edged selections. These soft edges result in partially selected pixels. If you set the overlay opacity to a lower percentage, your pixels are even less opaque, or "less selected." If this partially selected business sounds vaguely familiar, it's because this is also what happens when you feather selections, as we discuss in the section "Applying Marquee options," earlier in this chapter.

E+/iStockphoto LP

Painting with the Quick Selection Tool

Think of the Quick Selection tool as a combination Brush, Magic Wand, and Lasso tool. Good news — it lives up to its "quick" moniker. Better news — it's also easy to use. The best news? It gives pretty decent results, so give it a whirl.

Here's how to make short work of selecting with this tool:

1. Select the Quick Selection tool from the Tools panel.

The tool looks like a wand with a marquee around the end. It shares the same Tools panel space with the Selection Brush tool and the Magic Wand tool. You can also press the A key to cycle through the Quick Selection, Selection Brush, and Magic Wand tools.

FIGURE 6-8: The Selection Brush allows you to make a selection (right) by creating a mask (left).

This tool works in either Advanced or Quick mode.

Specify the options in the Tool Options.

Here's a description of the options:

- **New Selection:** The default option enables you to create a new selection. There are also options to add to and subtract from your selection.
- **Size:** Choose your desired brush size. Specify the diameter, from 1 to 2,500 pixels.
- Brush Settings: With these settings, you can specify hardness, spacing, angle, and roundness. For details on these settings, see Chapter 11.
- Sample All Layers: If your image has layers and you want to make a selection from all the layers, select this option. If you leave it deselected, you will select only from the active layer.

• Auto-Enhance: Select this option to have Elements automatically refine your selection by implementing an algorithm.

3. Drag or paint the desired areas of your image.

Your selection grows as you drag, as shown in Figure 6-9. If you stop dragging and click in another portion of your image, your selection includes that clicked area.

4. Add to or delete from your selection, as desired:

- To add to your selection, press the Shift key while dragging across your desired image areas.
- To delete from your selection, press the Alt (Option on the Mac) key while dragging across your unwanted image areas.

You can also select the Add to Selection and Subtract from Selection options in the Tool Options.

The selected portion is surrounded by a border

FIGURE 6-9: Paint a selection with the Quick Selection tool.

Screga K Photo and Video/Shutterstock

5. If you need to fine-tune your selection, click the Refine Edge option in the Tool Options and then change the settings, as desired.

The settings are explained in detail in the "Refining the edges of a selection" section, later in this chapter.

Note: If your object is fairly detailed, you may even need to break out the Lasso or another selection tool to make some final cleanups. Eventually, you should arrive at a selection you're happy with.

Selecting with the Auto Selection Tool

If the selection tools described so far in this chapter seem a little too taxing, this tool is made for you. The Auto Selection tool lives up to its name by quickly and easily selecting your desired object. This intelligent tool takes your rough selection, analyzes the pixels, and determines the object it thinks you want within that rough selection. It then snaps to that object.

Here's how to use this genius tool:

1. Select the Auto Selection tool from the Tools panel.

The tool looks like a wand with three small stars around the end, as shown in Figure 6-10. It shares the same Tools panel space with the Quick Selection, Selection Brush, and Magic Wand tools. You can also press the A key to cycle through those tools. Note that, by default, the New Selection option is highlighted.

This tool works in either Advanced or Quick mode.

Choose which tool you want to use to make your rough selection in the Tool Options.

You can choose from the Rectangular and Elliptical Marquee tools or the Lasso and Polygonal Lasso tools.

3. Specify other options in the Tool Options:

- Sample All Layers: If your image has layers and you want to make a selection from all the layers, select this option. If you leave it deselected, you will select only from the active layer.
- Constrain Selection: This option will keep your marquee selections perfectly square or circular.

4. Make a rough selection around the desired object in your image.

We used the Lasso tool and selected the girl, as shown in Figure 6-10.

When you release your mouse after making the selection, Elements smartly analyzes the pixels and snaps to your selected object, as shown in Figure 6-10.

- 5. Add or subtract from your selection as needed.
 - **To add to your selection**, press the Shift key while dragging across your desired image areas.
 - To delete from your selection, press the Alt key (Option key on the Mac) while dragging across your unwanted image areas.

You can also select the Add to Selection and Subtract from Selection options in the Tool Options.

6. If you need to fine-tune your selection, click the Refine Edge option in the Tool Options and adjust the settings, as desired.

The settings are explained in detail in the "Refining the edges of a selection" section, later in this chapter.

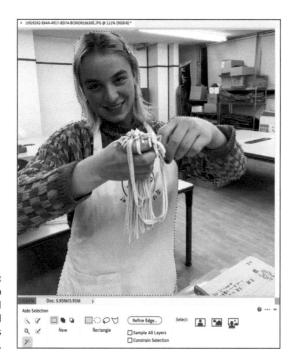

FIGURE 6-10: The Auto Selection tool easily and quickly selects your object.

TIP

If you think the Auto Selection tool is a game changer, you must check out the Background Changer Guided Edit. This edit, found under the Special Edits in Guided mode, lets you change the background in your image and even add a custom background.

Selecting Your Subject, Background, or Sky with One-Click Selecting

One of the most popular requests that Adobe receives when querying users about its software is "How can I select things more easily and more accurately?" Adobe heard the cries and supplied yet another two more ways to make a selection.

Here's how to use the three one-click selection commands:

 In either Advanced or Quick mode, choose Select

Subject or Background or Sky.

You can also click the Select Subject, Background or Sky icon buttons in the Tool Options of the Quick Selection, Selection Brush, Magic Wand, Refine Selection, and Auto Selection Tool, as shown in Figure 6-11.

2. If your selection needs some cleanup after Step 1, add to or subtract from your selection using any of the selection tools.

Our favorite tool for small cleanups is the Lasso tool, found in the Tool Options of the Auto Selection Tool.

- To add to your selection, press the Shift key while dragging across your desired image areas.
- To delete from your selection, press the Alt key (Option key on the Mac) while dragging across your unwanted image areas.

You can also select the Add to Selection and Subtract from Selection options in the Tool Options.

3. If you need to fine-tune your selection further, click the Refine Edge option in the Tool Options and adjust the settings as desired.

The settings are explained in detail in the "Refining the edges of a selection" section, later in this chapter.

FIGURE 6-11:
The Select
Subject
command
analyzes and
selects people,
animals, cars,
and other
objects.

Fine-Tuning with the Refine Selection Brush

As we mention in the beginning of this chapter, being able to make selections quickly and accurately is a coveted skill. Luckily, Elements has an additional tool to make this skill easier to obtain. The Refine Selection Brush helps you to add or delete portions of your selection by automatically detecting edges of your desired element.

Here's how to refine your selections with this tool:

 Make your selection using the Quick Selection tool, Selection Brush, or any other selection tool, for that matter.

Elements doesn't care how you make your initial selection, as long as you have one. Don't worry if it isn't perfect. That's where the Refine Selection Brush comes in.

Select the Refine Selection Brush.

This tool shares a tool slot with the Quick Selection tool, Magic Wand, Selection Brush, and Smart Selection tool.

Your cursor appears as two concentric circles. The outer circle reflects the Tolerance setting to detect an edge. For more on tolerance, see "Talking about Tolerance," earlier in this chapter.

Specify the settings in the Tool Options.

Here are descriptions of the options:

- Size: Use the slider to adjust your brush diameter from 1 to 2,500 pixels.
- **Snap Strength:** Use the slider to adjust your snap strength from 0 to 100 percent. Snap Strength indicates the intensity of the pull.
- Selection Edge: Use the slider to determine how hard or soft you want your edge. If you have an object that has wispier edges, such as hair, fur, or feathers, moving the slider more toward soft may be more effective in getting your desired selection. If you set your mode to Add and press and hold your cursor on your object, the selection within your concentric circles grows. Specifically, the lighter-colored area around your center circle, called the selection edge, grows. This area represents your object's edge. Be sure to include your entire edge within this area. Note that you can also "paint" the edge with the Refine Selection Brush tool. Getting the selection you want on a complex object may take a bit of experimentation and refining using the options, but hang in there and you should get the detail you want.
- Add/Subtract: Choose this mode to either add to or subtract from your selection.
- Push: Place your cursor inside the selection to increase your selection
 within the diameter of the outer circle of your cursor. It will snap to the
 edge of the element closest to the cursor. Place your cursor outside the
 selection to decrease your selection within the diameter of the outer circle.
- Smooth: If your selection border looks a little too jagged, use this mode to smooth your selection edge.
- View: Choose an option to view the selection. Options include viewing your selected object against a white or black background. Or you can choose Overlay to view it against a red semi-opaque overlay. Note that with the Overlay option, you can adjust the corresponding opacity of that overlay.
- 4. Continue to use the Refine Selection Brush to perfect your selection until you're satisfied. The finished selection is shown in Figure 6-12.

FIGURE 6-12: Use the Refine Selection Brush to fine-tune your selection.

kegfire/Adobe Stock Photos

Working with the Cookie Cutter Tool

The Cookie Cutter tool is a cute name for a pretty powerful tool. You can think of it as a Custom Shape tool for images. But, whereas the Custom Shape tool creates a mask and just hides everything outside the shape, the Cookie Cutter tool cuts away everything outside the shape. The preset libraries offer you a large variety of interesting shapes, from talk bubbles to Swiss cheese. (We're not being funny here — check out the food library.)

Here's the lowdown on using the Cookie Cutter:

Select the Cookie Cutter tool from the Tools panel.

There's no missing this tool; it looks like a flower. You can also press the C key. The Cookie Cutter shares a space with the Crop and Perspective Crop tools. If you don't see it, press C until you do, or select the Crop tool and then select the Cookie Cutter in the Tool Options.

2. Specify your options in the Tool Options.

Here's the list:

- Shape: Choose a shape from the Custom Shape picker preset library. To load other libraries, click the Shapes pop-up menu and choose one from the submenu.
- Geometry Options: These options let you draw your shape with certain parameters.
- Unconstrained: Enables you to draw freely.
- Defined Proportions: Enables you to keep the height and width proportional.
- Defined Size: Crops the image to the original, fixed size of the shape you choose. You can't make it bigger or smaller.
- Fixed Size: Allows you to enter your desired width and height.
- From Center: Allows you to draw the shape from the center outward.
- **Feather:** This option creates a soft-edged selection. See the section "Applying Marquee options," earlier in this chapter, for more details.
- Crop: Click this option to crop the image into the shape. The shape fills the image window.
- 3. Drag your mouse on the image to create your desired shape, size the shape by dragging one of the handles of the bounding box, and position the shape by placing the mouse cursor inside the box and dragging.

You can also perform other types of transformations, such as rotating and skewing. You can use these functions by dragging the box manually or by entering values in the Tool Options. For more on transformations, see Chapter 7.

4. Click the Commit button on the image or press Enter to finish the cutout.

See Figure 6-13 to see the image cut into a leaf shape. If you want to bail out of the bounding box and not cut out, you can always click the Cancel button on the image or press Esc.

FIGURE 6-13: Crop your photo into interesting shapes with the Cookie Cutter.

Evgeniya Moroz/Shutterstock

Eliminating with the Eraser Tools

The Eraser tools let you erase areas of your image. Elements has three Eraser tools: the regular Eraser, the Magic Eraser, and the Background Eraser. The Eraser tools look like those pink erasers you used in grade school, so you can't miss them. If you can't locate them, you can always press E to cycle through the three tools.

WARNING

When you erase pixels, those pixels are history — they're gone. So before using the Eraser tools, always have a backup of your image stored somewhere. Think of it as a cheap insurance policy in case things go awry.

The Eraser tool

The Eraser tool enables you to erase areas on your image to either your background color or, if you're working on a layer, a transparent background, as shown in Figure 6-14. For more on layers, check out Chapter 7.

FIGURE 6-14: Erase either to your background color (left) or to transparency (right).

samdiesel/iStockphoto LP

To use this tool, simply select it and drag through the desired area on your image, and you're done. Because it isn't the most accurate tool on the planet, remember to zoom way in and use smaller brush tips to do some accurate erasing.

You have several Eraser options to specify in the Tool Options:

- >>> Brush Presets Picker: Click the drop-down list to access the Brush presets. Choose a brush. Again, additional brush libraries are available on the Brush list. (Click the down-pointing arrow in the top-right corner.)
- >> Size: Slide the Size slider and choose a brush size between 1 and 2,500 pixels. You can also use the left and right bracket keys to decrease and increase the brush size, respectively.
- >> Opacity: Specify a percentage of transparency for your erased areas.

 The lower the Opacity setting, the less it erases. Opacity isn't available in Block mode.
- >> Type: Select Brush, Pencil, or Block. When you select Block, you're stuck with one size (a 16-x-16-pixel tip) and can't select other preset brushes.

The Background Eraser tool

The Background Eraser tool, which is savvier than the Eraser tool, erases the background from an image while being mindful of leaving the foreground untouched. The Background Eraser tool erases to transparency on a layer. If you use this tool on an image with only a background, Elements converts the background into a layer.

TIP

The key to using the Background Eraser is to carefully keep the *hot spot*, the crosshair at the center of the brush, on the background pixels while you drag. The hot spot samples the color of the pixels and deletes that color whenever it falls inside the brush circumference. But if you accidentally touch a foreground pixel with the hot spot, it's erased as well. And the tool isn't even sorry about it! This tool works better with images that have good contrast in color between the background and foreground objects, as shown in Figure 6–15.

FIGURE 6-15:
The
Background
Eraser erases
similarly
colored pixels
sampled by
the hot spot
of your brush
cursor.

webphotographeer/iStock/Getty Images

Here's the rundown on the Background Eraser options:

- **>> Brush Settings:** Click the Brush Settings button to bring up the settings to customize the Size, Hardness, Spacing, Roundness, and Angle of your brush tip. The Size and Tolerance settings at the bottom are for pressure-sensitive drawing tablets.
- >> Limits: Discontiguous erases all similarly colored pixels wherever they appear in the image. Contiguous erases all similarly colored pixels that are adjacent to those under the hot spot.

>> Tolerance: The percentage determines how similar the colors have to be to the color under the hot spot before Elements erases them. A higher value picks up more colors, whereas a lower value picks up fewer colors. See the section "Talking about Tolerance," earlier in this chapter, for more details.

The Magic Eraser tool

You can think of the Magic Eraser tool as a combination Eraser and Magic Wand tool. It selects *and* erases similarly colored pixels simultaneously. Unless you're working on a layer with the transparency locked (see Chapter 7 for more on locking layers), the pixels are erased to transparency. If you're working on an image with just a background, Elements converts the background into a layer.

Although the Magic Eraser shares most of the same options with the other erasers, it also offers unique options:

- >> Sample All Layers: Samples colors using data from all visible layers but erases pixels on the active layer only
- >> Contiguous: Selects and erases all similarly colored pixels that are adjacent to those under the hot spot
- >> Anti-aliasing: Creates a slightly soft edge around the transparent area

Using the Select Menu

In the following sections, we breeze through the Select menu. Along with the methods we describe in the "Modifying Your Selections" section, earlier in this chapter, you can use this menu to further modify selections by expanding, contracting, smoothing, softening, inversing, growing, and grabbing similarly colored pixels. If that doesn't satisfy your selection needs, nothing will.

Selecting all or nothing

The Select All and Deselect commands are no-brainers. To select everything in your image, choose Select 中 All or press Ctrl+A (第 +A on the Mac). To deselect everything, choose Select 中 Deselect or press Ctrl+D (第 +D on the Mac). Remember that you usually don't have to Select All. If you don't have a selection border in your image, Elements assumes that the whole image is fair game for any manipulation.

You can also inverse the selection by choosing Select ➪ Inverse. To feather your selection choose Select ➪ Feather. For more on feathering, see the "Applying Marquee options" section, earlier in this chapter.

Refining the edges of a selection

The Refine Edge option enables you to fine-tune the edges of your selection. It doesn't matter how you got the selection, just that you have one. You can find the command in the Tool Options of the Magic Wand, Lasso, and Quick Selection tools. And, of course, you can find it on the Select menu. Here's the scoop on each setting for this option, as shown in Figure 6-16:

>> View Mode: Choose a mode from the pop-up menu to preview your selection. Hover your cursor over each mode to get a tooltip. For example, Marching Ants shows the selection border. Overlay lets you preview your selection with the edges hidden and a semi-opaque layer of color in your unselected area. On Black and On White show the selection against a black or white background. Show Original shows the image without a

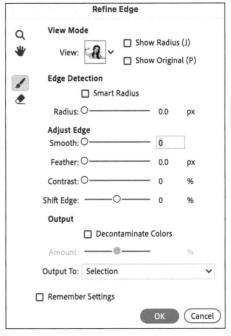

FIGURE 6-16: Fine-tune your selection with Refine Edge.

- selection preview. Show Radius displays the size of the area in which the edge refinement is happening.
- >> Smart Radius: Select this option to have Elements automatically adjust the radius for hard and soft edges near your selection border. If your border is uniformly hard or soft, you may not want to select this option. This enables you to have more control over the radius setting.
- >> Radius: Specifies the size of the selection border you will refine. Increase the radius to improve the edge of areas with soft transitions or a lot of detail.

 Move the slider while looking at your selection to find a good setting.
- >> Smooth: Reduces jaggedness along your selection edges.

- >> Feather: Move the slider to the right to create an increasingly softer, more blurred edge.
- >> Contrast: Removes artifacts while tightening soft edges by increasing the contrast. Try using the Smart Radius option before playing with Contrast.
- >> Shift Edge: Decreases or increases your selected area. Slightly decreasing your selection border can help to defringe (eliminate undesirable background pixels) your selection edges.
- >> Decontaminate Colors: Replaces background fringe with the colors of your selected element. Because decontamination changes the colors of some of the pixels, you will have to output to, or create, another layer or document to preserve your current layer. To see the decontamination in action, choose Reveal Layer for your View mode. Chapter 7 explains how to work with layers.
- >> Amount: Changes the level of decontamination.
- >> Output To: Choose whether you want to output your refined, decontaminated selection to a selection on your current layer, layer mask, layer, layer with layer mask, new document, or new document with layer mask.
- >> Refine Radius tool: Select the Paintbrush tool on the left and brush around your border to adjust the area you're refining. To understand exactly what area is being included or excluded, change your View mode to Marching Ants. Use the right and left brackets to decrease and increase the brush size.
- >> Erase Refinements tool: Use this tool (which looks like an Eraser), also located on the left, to clean up any unwanted refinements made with the Refine Radius tool.
- >> Zoom tool: Allows you to zoom in to your image to see the effects of your settings.
- **>> Hand tool:** Enables you to pan around your image window to see the effects of your settings.

- » Using the Layers panel and the Layer menu
- » Working with the Select menu
- » Creating new layers
- » Moving, merging, transforming, and flattening layers

Chapter **7**

Working with Layers

sing Elements without ever using layers would be like writing a book with a pen and paper pad: Sure, you could do it, but it wouldn't be fun. An even bigger issue would occur when it came time to edit that book and make changes. Correction tape, correction fluid, and erasers would make that task downright tedious, not to mention messy. The benefit of using layers is that you have tremendous flexibility. You can make as many edits as you want for as long as you want, as long as you keep your composite image in layers. Layers make working in Elements a lot more productive. Don't give a darn about productivity? Well, let's just say that layers also make it a breeze for you to bring out your more artsy side.

This chapter explains the tools and techniques you need to start working with layers. After you give layers a try, you'll wonder how you ever lived without them.

Getting to Know Layers

Think of layers as sheets of acetate or clear transparency film. You have drawings or photographs on individual sheets. What you place on each sheet doesn't affect any of the other sheets. Any area on the sheet that doesn't have an image on it is transparent. You can stack these sheets on top of each other to create a combined image, or *composite* (or *collage*, if you prefer). You can reshuffle the order of the sheets, add new sheets, and delete old sheets.

In Elements, *layers* are essentially digital versions of these clear acetate sheets. You can place elements, such as images, text, or shapes, on separate layers and create a composite, as shown in Figure 7–1. You can hide, add, delete, or rearrange layers. Because layers are digital, of course, they have added functionality. You can adjust how opaque or transparent the element on a layer is. You can also add special effects and change how the colors interact between layers.

Layers enable you to easily create composite images.

 $homy design/Shutterstock, \ mervas/Shutterstock, \ ArtFamily/Shutterstock, \ Alex_Rodionov/Shutterstock$

To work with layers, you must be in the Photo Editor in Expert mode.

Converting a background to a layer

When you create a new file with background contents of white or a background color, scan an image into Elements, or open a stock photo or a file from a CD or your digital camera, you basically have a file with just a *background*. There are no layers yet.

An image contains at most one background, and you can't do much to it besides paint on it and make basic adjustments. You can't move the background or change its transparency or blend mode. How do you get around all these limitations? Convert your background into a layer by following these easy steps:

1. Choose Window ➪ Layers to display the Layers panel.

The Layers panel is explained in detail in the following section.

2. Double-click Background on the Layers panel.

3. Name the layer or leave it at the default name of Layer 0.

You can also adjust the blend mode and opacity of the layer in the New Layer dialog box. Or you can do it via the Layers panel commands later.

You can also color-code your layers (but not your Background), which lets you better visually distinguish your layers within the Layers panel. If you decide to do it later, simply right-click (Control+click on the Mac) and choose a color from the contextual menu.

Click OK.

Elements converts your background into a layer, known also as an *image layer*.

When you create a new image with transparent background contents, the image doesn't contain a background but instead is created with a single layer.

Anatomy of the Layers panel

Elements keeps layers controlled with a panel named, not surprisingly, the *Layers panel*. To display the Layers panel, choose Window ➡ Layers in the Photo Editor in Expert mode. (Figure 7-2 shows you what you can expect.)

The order of the layers on the Layers panel represents the order in the image. We refer to this concept in the computer graphics world as the *stacking order*. The top layer on the panel is the top layer in your image, and so on. Depending on what you're doing, you can work on a single layer or on multiple layers at one time. Here are some tips for working with the Layers panel:

>> Select a layer. Click a layer name or its thumbnail. Elements highlights the active layer on the panel.

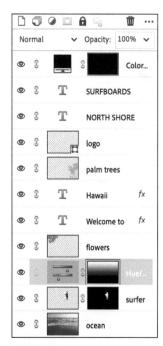

FIGURE 7-2: The Layers panel controls layers in your image.

- >> Select multiple contiguous layers. Click your first layer and then Shift-click your last layer.
- >> Select multiple noncontiguous layers. Ctrl+click (第 +click on the Mac) your desired layers.
- >> View and hide layers. To hide a layer, click the eye icon for that layer and the layer disappears. To redisplay the layer, click the blank space in the eye column. You can also hide all the layers except one by selecting your desired layer and Alt-clicking (Option-clicking on the Mac) the eye icon for that layer. Redisplay all layers by Alt-clicking (Option-clicking on the Mac) the eye icon again. Hiding all the layers except the one you want to edit can be helpful in allowing you to focus without the distraction of all the other imagery.

Only layers that are visible are printed. This can be useful if you want to have several versions of an image (each on a separate layer) for a project within the same file.

- >> Select the actual element (the nontransparent pixels) on the layer.

 Ctrl+click (# +click on the Mac) the layer's thumbnail (not the name) on the panel.
- >> Create a new blank layer. Click the Create a New Layer icon at the top of the panel.
- >> Create a new group. Elements enables you to better organize your layers by incorporating *layer groups*. Think of a layer group as the digital version of an analog manila folder. Select your desired layers and drag them into a group folder. You can expand or collapse layer groups to see or hide their contents. When collapsed, layer groups are a nice way to avoid endless scrolling in a file with many layers. Layer groups also let you apply opacity settings, blend modes, and layer styles to a group of layers at a time.
- >> To create a layer group, click the Create a New Group icon (the stacked layers icon) at the top of the Layers panel. You can also select New Group from the Layers panel pop-up menu or choose Layer >> New >> Group. The latter two methods prompt you for a group name in addition to a few other options (similar to regular layers). You can color-code your group and specify a blend mode and opacity setting. The default mode is Pass Through, which lets the blend modes applied to the individual layers remain intact (for more on blend modes, see Chapter 10). If you select any other mode, that mode overrides all the layers in the group. After you create your group, drag your layers into the group folder in the Layers panel. To collapse or expand the group, click the triangle icon to the left of the group icon. As with regular layers, you can select, duplicate, show, hide, lock, and rearrange layer groups.

A couple other tips:

- You can create a layer group from selected layers. Select the layers that you want to be in a group, and then select New Group from Layers from the Layers panel pop-up menu or choose Layer □ New □ Group from Layers. Name the group in the dialog box that appears and click OK.
- **Rename your group.** You can rename your group by double-clicking the group name in the Layers panel.
- >> Add a layer mask. Click the Add Layer Mask icon (rectangle with white circle) at the top of the panel. A layer mask enables you to selectively show and hide elements or adjustments on your layer, as well as creatively blend layers together.
- >> Create an Adjustment layer. Click the Create a New Fill or Adjustment Layer icon at the top of the panel. Adjustment layers are special layers that modify contrast and color in your image. You can also add fill layers layers containing color, gradients, or patterns by using this command.
- >> Duplicate an existing layer. Drag the layer to the Create a New Layer icon at the top of the panel.
- >> Rearrange layers. To move a layer to another position in the stacking order, drag the layer up or down on the Layers panel. While you drag, you see a fist icon. Release the mouse button when a highlighted line appears where you want to insert the layer.

- >> Rename a layer. When you create a new layer, Elements provides default layer names (Layer 1, Layer 2, and so on). If you want to rename a layer, double-click the layer name on the Layers panel and enter the name directly on the Layers panel.
- **>> Adjust the interaction between colors on layers and adjust the transparency of layers.** You can use the blend modes and the opacity options at the top of the panel to mix the colors between layers and adjust the transparency of the layers, as shown in Figure 7-3. For more on blend modes, see Chapter 10.
- >> Link layers. Sometimes you want your layers to stay grouped as a unit to make your editing tasks easier. If so, link your layers by selecting your desired layers in the panel and then clicking the Link/Unlink Layers icon on any one of the selected layers. To remove the link, click the Link/Unlink Layers icon again.
- >> Lock layers. Select your desired layer or layers and then click one of the two lock icons at the top of the panel. The *checkerboard square icon* locks all transparent areas of your layers. This lock prevents you from painting or

editing any transparent areas on the layers. The *lock icon* locks your entire layer and prevents it from being changed in any way, including moving or transforming the elements on the layer. You can, however, still make selections on the layer. To unlock the layer, simply click the icon again to toggle off the lock.

By default, the background is locked and can't be unlocked until you convert it into a layer by choosing Layer \$\sigma\\$ New \$\sigma\\$ Layer from Background.

>> Delete a layer. Drag it to the Trash icon.

Elements offers five kinds of layers. Although you'll spend most of your time creating image layers, note that there are also adjustment layers for modifying color and contrast, fill layers to add color, gradients, or patterns, shape layers to add shapes, and type layers to add type.

FIGURE 7-3: We created this effect by using blend modes and opacity options.

Rocksweeper/Shutterstock

Using the Layer and Select menus

As with many features in Elements, you usually have more than one way to do something. This is especially true when it comes to working with layers. Besides the commands on the Layers panel, you have two other menus that are applicable to layers — the Layer menu and the Select menu — both of which you can find on the main menu bar at the top of the application window (top of the screen on the Mac).

The Layer menu

Much of what you can do with the Layers panel icons you can also do by using the Layer menu on the menu bar and the Layers panel menu connected to the Layers panel. (Access the Layers panel menu by clicking the horizontally lined button in the upper-right corner of the Layers panel.) Commands, such as New, Duplicate, Delete, and Rename, are omnipresent throughout. But you find commands that are exclusive to the Layers panel, the main Layer menu, and the Layers panel menu, respectively. So if you can't find what you're looking for in one area, just go to another. Some commands require more explanation and are described in the sections that follow. However, here's a quick description of most of the commands:

- Delete Linked Layers and Delete Hidden Layers: These commands delete only those layers that have been linked or those hidden from display on the Layers panel.
- >> Layer Style: These commands manage the styles, or special effects, you apply to your layers.
- >> Arrange: This enables you to shuffle your layer stacking order with options, such as Bring to Front and Send to Back. Reverse switches the order of your layers if you have two or more layers selected.
- >> Create Clipping Mask: In a clipping mask, the bottommost layer (or base layer) acts as a mask for the layers above it. The layers above "clip" to the opaque areas of the base layer and don't show over the transparent areas of the base layer. Clipping masks work well when you want to fill a shape or type with different image layers.
- >> Type: The commands in the Type submenu control the display of type layers. For more on type, see Chapter 11.
- >> Rename Layer: This enables you to give a layer a new name. You can also simply double-click the name on the Layers panel.
- >> Simplify Layer: This converts a type layer, shape layer, or fill layer into a regular image layer. Briefly, a *shape layer* contains a vector object, and a *fill layer* contains a solid color, a gradient, or a pattern.
- >> Merge and Flatten: The various merge and flatten commands combine multiple layers into a single layer or, in the case of flattening, combine all your layers into a single background.
- >> Panel Options: You can select display options and choose to use a layer mask on your adjustment layers. Leave this option selected.

The Select menu

Although the Select menu's main duties are to assist you in making and refining your selections, it offers a few handy layer commands. Here's a quick introduction to each command:

- >> Select all layers. Want to quickly get everything in your file? Choose Select ▷ All Layers.
- >> Deselect all layers. If you want to ensure that nothing is selected in your document, simply choose Select

 □> Deselect Layers.

Tackling Layer Basics

Image layers are the heart and soul of the layering world. You can create multiple image layers within a single image. Even more fun is creating a composite from several different images. Add people you like; take out people you don't. Pluck people out of boring photo studios and put them in exotic locales. The creative possibilities are endless. In the following sections, we cover all the various ways to create image layers.

Creating a new layer from scratch

If you're creating a new, blank file, you can select the Transparent option for your background contents. Your new file is created with a transparent layer and is ready to go. If you have an existing file and want to create a new, blank layer, here are the ways to do so:

- >> Click the Create a New Layer icon at the top of the Layers panel.
- >> Choose New Layer from the Layers panel menu.
- >>> Choose Layer □ New □ Layer.

If you create a layer by using either of the menu commands, you're presented with a dialog box with options. In that dialog box, you can name your layer and specify options for creating a clipping mask, color coding, blending, and adjusting opacity. Provide a name for your layer and click OK. You can always adjust the other options directly on the Layers panel later.

TIP

You can also use the Copy and Paste commands without even creating a blank layer first. When you copy and paste a selection without a blank layer, Elements automatically creates a new layer from the pasted selection. A better method of copying and pasting between multiple images, however, is to use the drag-and-drop method, which we describe in the section "Dragging and dropping layers," later in this chapter.

The Copy Merged command on the Edit menu creates a merged copy of all visible layers within the selection.

After you create your layer, you can put selections or other elements on that layer by doing one or more of the following:

- >> Paint: Grab a painting tool, such as the Brush or Pencil, and paint on the layer.
- >> Copy a selection: Make a selection on another layer or on the background within the same document, or from another image entirely, and then choose Edit

 Copy. Select your new, blank layer on the Layers panel and then choose Edit

 Paste.
- >>> Cut a selection: Make a selection on another layer or on the background within the same document, or from another image, and then choose Edit □> Cut. Select your new, blank layer and then choose Edit □> Paste. Be aware that this action removes that selection from its original location and leaves a transparent hole, as shown in Figure 7-4.

FIGURE 7-4:
When you cut
a selection
from a layer,
take note of
the resulting
hole in the
original
location.

Alex_Rodionov/Shutterstock

If you cut a selection from a Background instead of an image layer, the space isn't a transparent hole; it's filled with the background color.

Using Layer via Copy and Layer via Cut

Another way to create a layer is to use the Layer via Copy and Layer via Cut commands on the Layer menu's New submenu. Make a selection on a layer or background and choose Layer New Layer via Copy or Layer via Cut. Elements automatically creates a new layer and puts the copied or cut selection on the layer. Remember that if you use the Layer via Cut command, your selection is deleted from its original location layer, and you're left with a transparent hole when cutting from an image layer. If you use the background for the source, your background color fills the space. A reminder: You can use these two commands only within the same image. You can't use them among multiple images.

Duplicating layers

Duplicating layers can be helpful if you want to protect your original image while experimenting with a technique. If you don't like the results, you can always delete the duplicate layer. No harm, no foul.

To duplicate an existing layer, select it on the Layers panel and do one of four things:

- >> Drag the layer to the Create a New Layer icon at the top of the panel. Elements creates a duplicate layer with *Copy* appended to the name of the layer.
- >> Choose Duplicate Layer from the Layers panel menu.
- >>> Choose Layer

 □ Duplicate Layer.
- >> Choose Layer ♥ New ♥ Layer via Copy. (Make sure you don't have an active selection when choosing this command.)

If you use the menu methods, with the exception of Layer ⇔ New ⇔ Layer via Copy, a dialog box appears, asking you to name your layer and specify other options. Provide a name for your layer and click OK. You can specify the other options later if you want.

Dragging and dropping layers

The most efficient way to copy and paste layers between multiple images is to use the drag-and-drop method. Why? Because it bypasses your *Clipboard*, which is the temporary storage area on your computer for copied data. Storing data, especially large files, can bog down your system. By keeping your Clipboard clear of data, your system operates more efficiently.

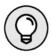

If you already copied data and it's lounging on your Clipboard, choose Edit ▷ Clear ▷ Clipboard Contents to empty your Clipboard.

TIP

Here's how to drag and drop layers from one file to another:

- 1. In your first (or source) file, select your desired layer in the Layers panel.
- Grab the Move tool (the four-headed arrow) from the Tools panel.
- Drag and drop the layer onto your second (or destination) file.

The dropped layer pops in as a new layer above the active layer in the image. You don't need to have a selection border to copy the entire layer. But if you want to copy just a portion of the layer, make your selection before you drag and drop with the Move tool. If you want the selected element to be centered on the destination file, press the Shift key while you drag and drop.

Moving a Layer's Content

Moving the content of a layer is a piece of cake: Grab the Move tool from the Tools panel, select your layer on the Layers panel, and drag the element on the canvas to your desired location. You can also move the layer in 1-pixel increments by using the keyboard arrow keys. Press Shift with the arrows to move in 10-pixel increments. *Note*: If you hold down the Alt (Option on the Mac) key while moving your element, you make a duplicate of that element.

TIP

The Auto Select Layer option in the Tool Options enables you to switch to a layer when you click any part of that layer's content with the Move tool. But be careful if you have a lot of overlapping layers because this technique can sometimes be more trouble than it's worth.

The Move tool has additional settings found in Tool Options. Here's the lowdown:

- >> Show Bounding Box: This option surrounds the contents of your layer with a dotted box that has handles, enabling you to easily transform your layer. Find details in the following section.
- >> Show Highlight on Rollover: Hover your mouse anywhere over the canvas to make an outline appear around the element on your layer. Click the highlighted layer to select it and then move it.
- Arrange submenu: This menu enables you to change your selected layer's position in the stacking order.
- >> Link Layers: This option, which resides not in the Tool Options, but in the Layers panel, connects the layers to make it easier to move (or transform) multiple layers simultaneously. Select a layer and then Ctrl+click (策 +click on the Mac) to select more layers. Click the Link Layers icon (chain).
- Align submenu: Align your selected layers on the left, center, right, top, middle, and bottom. As with linking, select your first layer and then Shift-click to select more layers. Ctrl+click (策 +click on the Mac) to select nonconsecutive layers. Choose an alignment option.
- >> Distribute submenu: Use this menu to evenly space your selected layers on the left, center, right, top, middle, and bottom. As with aligning, select your first layer and then Shift-click to select more layers. Ctrl+click (策 +click on the Mac) to select nonconsecutive layers. Choose your desired distribution option.

Transforming Layers

When working with layers, you may need to scale or rotate some of your layers. You can do so easily by applying the Transform and Free Transform commands. The methods to transform layers and selections are identical.

Here's how to transform a layer:

1. Select your desired layer.

You can also apply a transformation to multiple layers simultaneously by linking the layers first.

A bounding box with handles surrounds the contents of your layer.

- 3. Adjust (or transform) the bounding box.
 - Size the contents: Drag a corner handle.
 - Constrain the proportions: Press Shift while dragging a corner handle.
 - Rotate the contents: Move the mouse cursor just outside a corner handle until it turns into a curved arrow, and then drag. Or choose Image

 Rotate and select a rotation option.
 - Distort, skew, or apply perspective to the contents: Right-click and choose the desired command from the context menu. You can also click the rotate, scale, and skew icons in the Tool Options, as well as enter your transform values numerically in the fields.

If you want to apply just a single transformation, you can also choose the individual Distort, Skew, and Perspective commands from the Image

□
Transform menu.

4. When your layer is transformed to your liking, double-click inside the bounding box.

When the Move tool is active, you can transform a layer without choosing a command. Select the Show Bounding Box option in the Tool Options. This option surrounds the layer or selection with a box that has handles. Drag the handles to transform the layer or selection.

Flattening and Merging Layers

Layers are fun and fantastic, but they can quickly chew up your computer's RAM and bloat your file size. And sometimes, to be honest, having too many layers can start to make your file tedious to manage, thereby making you less productive. Whenever possible, you should merge your layers to save memory and space. *Merging* combines visible, linked, or adjacent layers into a single layer (not a Background). The intersection of all transparent areas is retained.

In addition, if you need to import your file into another program, certain programs don't support files with layers. Therefore, you may need to flatten your file before importing it. *Flattening* an image combines all visible layers into a Background, including type, shape, fill, and adjustment layers. You're prompted as to

whether you want to discard hidden layers, and any transparent areas are filled with white. We recommend, however, that before you flatten your image, you make a copy of the file with all its layers intact and save it as a native Photoshop file. That way, if you ever need to make any edits, you have the added flexibility of having your layers.

By the way, the only file formats that support layers are native Photoshop (.psd); Tagged Image File Format, or TIFF (.tif); and Portable Document Format, or PDF (.pdf) (called Photoshop PDF in PSE). If you save your file in any other format, Elements automatically flattens your layers into a background.

Flattening layers

To flatten an image, follow these steps:

 Make certain that all layers you want to retain are visible.

If you have any hidden layers, Elements asks whether you want to discard those hidden layers.

It's always good insurance to save a copy of an image with layers while flattening another copy. You just never know — you may need to make edits at a later date.

Choose Flatten Image from the Layers panel menu or the Layer menu.

All your layers are combined into a single background, as shown in Figure 7-5.

If you mistakenly flatten your image, choose Edit ➪ Undo or use your Undo History panel.

Merging layers

Unlike flattening layers, where all layers get combined into a single Background, you can choose to merge just a few layers. Also, remember, when you do choose to merge all your layers, they combine into a single layer versus a Background.

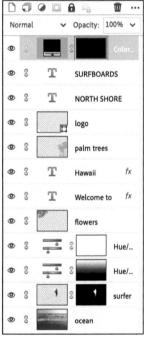

Flattening combines all your layers into a single background.

homydesign/Shutterstock, mervas/ Shutterstock, ArtFamily/Shutterstock, Alex_Rodionov/Shutterstock You can merge your layers in a few ways. Here's how:

- >> Select only those layers you want to merge. Choose Merge Layers from the Layers panel menu or the Layer menu.
- >> Display only those layers you want to merge. Click the eye icon on the Layers panel to hide those layers you don't want to merge. Choose Merge Visible from the Layers panel menu or the Layer menu.
- >> Arrange the layers you want to merge so that they're adjacent on the Layers panel. Select the topmost layer of that group and choose Merge Down from the Layers panel menu or the Layer menu. Merge Down merges your active layer with the layer directly below it.

- » Cropping, straightening, and recomposing your images
- » Using one-step auto fixes
- » Editing with Quick mode
- » Fixing small imperfections

Chapter 8 Simple Image Makeovers

ixing images quickly, without pain or hassle, is probably one of the most desirable features you'll find in Elements and one that we're sure you'll embrace frequently. Whether you're an experienced photographer or an amateur shutterbug, cropping away unwanted background, tweaking the lighting or color of an image, and erasing the minor blemishes of a loved one's face are all editing tasks you'll most likely tackle. With the simple image-makeover tools in Elements, completing these tasks is as easy as clicking a single button or making a few swipes with a brush.

Cropping and Straightening Images

Cropping a photo is probably one of the easiest things you can do to improve its composition. Getting rid of the unnecessary background around your subject creates a better focal point. Another dead giveaway of amateurish photography is crooked horizon lines. Not a problem. Elements gives you several ways to straighten those images after the fact. So after your next photo shoot, launch the Elements Photo Editor and then crop and straighten your images before you show them off.

Cutting away with the Crop tool

The most common way to crop a photo is by using the Crop tool. Simple, quick, and easy, this tool gets the job done. Here's how to use it:

1. In either Advanced or Quick mode, open an image and select the Crop tool from the Tools panel.

You can also press the C key. The Crop tool looks like two intersecting "L" shapes. For details on the different editing modes, see Chapter 1. For full details on Quick mode, see the section "Editing in Quick Mode," later in this chapter.

2. (Optional) Choose one of the four cropping suggestions Elements provides for you.

Simply hover your mouse over each of the crop suggestion thumbnails to get an idea of how it will frame your image. If you don't like any of the suggestions, proceed to Step 3.

3. Specify your aspect ratio and resolution options in the Tool Options under the image window.

Here are your choices:

- No Restriction: Allows you to freely crop the image at any size.
- Use Photo Ratio: Retains the original aspect ratio of the image when you crop.
- Preset Sizes: Offers a variety of common photographic sizes. When you crop, your image then becomes that specific dimension.

When you crop an image, Elements retains the original resolution of the file (unless you specify otherwise in the resolution option). Therefore, to keep your image at the same image size while simultaneously eliminating portions of your image, Elements must resample the file. Resampling means that the pixels are either added (upsampling) or deleted (downsampling) from your image. Consequently, your image must have sufficient resolution so that the effects of the resampling aren't too noticeable. This is especially true if you're choosing a larger preset size. Upsampling can reduce image quality.

• Width (W) and Height (H): Enables you to specify a desired width and height to crop your image.

- **Resolution:** Specify a desired resolution for your cropped image. Again, try to avoid upsampling your image.
- Pixels/in or Pixels/cm: Specify your desired unit of measurement.
- Grid Overlay: Elements gives you an added tool to help you frame your image prior to cropping. Choose from the three options: None, Rule of Thirds, or Grid.
- Rule of Thirds: This rule is a longtime photographic principle that encourages placing the most interesting elements, or your intended focal point, at one of four intersecting points in your grid of two vertical and two horizontal lines, as shown in Figure 8-1.
- Grid: Displays just that a grid of intersecting horizontal and vertical lines over the image.

Drag around the portion of the image you want to retain and release the mouse button.

When you drag, a crop marquee bounding box appears. Don't worry if your cropping marquee isn't exactly correct. You can adjust it in Step 5.

The area outside the cropping marquee (called a *shield*) appears darker than the inside in order to better frame your image, as shown in Figure 8-1.

5. Adjust the cropping marquee by dragging the handles of the crop marquee bounding box.

To move the entire marquee, position your mouse inside the marquee until you see a black arrowhead cursor, and then drag.

If you move your mouse outside the marquee, your cursor changes to a curved arrow. Drag with this cursor to rotate the marquee. This action allows you to both rotate and crop your image simultaneously — handy for straightening a crooked image. Just be aware that rotation, unless it's in 90-degree increments, also resamples your image.

6. Double-click inside the cropping marquee.

You can also just press Enter or click the blue Commit check mark next to the marquee. Elements then discards the area outside the marquee. To cancel your crop, click the blue X Cancel icon.

If you're in the Organizer and not the Photo Editor, click the Instant Fix button at the bottom. You can find the Crop tool at the top of the tool panel on the right.

TIP

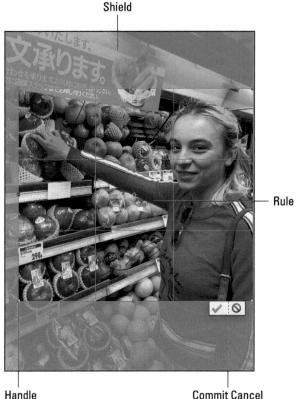

Rule of Thirds Overlay

FIGURE 8-1:
The shield and Rule of Thirds overlay allow for easy framing of your image.

Fixing distortion with the Perspective Crop tool

The Perspective Crop tool allows you to crop an image while also correcting keystone distortion. For example, if you shoot a tall building from below looking up or a long hallway from an angle, your object may appear trapezoidal rather than square or rectangular. Here's how to crop and correct this at the **same time**:

 In Advanced mode, select an image, and select the Perspective Crop tool from the Tools panel.

You can also press the C key until you get the tool, which shares a space with the Crop and Cookie Cutter tools.

- 2. Draw a marquee around the distorted image by clicking at each corner, as shown in Figure 8-2.
- 3. Adjust the edges and corners of your marquee as needed.

You have some options to choose if desired.

- Width (W) and Height (H): Specify a desired width and height to crop your image.
- **Resolution:** Specify a desired resolution for your cropped image. As with the Crop tool, try to avoid upsampling your image.
- Pixels/in or Pixels/cm: Specify your desired unit of measurement.
- **Show Grid:** Toggle the view on or off of a grid of intersecting horizontal and vertical lines over the image.

4. Double-click inside the cropping marquee.

You can also just press Enter or click the blue check-mark icon next to the marquee. To cancel your crop, click the blue Cancel X icon. Elements should improve the keystone distortion and crop your image.

If you're not happy with the result, choose Edit □ Undo and tweak the angle of your marquee in Step 3. Admittedly, it took us a couple tries to get the result we wanted, which is shown in Figure 8-2.

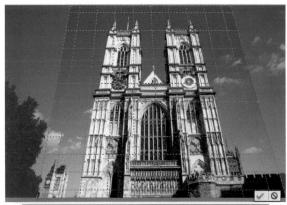

The Perspective Crop tool crops while correcting keystone distortion.

Source: Veni/Getty Images

If the Perspective Crop doesn't fix the distortion, you may want to try the Correct Camera Distortion filter (see Chapter 10).

Cropping with a selection border

You can alternatively crop an image by choosing Image r Crop in either Advanced or Quick mode. First, make a selection with any of the selection tools and then choose the command. You can use this technique with any selection border shape. That is, your selection doesn't have to be rectangular; it can be round or even freeform. Your cropped image doesn't take on that shape, but Elements crops as close to the boundaries of the selection border as it can. For details about making selections, see Chapter 6.

Straightening images

There may be times when you just didn't quite get that horizon straight when you took a photo of the beach. Or maybe you scanned a photo and it wasn't quite centered in the middle of the scanning bed. It's not a big deal. Elements gives you several ways to straighten an image.

Using the Straighten tool

This tool enables you to specify a new straight edge, and it then rotates the image accordingly. Here's how to use the Straighten tool:

 In Advanced mode, select the Straighten tool from the Tools panel (or press the P key).

It looks like an analog level tool.

2. Specify your desired setting from the Canvas Options in the Tool Options.

Here are your choices:

- **Grow or Shrink** rotates the image and increases or decreases the size of the canvas to fit the image area.
- Remove Background trims the background canvas outside the image area. This choice is helpful if you scan an image and white areas appear around your photo that you want removed.
- Original Size rotates your image without trimming any background canvas.

If you select either the Original Size or Remove Background option, you can select the Autofill Edges option. When selected, after you straighten the image,

the edges that have missing pixels will fill using the content-aware algorithm. **Note:** You can also vertically straighten your image by dragging along a vertical edge.

3. (Optional) Select Rotate All Layers.

If you have an image with layers and you want them all rotated, select this option.

Draw a line in your image to represent the new straight edge.

Your image is then straightened and, if you chose any of the crop options in Step 2, also cropped.

The Straighten Tool is also available in Quick mode. To straighten an image, draw a line with the Straighten tool in your After image to represent the new straight edge. Then choose an option to crop and resize your image. Choose to fill in empty spaces either by maintaining the image size or by maintaining the canvas size. In addition, you can choose the option to fill any empty edges using content-aware algorithms.

Using the Straighten menu commands

In addition to using the Straighten tool, you can straighten your images by using two commands on the Image menu, in either Advanced or Quick mode:

- >> To automatically straighten an image without cropping, choose Image □ Rotate □ Straighten Image. This straightening technique leaves the canvas around the image.
- >> To automatically straighten and crop the image simultaneously, choose Image ➡ Rotate ➡ Straighten and Crop Image.

Recomposing Images

This great tool actually allows you to resize, or as the name implies, *recompose*, your image without losing any vital content. For example, if you need to have people or animals in your shot closer together because you need the final, cropped image to be more square than rectangular, this tool can help. Here's how it works:

1. In Advanced mode, select the Recompose tool from the Tools panel.

You can also press the W key. The tool looks like a square with a gear on it.

2. In the Tool Options, select the Mark for Protection Brush (the brush with a plus sign icon) and brush over the areas in your image that you want to keep or protect.

You can specify your brush size with the Size option slider. You can erase any mistakes by using the Erase Highlights Marked for Protection tool (the eraser with a plus sign icon).

3. With the Mark for Removal Brush (the brush with a minus sign icon), brush over the areas in your image that you want to remove or aren't vital to your final image, as shown in Figure 8-3.

You can specify your brush size with the Size option slider. You can erase any mistakes by using the Erase Highlights Marked for Removal tool (the eraser with a minus sign icon).

4. Specify any other desired settings in the Tool Options.

Here are the other options:

- Threshold: The slider determines how much recomposing appears in your adjustment. Selecting 100% totally recomposes your image. Experiment to get the results you want.
- Preset Ratios: Choose from preset aspect ratios to have your image framed to those dimensions. Or choose No Restriction to have free rein.
- Width and Height: This option resizes your image to your specified dimensions.
- Highlight Skin Tones (green man icon): Select this option to prevent skin tones from distorting when resizing.
- Resize, or recompose, your image by dragging the corner or side handles.

The kangaroos are now closer together, as shown in Figure 8-4.

Click the Commit button (the blue check-mark icon) when you have your desired composition.

Note that you may have to do a little retouching at the seam. You can see in our image how the horizon line doesn't quite match up. Use the Clone Stamp or Healing Brush to clean up the seam. You can find out more about both tools later in this chapter.

FIGURE 8-3: Brush over areas you want to protect and remove in your image.

Cassandra Hannagan/Getty Images

FIGURE 8-4:
Recompose
your image to
your desired
size and aspect
ratio without
losing vital
content.

Cassandra Hannagan/Getty Images

Employing One-Step Auto Fixes

Elements has a variety of automatic lighting-, contrast-, and color-correction tools that can improve the appearance of your images with just one menu command. These commands are available in either Advanced or Quick mode, and they're all on the Enhance menu. For more on Quick mode, see the section "Editing in Quick Mode," later in this chapter.

The advantage of these one-step correctors is that they're extremely easy to use. You don't need to have one iota of knowledge about color or contrast to use them. The downside to using them is that sometimes the result isn't as good as you could get via a manual color-correction method. And sometimes these correctors may even make your image look worse than before by giving you weird color shifts. But because these correctors are quick and easy, you can try them on an image that needs help. Usually, you don't want to use more than one of the auto fixes. If one doesn't work on your image, undo the fix and try another. If you still don't like the result, move on to one of the manual methods we describe in Chapter 9.

Auto Smart Fix

The Auto Smart Fix tool is an all-in-one command touted to adjust it all. It's designed to improve the details in shadow and highlight areas as well as correct the color balance, as shown in Figure 8-5. The overexposed, overly green image on the left was improved quite nicely with the Auto Smart Fix command.

FIGURE 8-5:
In a hurry?
Apply the
Auto Smart
Fix command
to quickly
improve an
image.

If the Auto Smart Fix was just too "auto" for you, you can crank it up a notch and try Adjust Smart Fix. This command is similar to Auto Smart Fix but gives you a slider that allows you, not Elements, to control the amount of correction applied to the image.

Auto Smart Tone

The Auto Smart Tone auto fix is designed to adjust the tonal values in your image.

Here are the steps to use this adjustment:

1. In either Advanced or Quick mode, with your image open, choose Enhance ➡ Auto Smart Tone.

Elements automatically applies a default correction.

Moving the controller "joystick" (double circle icon in the center of the image), fine-tune your correction.

The thumbnail previews in each corner, as shown in Figure 8-6, give you an idea of how the image will look when you move the joystick in that particular direction.

Move the Before and After toggle to see the before-and-after adjustment previews.

Select the Learn from This Correction option (arrow with lines icon) in the lower-left corner of the dialog box to have Elements "learn" from this editing session.

If you select this option, Elements remembers the corrections you made on this image and positions the joystick on the basis of that correction on the next image you open and correct. The more images that are corrected, the smarter the Auto Smart Tone corrections become. This intelligent algorithm can distinguish between various image types (based on the tonal characteristics) and remembers the adjustment for that particular type of image.

If your adjustments are starting to get out of whack and you need to reset the learning archive, choose Edit

Settings

General

Reset Auto Smart Tone Learning (on the Mac, Adobe Photoshop Elements Editor

Settings

General

Reset Auto Smart Tone Learning).

4. After you're satisfied with the adjustment, click OK.

If you want to start over, click the Reset button.

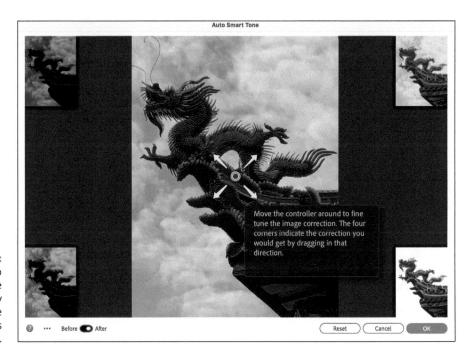

FIGURE 8-6: Apply Auto Smart Tone to quickly adjust the tonal values in an image.

Auto Levels

The Auto Levels command adjusts the overall contrast of an image. This command works best on images that have pretty good contrast (an even range of tones and detail in the shadow, highlight, and midtone areas) to begin with and need just a minor amount of adjustment. Auto Levels works by *mapping*, or converting, the lightest and darkest pixels in your image to black and white, thereby making highlights appear lighter and shadows appear darker, as shown in Figure 8–7.

FIGURE 8-7: Auto Levels adjusts the overall contrast of an image.

Although the Auto Levels command can improve contrast, it may also produce an unwanted *color cast* (a slight trace of color). If this happens, undo the command and try the Auto Contrast command instead. If that still doesn't improve the contrast, it's time to bring out the big guns. Try the Levels command that we describe in Chapter 9.

Auto Contrast

The Auto Contrast command is designed to adjust the overall contrast in an image without adjusting its color. This command may not do as good a job of improving contrast as the Auto Levels command, but it does a better job of retaining the color balance of an image. Auto Contrast usually doesn't cause the funky color casts that can occur when you're using Auto Levels. This command works well on images with a haze, as shown in Figure 8–8.

The Auto
Contrast
command
adjusts
contrast
without
messing up
color.

Auto Haze Removal

Although the Auto Contrast command does a good job of removing haze in images, the Auto Haze Removal command does a great job with this task, as shown in Figure 8–9. But also be sure to check out the Haze Removal command under the Enhance menu in both Advanced and Quick modes. Under that command, you have a couple more options to really home in on to add clarity to your image. Find out more about this command in Chapter 9.

Auto Color Correction

The Auto Color Correction command adjusts both the color and contrast of an image, based on the shadows, midtones, and highlights it finds in the image instead of the color channels. It then balances the midtones and adjusts the value of the white and black pixels. You usually use this command to remove a color cast or to balance the color in your image, as shown in Figure 8–10. Occasionally, this command can also be useful in correcting oversaturated or undersaturated colors.

FIGURE 8-9: The Auto Haze Removal command works wonders on hazy images.

FIGURE 8-10: Use Auto Color Correction to remove a color cast.

Auto Sharpen

Photos taken with a digital camera or scanned on a flatbed scanner often suffer from a case of overly soft focus. Sharpening gives the illusion of increased focus by increasing the contrast between pixels. Auto Sharpen attempts to improve the focus, as shown in Figure 8-11, without overdoing it. What happens when you oversharpen? Your images go from soft to grainy and noisy. For more precise sharpening, check out the Unsharp Mask and Adjust Sharpness features that we cover in Chapter 9.

Always make sharpening your last fix after you make all your other fixes and enhancements.

TIP

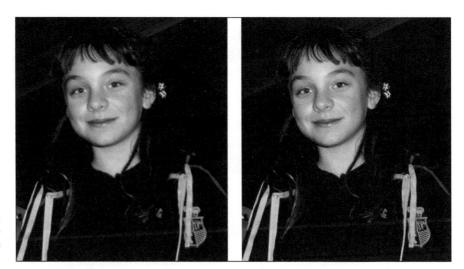

FIGURE 8-11: Use Auto Sharpen to improve focus.

Auto Red Eye Fix

The Auto Red Eye Fix command is self-explanatory. It automatically detects and fixes red eye in an image. Red eye happens when a person or an animal (where red eye can also be yellow, green, or even blue eye) looks directly into the flash.

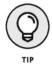

If for some reason the Auto Red Eye Fix doesn't quite do the trick, you can always reach for the Red Eye tool on the Tools panel. Here's how to remove red eye manually:

- Select the Red Eye Removal tool from the Tools panel.
 You can also press Y.
- 2. Using the default settings, click the red portion of the eye in your image.

This one-click tool darkens the pupil while retaining the tonality and texture of the rest of the eye, as shown in Figure 8-12. Repeat for the other eye.

- 3. If you're unhappy with the fix, adjust one or both of these settings in the Tool Options:
 - Pupil Radius: Use the slider to increase or decrease the size of the pupil.
 - Darken: Use the slider to darken or lighten the color of the pupil.

Note that there is also an option for fixing images whose subject has closed their eyes. You will need another image in which their eyes are open. If that isn't available you will have to provide another source image. Find out how this option works in Chapter 9, in the section "Opening closed eyes."

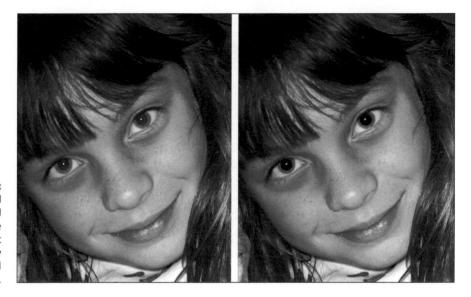

FIGURE 8-12: The Auto Red Eye Fix and the Red Eve tools detect and destroy dreaded red eye.

Pets can get white, green, blue, or yellow eyes from the flash. Elements provides a Pet Eye option in Tool Options. If this option still doesn't do it, your best bet is to use the Color Replacement tool.

Editing in Quick Mode

Quick mode is a pared-down version of Advanced mode that conveniently provides basic fixing tools and tosses in a few unique features, such as a beforeand-after preview of your image.

Here's a step-by-step workflow that you can follow in Quick mode to repair your photos:

1. Select one or more photos in the Organizer, click the Editor button at the bottom of the workspace, and then click the Quick button at the top of the workspace.

Or, if you're in Advanced mode, select your desired image(s) from the Photo Bin and then click the Quick button at the top of the workspace.

Note: You can also open images by simply clicking the Open button and selecting your desired files.

2. Specify your preview preference from the View drop-down list at the top of the workspace.

You can choose to view just your original image (Before Only), your fixed image (After Only), or both images side by side (Before & After) in either portrait (Vertical) or landscape (Horizontal) orientation, as shown in Figure 8-13.

Use the Zoom and Hand tools to magnify and navigate around your image.

Click your image with the Zoom tool to zoom in. Press Alt (Option on the Mac) to zoom out. Drag within the image window to move around the image. You can also specify the Zoom percentage by using the Zoom slider in the Tool Options or in the top right of the workspace.

4. Choose your desired window view by clicking one of the following buttons located in the Tool Options: 1:1 (Actual Pixels), Fit Screen, Fill Screen (which zooms your image to fill your screen), or Print Size.

You also have another Zoom slider located in the Tool Options.

5. Crop your image by using the Crop tool on the Tools panel.

You can also use any of the methods we describe in the "Cropping and Straightening Images" section, earlier in this chapter.

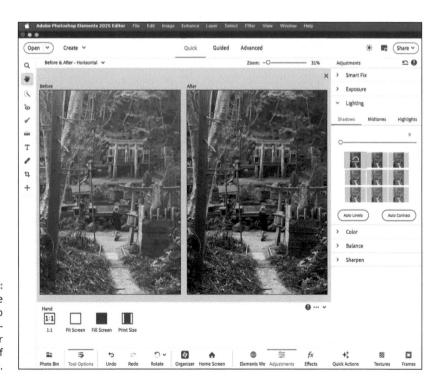

FIGURE 8-13: Quick mode enables you to view beforeand-after previews of your image.

- 6. To rotate the image in 90-degree increments, click the Rotate Left or Rotate Right (which is accessed via the arrow next to Rotate Left) button under the Options panel on the bottom-left side of the workspace.
- Apply any necessary auto fixes, such as Auto Smart Fix, Auto Levels, Auto Contrast, and Auto Color Correction.

All these commands are on the Enhance menu or in the Smart Fix, Lighting, and Color sections in the Adjustments pane of the workspace. If the commands aren't visible, click the Adjustments button in the bottom-right corner of the workspace.

Each of these fixes is described in detail in the section "Employing One-Step Auto Fixes," earlier in this chapter. Remember that usually one of the fixes is enough. Don't stack them on top of each other. If one doesn't work, click the Reset button in the top-right corner of the image preview and try another. If you're not happy with the results, go to Step 8. If you are happy, skip to Step 9.

8. If the auto fixes don't quite cut it, get more control by using the sliders, or by clicking the thumbnails, available for Smart Fix, Exposure, Lighting, Color, and Balance, in the Adjustments panel located on the right side of the workspace.

For all adjustments, you can hover your mouse over any of the thumbnails in the pane to get a dynamic preview of that particular adjustment. The slider automatically moves accordingly.

Here's a brief description of each available adjustment, which are available under the Exposure, Lighting, Color, and Balance drop-down menus:

- **Exposure:** Adjusts the brightness or darkness of an image. Move the slider left to darken and right to lighten. The values are in increments of *f*-stops and range from –4 to 4.
- Shadows: When you drag the slider to the right, it lightens the darker areas of your image without adjusting the highlights.
- Midtones: Adjusts the contrast of the middle (gray) values and leaves the highlights and shadows as they are.
- Highlights: When you drag the slider to the right, it darkens the lighter areas of your image without adjusting the shadows.
- Saturation: Adjusts the intensity of the colors.
- Hue: Changes all colors in an image. Make a selection first to change the color of just one or more elements. Otherwise, use restraint with this adjustment.

- **Vibrance:** Adjusts the saturation of an image by increasing the saturation of less saturated colors more than those that are already saturated. This option tries to minimize *clipping* (or loss of color) as it increases saturation and preserves skin tones. Move the slider right to increase saturation.
- Temperature: Adjusts the colors to make them warmer (red) or cooler (blue). You can use this adjustment to correct skin tones or to correct overly cool images (such as snowy winter photos) or overly warm images (such as photos shot at sunset or sunrise).
- **Tint:** Adjusts the tint after you adjust temperature to make the color more green or magenta.

If you still don't get the results you need, move on to one of the more manual adjustments that we describe in Chapter 9.

You can also apply fixes to just selected portions of your image. Quick mode offers the Quick Selection tool for your selection tasks. For details on using this tool, see Chapter 6.

Add finishing fixes by using the remaining tools in the Tools panel.

Here's a description of each tool:

- Red Eye Removal tool: Try the Auto Red Eye Fix to remove red eye from people's eyes. But if it doesn't work, try using the Red Eye tool. This method is described in the section "Auto Red Eye Fix," earlier in this chapter.
- Whiten Teeth: This fix does what it says it whitens teeth. Be sure to choose an appropriate brush size from the Size slider in the Tool Options. Click the Brush Settings option to specify Hardness, Spacing, Roundness, and Angle of the brush tip. (For more on brush options, see Chapter 11.) Using a brush diameter that's larger than the area of the teeth also whitens/brightens whatever else it touches lips, chin, and so on. Click the teeth. (Note: This tool makes a selection and whitens simultaneously.) After your initial click, your selection option converts from New Selection to Add to Selection in the Tool Options. If you pick up too much in your dental selection, click the Subtract from Selection option and click the area you want to eliminate. When you're happy with the results of your whitening session, choose Select ▷ Deselect or press Ctrl+D (光+D on the Mac).
- Spot Healing Brush/Healing Brush/Remove Tool: These tools are great for fixing flaws, both big (Remove Tool), medium (Healing Brush and small (Spot Healing Brush). For a detailed explanation on using these tools, see the upcoming sections "Retouching with the Healing Brush," "Zeroing in with the Spot Healing Brush," and "Eliminating objects with the new Remove tool."

10. (Optional) Add any desired text by clicking your image with the Text tool.

See Chapter 11 for details on working with text.

Use the Move tool in Quick mode to fine-tune the positioning of your text.

Sharpen your image automatically by clicking the Auto button under Sharpen in the right pane.

You can also choose Enhance Auto Sharpen. If automatically sharpening doesn't do the fix, you can manually drag the Sharpen slider.

As noted earlier in the chapter, this fix should always be the last adjustment you make on your image.

The Quick mode sports additional panels. Click the Effects icon in the bottom-right corner of the workspace to access various effects. Click the Classic tab and you will find effects, such as Toy Camera and Cross Process, that you can apply to your image. Click the Frames icon to apply borders, such as Scrapbook and Comic, to the perimeter of your photo. You can also click the Textures icon to access textures, such as Cracked Paint and Sunburst. Click the Adjustments icon to return to your default panel settings. To apply any effect, texture, or frame, simply click the appropriate thumbnail in the pane.

Fixing Small Imperfections with Tools

Elements provides you with several handy tools to correct minor imperfections in your photos. You can use the Clone Stamp tool to clone parts of your image, heal blemishes with the Healing Brush or Spot Healing Brush tools, lighten or darken small areas with the Dodge and Burn tools, soften or sharpen the focus with the Blur or Sharpen tools, and fix color with the Sponge or Color Replacement tools.

Cloning with the Clone Stamp tool

Elements enables you to clone elements without the hassle of genetically engineering DNA. In fact, the Clone Stamp tool works by just taking sampled pixels from one area and copying, or *cloning*, them onto another area. The advantage of cloning, rather than making a selection and then copying and pasting, is that it's easier to realistically retain soft-edged elements, such as shadows, as shown in Figure 8-14.

FIGURE 8-14:
The Clone
Stamp tool
enables you
to realistically
duplicate
soft-edged
elements, such
as shadows.

The Clone Stamp doesn't stop there. You can also use this tool for fixing flaws, such as scratches, bruises, date/time stamp imprints from cameras, and other minor imperfections. Although the birth of the healing tools (discussed in the following sections) has somewhat pushed the Clone Stamp tool out of the retouching arena, it can still do a good repair job in many instances.

Here's how to use the Clone Stamp tool:

- In Advanced mode, choose the Clone Stamp tool from the Tools panel.
 It looks like an analog rubber stamp. If the Pattern Stamp was the last used tool, be sure to select the Clone Stamp tool for the Tool options.
- 2. In the Tool Options, choose a brush from the Brush Preset Picker panel and then use the brush as is or adjust its size with the Size slider.

Keep in mind that the size of the brush you specify should be appropriate for what you're trying to clone or retouch. If you're cloning a large object, use a large brush. For repairing small flaws, use a small brush. Cloning with a soft-edged brush usually produces more natural results. For details on brushes, see Chapter 11.

3. Choose your desired Opacity and Blend Mode percentage.

For more on blend modes, see Chapter 10. To make your cloned image appear ghosted, use an Opacity percentage of less than 100 percent.

4. Select or deselect the Aligned option.

With Aligned selected, the clone source moves when you move your cursor to a different location. If you want to clone multiple times from the same location, leave the Aligned option deselected.

5. Select or deselect the Sample All Layers check box.

This option enables you to sample pixels from all visible layers for the clone. If this option is deselected, the Clone Stamp tool clones from only the active layer. Check out Chapter 7 for details about working with layers.

6. Click the Clone Overlay button if you want to display an overlay.

Displaying an overlay can be helpful when what you're cloning needs to be in alignment with the underlying image. In the Clone Overlay dialog box, select the Show Overlay check box. Adjust the opacity for your overlay. If you select Auto Hide, when you release your mouse, you see a ghosted preview of how your cloned pixels will appear on the image. While you're cloning, however, the overlay is hidden. Select Clipped to have the overlay contained only within the boundaries of your brush. We think that this makes it easier to more precisely clone what you want. Finally, select Invert Overlay to reverse the colors and tones in your overlay.

7. Alt-click (Option-click on the Mac) the area of your image that you want to clone to define the source of the clone.

8. Click or drag along the area where you want the clone to appear.

While you drag, Elements displays a crosshair cursor along with your Clone Stamp cursor. The crosshair is the source you're cloning from, and the Clone Stamp cursor is where the clone is being applied. While you move the mouse, the crosshair also moves, so you have a continuous reference to the area of your image that you're cloning. Watch the crosshair, or else you may clone something you don't want.

9. Repeat Steps 7 and 8 until you've finished cloning your desired element.

If you've selected the Aligned option when cloning an element, try to clone it without lifting your mouse. Also, when you're retouching a flaw, try not to overdo it. One or two clicks on each flaw is usually plenty. If you're heavy-handed with the Clone Stamp, you get a blotchy effect that's a telltale sign something has been retouched.

Retouching with the Healing Brush

The Healing Brush tool is similar to the Clone Stamp tool in that you clone pixels from one area onto another area. But the Healing Brush is superior in that it takes into account the tonality (highlights, midtones, and shadows) of the flawed area. The Healing Brush clones by using the *texture* from the sampled area (the *source*) and then using the *colors* around the brush stroke while you paint over the flawed area (the *destination*). The highlights, midtones, and shadow areas remain intact, giving you a realistic and natural repair that isn't as blotchy or miscolored as the repair you get with the Clone Stamp tool.

Here are the steps to heal a photo:

In Advanced mode, open an image in need of a makeover and select the Healing Brush tool from the Tools panel.

The tool looks like a bandage. You can also press J to cycle between the Healing Brush and Spot Healing Brush tools. You can also select either of these tools and then choose the other tool from the Tool Options.

You can also heal between two images, but be sure that they have the same color mode — for example, both RGB (red, green, blue). We chose a couple who are super photogenic but might appreciate a little tune-up, as shown in Figure 8-15.

2. Specify a size for the Healing Brush tool in the Tool Options.

You can also adjust the hardness, spacing, angle, and roundness in the Brush Settings. For details on these options, see Chapter 11. Don't be shy. Be sure to adjust the size of your brush as needed. Using the appropriate brush size for the flaw you're retouching is critical to creating a realistic effect.

3. Choose your desired blend mode.

For most retouching jobs, you probably should leave the mode as Normal. Replace mode preserves textures, such as noise or film grain, around the edges of your strokes.

4. Choose one of these Source options:

- **Sampled** uses the pixels from the image. You use this option for the majority of your repairs.
- Pattern uses pixels from a pattern chosen from the Pattern Picker drop-down panel.

5. Select or deselect the Aligned option.

For most retouching tasks, you probably should leave Aligned selected. Here are the details on each option:

With Aligned selected: When you click or drag with the Healing Brush,
 Elements displays a crosshair along with the Healing Brush cursor.

The crosshair represents the sampling point, also known as the *source*. When you move the Healing Brush tool, the crosshair also moves, providing a constant reference to the area you're sampling.

- With Aligned deselected: Elements applies the source pixels from your initial sampling point, no matter how many times you stop and start dragging.
- Select the Sample All Layers check box to heal an image by using all visible layers.

If this option is deselected, you heal from only the active layer.

To ensure maximum editing flexibility later, select the Sample All Layers check box and add a new, blank layer above the image you want to heal. When you heal the image, the pixels appear on the new layer and not on the actual image, which means you can adjust opacity and blend modes and make other adjustments to the healed layer.

7. (Optional) Click the Clone Overlay button.

See the earlier section, "Cloning with the Clone Stamp tool," for details on using an overlay.

8. Establish the sampling point by Alt-clicking (Option-clicking on the Mac).

Make sure to click the area of your image that you want to clone from. In our example, we clicked a smooth area of the forehead when working on each person.

Release the Alt (Option on the Mac) key and click or drag over a flawed area of your image.

Keep an eye on the crosshair because that's the area you're healing from. We brushed over the wrinkles under and around the eyes, mouth, and forehead. (Refer to Figure 8-15.) This couple never looked so good, and they endured absolutely no recovery time.

stockfour/Shutterstock

FIGURE 8-15: Wipe out ten years in two minutes with the Healing Brush tool.

Zeroing in with the Spot Healing Brush

Whereas the Healing Brush is designed to fix larger flawed areas, the Spot Healing Brush is designed for smaller imperfections, with one exception — the Content-Aware option, which we explain in Step 3 in the following steps. The Spot Healing Brush doesn't require you to specify a sampling source. It automatically takes a sample from around the area to be retouched. It's quick, easy, and often effective. But it doesn't give you control over the sampling source, so keep an eye out for less-than-desirable fixes.

Here's how to quickly fix flaws with the Spot Healing Brush tool:

1. In Advanced mode, open your image and grab the Spot Healing Brush tool.

The tool looks like a bandage with a dotted oval behind it. You can also press J to cycle between the Healing Brush and Spot Healing Brush tools. You can also select either of these tools and then choose the other tool from the Tool Options.

In the Tool Options, click the Brush Preset Picker and select a brush tip.
You can further adjust the diameter by dragging the Size slider. You can
also press the left and right brackets to decrease and increase the brush
size, respectively.

Select a brush that's a little larger than the flawed area you're fixing.

- 3. Choose a type in the Tool Options:
 - Proximity Match: This type samples the pixels around the edge of the selection to fix the flawed area.
 - Create Texture: This type uses all the pixels in the selection to create a texture to fix the flaw.
 - Content-Aware: If you want to eliminate something larger than a mole or freckle, this is the option of choice where actual content from the image is used as a kind of patch for the flawed area. Large objects can be zapped away; Figure 8-16 shows how we eliminated the girl on the swing. Note: You may have to paint over the offending object a couple of times to get your desired result. Also, a touch-up with the Clone Stamp or other healing tools may be needed.

Try Proximity Match first, and if it doesn't work, undo it and try Create Texture or Content-Aware.

TIP

TIP

For removal of larger areas, you also have the option of using Edit 🖒 Fill Selection and choosing Content-Aware from the Use pop-up menu.

 Select the Sample All Layers check box to heal an image by using all visible layers.

If you leave this check box deselected, you heal from only the active layer.

5. Click, drag, or "paint" over the area you want to fix.

We painted over the girl on the swing with the Spot Healing Brush and achieved realistic results, as shown in the after image in Figure 8-16.

Don Mason/Getty Images

Eliminating objects with the new Remove tool

FIGURE 8-16: Eliminate kids on swings and other objects with the Content-Aware option.

NEW

With the Elements 2025 release, Adobe harnessed its progress in AI with the new Remove tool. Although you may be able to remove what you want with the Healing and Spot Healing brushes, this new tool is very easy to use and gives great results, so give it a try.

Here's how to remove objects with the Remove tool:

1. In Advanced mode, open your image and grab the Remove tool.

The tool looks like a bandage with two stars. You can also press J to cycle between the Healing Brush, Spot Healing Brush and Remove tools.

- 2. In the Tool Options, use the Size slider to adjust the size of your brush.

 Be sure to choose a brush that will cover your desired object to be removed.
- 3. Select the Remove after Each Stroke option to eliminate your object in steps, or strokes.
- Select the Sample All Layers check box to remove the object on all visible layers.

If you leave this check box deselected, you remove from only the active layer.

Click, drag, or "paint" over the area you want to remove.

We painted over the ugly electrical wire ruining our view of Mt. Fuji from our bullet train window. You can see our intermediate progress in Figure 8-17. After we finished the removal, you could not tell the wire was there at all!

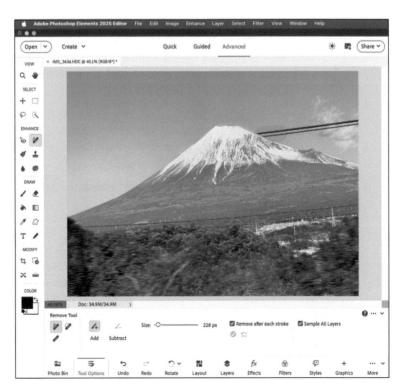

FIGURE 8-17:
Eliminate
distracting
objects with
the new
Remove tool.

The Object Removal Guided Edit has also been modified to use the new Remove tool.

Repositioning with the Content-Aware Move tool

The Content-Aware Move tool enables you to select and move a portion of an image. The best thing, however, is that when you move that portion, the hole left behind is miraculously filled using content-aware technology. In other words, Elements analyzes the area surrounding the selected portion you're moving and then fills the hole with matched content.

Here's how to use this beneficial editing tool:

1. In Advanced mode, open your image and select the Content-Aware Move tool.

The tool looks like two arrows. You can also press the Q key.

Choose either Move or Extend mode.

- Move: Elements moves your selection to a new location and then fills the remaining hole with content-aware pixels. The Move mode works great when you need to move an object, or objects, in your image for a more desirable composition. Keep in mind that this technique works best when the background of the new location of the object is similar to the background from which it was plucked.
- Extend: Elements extends your selected area while maintaining any lines and structural elements and blending them into the existing object. This option works great for expanding or contracting objects such as hair, fur, trees, buildings, and so on.

For Figure 8-18, we chose the Move mode to move the girl to the right so that we could add some type.

Choose your desired Healing setting.

Healing controls the amount of flexibility Elements uses in determining how to shift pixels around and how strictly regions are preserved when determining the content-aware fill. The default setting is smack-dab in the middle, which is what we stuck with.

You can also select the Sample All Layers check box to use content from all your layers. If you leave this check box deselected, you use only content from the active layer.

4. Drag around the area of your image that you want to move or extend.

If you need to fine-tune your selection, you can use the Path Operations options on the Options bar. Or you can press the Shift key to add to your selected area or press Alt (Option on the Mac) to delete from your selection.

You can also transform — scale or rotate — your selected area by selecting the Transform On Drop option. When you move your selection, the transform box will appear and the Transform options will appear in the Options bar. You can select your options there or manually drag or rotate the handles of your transform box. Click the Commit button (the blue check-mark icon) to complete the transformation.

- If you did not select the Transform On Drop option in Step 4, move your selection to your desired location. Deselect the selection.
- 6. Touch up any areas that require it.

You can break out the Healing tools or the Clone Stamp tool to fix any mismatches or remaining flaws. We fixed a few spots along the girl that weren't quite matched up, as shown in Figure 8-18. We also spot-healed the ugly light fixture at the top of the image.

FIGURE 8-18: Recompose your image by using the Content-Aware Move tool.

You also have the option of filling any selected area with a Content-Aware option. Make a selection and choose Edit ⇔ Fill. Under Contents, choose Content-Aware from the Use pop-up menu.

Lightening and darkening with Dodge and Burn tools

The techniques of dodging and burning originated in the darkroom, where photographers fixed negatives that had overly dark or light areas by adding or subtracting exposure, using holes and paddles as an enlarger made prints. The Dodge and Burn tools are even better than their analog ancestors because they're more flexible and much more precise. You can specify the size and softness of your tool by simply selecting from one of the many brush tips. You can also limit the correction to various tonal ranges in your image — shadows, midtones, or highlights. Finally, you can adjust the amount of correction that's applied by specifying an exposure percentage.

Use these tools only on small areas (such as the girl's face shown in Figure 8–19) and in moderation. You can even make a selection prior to dodging and burning to ensure that the adjustment is applied only to your specific area. Also, keep in mind that you can't add detail that isn't there to begin with. If you try to lighten extremely dark shadows that contain little detail, you get gray areas. If you try to darken overly light highlights, you just end up with white blobs.

FIGURE 8-19: Use the Dodge and Burn tools to lighten and darken small areas.

Follow these steps to dodge or burn an image:

 In Advanced mode, choose either the Dodge (to lighten) or Burn (to darken) tool from the Tools panel.

These tools look like a darkroom paddle and a hand making an *O*, respectively. Press O to cycle through the Dodge and Burn tools. You can also select any of these tools and then choose your desired tool from the Tool Options.

2. Select a brush from the Brush Preset Picker panel and also adjust the brush size if necessary.

Larger, softer brushes spread the dodging or burning effect over a larger area, making blending with the surrounding area easier.

3. From the Range drop-down list, choose Shadows, Midtones, or Highlights.

Choose Shadows to darken or lighten the darker areas of your image. Choose Midtones to adjust the tones of average darkness. Choose Highlights to make the light areas lighter or darker.

In Figure 8-19, the original image had mostly dark areas, so we dodged the shadows.

Choose the amount of correction you want to apply with each stroke by adjusting the Exposure setting in the Tool Options.

Start with a lower percentage to better control the amount of darkening or lightening. Exposure is similar to the opacity setting that you use with the regular Brush tool. We used a setting of 8 percent.

5. Paint over the areas you want to lighten or darken.

If you don't like the results, press Ctrl+Z (第+Z on the Mac) to undo.

Smudging away rough spots

The Smudge tool (see Figure 8-20), one of the focus tools, pushes your pixels around using the color that's under the cursor when you start to drag. Think of it as dragging a brush through wet paint. You can use this tool to create a variety of effects. When it's used to the extreme, you can create a warped effect. When it's used more subtly, you can soften the edges of objects in a more natural fashion than you can with the Blur tool. Or you can create images that take on a painterly effect, as shown in Figure 8-20. Keep an eye on your image while you paint, however, because you can start to eliminate detail and wreak havoc if you're not careful with the Smudge tool.

To use the Smudge tool, follow these steps:

1. In Advanced mode, select the Smudge tool from the Tools panel.

The tool looks like a finger. Press R to cycle through the Smudge, Blur, and Sharpen tools. You can also select any of these tools and then choose your desired tool from the Tool Options.

The Smudge tool can make your images appear to be painted.

Select a brush from the Brush Preset Picker panel. Use the Size slider to fine-tune your brush diameter.

Use a small brush for smudging tiny areas, such as edges. Larger brushes produce more extreme effects.

- 3. Choose a blending mode from the Mode drop-down list.
- Choose the strength of the smudging effect with the Strength slider or text box.

The lower the value, the lighter the effect.

5. If your image doesn't have layers, skip to Step 6. If your image has multiple layers, select the Sample All Layers check box to make Elements use pixels from all the visible layers when it produces the effect.

The smudge still appears on only the active layer, but the look is a bit different, depending on the colors of the underlying layers.

6. Use the Finger Painting option to begin the smudge by using the foreground color.

Rather than use the color under your cursor, this option smears your foreground color at the start of each stroke. If you want the best of both

worlds, you can quickly switch into Finger Painting mode by pressing the Alt (Option on the Mac) key while you drag. Release Alt (Option on the Mac) to go back to Normal mode.

7. Paint over the areas you want to smudge.

Pay attention to your strokes because this tool can radically change your image. If you don't like the results, press Ctrl+Z (\Re +Z on the Mac) to undo the changes and then lower the Strength percentage (discussed in Step 4) even more.

Softening with the Blur tool

The Blur tool (looks like a teardrop) can be used to repair images, as well as for more artistic endeavors. You can use the Blur tool to soften a small flaw or part of a rough edge. You can add a little blur to an element to make it appear as though it was moving when photographed. You can also blur portions of your image to emphasize the focal point, as shown in Figure 8–21, where we blurred everything except the girl's face. The Blur tool works by decreasing the contrast among adjacent pixels in the blurred area.

The Blur tool can be used to emphasize a focal point.

Digital Vision./Getty Images

The mechanics of using the Blur tool and its options are similar to those of the Smudge tool, as we describe in the preceding section. When you use the Blur tool, be sure to use a small brush for smaller areas of blur.

Focusing with the Sharpen tool

If the Blur tool is yin, the Sharpen tool is yang. The Sharpen tool (looks like a triangle) increases the contrast among adjacent pixels to give the illusion that things are sharper. You should use this tool with restraint, however. Sharpen can quickly give way to overly grainy and noisy (random bright and dark pixels) images if you're not cautious.

Use a light hand and keep the areas you sharpen small. Sometimes, the eyes in a soft portrait can benefit from a little sharpening, as shown in Figure 8-22. You can also slightly sharpen an area to emphasize it against a less-than-sharp background.

Reserve the Sharpen tool for small areas, such as eyes.

dp_photo/Getty Images

To use the Sharpen tool, grab the tool from the Tools panel and follow the steps provided for the Smudge tool in the section "Smudging away rough spots," earlier in this chapter. Here are some additional tips for using the Sharpen tool:

- >> Use a low value, around 25 percent or less.
- >> Remember that you want to gradually sharpen your element to avoid the nasty, noisy grain that can occur from oversharpening.
- Because sharpening increases contrast, if you use other contrast adjustments, such as Levels, you boost the contrast of the sharpened area even more.
- Select the Protect Detail option to enhance the details in the image and minimize artifacts. If you leave this option deselected, your sharpening is more pronounced.

If you need to sharpen your overall image, try choosing either Enhance ♀ Unsharp Mask or Enhance ♀ Adjust Sharpness instead. These features offer more options and better control.

Sponging color on and off

The Sponge tool soaks up color or squeezes it out. In more technical terms, this tool reduces or increases the intensity, or *saturation*, of color in both color and grayscale images. Yes, the Sponge tool also works in Grayscale mode by darkening or lightening the brightness value of those pixels.

As with the Blur and Sharpen tools, you can use the Sponge tool to reduce or increase the saturation in selected areas in order to draw attention to or away from those areas.

Follow these steps to sponge color on or off your image:

- 1. In Advanced mode, choose the Sponge tool from the Tools panel.
 - The tool looks like a sponge. Press O to cycle through the Sponge, Dodge, and Burn tools. You can also select any of these tools and then choose your desired tool from the Tool Options.
- Select a brush from the Brush Preset Picker panel. Further adjust the size of the brush tip if needed.
 - Use large, soft brushes to saturate or desaturate a larger area.
- 3. Choose either Desaturate or Saturate from the Mode drop-down list to decrease or increase color intensity, respectively.

4. Choose a flow rate with the Flow slider or text box.

The *flow rate* is the speed with which the saturation or desaturation effect builds while you paint. Start with a lower rate and then adjust as desired.

5. Paint carefully over the areas you want to saturate or desaturate with color.

In the example shown in Figure 8-23, we used saturation to make the pup the focal point and desaturated the humans.

The Sponge tool increases or decreases the intensity of the color in your image.

Pressmaster/Shutterstock.com

- » Editing your photos logically
- » Adjusting lighting, color, and clarity
- » Working with the Smart Brush tools

Chapter **9**

Correcting Contrast, Color, and Clarity

f you've tried the quick and easy automatic fixes on your images and they didn't quite do the job, you've come to the right place. The great thing about Elements is that it offers multiple ways and multiple levels of repairing and enhancing your images. If an auto fix doesn't cut it, move on to a manual fix.

If you're still not happy, you can consider shooting in Camera Raw format, as long as your camera can do so. Elements has wonderful Camera Raw support, enabling you to process your images to your exact specifications. For details on Camera Raw check out Chapter 5, "Editing Camera Raw Images." Chances are good that if you can't find the tools to correct and repair your images in Elements, those images are probably beyond salvaging.

This chapter covers the manual fixes you can make to your photos to correct lighting, contrast, color casts, artifacts, dust, scratches, sharpening, and blurring. We also cover using the Smart Brush tools to selectively apply an image adjustment.

Editing Your Photos Using a Logical Workflow

With the information in Chapter 8 (where we explain quick fixes) and this chapter at your fingertips, you can develop a logical workflow when you tackle the correction and repair of your images. By performing steps in a particular order, you will be less likely to exacerbate the flaws and more able to accentuate what's good. For example, we use the following workflow when editing photos:

- 1. Crop, straighten, and resize your images, if necessary.
- When you have the images in their proper physical state, correct the lighting and establish good tonal range for your shadows, highlights, and midtones to display the greatest detail possible.

Often, just correcting the lighting solves minor color problems. If not, move on to adjusting the color balance.

- 3. Eliminate any color casts and adjust the saturation, if necessary.
- Grab the retouching tools, such as the healing tools and filters, to retouch any flaws.
- 5. (Optional) Apply any enhancements or special effects.
- Sharpen your image if you feel that it could use a boost in clarity and sharpness.

By following these steps and allocating a few minutes of your time, you can get all your images in shape to print, post, and share with family and friends.

Adjusting Lighting

Elements has several simple, manual tools to use to fix lighting if the Auto tools that we describe in Chapter 8 didn't work or were just too, well, automatic for you. The manual tools offer more control over adjusting overall contrast as well as bringing out details in shadows, midtones, and highlight areas of your images. You can find all lighting adjustments in both Advanced and Quick modes.

Fixing lighting with Shadows/Highlights

The Shadows/Highlights command offers a quick and easy method of correcting over- and underexposed areas, as shown on the left in Figure 9-1. This feature works especially well with images shot in bright, overhead light or in light coming from the back (backlit). These images usually suffer from having the subject partially or completely covered in shadows.

FIGURE 9-1: Correct the lighting in your images with the Shadows/ Highlights adjustment.

To use the Shadows/Highlights adjustment, follow these steps:

1. In Advanced or Quick mode, choose Enhance

Adjust Lighting

Shadows/Highlights and make sure the Preview check box is selected.

When the dialog box appears, the default correction is applied automatically in your preview.

 If the default adjustment doesn't quite do the job, move the sliders (or enter a value) to adjust the amount of correction for your shadows (dark areas), highlights (light areas), and midtones (middle-toned areas).

Your goal is to reveal more detail in the dark and light areas of your image. If, after you do so, your image still looks like it needs more correction, add or delete contrast in your midtone areas.

TIP

If only part of your image needs correcting, you can select just that portion before applying the adjustment. For more on selections, see Chapter 6.

Click OK to apply the adjustment and close the dialog box.

If you want to start over, press the Alt (Option on the Mac) key, and the Cancel button becomes Reset. Click Reset to start again.

Using Brightness/Contrast

Despite its aptly descriptive moniker, the Brightness/Contrast command doesn't do a great job of *brightening* (making an image darker or lighter) or adding or reducing contrast. Initially, users tend to be drawn to this command because of its appropriate name and ease of use. But after users realize its limitations, they move on to better tools with more control, such as Shadows/Highlights and Levels.

The problem with the Brightness/Contrast command is that it applies the adjustment equally to all areas of your image. For example, a photo's highlights may need darkening, but all the midtones and shadows are perfect. The Brightness slider isn't smart enough to recognize that, so when you darken the highlights in your image, the midtones and shadows also become darker. To compensate for the unwanted darkening, you try to adjust the contrast, which doesn't fix the problem.

The moral is, if you want to use the Brightness/Contrast command, select only the areas that need the correction, such as Alcatraz, shown in Figure 9-2. (For more on selections, see Chapter 6.) After you make your selection, choose Enhance ⇔ Adjust Lighting ⇔ Brightness/Contrast.

FIGURE 9-2:
The
Brightness/
Contrast
adjustment is
best reserved
for correcting
selected areas
(left) rather
than the entire
image (right).

Pinpointing proper contrast with Levels

If you want real horsepower when it comes to correcting the brightness and contrast (and even the color) in your image, look no further than the Levels command. Granted, the dialog box is a tad more complex than what you find with the other lighting and color adjustment commands, but when you understand how the Levels dialog box works, it can be downright user friendly.

You can get a taste of what Levels can do by using Auto Levels, detailed in Chapter 8. The Levels command, its manual cousin, offers much more control. And unlike the primitive Brightness/Contrast control, Levels enables you to darken or lighten 256 different tones. Keep in mind that you can use the Levels command on your entire image, a single layer, or a selected area.

If you're serious about image editing, the Levels command is one tool you want to know how to use. Here's how Levels works:

We recommend using Advanced mode for this command, where you'll have access to the Info panel in Step 2. If you're in Quick mode, skip to Step 3.

The Levels dialog box appears, displaying a histogram, as shown in Figure 9-3. This graph displays how the pixels of the image are distributed at each of the 256 available brightness levels. Shadows are shown on the left side of the histogram, midtones are in the middle, and highlights are on the right.

Note: In addition to viewing the histogram of the composite RGB channel (the entire image), you can view the histogram of just the Red, Green, or Blue channel by selecting one of them from the Channel drop-down menu.

Although you generally make changes to the entire image by using the RGB channel, you can apply changes to any one of an image's component color channels by selecting the specific channel from the Channel drop-down menu. You can also make adjustments to just selected areas, which can be helpful when one area of your image needs adjusting and others don't.

- In Advanced mode, choose Window

 Info to open the Info panel.
- 3. In the Levels dialog box, set the white point manually by using the eyedroppers in the dialog box:
 - a. Select the White Eyedropper tool and then move the cursor over the image.
 - Look at the Info panel, try to find the lightest white in the image, and then select that point by clicking it.

The lightest white has the highest RGB values.

4. Repeat Step 3, this time using the Black Eyedropper tool and trying to find the darkest black in the image.

The darkest black has the lowest RGB values.

When you set the pure black and pure white points, the remaining pixels are redistributed between those two points.

You can also reset the white and black points by moving the position of the white and black triangles on the input sliders (just below the histogram). Or you can enter values in the Input Levels boxes. The three boxes represent the black, gray, and white triangles, respectively. Use the numbers 0 to 255 in the white and black boxes.

Use the Gray Eyedropper tool to remove any color casts by selecting a neutral gray portion of your image, one in which the Info panel shows equal values of red, green, and blue.

If your image is grayscale, you can't use the Gray Eyedropper tool.

If you're not sure where there's a neutral gray, you can also remove a color cast by choosing a color channel from the Channel drop-down list and doing one of the following:

- Choose the Red channel and drag the midtone slider to the right to add cyan or to the left to add red.
- Choose the Green channel and drag the midtone slider to the right to add magenta or to the left to add green.
- Choose the Blue channel and drag the midtone slider to the right to add yellow or to the left to add blue.

6. If your image requires a tweak in reducing contrast, adjust the Output Levels sliders at the bottom of the Levels dialog box.

Moving the black triangle to the right reduces the contrast in the shadows and lightens the image. Moving the white triangle to the left reduces the contrast in the highlights and darkens the image.

Adjust the midtones (or gamma values) with the gray triangle input slider.

The default value for gamma is 1.0. Drag the triangle to the left to lighten midtones and drag to the right to darken them. You can also enter a value.

f 8. Click OK to apply your settings and close the dialog box.

Your image should be greatly improved, as shown in Figure 9-4.

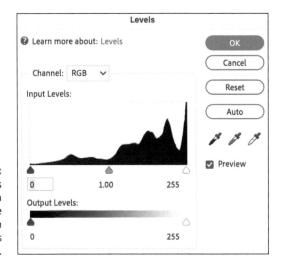

FIGURE 9-3: The Levels histogram displays the distribution of brightness levels.

Improve the contrast of an image with the intelligent Levels command.

FIGURE 9-4:

If you're not up to the task of manually adjusting your levels, you can opt to click the Auto button in the Levels dialog box. Elements applies the same adjustments as the Auto Levels command, as we explain in Chapter 8. Note the changes and subsequent pixel redistribution made to the histogram after you click this button.

Adjusting Color

Getting the color you want can seem about as attainable as winning the state lottery. Sometimes an unexpected *color cast* (a shift in color) can be avoided at the shooting stage, for example, by using (or not using, in some cases) a flash or lens filter or by setting the camera's white balance for lighting conditions that aren't present. After the fact, you can usually do a pretty good job of correcting the color with one of the many Elements adjustments. Occasionally, you may want

to change the color of your image to create a special effect. Conversely, you may want to strip out an image's color altogether to create a vintage feel. Remember that you can apply all these color adjustments to your entire image, a single layer, or just a selection. Whatever your color needs are, they'll no doubt be met in Elements.

You can find all color adjustments in either Advanced or Quick mode, except for Defringe Layers, which is reserved for Advanced mode only.

If you shoot your photos in the Camera Raw file format, you can open and fix your files in the Camera Raw dialog box. Remember that Camera Raw files haven't been processed by your camera. You're in total control of the color and exposure. For more about editing Camera Raw images, see Chapter 5, "Editing Camera Raw Images."

Removing color casts automatically

If you ever took a photo in an office or classroom and got a funky green tinge in your image, it was probably the result of the overhead fluorescent lighting. To eliminate this green color cast, you can apply the Remove Color Cast command. This feature is designed to adjust the image's overall color and remove the cast.

Follow these short steps to correct your image:

In either Advanced or Quick mode, choose Enhance

Adjust Color

Remove Color Cast.

The Remove Color Cast dialog box appears. Move the dialog box to better view your image.

Click an area in your photo that should be white, black, or neutral gray, as shown in Figure 9-5.

In our example, we clicked the girl's white T-shirt in the image on the left.

The colors in the image are adjusted according to the color you choose. Which color should you choose? The answer depends on the subject matter of your image. Feel free to experiment. Your adjustment is merely a preview at this point and isn't applied until you click OK. If you goof up, click the Reset button, and your image reverts to its unadjusted state.

Repeat Step 2 if you aren't happy with your image. If you're satisfied with the adjustment, click OK to accept it and close the dialog box.

FIGURE 9-5: Get rid of nasty color shifts with the Remove Color Cast command.

If the Remove Color Cast command doesn't cut it, try applying a photo filter (as we describe in the section "Adjusting color temperature with photo filters," later in this chapter). For example, if your photo has too much green, try applying a magenta filter.

Adjusting with Hue/Saturation

The Hue/Saturation command enables you to adjust the colors in your image based on their hue, saturation, and lightness. *Hue* is the color in your image. *Saturation* is the intensity, or richness, of that color. And *lightness* controls the brightness value.

Follow these steps to adjust color by using the Hue/Saturation command:

1. In either Advanced or Quick mode, choose Enhance

Adjust Color

Adjust Hue/Saturation.

The Hue/Saturation dialog box appears. Be sure to select the Preview check box so that you can view your adjustments. The Hue/Saturation command is also available in Guided mode.

Choose Master from the Edit drop-down list to adjust all the colors or choose one color to adjust.

3. Drag the slider for one or more of the following attributes to adjust the colors as described:

- Hue: Shifts all the colors clockwise (drag right) or counterclockwise (drag left) around the color wheel.
- Saturation: Increases (drag right) or decreases (drag left) the richness of the colors. *Note:* Dragging all the way to the left gives the photo the appearance of a grayscale image.
- Lightness: Increases the brightness values by adding white (drag right) or decreases the brightness values by adding black (drag left).

The top color bar at the bottom of the dialog box represents the colors in their order on the color wheel before you make any changes. The lower color bar displays the colors after you make your adjustments.

When you select an individual color to adjust, sliders appear between the color bars so that you can define the range of color to be adjusted. You can select, add, or subtract colors from the range by choosing one of the Eyedropper tools and clicking in the image.

The Hue/Saturation dialog box also lets you colorize images, a useful option for creating sepia-colored images.

4. (Optional) Select the Colorize option to change the colors in your image to a new, single color. Drag the Hue slider to change the color to your desired hue.

The pure white and black pixels remain unchanged, and the intermediate gray pixels are colorized.

5. Click OK to apply your adjustments and exit the dialog box.

TIP

Use the Hue/Saturation command with the Colorize option to create tinted photos, such as the one shown in Figure 9-6. You can also make selections in a grayscale image and apply a different tint to each selection. This can be especially fun with portraits. Tinted images can create a vintage or moody feel, and they can transform even mediocre photos into something special.

Eliminating color with Remove Color

Despite all the talk in this chapter about color, we realize that there may be times when you don't want *any* color. With the Remove Color command, you can easily eliminate all the color from an image, a layer, or a selection. To use this one-step command, simply choose Enhance \Leftrightarrow Adjust Color \Leftrightarrow Remove Color.

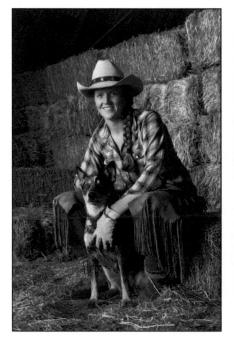

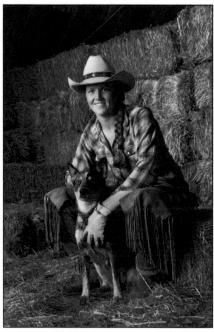

iofoto/Shutterstock

Adjust the color, intensity, or brightness of your image with the Hue/Saturation command.

Sometimes, stripping away color with this command can leave your image *flat*, or low in contrast. If this is the case, adjust the contrast by using one of Elements' many lighting fixes, such as Auto Levels, Auto Contrast, or Levels.

If you want to convert a selection, a layer, or an entire image to grayscale, you can do that with the Convert to Black and White dialog box, as shown in Figure 9-7. (Choose Enhance Convert to Black and White.) But rather than just arbitrarily strip color as the Remove Color command does, the Convert to Black and White command enables you to select a conversion method by first choosing an image style. To further tweak the results, you can add or subtract colors (red, green, or blue) or contrast by moving the Intensity sliders until your grayscale image looks the way you want. *Note:* You aren't really adding color; you're simply altering the amount of data in the color channels.

Switching colors with Replace Color

The Replace Color command enables you to replace designated colors in your image with other colors. You first select the colors you want to replace by creating a *mask*, which is a selection made by designating white (selected), black (unselected), and gray (partially selected) areas. You can then adjust the hue and/or saturation of those selected colors.

CHAPTER 9 Correcting Contrast, Color, and Clarity

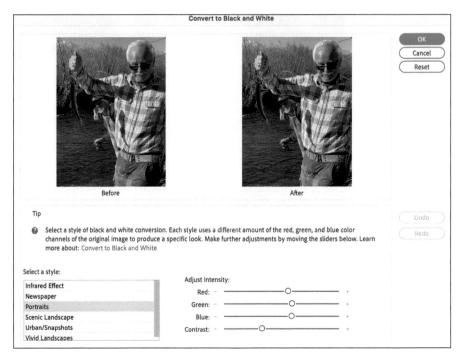

FIGURE 9-7: Wash away color with the Convert to Black and White command.

Follow these steps to get on your way to replacing color:

1. In Advanced or Quick mode, choose Enhance ➪ Adjust Color ➪ Replace Color.

The Replace Color dialog box appears.

- 2. Select the Preview check box and then choose either Selection or Image:
 - **Selection** shows the mask in the Preview area. The deselected areas are black, partially selected areas are gray, and selected areas are white.
 - Image shows the actual image in the Preview area.
- 3. With the Eyedropper tool, click the colors you want to select in either the image or the Preview area.
- 4. Shift-click or use the plus sign (+) Eyedropper tool to add more colors.
- Press the Alt (Option on the Mac) key or use the minus sign (-)
 Eyedropper tool to delete colors.
- To add colors similar to the ones you select, use the Fuzziness slider to fine-tune your selection, adding to or deleting from the selection based on the Fuzziness value.

If you can't quite get the selection you want with the Fuzziness slider, try selecting the Localized Color Clusters option. This option enables you to select multiple clusters, or areas, of color and can assist in getting a cleaner, more precise selection, especially when trying to select more than one color.

 Move the Hue and/or Saturation sliders to change the color or color richness, respectively. Move the Lightness slider to lighten or darken the image.

Be careful to use a light hand (no pun intended) with the Lightness slider. You can reduce the tonal range too much and end up with a mess.

- 8. View the result in the image window.
- 9. If you're satisfied, click OK to apply the settings and close the dialog box.

Figure 9-8 shows the result of substituting the color of our tulips to change them from red to blue.

The Replace
Color
command
enables you
to replace
one color with
another.

JeniFoto/Shutterstock

Changing an object's color

NEW

The new Change Object Color command also allows you to change the color of desired objects in your image but using a different process than the Replace Color command (described in the previous section). You may find this new command a bit easier to use than the older Replace Color command because no masking is required.

Here is how to use the Change Object Color command:

- 2. Using one of the selection tools, select the object whose color you want to change.

You can choose one of the Auto Selection tools in the top-right panel or use one of the manual tools, such as the Lasso tool, in the bottom panel. We used the Selection Brush to select the girl's hat.

3. Choose your desired new color from the color, black, or white color pickers.

We clicked the color picker and chose a green to match her sweater.

- 4. Further adjust your new color by using different blending modes (see more on blending modes in Chapter 10) or varying the lightness to make the color lighter or darker.
- 5. Use the Refine Edges brushes to tidy up your color application.

Use the Reveal brush to add the new color to any missed edges or spots that didn't get the color application in Step 3. Conversely, if you inadvertently applied the new color to an unwanted area, choose the Hide brush to remove the new color.

6. If you're satisfied, click OK to apply the settings and close the dialog box. Figure 9-9 shows the girl's hat changing from blue to green.

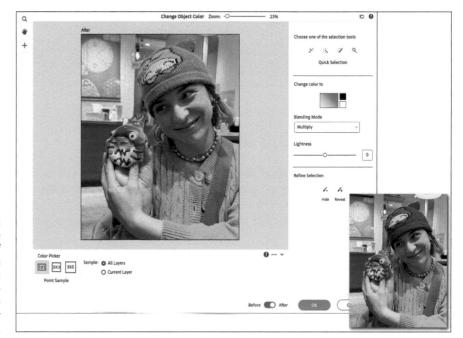

FIGURE 9-9: Change the color of desired objects within an image with the new Change **Object Color** command.

Correcting with Color Curves

Elements borrowed a much-used feature from Photoshop named Curves. However, Elements adds the word *Color*, and Color Curves doesn't have all the sophistication of its Photoshop cousin. Nevertheless, the Color Curves adjustment attempts to improve the tonal range in color images by making adjustments to highlights, shadows, and midtones in each color channel. Try using this command on images in which the foreground elements appear overly dark due to backlighting. Conversely, the adjustment is designed to correct images that appear overexposed and washed out.

Here's how to use this great adjustment on a selection, a layer, or an entire image:

1. In Advanced or Quick mode, select an image and choose Enhance

Adjust Color

Adjust Color Curves.

The Adjust Color Curves dialog box appears.

- Select a curve adjustment style from the Select a Style area to make your desired adjustments while viewing your image in the After window.
- (Optional) If you need greater precision, use the highlights, brightness, contrast, and shadows adjustment sliders, as shown in Figure 9-10, and then adjust the sliders as desired.

The graph in the lower right represents the distribution of tones in your image. When you first access the Color Curves dialog box, the tonal range of your image is represented by a straight line. While you drag the sliders, the straight line is altered, and the tonal range is adjusted accordingly.

Note that you can often easily increase the contrast in an image by creating a subtle S-shaped curve. To achieve this, decrease the shadows value and

increase the highlights value equally.

To start over, click the Reset button.

Click OK when you've adjusted the image satisfactorily.

Check out Figure 9-11 for another before-and-after image.

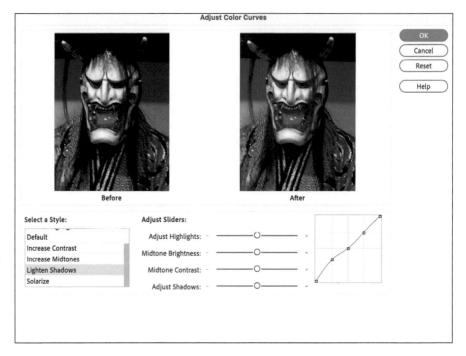

FIGURE 9-10:
The Color
Curves
adjustment
provides both
basic and
advanced
adjustment
controls.

After the Color Curves adjustment

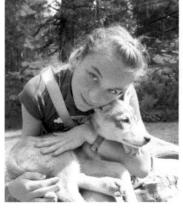

FIGURE 9-11: Color Curves improves tonal range in color images.

Adjusting skin tones

Occasionally, you may find that the skin tone of people in your photos has taken on a shade of green, red, or some other tone not natural to them. To rectify that problem, Elements has the Adjust Color for Skin Tone command specifically designed to adjust the overall color in the image and get skin tones back to their natural shades.

Here's how to use this feature:

- 1. Open your image in Advanced or Quick mode and do one or both of the following:
 - Select the layer that needs to be adjusted. If you don't have any layers, your entire image is adjusted.
 - Select the areas of skin that need to be adjusted. Only the selected
 areas are adjusted. This is a good way to go if you're happy with the color
 of your other elements and just want to tweak the skin tones. For more on
 selection techniques, see Chapter 6.
- 2. Choose Enhance

 Adjust Color

 Adjust Color for Skin Tone.

The Adjust Color for Skin Tone dialog box appears. This command is also found in Guided mode.

3. In the image window, click the portion of skin that needs to be corrected.

The command adjusts the color of the skin tone, as well as the color in the overall image, layer, or selection, depending on what you selected in Step 1.

- 4. If you're not satisfied with the results, click another area or fiddle with the Skin and Ambient Light sliders:
 - Tan adds or removes the amount of brown in the skin.
 - Blush adds or removes the amount of red in the skin.
 - **Temperature** adjusts the overall color of the skin, making it warmer (right toward red) or cooler (left toward blue).

To start anew, click the Reset button. And, of course, to bail out completely, click Cancel.

5. When you're happy with the correction, click OK to apply the adjustment and close the dialog box.

The newly toned skin appears, as shown in Figure 9-12.

FIGURE 9-12:
Give your friends and family a complexion makeover with the Adjust Color for Skin Tone command.

Defringing layers

A telltale sign of haphazardly composited images is selections with fringe. We don't mean the cute kind hanging from your leather jacket or upholstery; we mean the unattractive kind that consists of background pixels that surround the edges of your selections, as shown in Figure 9-13.

Inevitably, when you move or paste a selection, some background pixels are bound to go along for the ride. These pixels are referred to as a *fringe* or *halo*. Luckily, the Defringe command replaces the color of the fringe pixels with the colors of neighboring pixels that don't contain the background color. In our example, we plucked the red flower out of a blue background and placed it on a white background. Some of the background pixels were included in our selection and appear as a blue fringe. When we apply the Defringe command, those blue fringe pixels are changed to colors of nearby pixels, such as red (refer to Figure 9-13).

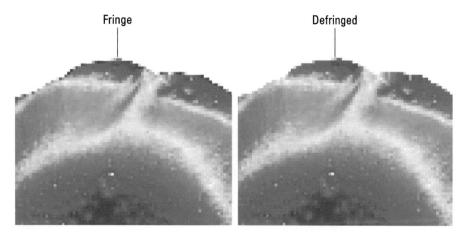

Remove the colored halo around your selections with the Defringe command.

Follow these steps to defringe your selection:

 In Advanced or Quick mode, copy and paste a selection onto a new or existing layer, or drag and drop a selection onto a new document.

For more on selections, see Chapter 6.

2. Choose Enhance

Adjust Color

Defringe Layer.

The Defringe dialog box appears.

3. Enter a value for the number of pixels you want to convert.

Try entering 1 or 2 first to see whether that does the trick. If not, you may need to enter a slightly higher value.

4. Click OK to accept the value and close the dialog box.

Eliminating haze

Elements provides a useful and easy-to-use feature to quickly eliminate haze from your photos. Haze, caused by light hitting particles in the air, dust, dirt, and so on, can be further enhanced by weather and time of day. Sometimes, increasing the contrast and sharpness in your image can help to lessen the effect of haze in your image. But with this feature, eliminating it has never been easier.

Here are the steps to eliminate haze from your images:

- 1. Open an image in Advanced or Quick mode.
- 2. Choose Enhance 🖒 Haze Removal.

The Haze Removal dialog box appears.

- 3. Specify your Haze Reduction setting by adjusting the slider.

 Sliding right will increase the amount of haze that is reduced.
- **4.** Specify your Sensitivity setting by adjusting the slider.

 Sliding right will increase the threshold of how much haze is detected.
- Toggle your Before and After button to check your results and then click OK.

The results of this great feature are shown in Figure 9-14.

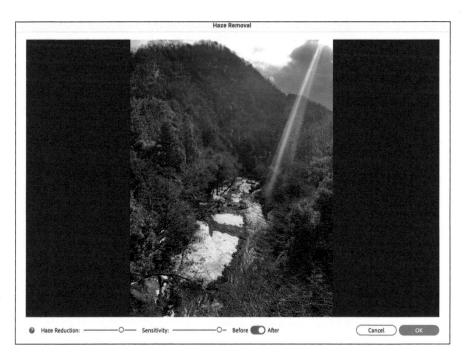

FIGURE 9-14: Get rid of haze with the Haze Removal command.

Adjusting color temperature with photo filters

Light has its own color temperature. A photo shot in a higher color temperature of light makes the image blue. Conversely, a photo shot in a lower color temperature makes the image yellow. In the old days, photographers placed colored glass filters in front of their camera lenses to adjust the color temperature of the light. They did this to either warm up or cool down photos or to just add a hint of color for subtle special effects. Elements gives you the digital version of these filters with the Photo Filter command.

To apply the Photo Filter adjustment, follow these steps:

- 1. In Advanced or Quick mode, choose Filter ➪ Adjustments ➪ Photo Filter. The Photo Filter dialog box appears.
- 2. In the dialog box, select Filter to choose a preset filter from the dropdown list, or select Color to choose your own filter color from the Color Picker.

Here's a brief description of each of the preset filters:

- Warming Filter (85), (81), and (LBA): These adjust the white balance in an image to make the colors warmer, or more yellow. Filter (81) is like (85) and (LBA), but it's best used for minor adjustments.
- Cooling Filter (80), (82), and (LBB): These also adjust the white balance that's shown, but instead of making the colors warmer, they make the colors cooler, or bluer. Filter (82) is like (80) and (LBB), but it's designed for slight adjustments.
- Red, Orange, Yellow, and so on: The various color filters adjust the hue, or color, of a photo. Choose a color filter to try to eliminate a color cast or to apply a special effect.
- 3. Adjust the Density option to specify the amount of color applied to your image.
- 4. Select the Preserve Luminosity option to prevent the photo filter from darkening your image.
- 5. Click OK to apply your filter and close the dialog box.

One way to minimize the need for color adjustments is to be sure you set your camera's white balance for your existing lighting conditions before shooting your photo.

Mapping your colors

Elements provides color mapper commands that change the colors in your image by mapping them to other values. You find the color mappers on the Filter 🖒 Adjustments submenu. Figure 9-15 shows an example of each command, and we explain all in the following list:

>> Equalize: This mapper first locates the lightest and darkest pixels in the image and assigns them values of white and black. It then redistributes all the remaining pixels among the grayscale values. The exact effect depends on your individual image.

- >> Gradient Map: This command maps the tonal range of an image to the colors of your chosen gradient. For example, colors (such as orange, green, and purple) are mapped to the shadow, highlight, and midtone areas.
- >> Invert: This command reverses all the colors in your image, creating a kind of negative. Black reverses to white, and colors convert to their complementary hues. Complementary colors (which are opposite each other on the color wheel), when combined in the proper proportions, produce white, gray, or black. So blue goes to yellow, red goes to cyan, and so on.
- >> Posterize: This command reduces the number of brightness levels in your image. Choose a value between 2 and 255 levels. Lower values create an illustrative, poster-like look, and higher values produce a more photo-realistic image.
- >> Threshold: Threshold makes your image black and white, with all pixels that are brighter than a value you specify represented as white and all pixels that are darker than that value as black. You can change the threshold level to achieve different high-contrast effects.

Equalize Gradient Map Invert Posterize Threshold

Threshold

FIGURE 9-15: Change the colors in your image by remapping them to other values.

Vetta/Getty Images

Adjusting Clarity

After your image has the right contrast and color, and you fix any flaws (as we describe in Chapter 8), you're ready to work on the overall clarity of that image. Although you may have fixed the nitpicky blemishes with the healing tools, if your image suffers from an overall problem, such as dust, scratches, or *artifacts* (blocky pixels or halos), you may need to employ the help of a filter. After you totally clean up your image, your last chore is to give it a good sharpening. Why wait until the bitter end to do so? Sometimes, while you're improving the contrast and color and getting rid of flaws, you can reduce the clarity and sharpness of an image. So you want to be sure that your image is as soft as it's going to get before you tackle your sharpening tasks.

Sharpening increases contrast, so depending on how much of your image you're sharpening, you may need to go back and fine-tune it by using the lighting adjustments described in the section "Adjusting Lighting," earlier in this chapter.

Finally, with all this talk about sharpening, we know that you may find it strange when we say that you may also need to occasionally blur your image. You can use blurring to eliminate unpleasant patterns that occur during scanning, to soften distracting backgrounds to give a better focal point, or even to create the illusion of motion.

Removing noise, artifacts, dust, and scratches

Surprisingly, the tools you want to use to eliminate junk from your images are found on the Filter r Noise submenu in Advanced or Quick mode. With the exception of the Add Noise filter, the others help to hide noise, dust, scratches, and artifacts. Here's the list of junk removers:

- >> Despeckle: Decreases the contrast, without affecting the edges, to make the dust in your image less pronounced. You may notice a slight blurring of your image (that's what's hiding the junk), but hopefully the edges are still sharp.
- Dust & Scratches: Hides dust and scratches by blurring those areas of your image that contain the nastiness. (It looks for harsh transitions in tone.) Specify your desired Radius value, which is the size of the area to be blurred. Also, specify the Threshold value, which determines how much contrast between pixels must be present before they're blurred.

WADNING

Use this filter with restraint because it can obliterate detail and make your image go from bad to worse.

- >> Median: Reduces contrast around dust spots. The process the filter goes through is rather technical, so suffice it to say that the light spots darken, the dark spots lighten, and the rest of the image isn't changed. Specify your desired radius, which is the size of the area to be adjusted.
- >> Reduce Noise: Designed to remove luminance noise and artifacts from your images. Luminance noise is grayscale noise that makes images look overly grainy. Specify these options to reduce the noise in your image:
 - Strength: Specify the amount of noise reduction.
 - Preserve Details: A higher percentage preserves edges and details but reduces the amount of noise that's removed.

- Reduce Color Noise: Remove random colored pixels.
- Remove JPEG Artifact: Remove the blocks and halos that can occur from low-quality JPEG compression.

Blurring when you need to

It may sound odd that anyone would intentionally want to blur an image. But, if your photo is overly grainy or suffers from a nasty *moiré* (wavy) pattern (as described in the following list), you may need to blur the image to correct the problem. Often, you may even want to blur the background of an image to de-emphasize distractions or to make the foreground elements appear sharper and provide a better focal point.

All the blurring commands are found on the Filter 🖒 Blur menu in Advanced or Quick mode, with the exception of the Blur tool itself, found in the Tools panel (explained in Chapter 8):

- >> Average: This one-step filter calculates the average value of the image or selection and fills the area with that average value. You can use it for smoothing overly noisy areas in your image.
- **Blur:** Another one-step filter, this one applies a fixed amount of blurring to the whole image.
- **>> Blur More:** This one-step blur filter gives the same effect as Blur, but more intensely.

NEW

- >> Depth Blur: This filter enables you to have your subject in focus while blurring or hazing out the background or more undesired areas of the image. You can adjust the focal range and blur strength for more or less blur. If, by chance, the subject identified by the filter isn't what you want in focus, simply click your desired area in your image.
- Gaussian Blur: This blur filter is probably the one you'll use most often. It offers a Radius setting to let you adjust the amount of blurring you desire.

TIP

Use the Gaussian Blur filter to camouflage moiré patterns on scanned images. A *moiré pattern* is caused when you scan halftone images. A *halftone* is created when a continuous-tone image, such as a photo, is digitized and converted into a screen pattern of repeating lines (usually between 85 and 150 lines per inch) and then printed. When you then scan that halftone, a second pattern results and is overlaid on the original pattern. These two different patterns bump heads and create a nasty moiré pattern. The Gaussian Blur filter doesn't eliminate the moiré — it simply merges the dots and reduces the appearance of the pattern. Play with the Radius slider until you get an acceptable trade-off

between less moiré and less focus. If you happen to have a descreen filter (which attempts to remove the moiré pattern on scanned halftones) built into your scanning software, you can use that as well during the scanning of the halftone image.

- >> Lens Blur: See details in the paragraph after this list on why and how to apply this blur filter.
- >> Motion Blur: This filter mimics the blur given off by moving objects. Specify the angle of motion and the distance of the blur. Make sure to select the Preview check box to see the effect while you enter your values.
- >> Radial Blur: Need to simulate a moving Ferris wheel or some other round object? This filter produces a circular blur effect. Specify the amount of blur you want. Choose the Spin method to blur along concentric circular lines, as shown in the thumbnail. Or choose Zoom to blur along radial lines and mimic the effect of zooming in to your image. Specify your desired Quality level. Because the Radial Blur filter is notoriously slow, Elements gives you the option of Draft (fast but grainy), Good, or Best (slow but smooth). The difference between Good and Best is evident only on large, high-resolution images. Finally, indicate where you want to place the center of your blur by moving the blur diagram thumbnail.
- >> Smart Blur: This filter provides several options to enable you to specify how the blur is applied. Specify a value for the radius and threshold, both defined in the following section. Start with a lower value for both and adjust from there. Choose a quality setting from the drop-down list. Choose a mode setting:
 - Normal blurs the entire image or selection.
 - Edge Only blurs only the edges of your elements and uses black and white in the blurred pixels.
- >> Overlay Edge also blurs just the edges, but it applies only white to the blurred pixels.
- >> Surface Blur: This filter blurs the surface or interior of the image instead of the edges. If you want to retain your edge details but blur everything else, use this filter.

If you've ever experimented with the aperture settings on a camera, you know that you can set how shallow or deep your depth of field is. Depth of field relates to the *plane of focus* (the areas in a photo that are in front of or behind the focal point and that remain in focus) or how in focus the foreground elements are when you compare them with the background elements. The Lens Blur filter, as shown in Figure 9–16, enables you to give the effect of a shallower depth of field after you've already captured your image, thereby enabling you to take a fully focused image and create this selective focus.

FIGURE 9-16: Use the Lens Blur filter to create a shallow depthof-field effect.

Adobe, Inc.

Here's how to use the Lens Blur filter:

1. Choose Filter

Blur

Lens Blur.

The Lens Blur Filter dialog box appears.

2. Select your Preview mode.

The Faster option gives you a quick preview, whereas More Accurate shows you the final rendered image.

3. Choose a Source from the drop-down list for your depth map, if you have one.

You can choose between a layer mask and a transparency. The filter uses a depth map to determine how the blur works.

A good way to create an image with this shallow depth-of-field effect is to create a layer mask on your image layer and fill it with a white-to-black gradient — black where you want the most focus, and white where you want the least focus or most blur. Choose Transparency to make an image blurrier and more transparent.

4. Drag the Blur Focal Distance slider to specify how blurry or in focus an area of the image is. Or click the crosshair cursor on the part of the image that you want to be in full focus.

Dragging the slider enables you to specify a value. You can also select Invert to invert, or reverse, the depth map source.

Choose an Iris shape, such as triangle or octagon, from the Shape drop-down list.

The Iris settings are meant to simulate the aperture blades of a camera lens. Specify the shape of the lens, as well as the radius (size of the iris), blade curvature (the smoothness of the iris's edges), and rotation of that shape.

6. Set the Brightness and Threshold values in the Specular Highlights area.

The Lens Blur filter averages the highlights of an image, which, if left uncorrected, cause some highlights to appear grayish. The Specular Highlights controls help to retain Specular Highlights, or those highlights that should appear very white. Set the Threshold value to specify which highlights should be *specular* (remain white). Set a Brightness value to specify how much to relighten any blurred areas.

 Drag the Amount slider in the Noise area to add noise back into your image. Choose Monochromatic to add noise without affecting the color.

Blurring obliterates any noise (or *film grain*) that an image may have. This absence of noise can cause the image to appear inconsistent or unrealistic, in many cases.

8. Click OK to apply the Lens Blur and exit the dialog box.

Sharpening for better focus

Of course, if your images don't need any contrast, color, and flaw fixing, feel free to jump right into sharpening. Sometimes, images captured by a scanner or a digital camera are a little soft, and it's not due to any tonal adjustments. Occasionally, you may even want to sharpen a selected area in your image just so that it stands out more.

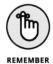

You can't really improve the focus of an image after it's captured. But you can do a pretty good job of faking it.

All sharpening tools work by increasing the contrast between adjacent pixels. This increased contrast causes the edges to appear more distinct, thereby giving the illusion that the focus is improved, as shown in Figure 9-17. Remember that you can also use the Sharpen tool for small areas, as described in Chapter 8. Here's a description of the two sharpening commands:

>> Unsharp Mask: Found on the Enhance menu in Advanced or Quick mode, Unsharp Mask (which gets its odd name from a darkroom technique) is the sharpening tool of choice. It gives you several options that enable you to control the amount of sharpening and the width of the areas to be sharpened. Use them to pinpoint your desired sharpening:

- Amount: Specify an amount (from 1 to 500 percent) of edge sharpening. The higher the value, the more contrast between pixels around the edges. Start with a value of 100 percent (or less), which usually gives good contrast without appearing overly grainy.
- Radius: Specify the width (from 0.1 to 250 pixels) of the edges that the filter will sharpen. The higher the value, the wider the edge. The value you use is largely based on the resolution of your image. Low-resolution images require a smaller radius value. High-resolution images require a higher value.

Be warned that specifying a value that's too high overemphasizes the edges of your image and makes it appear too "contrasty" or even "goopy" around the edges.

Threshold: Specify the difference in brightness (from 0 to 255) that must be present between adjacent pixels before the edge is sharpened. A lower value sharpens edges with very little contrast difference. Higher values sharpen only when adjacent pixels are very different in contrast. We recommend leaving Threshold set at 0 unless your image is very grainy. Setting the value too high can cause unnatural transitions between sharpened and unsharpened areas.

Occasionally, the values you enter for Amount and Radius may sharpen the image effectively but in turn create excess grain, or noise, in your image. You can sometimes reduce this noise by increasing the Threshold value.

>> Adjust Sharpness: When you're looking for precision in your image sharpening, Unsharp Mask is one option. The Adjust Sharpness command, as shown in Figure 9-18, is the other. This feature enables you to control the amount of sharpening applied to shadow and highlight areas. It also allows you to select from various sharpening algorithms.

Here are the various options you can specify:

 Amount and Radius: These work similar to the Unsharp Mask command; see the previous bullet.

- Preset: You can save your sharpening settings as a preset that you can load and use later.
- Remove: Choose your sharpening algorithm. Gaussian Blur is the algorithm used for the Unsharp Mask command. Lens Blur detects detail in the image and attempts to respect the details while reducing the nasty halos that can occur with sharpening. Motion Blur tries to sharpen the blurring that occurs when you move the camera (or if your subject doesn't sit still).
- Angle: Specify the direction of motion for the Motion Blur algorithm, described in the preceding bullet.
- Shadows/Highlights: You can control the amount of sharpening in the Shadow and Highlight areas of your image. Determine the amount of sharpening with the Fade Amount setting. For the Tonal Width option, specify the range of tones you want to sharpen. Move the slider to the right to sharpen only the darker of the shadow areas and the lighter of the highlight areas. Finally, for the Radius setting, specify the amount of space around a pixel that's used to determine whether a pixel is in the shadow or the highlight area. Move the slider right to specify a greater area.

FIGURE 9-17:
Sharpening
mimics an
increase
in focus by
increasing
contrast
between
adjacent pixels.

Opening closed eyes

It's hard to get everyone in your photo to have great smiles and open eyes at the exact same instant. Luckily, now you have a tool to at least fix the eye problem. The Open Closed Eyes feature lets you use another photo of the same person(s) in which their eyes were open and merge the two images into a nice hero shot.

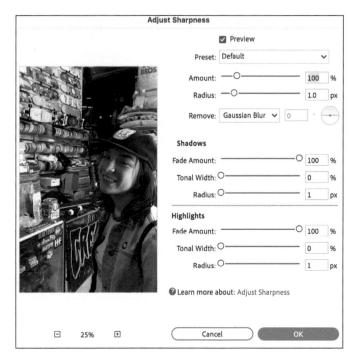

The Adjust Sharpness dialog box.

Here's what you do:

1. Open an image in Advanced or Quick mode.

You can open a photo from your computer, the Organizer, or the Photo Bin.

2. Choose Enhance → Open Closed Eyes or click the Eye tool in the Tools panel and then click the Open Closed Eyes button in the tool options.

The Open Closed Eyes dialog box appears, as shown in Figure 9-19.

In the dialog box, a circle surrounds the area that will be affected by the adjustments.

- 3. Choose a photo as your eye source image.
- 4. Click the source image to apply it.

Elements automatically applies the eyes from the source image and replaces the closed eyes.

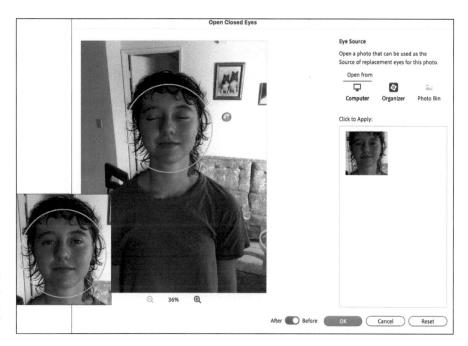

FIGURE 9-19: Fix images with the Open Closed Eyes feature.

Colorizing a photo

This enhancement enables you to either add color to black-and-white images, or edit the color in colored images. Yes, you can also colorize images in Elements a couple different ways — using Hue/Saturation (described earlier in this chapter) or using the Brush tool with a Color blending mode applied — but this technique can give your image more of a vintage, hand-painted look.

Follow these steps to colorize a photo:

- 1. Open an image in Advanced or Quick mode.
- 2. Choose Enhance ⇔ Colorize Photo.

Note that you may be prompted to download a file when first choosing this option. The Colorize Photo dialog box appears.

- 3. Choose either Auto or Manual mode.
- 4. If you choose Auto mode, choose one of four presets in Basic mode.

Each one creates a more contrasty image.

- 5. If you want a little more customization, choose Manual mode and follow these steps:
 - (a) Use either the Quick Selection or Lasso tool and select an area where you want more color.
 - If you are using the Quick Selection tool you can make the tool's diameter larger or smaller by adjusting the Size slider.
 - (b) With either tool, use the Add to or Subtract From buttons to further define your desired area (you can also press the Shift key to add and the Option/Alt key to subtract).
 - (c) Select the Droplet Tool and then click inside your selected area to mark the area to be colorized.
 - (d) Click your desired color swatch from the Color Palette or from the All Applicable Colors panel.
 - (e) Repeat the steps as desired.

If the Manual method is confusing, click the arrow just to the right of the word *Manual*. You will be presented with a short Colorize Photo tutorial video on Adobe.com.

 If you're happy with the results, click OK. If you want to start over, click the Reset button.

See Figure 9-20 for two colorized variations using Manual mode.

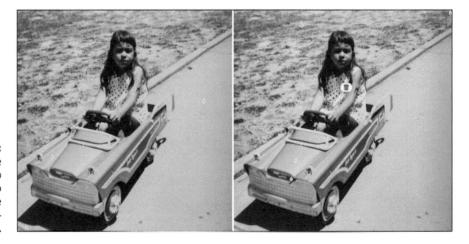

Use the Colorize Photo feature to bring life to black-andwhite images.

Smoothing skin

Elements gives you yet another feature to make people look better in the digital world than they do in real life. Luckily, the new Smooth Skin feature doesn't allow you to go crazy and eliminate all traces of having lived life, but instead just softens and refreshes lines and blemishes.

Here's how to use the Smooth Skin feature:

- 1. Open an image in Advanced or Quick mode.

The Smooth Skin dialog box appears.

In the dialog box, a circle surrounds the area that will be affected by the adjustments.

- 3. Use the Smoothness slider to apply the amount of smoothing desired, as shown in Figure 9-21.
- 4. Toggle your Before and After button to view your results.
- If you like the results, click OK. If not, click Reset or Cancel.

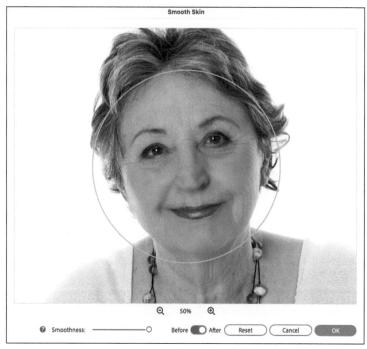

FIGURE 9-21: The Smooth Skin feature quickly softens wrinkles and blemishes.

Adobe, Inc.

If you feel that your subject needs a little more "work," check out the Perfect Portrait feature in the Special Edits category in Guided Edit mode. The Smooth Skin feature is part of that edit, along with the abilities to whiten teeth, darken eyebrows, brighten eyes, and perform other enhancements.

Adjusting facial features

The Adjust Facial Features command is a light, automated version of the infamous Liquify feature, the power tool used to retouch many a magazine photo. Adjust Facial Features doesn't allow for much manual manipulation, but the effect is pretty dramatic, not to mention seamless and easy to use. Get ready for retouching requests from friends and family!

Here's how to use this feature:

- 1. Open an image in Advanced or Quick mode.
- 2. Choose Enhance ➪ Adjust Facial Features.

The Adjust Facial Features dialog box appears.

In the dialog box, a circle surrounds the area that will be affected by the adjustments. Note that Elements first analyzes whether it's truly a face. We tried it with an image of a cat. No dice.

Use the sliders to modify facial features such as eyes, nose, lips, chin, and face, as shown in Figure 9-22.

The Face Tilt feature enables you to adjust the various angles of the face.

- 4. Toggle your Before and After button to view your results.
- 5. Satisfied? Click OK. Not satisfied? Start over by clicking Reset.

Figure 9-22 shows the seamless adjustment of the model's features.

Moving Overlays

Moving Overlays is a fun animated feature that enables you to add moving content from three different categories to your static photos.

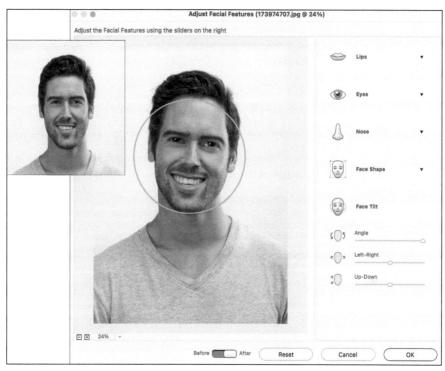

FIGURE 9-22: The Adjust Facial Features command easily modifies facial characteristics.

Adobe, Inc.

Follow these steps to add moving overlays:

- 1. Open an image in Advanced or Quick mode.

The Moving Overlays dialog box appears.

- 3. On the right side of the dialog box, select either Overlays, Graphics, or Frames from the drop-down menu.
- 4. Double-click the motion overlay that you want to apply to your image.

Note that if you are choosing a frame or graphic, you can size it by dragging a handle of the accompanying transform box.

Elements takes a minute or two to generate a preview.

5. (Optional) Select the Protect Subject option to put your motion content behind your static image.

You can also adjust the Opacity slider to make your motion content less opaque.

(Optional) Click the Refine Overlay button to Subtract content if you want. Note that you can adjust your brush size and opacity using the sliders.

If you change your mind, you can always use the Add button to bring it back in.

7. Click the Play/Stop button under your image.

The motion effect is added to your photo, as you can see in Figure 9-23.

8. When you're pleased with the results, click the Export button at the bottom of the dialog box.

Your file can be exported either as an animated GIF or, as an MP4 file. You can then use your file on websites, Facebook, Twitter, and in iPhone messages.

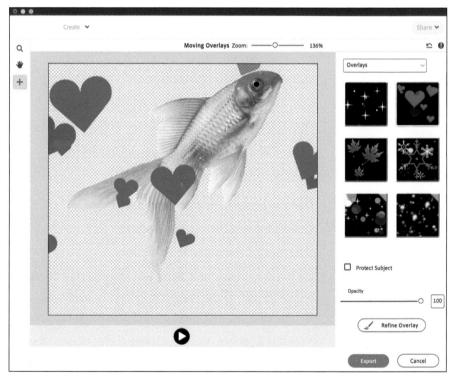

FIGURE 9-23:
Add animated
content to
your static
images with
the Moving
Overlays
enhancement.

Adobe, Inc.

Moving Photos

The Moving Photos feature enables you to take your still images and give them a little motion. It's so surprisingly easy that you'll wonder how in the heck those Adobe programmers hid all the technical machinations behind the curtain.

Here's how to use it:

- 1. Open an image in Advanced or Quick mode.

The simple Moving Photos dialog box appears.

On the right side of the dialog box, double-click the motion effect that you want to apply to your image.

Give Elements a few moments to generate a preview.

4. Click the Play/Stop button under your image.

Amazingly the motion effect is applied to your photo, as you sadly can't see in Figure 9-24!

- By default, the 3D Effect is applied, thereby giving your image more depth. Toggle it off to see it without the 3D Effect.
- When you're happy with the file, click the Export button at the bottom of the dialog box.

Your moving image can be exported either as an animated GIF or MP4 file. Show it off on social media sites or in your iPhone messages.

Moving Elements

Elements has yet another feature in the animated enhancement category. The Moving Elements feature enables you to animate certain regions within your static image. It's simple to do and loads of fun. Here's how to use it:

- 1. Open an image in Advanced or Quick mode.

The Moving Elements dialog box appears.

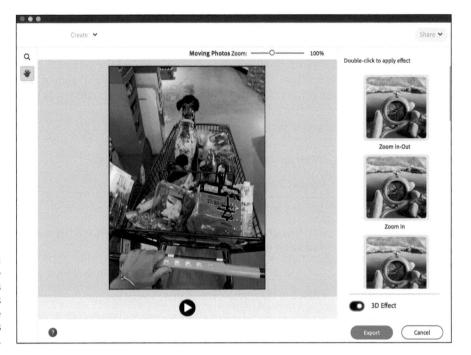

FIGURE 9-24: Create animated GIFs or MP4 files easily with the Moving Photos enhancement.

3. On the right side of the dialog box, select the area where you want to add motion. We chose the sky in our image.

If you choose the Manual option, you can choose the Brush tool, Quick Selection tool or Magic Wand (Auto) to make your selection. The Show Mask option will display a red overlay indicating your selection. Note that with this feature, making a rough selection rather than a very accurate selection may actually result in better output.

- 4. Select the arrow button and drag the desired direction of your motion.
 - See the turquoise direction arrow in Figure 9-25. For best results, use fewer arrows rather than more.
- Choose your desired speed of motion using the speed slider, and select Select All to have your entire selection move at that speed.
- 6. Click the Play button (the white arrow on a black circle) under your image to generate a preview. When you are satisfied, click the Export button. Finally, click Done to exit the dialog box.

Your moving image will be exported as an MP4 file.

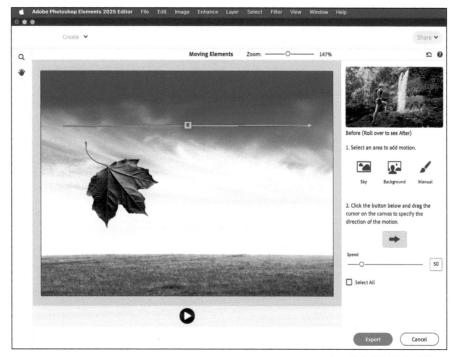

FIGURE 9-25:
Give selected
areas of
your image
movement
with the
Moving
Elements
feature.

Sean Gladwell/Adobe Stock Photos

Working Intelligently with the Smart Brush Tools

The Smart Brush and Detail Smart Brush tools enable you to selectively apply an image adjustment or special effect that appears on all or part of your image. What's even more exciting is that these adjustments and effects are applied via an adjustment layer, meaning that they hover over your layers and don't permanently alter the pixels in your image. It also means that you can flexibly edit or delete adjustments, if so desired.

Follow these steps to use the Smart Brush tool:

1. In Advanced mode, select the Smart Brush tool from the toolbar.

The tool icon looks like a house paintbrush. You can also press F, or Shift+F, if the Detail Smart Brush tool is visible.

2. Select an adjustment category and then your particular preset adjustment from the Preset Picker drop-down list in the Tool Options.

In the Preset menu, you can find adjustments ranging from Photographic effects, such as a vintage Yellowed Photo, to Nature effects, such as Create a Sunset (which gives a warm, orange glow to your image).

The Textures category has 13 presets, such as Broken Glass and Old Paper. Use these textures with your smart brushes to jazz up backgrounds and other elements in your images. For example, if that white wall in your shot is less than exciting, give it a Brick wall texture. If the drop cloth behind your portrait to reduce background clutter is a tad boring, give it a satin ripple.

 Choose your desired brush attributes, such as size, as shown in Figure 9-26.
 Or adjust attributes such as hardness, spacing, roundness, and angle from the Brush Settings drop-down panel.

For more on working with brushes, see Chapter 11.

4. Paint an adjustment on the desired layer in your image.

While you paint, the Smart Brush tool attempts to detect edges in your image and snaps to those edges. In addition, while you brush, a selection border appears.

A new adjustment layer is created automatically with your first paint stroke. The accompanying layer mask also appears on that layer. Essentially, the layer mask acts like a sheet of acetate over your adjustment layer. Where you see the white areas on the mask, the effect shows through. Where you see the black areas, the effect is hidden. In our example, the Colored Pencil effect shows only in the white areas of our layer mask.

Using the Add and Subtract Smart Brush modes in the Tool Options, fine-tune your adjusted area by adding to and subtracting from it.

When you add to and subtract from your adjusted area, you're essentially modifying your layer mask. Adding to your adjusted area adds white to your layer mask, and subtracting from your adjusted area adds black to your layer mask.

6. Make your necessary adjustments in the dialog box:

- Refine your selected area. Select the Refine Edge option in the Tool Options. For more on the Refine Edge option, see Chapter 6.
- Apply the adjustment to your unselected area. Select the Inverse option in the Tool Options.
- Modify your adjustment. Double-click the Adjustment Layer pin on your image. The pin is annotated by a small, square, black-and-red gear icon. After you double-click the pin, the dialog box corresponding

to your particular adjustment appears. For example, if you double-click the Shoebox photo adjustment (under Photographic), you access the Hue/Saturation dialog box.

- 7. Click OK.
- Deselect.

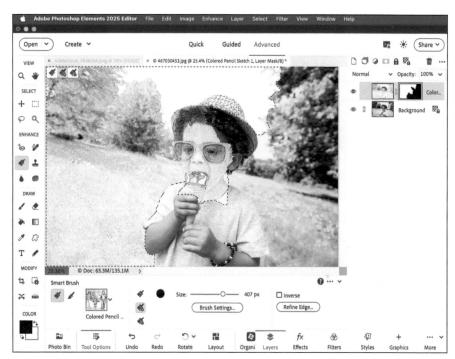

FIGURE 9-26: The Smart Brush enables you to paint on adjustments.

wundervisuals/Getty Images

the Smart Brush tool and apply additional adjustments.

Follow these steps to work with the Detail Smart Brush tool:

- In Advanced mode, select the Detail Smart Brush tool in the toolbar. This tool shares the flyout menu with the Smart Brush tool. The tool icon looks
 - like an art paintbrush. You can also press F, or Shift+F, if the Smart Brush tool is visible.

You can add multiple Smart Brush adjustments. After you apply one effect, reset

2. Select your desired adjustment category and then your particular preset adjustment from the Preset Picker drop-down list in the Tool Options.

3. Choose a brush tip from the Brush Preset Picker drop-down list. Also choose your desired brush size.

Feel free to change your brush tip and size as needed for your desired effect. You can also choose other brush preset libraries from the Brush drop-down list in the Brush tip preset menu. For more on working with brushes, see Chapter 11.

Several of the Special Effect adjustments are shown in Figure 9-27.

4. Paint an adjustment on the desired portion of your image.

A new adjustment layer is created automatically with your first paint stroke, along with an accompanying layer mask.

5. Follow Steps 5 through 8 in the preceding list for the Smart Brush tool.

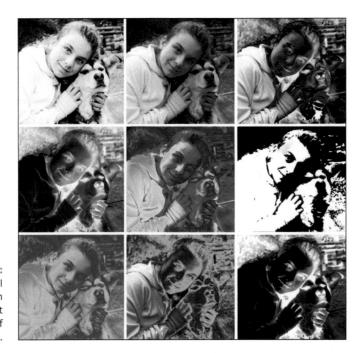

FIGURE 9-27: The Detail Smart Brush lets you paint on a variety of special effects.

Exploring Your Inner Artist

IN THIS PART . . .

Use tools to draw and paint on existing photos. Or create new, blank documents and create your own drawings.

Apply different artistic effects by using many tools and customizing them for your own use.

Discover tips for applying filters and styles to create dazzling images.

Explore how to add and edit text on your image.

- » Fooling with filters and exploring the Filter Gallery
- » Fixing camera distortion and enhancing with effects
- » Changing colors with blending modes
- » Combining Photos

Chapter **10**

Playing with Filters, Effects, Styles, and More

fter giving your images a makeover — edges cropped, color corrected, flaws repaired, focus sharpened — you may want to get them all gussied up for a night out on the town. You can do just that with filters, effects, layer styles, and blending modes. These features enable you to add that touch of emphasis, drama, whimsy, or just plain goofy fun. We're the first to admit that often the simplest art (and that includes photographs) is the best. That gorgeous landscape or the portrait that perfectly captures the expression on a child's happy face is something you may want to leave unembellished. But for the times when a little artistic experimentation is in order, turn to this chapter as your guide.

Having Fun with Filters

Filters have been around since the early days of digital imaging, when Photoshop was just a little bitty program. *Filters*, also dubbed *plug-ins* because they can be installed or removed independently, change the look of your image in a variety of ways, as shown in Figure 10–1. They can correct less-than-perfect images by

making them appear sharper or by covering up flaws, as we describe in Chapter 9. Or they can enhance your images by making them appear as though they're painted, tiled, photocopied, or lit by spotlights. The following sections give you the basics on how to apply a filter.

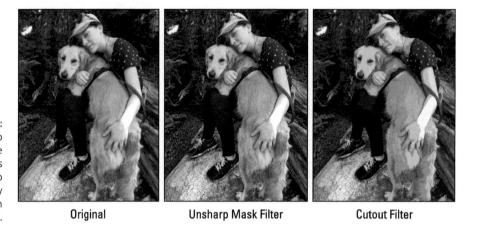

Use filters to correct image imperfections or to completely transform images.

You can't apply filters to images that are in Bitmap or Indexed Color mode. And some filters don't work on images in Grayscale mode.

Applying filters

You can apply a filter in three ways:

- >> The Filter menu: In either Advanced or Quick mode, from the Filter menu, choose your desired filter category and then select a specific filter.
- >> The Filters panel: In Advanced mode, open the panel by choosing Window □
 Filters or by clicking the Filters icon in the bottom right of the workspace.
 Choose your filter category from the drop-down list at the top of the panel.
 Click the thumbnail of your desired filter.

Filters have sliders, which appear for most filters when you click them. You can then adjust the various settings for that particular filter. Some filters also have an Advance Options button. Click to go to the dialog box with additional filter settings. Note that some filters, however, are still one-click filters (for example, Blur). Of these filters, some have an Apply More button, which does just that when clicked. Click the Revert button (the curved arrow icon) at the top of the panel to start back at square one.

>> The Filter Gallery: In either Advanced or Quick mode, choose Filter
Gallery to apply one or more filters in a flexible editing environment. The Filter
Gallery is described in the section "Working in the Filter Gallery," later in this
chapter.

When you're using the Filter Gallery, make a backup copy of your image (or at least create a duplicate layer) before you apply filters. Filters change the pixels of an image permanently, and when you exit the Filter Gallery, the filters you apply can't be removed, except for using the Undo command or History panel. But when those options are exhausted, you're stuck with the image as is.

Corrective or destructive filters

Although there are no hard-and-fast rules, most digital-imaging folks classify filters into two basic categories:

- >> Corrective filters usually fix some kind of image problem. They adjust color, improve focus, remove dust or artifacts, and so on. Don't get us wrong pixels are still modified. It's just that the basic appearance of the image remains the same, albeit modified, we hope, for the better. Two of the most popular corrective filters, Sharpen and Blur, are covered in Chapter 9.
- >> Destructive filters are used to create some kind of special effect. Pixels are also modified, but the image may look quite different from its original. These kinds of filters create effects, such as textures, brush strokes, mosaics, lights, and clouds. They can also distort an image with waves, spheres, and ripples.

One-step or multistep filters

All corrective and destructive filters are one or the other:

- >> One-step filters have no options and no dialog boxes; select the filter and watch the magic happen.
- >> Multistep filters act almost like mini-applications. When you choose a multistep filter, you specify options in a dialog box. The options vary widely depending on the filter, but most come equipped with at least one option to control the intensity of the filter. A multistep filter appears on the menu with an ellipsis following its name, indicating that a dialog box opens when you choose the command.

Working in the Filter Gallery

When you apply a filter, don't be surprised if you're presented with a gargantuan dialog box. This *editing window*, as it's officially called, is the Filter Gallery. You can also access it by choosing Filter \Rightarrow Filter Gallery. In the flexible Filter Gallery, you can apply multiple filters, tweak their order, and edit them *ad nauseam*.

Follow these steps to work in the Filter Gallery:

1. In either Advanced or Quick mode, choose Filter

Filter Gallery.

The Filter Gallery editing window appears, as shown in Figure 10-2.

2. In the center of the editing window, click your desired filter category folder.

The folder expands and shows the filters in that category. A thumbnail displays each filter's effect.

3. Select your desired filter.

You get a large, dynamic preview of your image on the left side of the dialog box. To preview a different filter, just select it. Use the magnification controls to zoom in and out of the preview. To hide the Filter menu and get a larger preview box, click the arrow to the left of OK.

4. Specify any settings associated with the filter.

The preview is updated accordingly.

- When you're happy with the results, click OK to apply the filter and close the editing window.
- (Optional) If you want to apply another filter, click the New Effect Layer button at the bottom of the editing window.

This step duplicates the existing filter.

 Choose your desired new filter, which then replaces the duplicate in the Applied Filters area of the dialog box.

Each filter you apply is displayed in the lower-right area of the Filter Gallery dialog box.

You can make these changes to your filter:

- **Delete a filter.** Select it and click the Delete Effect Layer button.
- Edit a filter's settings. Select the filter from the list and make any
 changes. Keep in mind that when you edit a filter's settings, the edit
 may affect the look of any subsequent filters you've applied.

- Rearrange the order of the applied filters. Drag one of the filters above or below the other(s). Doing so changes the overall effect, however.
- 8. When you're completely done, click OK to apply the filters and close the editing window.

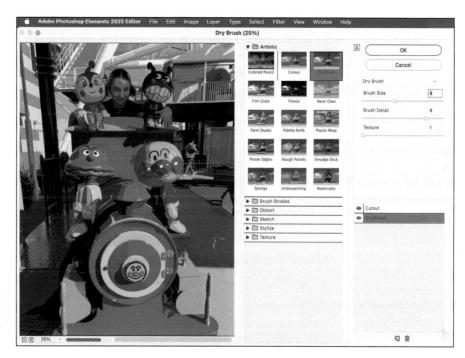

Apply and edit multiple filters in the Filter Gallery.

Distorting with the Liquify filter

The Liquify filter is really much more than a filter. It's a distortion that allows you to manipulate an image as though it were warm taffy. You can interactively twist, pull, twirl, pinch, and bloat parts of your image. You can even put your image on a diet, as we did in Figure 10–3. In fact, most ads and magazine covers feature models and celebrities whose photos have "visited" the Liquify filter once or twice. You can apply this distortion filter on the entire image, on a layer, or on a selection. This *überfilter* comes equipped with a mega—dialog box that has its own set of tools and options, as shown in Figure 10–3.

The Liquify filter enables you to interactively distort your image.

FIGURE 10-3:

Aedka Studio/Shutterstock

Adobe, Inc.

Follow these steps to give your image a makeover or turn your photo into a melted Dalí-esque wannabe:

In either Advanced or Quick mode, choose Filter
 □ Distort
 □ Liquify.
 Your image appears in the preview area.

2. Choose your distortion weapon of choice.

You also have a number of tools to help zoom and navigate around your image window.

Here's a description of each tool to help you decide which to use. (The letter in parentheses is the keyboard shortcut.)

- Warp (W): This tool pushes pixels forward while you drag, creating a stretched effect. Use short strokes or long pushes.
- Twirl Clockwise (R) and Twirl Counterclockwise (L): These options
 rotate pixels either clockwise or counterclockwise. Place the cursor in one
 spot, hold down the mouse button, and watch the pixels under your brush
 rotate; or drag the cursor to create a moving twirl effect.
- Pucker (P): Click and hold or drag to pinch your pixels toward the center
 of the area covered by the brush. To reverse the pucker direction (bloat),
 press the Alt (Option on the Mac) key while you hold or drag.
- Bloat (B): Click and hold or drag to push pixels toward the edge of the brush area. To reverse the bloat direction (pucker), press the Alt (Option on the Mac) key while you hold or drag.

- Shift Pixels (S): This tool moves pixels to the left when you drag the tool straight up. Drag down to move pixels to the right. Drag clockwise to increase the size of the object being distorted. Drag counterclockwise to decrease the size. To reverse any direction, press the Alt (Option on the Mac) key while you hold or drag.
- **Reconstruct (E):** See Step 4 for an explanation of this tool's function.
- Zoom (Z): This tool, which works like the Zoom tool on the Elements Tools panel, zooms the focus in and out so that you can better see your distortions.

You can zoom out by holding down the Alt (Option on the Mac) key when you press Z. You can also zoom by selecting a magnification percentage from the pop-up menu in the lower-left corner of the dialog box.

Hand (H): This tool works like the Hand tool on the Elements Tools panel.
 Drag with the Hand tool to move the image around the preview window.

3. Specify your options in the Tool Options:

- **Size:** Drag the pop-up slider or enter a value from 1 to 15,000 pixels to specify the width of your brush.
- Pressure: Drag the pop-up slider or enter a value from 1 to 100 to change the pressure. The higher the pressure, the faster the distortion effect is applied.
- Stylus Pressure: If you're lucky enough to have a graphics tablet and stylus, click this option to select the pressure of your stylus.
- 4. (Optional) If you get a little carried away, select the Reconstruct tool and then hold down or drag the mouse on the distorted portion of the image that you want to reverse or reconstruct.

Reconstructing enables you to undo portions of your distorted image back to a less distorted or original state. (The reconstruction occurs faster at the center of the brush's diameter.) To partially reconstruct your image, set a low brush pressure and watch closely while your mouse drags across the distorted areas.

Click OK to apply the distortions and close the dialog box.

If you mucked things up and want to start again, click the Revert button to get your original, unaltered image back. This action also resets the tools to their previous settings.

Correcting Camera Distortion

If you've ever tried to capture a looming skyscraper or cathedral in the lens of your camera, you know that it often involves tilting your camera and putting your neck in an unnatural position. And then, after all that, what you end up with is a distorted view of what was an impressive building in real life, as shown with the before image on the left in Figure 10–4. Fortunately, that's not a problem with Elements. The Correct Camera Distortion filter fixes the distorted perspective created by both vertical and horizontal tilting of the camera. As a bonus, this filter also corrects other kinds of distortions caused by lens snafus.

FIGURE 10-4:
The Correct
Camera
Distortion
filter fixes
distortions
caused by
camera tilt and
lens flaws.

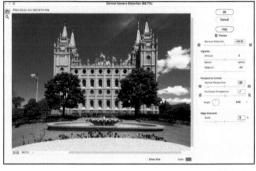

kontrast-fotodesign/Getty Images

Adobe, Inc.

Here's how to fix it all:

- 1. In either Advanced or Quick mode, choose Filter

 Correct Camera Distortion.
- 2. In the Correct Camera Distortion dialog box that appears, select the Preview option.
- Specify your correction options:
 - Remove Distortion: Corrects lens barrel, which causes your images to appear spherized or bloated. This distortion can occur when you're using wide-angle lenses. It also corrects pincushion distortion, which creates images that appear to be pinched in at the center, a flaw that's found when using telephoto or zoom lenses. Move the slider while keeping an eye on the preview. Use the handy grid as your guide for proper alignment.
 - Vignette: Adjusts the amount of lightening or darkening around the edges
 of your photo that you can get sometimes from incorrect lens shading.
 Change the width of the adjustment by specifying a midpoint value.
 A lower midpoint value affects more of the image. Then move the
 Amount slider while viewing the preview.

- Vertical Perspective: Corrects the distorted perspective created by tilting
 the camera up or down. Again, use the grid to assist in your correction. We
 used the vertical perspective to correct Westminster Abbey, as shown in
 Figure 10-4. It was a nice shot as is, but it could use a little tweaking.
- Horizontal Perspective: Also corrects the distorted perspective. Use the grid to make horizontal lines (real and implied) in your image parallel. For better results, set the angle of movement under the Angle option.
- Angle: Enables you to rotate the image to compensate for tilting the camera. You may also need to tweak the angle slightly after correcting the vertical or horizontal perspective.
- Edge Extension Scale: When you correct the perspective on your image, you may be left with blank areas on your canvas. You can scale your image up or down to crop into the image and eliminate these holes. Scaling up results in interpolating your image up to its original pixel dimensions. Basically, interpolation means Elements analyzes the colors of the original pixels in your image and creates new ones, which are then added to the existing ones. This often results in less than optimum quality. Therefore, if you do this, be sure to start with an image that has a high-enough pixel dimension, or resolution, to avoid severe degradation.
- Show Grid: Shows and hides the grid, as needed. You can also choose the color of your gridlines by clicking on the Color option.
- Zoom Tool: Zooms in and out for your desired view. You can also use plus
 (+) and minus (-) icons and the Magnification pop-up menu in the bottom-left corner of the window.
- Hand Tool: Moves you around the image window when you're zoomed in.
- 4. Click OK to apply the correction and close the dialog box.

Exploring Elements' Unique Filters

Elements has a set of its very own filters. Prior to Elements 11, all the filters were hand-me-downs from Photoshop. You can find the three unique filters under the Filter \Leftrightarrow Sketch submenu. To really get a feel for the cool effects these filters can create, we invite you to open a couple of your favorite images and play with the various presets and settings.

Here are the general steps to apply any of these filters:

In either Advanced or Quick mode, choose Filter

Sketch

Your Specific Filter.

For example, if you want to use the Comic filter, choose Filter ⇔ Sketch ⇔ Comic.

- 2. In the filter dialog box, choose from four presets.
- Adjust any default settings.

You can find details about each filter's settings in the following sections outlining each filter.

If you want to reset your sliders back to the default values for the preset, hold down the Alt (Option on the Mac) key, and the Cancel button in the dialog box changes to a Reset button.

- 4. Adjust your view as needed by using the following controls:
 - Zoom: Zoom in and out for your desired view. You can also use the 1:1 view (recommended) or Fit in Window view.
 - Hand: Moves you around the image window when you're zoomed in.
- 5. Click OK to apply the filter and close the dialog box.

Creating a comic

The Comic filter takes your image and creates an effect that mimics a hand-drawn comic book illustration. In the Comic filter dialog box, you can choose from four presets, as shown in Figure 10-5:

- >> Comic: The default setting creates a basic comic book illustrative effect.
- >> Grayscale: Like comic, but converts all colors to grayscale.
- >> Sunny Day: Makes a high-contrast, vivid effect.
- >> Old Print: Creates a more desaturated, old-newspaper effect.

Using the sliders, you can adjust the default settings for the Color and Outline areas of the filtered image:

- >> Soften: Creates rounder or rougher areas of colors.
- >> Shades: A higher value adds more tonal levels.
- >> Steepness: A higher value makes the colored areas more defined and contrasty.

- >> Vibrance: Brightens the overall color of the image.
- >> Thickness: Affects the thickness and blackness of the outlined strokes.
- >> Smoothness: Fine-tunes your edges and enhances the overall filter effect.

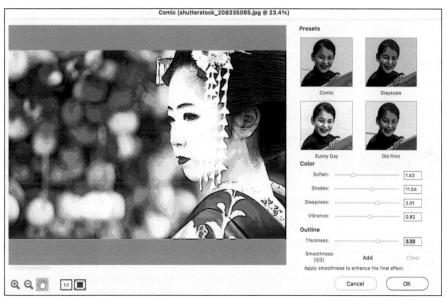

The Comic filter turns a photo into an illustration.

Adobe, Inc.

Getting graphic

The Graphic Novel filter might take a bit of experimentation to create the effect you want — at least it did for us. But after you get your settings established, the look is pretty fun and the result is like an illustration sketched for a graphic novel. *Note*: All the colors in your images convert to grayscale when you use this filter.

In the Graphic Novel filter dialog box, choose from four presets, as shown in Figure 10-6:

- >> Painted Gray: Creates an effect with a lot of midtone grays
- >> Fine Detail: Results in an image with more white areas and an emphasis on retaining detail
- >> Hard Edges: Like Fine Detail, but the overall look is more contrasty and the edges are more "sketchy" and less finely rendered
- >> Twisted Plot: Creates a harsher effect with more dark areas

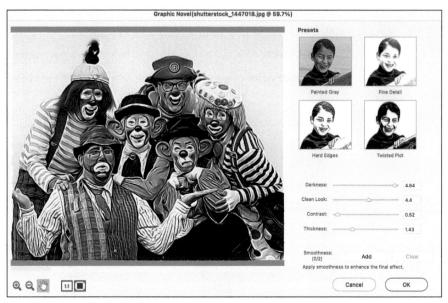

FIGURE 10-6: Create an image worthy of a graphic novel.

Adobe, Inc.

Then, using the sliders, you can adjust the default settings for the filtered image:

- >> Darkness: A higher value creates more areas of lightness.
- >> Clean Look: A higher value makes smoother, more refined strokes.
- >> Contrast: The higher the value, the more contrasty and, overall, darker an image appears. A lower value produces a lower-contrast, light-gray image.
- >> Thickness: Affects the thickness and blackness of the outlined strokes. A higher value produces a "goopier" stroke appearance.
- >> Smoothness: Fine-tunes your edges and enhances the overall filter effect.

Using the Pen and Ink filter

The Pen and Ink filter creates an effect that looks like a hand-drawn pen-and-ink sketch.

In the Pen and Ink filter dialog box, choose from four presets, as shown in Figure 10 7. Each preset colors the image blue, purple, gray, or green, respectively.

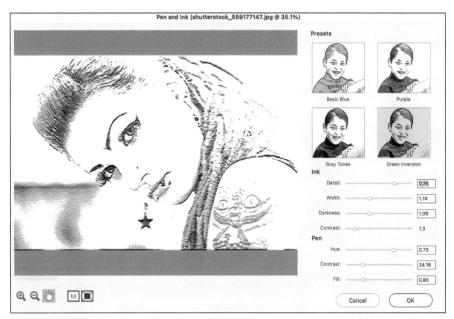

Create a cartoon-like image with the Pen and Ink filter.

Adobe, Inc.

Then you can adjust the default setting of the sliders for the various settings for the Pen and Ink areas of the filtered image:

- >> Detail: A higher value creates finer, crisper edges.
- >> Width: A higher value creates thicker, goopier strokes, and a lower value creates crisper strokes.
- >> Darkness: A higher value creates more areas of darkness.
- Contrast: The higher the value, the more contrasty the image and the more dark ink strokes are applied.
- >> Hue: Adjust the slider to select your desired color along the color ramp.
- >> Contrast: A higher value adds more contrast, darkness, and colored areas.
- >> Fill: A higher value fills the image with more areas of color and less white.

Dressing Up with Photo and Text Effects

In addition to the multitude of filters at your disposal, Elements provides a lot of effects that you can apply to enhance your photos, such as the Fluorescent Chalk effect we applied in Figure 10–8. *Note:* Some effects automatically create a

duplicate of the selected layer, whereas other effects can work only on flattened images. (See Chapter 7 for details on layers.)

FIGURE 10-8: Enhance your images by adding effects.

Anton Zabielskyi/Shutterstock

Unlike with filters, you can't preview how an effect will look on your image or type, nor do you have any options to specify.

Here are the steps to follow to apply an effect:

- 1. In Advanced mode, select your desired image layer in the Layers panel. Or, if you're applying the effect to just a selection, make the selection before applying the effect.
- 2. Choose Window ➪ Effects or click the Effects icon in the bottom right of the workspace.
- 3. Under the Classic tab, choose your desired category of effects from the drop-down list at the top of the panel.
 - Faded Photo, Monotone Color, and Vintage: This group of effects makes your image fade from color to grayscale, appear as a single color, or look like an old pencil sketch or a photo on old paper.

- Glow: This group adds a soft focus, a white glow, or both to your images.
- Painting: Makes your images look like paintings or chalk illustrations.
- Panels: These effects divide your image into paneled sections.
- Seasons: Includes effects to make your image appear snowy, rainy, sunny (bright and yellow), or wintery (white and overexposed).
- **Textures:** Gives your images a lizard skin or rubber stamped appearance.

Under the Artistic tab you'll find effects that mimic art styles such as Post Impressionistic and Traditional Oil. Others include effects such as Cubist and Woodblock and many more.

4. Under the Color Match tab, select one of preset images in the panel.

The Color Match tab enables you to match the color of one photo to another. Note that if you are working in Advanced mode, you can also choose your own image as a custom preset.

On the Effects panel, click your desired effect or drag the effect onto the image.

You can view your styles and effects as just thumbnails or as thumbnails with the name of the style or effect. Click the down-pointing arrow in the upperright corner of the panel to access the menu commands. If you select one of the new Color Match effects, you can also further adjust the color by using the Saturation, Hue, and Brightness sliders at the bottom of the panel.

Quick mode sports its very own Effects panel. Be sure to check it out — you'll find Classic Effects not found in Advanced mode, such as Toy Camera and Cross Process. Click the Effects icon in the bottom-right corner of the workspace. To apply an effect, double-click it or drag it onto your image.

You may also want to check out the interesting effects found in Guided mode. Guided mode is nicely organized into categories of effects with corresponding interactive thumbnail images.

One of the best edits is Double Exposure under Fun Edits, as shown in Figure 10-9. All the effects in Guided mode are very user friendly (hence, the name). Simply click your desired effect and follow the detailed steps delineated in the panel on the right of the workspace.

The Double Exposure edit enables you to creatively merge two photos.

the stock company/Shutterstock

Adding Shadows, Glows, and More

Styles, also known as Layer Styles, go hand in hand with filters and photo effects. Also designed to enhance your image and type layers, styles range from simple shadows and bevels to the more complex styles, such as buttons and patterns.

The wonderful thing about styles is that they're completely nondestructive. Unlike filters, styles don't change your pixel data. You can edit them or even delete them if you're unhappy with the results.

Here are some important facts about styles:

- >> Styles can be applied only to layers. If your image is just a background, convert it to a layer first.
- >> Styles are dynamically linked to the contents of a layer. If you move or edit the contents of the layers, the results are updated.
- >> When you apply a style to a layer, an fx symbol appears next to the layer's name on the Layers panel. Double-click the fx icon to bring up the Style Settings dialog box and perform any editing that's necessary to get the look you want.

Applying styles

Styles are stored in a few different libraries. You can add shadows, glows, beveled and embossed edges, and more complex styles, such as neon, plastic, chrome, and various other image effects. Figure 10-10 shows a sampling of styles.

Inner Shadow

Drop Shadow

Add dimension by applying shadows and bevels to your object or type.

FIGURE 10-10:

creativepictures/Getty Images

Here are the steps to apply a style and a description of each style library:

- Select your desired image, shape, or type layer in the Layers panel.
 You can apply styles to type layers, and the type layer doesn't need to be simplified.
- 2. Choose Window ▷ Styles or click the Styles icon in the bottom-right corner of the workspace.
- Select your desired library of styles from the drop-down list at the top of the panel:
 - Bevels: Bevels add a three-dimensional edge on the outside or inside edges of the contents of a layer, giving the element some dimension. Emboss styles make elements appear as though they're raised off or punched into the page. You can change the appearance of these styles, depending on the type of bevel chosen. Adjust parameters, such as the lighting angle, distance (how close the shadow is to the layer contents), size, bevel direction, and opacity.
 - Drop and Inner Shadows: Add a soft drop or an inner shadow to a layer.
 Choose from the garden-variety shadow or one that includes noise, neon, or outlines. You can adjust the lighting angle, distance, size, and opacity as desired.

- Outer and Inner Glows: Add a soft halo that appears on the outside or inside edges of your layer contents. Adjust the appearance of the glow by changing the lighting angle, size, and opacity of the glow.
- Strokes: Add a stroke of varying width (size), opacity, and color to your selection or layer. You can position the stroke on the inside, center, or outside of your selection marquee.
- **Visibility:** Click Show, Hide, or Ghosted to display, hide, or partially show the layer contents. The layer style remains fully displayed.
- Complex and others: The remaining layer styles are a cornucopia of different effects ranging from simple Glass Buttons to the more exotic effects, such as Groovy and Rose Impressions (under Complex). You can customize all these layer styles to a certain extent by adjusting the various settings, which are similar to those for other styles in this list.
- On the Styles panel, click your desired effect or drag the effect onto the image.

The style, with its default settings, is applied to the layer. Styles are cumulative. You can apply multiple styles — specifically, one style from each library — to a single layer.

Working with styles

Here are a few last tips for working with styles:

>> Edit the style's settings. Do one of the following: Double-click the fx icon on the Layers panel; choose Layer ➡ Layer Style ➡ Style Settings; or click the gear icon located just below the Styles tab.

- >> Delete a layer style or styles. Choose Layer

 □ Layer Style □ Clear Layer Style, or drag the fx icon on the Layers panel to the Trash icon.
- >> Copy and paste layer styles onto other layers. Select the layer containing the layer style and choose Layer ♣ Layer Style ♣ Copy Layer Style. Select the layer(s) on which you want to apply the effect and choose Layer ♣ Layer Style ♣ Paste Layer Style. If it's easier, you can also just drag and drop an effect from one layer to another while holding down the Alt (Option on the Mac) key.
- ➤ Hide or show layer styles. Choose Layer
 Layer Style
 Hide All Effects or Show All Effects.

>> Scale a layer style. Choose Layer □ Layer Style □ Scale Effects. Select the Preview option and enter a value between 1 and 1,000 percent. This action allows you to scale the style without scaling the element.

If by chance you apply a layer style and nothing seems to happen, choose Layer ▷ Layer Style ▷ Show All Effects.

Using the Graphics panel

If you're looking for an interesting graphic, frame, background, shape, or text to go along with your photographic composition, don't bother with searching and downloading a stock image. Look no further than the Graphics panel (shown in Figure 10–11). This panel is a cinch to use. Here's how:

- 1. In Advanced mode, choose Window Graphics or click the Graphics icon in the bottom right of the workspace.
- Choose your desired category of graphics from the left drop-down list at the top of the panel.

For example, choose by color, event, seasons, and so on. Depending on your selection, choose a more specific category from the right drop-down list. For example, if you choose Event, you may choose Birthday or Wedding.

 Choose your desired type of art — Backgrounds, Frames, Graphics, Shapes, or Text — from the upper-right drop-down list.

In the last release the Adobe Stock service was implemented in several areas within the application. While in Advanced mode, when you select Background as your graphics category you will see the Adobe Stock button at the top of the panel. When you click this button, the Adobe Stock photos dialog box appears, enabling you to choose from many free images. Click a category or enter your desired Search criteria. Select your image and click the License for Free button.

 On the Graphics panel, click your desired effect or drag the effect onto the image.

Be sure to convert your image into a layer before you select a Background graphic. Otherwise, the Background graphic will essentially replace your image.

If you have a layered file and you choose Frame, you'll get a message in the frame to "Click here to add photo or drag photo here." If your image is not a layer, Elements will automatically fill the frame opening with your image.

5. In your Layers panel, select your graphic layer(s) and choose Image

Transform

Free Transform to scale and rotate your graphic.

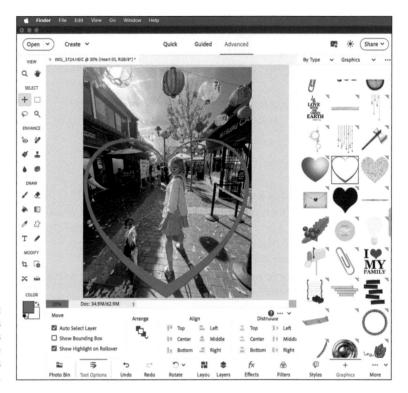

The Graphics panel provides an abundance of backgrounds and frames.

With each annual release, Elements adds new graphics, frames, and backgrounds. The newest ones are easy to find. They're at the top of the panel.

Mixing It Up with Blending Modes

Elements sports a whopping 25 blending modes. *Blending modes* affect how colors interact between layers as well as how colors interact when you apply paint to a layer. Not only do blending modes create interesting effects, but you can also easily apply, edit, or remove blending modes without touching your image pixels.

The various blending modes are located on a drop-down list at the top of your Layers panel in Advanced mode. The best way to get a feel for the effect of blending modes is not to memorize the descriptions. Instead, grab an image with some layers and apply each of the blending modes to one or more of the layers to see what happens. The exact result varies, depending on the colors in your image layers.

General blending modes

The Normal blending mode needs no introduction. It's the one you probably use the most. Dissolve is the next one on the list and, ironically, is probably the one you use the least. Figure 10-12 shows both blending modes:

FIGURE 10-12:
The Dissolve
blending
mode allows
pixels from
one layer to
peek randomly

through another.

Dissolve

Maria teijeiro/Getty Images

kwanchai.c/Shutterstock

Darken blending modes

These blending modes produce effects that darken your image in various ways, as shown in Figure 10-13.

Lighten blending modes

The lighten blending modes are the opposite of the darken blending modes. All these blending modes create lightening effects on your image, as shown in Figure 10-14.

Lighting blending modes

This group of blending modes plays with the lighting in your layers, as shown in Figure 10-15.

Inverter blending modes

The inverter blending modes invert your colors and tend to produce some radical effects, as shown in Figure 10-16.

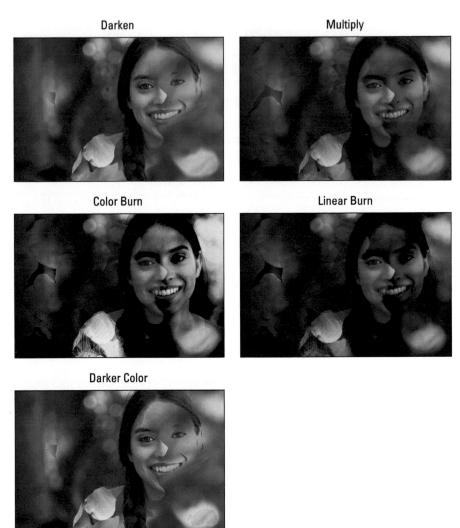

FIGURE 10-13: These blending modes darken your image layers.

© Maria teijeiro/Getty Images Image #200364729-001, kwanchai.c/Shutterstock Image #180304241

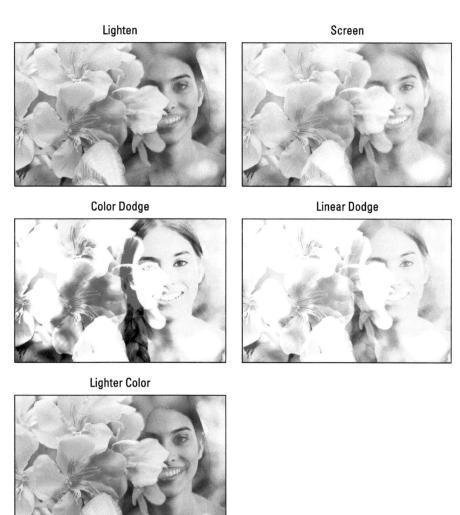

FIGURE 10-14: These blending modes lighten your image layers.

© Maria teijeiro/Getty Images Image #200364729-001, kwanchai.c/Shutterstock Image #180304241

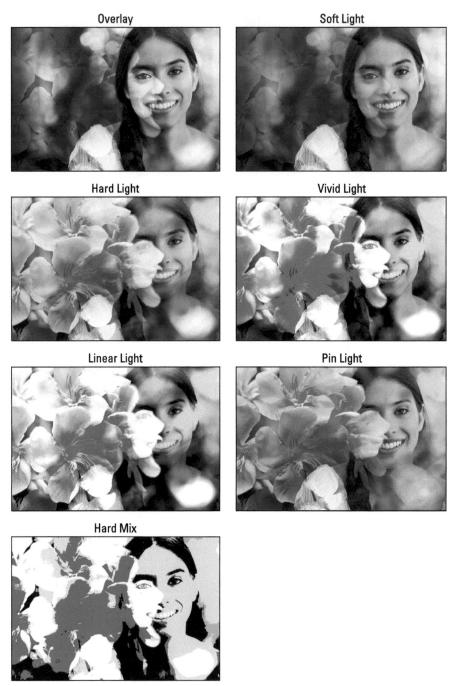

FIGURE 10-15: Some blending modes adjust the lighting between your image layers.

© Maria teijeiro/Getty Images Image #200364729-001, kwanchai.c/Shutterstock Image #180304241

Difference

Exclusion

© Maria teijeiro/Getty Images Image #200364729-001, kwanchai.c/Shutterstock Image #180304241

HSL blending modes

These blending modes use the HSL (hue, saturation, lightness) color model to mix colors, as shown in Figure 10-17.

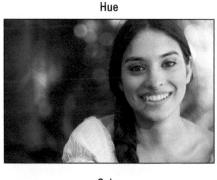

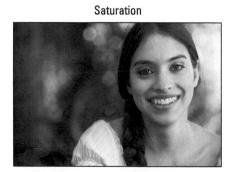

Color

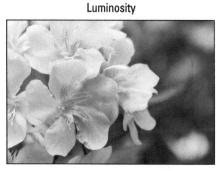

Some blending modes mix colors based on the actual hue, richness, and brightness of color.

FIGURE 10-17:

FIGURE 10-16: Difference and Exclusion blending modes invert colors.

© Maria teijeiro/Getty Images Image #200364729-001, kwanchai.c/Shutterstock Image #180304241

Using Photomerge

The awesome Photomerge features help you to create fabulous composites from multiple images. Whether it's creating the perfect shot of a group of friends or of your favorite vacation spot (without the passing cars and people), the Photomerge feature is the go-to tool to get it done.

All Photomerge commands have been migrated over to Guided mode only, so they are easy to implement. We cover two of our favorites here.

The Photomerge Scene Cleaner is no longer available, having been replaced by the new AI-powered Remove tool. The previous Photomerge Compose has been retooled as the new Combine Photos feature.

Photomerge Panorama

The Photomerge Panorama command enables you to combine multiple images into a single panoramic image. From skylines to mountain ranges, you can take several overlapping shots and stitch them together into one.

The following tips can help you start with good source files that will help you successfully merge photos into a panorama:

- >> Make sure that when you shoot your photos, you overlap your individual images by 15 to 40 percent, but no more than 50 percent.
- >> Avoid using distortion lenses (such as fish-eye) as well as your camera's zoom setting. 50mm is a good focal length to use for panoramas.
- >> Try to keep the same exposure settings for even lighting.
- >> Try to stay in the same position and keep your camera at the same level for each photo. If possible, using a tripod and moving both the tripod and camera along a level surface, taking the photos from the same distance and angle, is the best approach. However, if conditions don't allow for this, using a tripod and just rotating the head is the next best method. Be aware, however, that it can be harder to keep the lighting even, depending on the angle of your light source relative to the camera. You can also run into perspective-distortion issues with your shots.

Follow these steps to create a Photomerge Panorama image:

- 1. Select your desired photos in the Photo Bin.
- 2. In Guided mode, click the Photomerge tab at the top of the Guided window. Choose the Photomerge Panorama option.

The Photomerge Panorama window opens, as shown on Figure 10-18.

3. Choose your desired mode under Panorama Settings.

Here's a brief description of each mode:

- Auto Panorama: Elements analyzes your images.
- Perspective: If you shot your images with perspective or at extreme angles, this is your mode. Try this mode if you shot your images with a tripod and rotating head.
- Cylindrical: If you shot your images with a wide-angle lens or you have those 360-degree, full-panoramic shots, this is a good mode.
- Spherical: This projection method aligns images by rotating, positioning, and uniformly scaling each image. It may be the best choice for true panoramas, but you can also find it useful for stitching images together using common features.
- Collage: This mode is handy when stitching together a 360-degree panorama, in which you have a wide field of view, both horizontally and vertically. Use this option for shots taken with a wide-angle lens.
- Reposition: Elements doesn't take any distortion into account; it simply scans the images and positions them as best it can.

4. Select from the following Settings:

- Blending Images Together: Corrects the color differences that can occur from blending images with different exposures
- Vignette Removal: Corrects exposure problems caused by lens vignetting (when light at the edges of images is reduced and the edges are darkened)
- Geometric Distortion Correction: Corrects lens problems such as radial distortions — for instance, barrel distortion (bulging out) and pincushion distortion (pinching in)
- Content Aware Fill Transparent Areas: Intelligently fills in transparent areas that may be created during the stitching of the images by analyzing adjacent pixels

TIP

Click Create Panorama.

Elements automatically assembles the source files to stitch together the composite panorama in a new file. Note that Elements may ask if you want to fill in the edges of the image. Click Yes.

 After the images are stitched, Elements will ask what you want to do next: Save the image or continue editing in either Quick or Advanced mode. You can also click Done to return to the Photomerge Guided window.

Elements creates your merged image in layers. You'll also notice that a layer mask has been added to each layer to better blend your panoramic image. You can edit your layer masks or move your layers to fine-tune the stitching of the images. For more on layer masks, see Chapter 7.

Note that Elements alerts you if it can't composite your source files. If that happens, you may have to composite your images manually by creating a large canvas and then dragging and dropping your images onto that canvas.

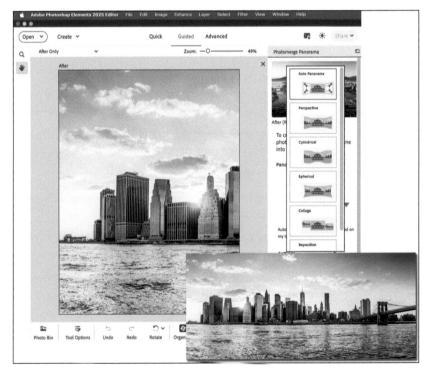

FIGURE 10-18:
Combine
multiple
images into
a single
panorama with
Photomerge
Panorama.

FilippoBacci/Getty Images

Combine Photos

The new Combine Photos feature enables you to combine multiple images into a single composite image. You have several more manual ways to combine images in Elements, of course, but this new feature makes doing so simple.

Here's how to combine images into a composite:

1. In Advanced or Quick mode, choose Image ⇔ Combine Photos.

You can also choose the Combine Photos command in Guided mode on the Photomerge tab.

2. Choose your layout dimensions.

You can choose from Standard aspect ratios or from a variety of social media file-dimension choices.

We chose the Standard 1:1 layout.

3. Add your media from your Computer, the Organizer, or Adobe Stock.

We chose two images from our computer, the boy in a field and a beach scene, as shown in Figure 10-19. Note that you can toggle Show Layers in the top left to see your Layers panel so that you can see the stacking order of your photos. If you need more information on layers, see Chapter 7.

Click the Edit button in the bottom right to open the Edit panel.

In this panel, you can choose Remove Background or Extract Object on your first image, which is the boy image in our example. Clean up your extracted object using the Hide or Reveal brushes. Hide will eliminate more of what you don't want, whereas Reveal will bring back something you want to retain.

You can also size, flip, and rotate your extracted object as well as adjust its opacity. If your first image is also your background, toggle Use as Background.

If your images are not quite matching in terms of lighting or color, click the Adjustments button in the bottom right to open the Adjustments panel.

You find sliders for Contrast, Saturation, Temperature, and Luminance. Adjust as needed for the best match. Our boy was a bit too warm or orange, so we reduced the Temperature of the color to make him a bit cooler, or bluer.

6. Select your other image layers and repeat Steps 4 and 5.

We had only one other image: our beach. We wanted to use it as our background, so we had nothing to extract. We just toggled Use as Background on that image layer.

Our boy on the beach composite is shown in Figure 10-20.

FIGURE 10-19: Select the two images that you want to composite.

wundervisuals/Getty Images and Alex_Rodionov/Shutterstock

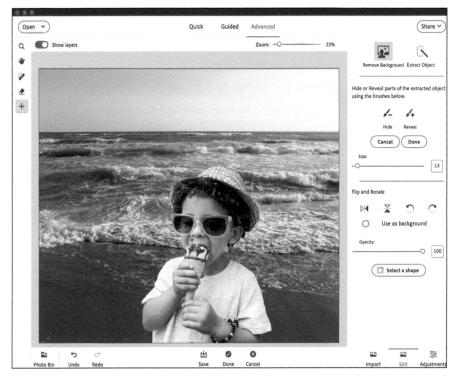

Composite two images seamlessly with Combine Photos.

wundervisuals/Getty Images and Alex_Rodionov/Shutterstock

- » Choosing colors and drawing with Pencil and Brush
- » Filling and outlining your selections
- » Pouring color with the Paint Bucket tool
- » Creating gradients and patterns
- » Creating and editing shapes
- » Creating and editing text

Chapter **11**

Drawing, Painting, and Typing

lements is such a deluxe, full-service image-editing program that it doesn't stop at giving you tools to select, repair, organize, and share your images. It figures that you may need to add a swash of color, either freeform with a brush or pencil, or in the form of a geometric or organic shape. Don't worry: This drawing and painting business isn't just for those with innate artistic talent. In fact, Elements gives you plenty of preset brushes and shapes to choose from. If you can pick a tool and drag your mouse, you can draw and paint.

Choosing Color

Before you start drawing or painting, you may want to change your color to something other than the default color of black. If you read the earlier chapters in this book, you may have checked out the Elements Tools panel and noticed the

two overlapping color swatches at the bottom of the panel. These two swatches represent two categories of color: *foreground* and *background*.

Here's a quick look at how they work with different tools:

- Foreground: When you add type, paint with the Brush tool, or create a shape, you're using the foreground color.
- **>> Background:** On the background layer of an image, when you use the Eraser tool, or when you increase the size of your canvas, you're revealing the background color.
- >> Foreground and background: When you drag with the Gradient tool, as long as your gradient is set to the default, you're laying down a blend of color from the foreground to the background.

Elements gives you three ways to choose your foreground and background colors: the Color Picker, the color swatches, and the Eyedropper tool, which samples color in an image. In the following sections, we explore each one.

Working with the Color Picker

By default, Elements uses a black foreground color and a white background color. If you're experimenting with color and want to go back to the default colors, press the D key. If you want to swap between foreground and background colors, press the X key. If you want any color other than black and white, click your desired swatch (either foreground or background) at the bottom of the Tools panel. This action transports you to the Color Picker, as shown in Figure 11–1.

Here are the steps to choose your color via the Color Picker:

 Click either the foreground or background color swatch on the Tools panel.

The Color Picker appears.

- Drag the color slider (the white double-arrow icon) or click the color bar to get close to the general color you desire.
- Choose the exact color you want by clicking in the large square, or color field, on the left.

The circle cursor targets your selected color. The two swatches in the upperright corner of the dialog box represent your newly selected color and the original foreground or background color.

FIGURE 11-1: Choose your desired color from the Color Picker.

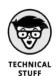

WARNING

The numeric values on the right side of the dialog box also change according to the color you selected. If you happen to know the values of your desired color, you can enter them in the text boxes. RGB (red, green, blue) values are based on brightness levels from 0 (black) to 255 (white). You can also enter HSB (hue, saturation, brightness) values or the hexadecimal formula for web colors.

If a 3D cube icon appears when choosing your color, it means your color is not web safe. Web-safe colors appear consistently in all browsers on all platforms. To get the closest web-safe color match, click the small swatch directly below the 3D cube icon.

When you're happy with your color, click OK.

If you want to save your color for later use, do so by using the Color Swatches panel, described in the following section.

Dipping into the Color Swatches panel

Elements enables you to select a foreground or background color by selecting a color on the Color Swatches panel. The Color Swatches panel is a digital version of the artist's paint palette. In addition to preset colors, you can mix and store your own colors for use now and later. You can have palettes for certain types of projects or images. For example, you may want a palette of skin tones for retouching portraits. Choose Window Color Swatches to bring up the panel, as shown in Figure 11-2.

To grab a color from the Color Swatches panel, click the color swatch you want. By the way, it doesn't matter which tool you have. As soon as you move the tool over the panel, it temporarily converts to an eyedropper that samples the color and makes it your new foreground or background color.

Although the Color Swatches panel is a breeze to use, here are a few tips to help you along:

- >> Change the background color. Either first click the background swatch on the Tools panel or Ctrl+click (策+click on the Mac) a swatch in the Color Swatches panel.
- >> Use preset colors. To load a particular preset swatch library, choose it from the drop-down list at the top of the Color Swatches panel. Elements offers libraries specific to web graphics, photo filters, and Windows and macOS systems.

FIGURE 11-2:

- >> Add a color to the Color Swatches panel. Choose New Swatch from the panel menu. You can also simply click an empty portion of the panel. Name your swatch and click OK. Remember, it doesn't matter whether you created the color by using the Color Picker or by sampling with the Eyedropper tool adding the color for later use is done the same way.
- >> Save swatches. Choose Save Swatches from the panel menu in the upper-right corner of the panel. We recommend saving the swatch library in the default Color Swatches folder in the Presets folder. If by chance this folder doesn't come up by default, just navigate to the Color Swatches folder by following this partial path: Program Files\Adobe\Photoshop Elements 2025\Presets\Color Swatches (Windows) or Applications\Adobe Photoshop Elements 2025/Support Files/Presets/color swatches (Mac).
- >> Save swatches for Exchange. Choose this command from the panel menu to save your swatches for use in another Adobe program. Name the swatch set and save it in the same folder listed in the preceding bullet point.
- >> Load swatches. If you want to load a custom library created by you or someone else, choose Load Swatches from the panel menu. In the dialog box, select your desired library from the Color Swatches folder. The new library is added to your current library.

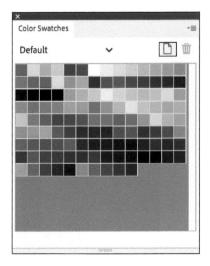

You can also work with swatches by using the Preset Manager.

- >> Delete swatches. To delete a swatch, drag it to the Trash icon at the top of the panel or Alt-click (Option-click on the Mac) the swatch.
- >> Change the panel's appearance. Click the panel menu in the upper-right corner to choose Small or Large Thumbnail (swatch squares) or Small or Large List (swatch squares with a name).
- >> Replace your current swatch library with a different library. Choose Replace Swatches from the panel menu. Choose a library from the Color Swatches folder.

Sampling with the Eyedropper tool

Another way that Elements enables you to choose color is via the Eyedropper tool. The Eyedropper tool comes in handy when you want to sample an existing color in an image and use it for another element. For example, you may want your text to be the same color as the green background in the image shown in Figure 11–3. Grab the Eyedropper tool (or press I) and click a shade of green in the background. The tool samples the color and makes it your new foreground color. You can then create the type with your new foreground color.

Here are a few things to remember when you're using the Eyedropper tool:

>> Sample a new foreground or background color. Obviously, you can select either the foreground or the background swatch on the Tools panel before you sample a color. But if the foreground color swatch is active, holding down the

Evgeny Litvinov/Shutterstock

FIGURE 11-3:

The Eyedropper tool enables you to sample color from your image to use with other elements, such as type.

Alt (Option on the Mac) key will open the Color Picker and enables you to sample a new background color, and vice versa.

- >> Choose a color from any open image. If you have multiple images open, you can even sample a color from an image that you're not working on!
- >> Choose your sample size in the Tool Options. You can select the color of just the single pixel you click (Point Sample), or Elements can average the colors of the pixels in a 3-x-3- or 5-x-5-pixel area.
- >> Specify web colors. If you right-click your image to bring up the contextual menu, you have a hidden option: Copy Color as HTML. This option provides the web hexadecimal color formula for that sampled color and copies it to the Clipboard. You can then paste that formula into an HTML file or grab the Type tool and choose Edit ❖ Paste to view the formula in your image.
- >> Choose to sample All Layers or just the Current Layer. If you have multiple layers in your image, you can choose to sample from all those layers or just your currently active layer in the Tool Options.
- >> Toggle between the Eyedropper and other tools. Elements, multitasker that it is, enables you to temporarily access the Eyedropper tool when you're using the Brush, Pencil, Color Replacement, Gradient, Paint Bucket, Cookie Cutter, or Shape tool. Simply press the Alt (Option on the Mac) key to access the Eyedropper tool. Release the Alt (Option on the Mac) key to go back to your original tool.

Getting Artsy with the Pencil and Brush Tools

If you want to find out how to paint and draw with a color you've chosen, you've come to the right place. The Pencil and Brush tools give you the power to put your creative abilities to work, and the following sections show you how.

TIP

When you use these two tools, you benefit immensely from the use of a pressuresensitive digital drawing tablet. The awkwardness of trying to draw or paint with a mouse or trackpad disappears and leaves you with tools that behave much closer to their analog ancestors.

Drawing with the Pencil tool

Drawing with the Pencil tool creates hard edges. You can't get the soft, feathery edges that you can with the Brush tool. In fact, the edges of a pencil stroke can't even be *anti-aliased*. (For more on anti-aliasing, see the following section.) Keep in

mind that if you draw anything other than vertical or horizontal lines, your lines will have some jaggies when they're viewed up close. But hey, don't diss the Pencil just yet. Those hard-edged strokes can be perfect for web graphics. What's more, the Pencil tool can erase itself, and it's great for digital sketches, as shown in Figure 11-4.

Follow these steps to become familiar with the Pencil tool:

1. Select the Pencil tool from the Tools panel.

You can also press the N key. By default, the Pencil tool's brush tip is the 1-pixel brush. Yes, even though the Pencil tip is hard-edged, we still refer to it as a brush. In the next few steps, you customize the brush by setting various options.

FIGURE 11-4: You can use the Pencil tool for

digital drawings.

(Optional) To load another preset library, click the Brushes menu at the top of the panel.

You aren't limited to the standard old brushes. Check out the Assorted and Special Effects brushes found in the Brush drop-down list at the top of the Brush Preset Picker panel, as shown in Figure 11-5. You'll be surprised by the interesting brushes lurking on these panels. Use them to create stand-alone images or to enhance your photographic creations.

Access the menu on the Brush Preset Picker panel to save, rename, or delete individual brushes and also save, load, and reset brush libraries. For more on these operations, see the following section.

- 4. Choose your brush size, and optionally, if you want to change the size of that brush tip, drag the Size slider.
- (Optional) If you want the background to show through your strokes, adjust the opacity by dragging the slider or entering an opacity percentage less than 100 percent.

The lower the percentage, the more the background images show through.

Your strokes must be on a separate layer above your images for you to be able to adjust the opacity and blend modes after you draw them. For more on layers, see Chapter 7.

6. Select a blend mode.

Blend modes alter the way the color you're applying interacts with the color on your canvas. You can find more about blend modes in Chapter 10.

(Optional) Select Auto Erase if you want to remove portions of your pencil strokes.

For example, say that your foreground color is black and your background color is white, and you apply some black strokes. With Auto Erase enabled, you apply white if you drag back over the black strokes. If you drag over the white background, you apply black.

8. Click and drag with the mouse to create your freeform lines.

To draw straight lines, click at a starting point, release the mouse button, and then Shift-click at a second point.

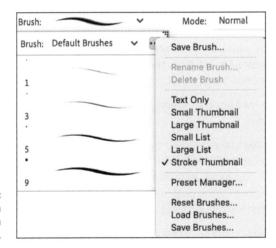

FIGURE 11-5: Choose from other brush libraries.

If you like the organic look of a pencil sketch, be sure to check out the Partial Sketch feature under Fun Edits in Guided mode. This edit allows you to selectively brush in a hand-sketched effect on your photo.

Painting with the Brush tool

The Brush tool creates soft-edged strokes. How soft those strokes are depends on which brush you use. By default, even the hardest brush has a slightly soft edge because it's anti-aliased. *Anti-aliasing* creates a single row of partially filled pixels along the edges to produce the illusion of a smooth edge. You can also get even softer brushes, which use feathering.

The Brush tool shares most of the options found in the Pencil tool, except that the Auto Erase feature isn't available. Here's the lowdown on the unique Brush options:

- **Airbrush:** Click the Airbrush button in the Options panel to apply the Airbrush mode. In this mode, the longer you hold down the mouse button, the more paint the Brush pumps out and the wider the airbrush effect spreads.
- >> Tablet Settings: If you're using a pressure-sensitive digital drawing tablet, check the settings you want the tablet to control, including size, scatter, opacity, roundness, and hue jitter. The harder you press with the stylus, the greater the effect of these options.
- >>> Brush Settings: These options, referred to as brush dynamics, change while you apply your stroke. See Figure 11-6 for an example of each one. These options include the following:
 - Fade: The lower the value, the more quickly the stroke fades. However, 0 creates no fade.
 - Hue Jitter: Vary the stroke between the foreground and background colors. The higher the value, the more frequent the variation.
 - Scatter: The higher the value, the higher the number of brush marks and the farther apart they are.

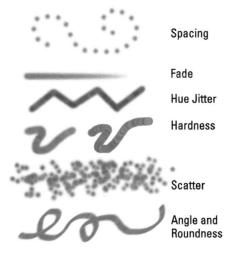

FIGURE 11-6: Change brush options to create a custom brush.

- Spacing: The higher the number, the more space between marks.
- Hardness: The higher the value, the harder the brush.
- Roundness: A setting of 100 percent is totally circular. The lower the percentage, the more elliptical your brush becomes.
- Angle: If you create an oval brush by adjusting the roundness, this option
 controls the angle of that oval brush stroke. It's so much easier to drag the
 points and the arrow on the diagram than to guesstimate values in the
 text boxes.

You can lock in these brush dynamics by selecting the Set This as a Default check box; this ensures that every brush you select adopts these settings.

As with the Pencil tool, you can load additional Brush libraries from the Brush drop-down list at the top of the Brush Preset Picker panel. Additional features for the Brush tool also appear in the menu on the Brush Preset Picker panel. Here's a quick description of each:

- >> Save Brush: Allows you to save a custom brush as a preset. See the following section for details.
- >> Rename Brush: Don't like your brush's moniker? Change it with this option.
- >> Delete Brush: Don't like your entire brush? Eliminate it with this option.
- >> The display options: Not a single command, but a set of commands that enable you to change the way your brush tips are displayed. The default view is Stroke Thumbnail, which displays the appearance of the stroke. These commands include Text Only, Small and Large Thumbnail, and Small and Large List.
- >> Reset Brushes: Reverts your current brush library to the default.
- >> Save Brushes: Saves custom brushes in a separate library.
- >> Load Brushes: Loads a preset or custom brush library.

Using the Impressionist Brush

The Impressionist Brush is designed to paint over your photos in a way that makes them look like fine art paintings. You can set various options that change the style of the brush strokes.

Here's how to use this artistic brush:

Select the Impressionist Brush from the Tools panel.

It looks like a brush with a curlicue next to it. You can also press B to cycle through the brushes.

2. Set your brush options.

The Brushes presets (Size, Opacity, and Mode options) are identical to those found with the Brush tool, described in the section "Painting with the Brush tool," earlier in this chapter. You can also find some unique options on the Advanced drop-down panel in the Tool Options:

- **Style:** This drop-down list contains various brush stroke styles, such as Dab and Tight Curl.
- **Area:** Controls the size of your brush stroke. The larger the value, the larger the area covered.
- **Tolerance:** Controls how similar color pixels have to be before they're changed by the brush stroke.

3. Drag on your image and paint with your brush strokes, as shown in Figure 11-7.

The best way to get a feel for what this tool does is to open your favorite image, grab the tool, and take it for a test drive.

FIGURE 11-7:
The
Impressionist
Brush turns
your photo
into a painting.

monticelllo/Getty Images

The remaining brush tool, the Color Replacement tool, allows you to replace the original color of an image with the foreground color while also retaining the photo's tones.

Filling and Outlining Selections

At times, you may want to create an element on your canvas that can't quite be created with a brush or pencil stroke. Maybe it's a perfect circle or a five-point star. If you have a selection, you can fill or stroke that selection to create that element, rather than draw or paint it on. The Fill command adds a color or a pattern to the entire selection, whereas the Stroke command applies the color to only the edge of the selection border.

Fill 'er up

You won't find a Fill tool on the Tools panel. Elements decided to avoid the over-populated panel and placed the Fill and Stroke commands on the Edit menu.

Here are the simple steps to fill a selection:

 Grab the selection tool of your choice and create your selection on a new layer.

Although you don't have to create a new layer to make a selection to fill, we recommend doing so. That way, if you don't like the filled selection, you can delete the layer, and your image or background below it remains safe. See Chapter 6 for more on selections and Chapter 7 for details on working with layers.

Select either the foreground or background color and then choose a fill color.

See the section "Choosing Color," earlier in this chapter, if you need a refresher.

Choose Edit

Fill Selection.

The Fill Layer dialog box, shown in Figure 11-8, appears.

If you want to bypass the Fill Layer dialog box (and the rest of these steps), you can use these handy keyboard shortcuts instead:

- To fill the selection with the foreground color, press
 Alt+Backspace (Option+Delete on the Mac).
- To fill the selection with the background color, press
 Ctrl+Backspace (第+Delete on the Mac).

FIGURE 11-8: Fill your selection or layer with color or a pattern.

4. Choose your desired fill from the Use drop-down list.

You can select whether to fill with the foreground or background color. You also can select Color, Pattern, Black, 50% Gray, or White. If you select Color, you're transported to the Color Picker. If you choose Pattern, you must then choose a pattern from the Custom Pattern drop-down panel. For more on patterns, see the section "Working with Gradients and Patterns," later in this chapter.

If you don't have an active selection border in your image, the command says Fill Layer and your entire layer is filled with your color or pattern.

You can also fill your selection using the Content-Aware option, which will fill your selection with pixels sampled from content nearby.

In the Blending area, specify whether to preserve transparency, which enables you to fill only the portions of the selection that contain pixels (the nontransparent areas).

Although you can also choose a *blend mode* (how the fill color interacts with colors below it) and opacity percentage, we urge you not to adjust your blend mode and opacity in the Fill Layer dialog box. Make those adjustments on your layer later by using the Layers panel commands, which give you more flexibility for editing.

6. Click OK.

The color or pattern fills the selection.

Outlining with the Stroke command

Stroking a selection enables you to create colored outlines, or *borders*, of selections or layers. You can put this border inside, outside, or centered on the selection border. Here are the steps to stroke a selection:

- 1. Choose a foreground color and create a selection.
- 2. Choose Edit ⇔ Stroke (Outline) Selection.

The Stroke dialog box opens.

Select your desired settings.

Many settings are the same as those found in the Fill Layer dialog box, as we explain in the preceding section. Here's a brief rundown of the options that are unique to strokes:

- **Width:** Enter a width of 1 to 250 pixels for the stroke.
- Location: Specify how Elements should apply the stroke: outside the selection, inside the selection, or centered on the selection border.

4. Click OK to apply the stroke.

We gave a 30-pixel centered stroke to our selection, as shown in Figure 11-9.

Splashing on Color with the Paint Bucket Tool

FIGURE 11-9: Stroke a selection to create a colored border.

The Paint Bucket tool is a longtime occupant of the Tools panel. This tool, whose icon looks just like a

bucket, behaves like a combination of the Fill command and the Magic Wand tool. (See Chapter 6.) The Paint Bucket tool makes a selection based on similarly colored pixels and then immediately fills that selection with color or a pattern. Like the Magic Wand tool, this tool is most successful when you have a limited number of colors, as shown in Figure 11–10.

The Paint
Bucket tool
makes a
selection and
fills it at the
same time.

Dancestrokes/Shutterstock

To use the Paint Bucket tool, simply click inside the selection you want to fill. Before you click, however, specify your settings in the Tool Options:

- >> Color: Choose between Paint (a fill of the foreground color) or a Pattern fill.
- >> Pattern: If you select Pattern, choose a preset pattern from the Pattern Picker drop-down panel. For more details on patterns, see the section "Working with Gradients and Patterns," later in this chapter.
- >> Opacity: Adjust the opacity to make your fill more or less transparent.
- >> Tolerance: Choose a tolerance level that specifies how similar in color a pixel must be before it's selected and then filled. The lower the value, the more similar the color must be. For more on tolerance, see the section on the Magic Wand in Chapter 6.
- >> Mode: Select a blending mode to change how your fill color interacts with the color below it.
- **All Layers:** This option selects and fills pixels within the selection in all layers that are within your tolerance level.
- >> Contiguous: If selected, this option selects and fills only pixels that are touching within your selection. If the option is deselected, pixels are selected and filled wherever they lie within your selection.
- **>> Anti-aliasing:** Choose this option to smooth the edges between the filled and unfilled areas.

Working with Gradients and Patterns

If one color isn't enough for you, you'll be pleased to know that Elements enables you to fill a selection or layer with a gradient. A *gradient* is a blend of two or more colors that gradually dissolve from one to another. Elements provides a whole slew of preset gradients so it is fun and easy. And if you've ever seen someone wearing leopard-print pants with an argyle sweater and a plaid blazer, you're familiar with patterns. You can use patterns to occasionally fill selections or layers. (Don't go overboard, though — patterns aren't always pretty when used without restraint.) You can also stamp your image by using the Pattern Stamp tool. Elements offers a lot of preset patterns to keep you happy.

Applying a preset gradient

Similar to colors, patterns, and brushes, gradients have a whole group of presets that you can apply to your selection and layers. You can also load other libraries of gradients from the Gradient panel menu.

Here's how to apply a preset gradient:

1. Make the selection you want to fill with a gradient.

We recommend making the selection on a new layer so that you can edit the gradient later without harming the underlying image.

If you don't make a selection, the gradient is applied to the entire layer or background.

2. Select the Gradient tool from the Tools panel or press the G key.

It looks like a rectangle that goes from black on the left to white on the right.

In the Tool Options, click the down-pointing arrow on the Gradient Picker swatch.

The Gradient Picker drop-down panel appears.

4. Choose a preset gradient.

Remember that you can choose other preset libraries from the Gradient panel menu. Libraries, such as Color Harmonies and Metals, contain interesting presets.

- 5. Choose your desired gradient type by clicking one of the icons.
- 6. Choose from the following options in the Tool Options:
 - Mode: Select a blending mode to change how the color of the gradient interacts with the colors below it.
 - Opacity: Specify how opaque or transparent the gradient is.
 - **Reverse:** Reverse the order in which the colors are applied.
 - Transparency: Deselect this option to make Elements ignore any transparent areas in the gradient, making them opaque instead.
 - **Dither:** Add *noise,* or random information, to produce a smoother gradient that prints with less *banding* (weird stripes caused by printing limitations).
- Position your gradient cursor at your desired starting point within your selection or layer.

8. Drag in any direction to your desired end point for the gradient.

TIP

Longer drags result in a subtler transition between colors, whereas shorter drags result in a more abrupt transition. Hold down the Shift key to restrain the direction of the gradient to multiples of a 45-degree angle.

9. Release the mouse button to apply the gradient.

We applied an Orange, Yellow radial gradient from the Color Harmonies 2 preset library to a selection of a sun in Figure 11-11. We selected the Reverse option and dragged from the center of the sun to the tip of the top ray.

FIGURE 11-11:
We filled our sun selection with a radial Orange, Yellow gradient.

Applying a preset pattern

Although you can apply patterns by using many different tools, this chapter sticks with applying patterns as fills. To fill a layer or selection with a preset pattern, follow these steps:

1. Choose the layer or selection you want to fill with a pattern.

TIP

Again, we recommend making your selection on a new layer above your image for more flexible editing later on.

3. Click the down-pointing arrow and choose a pattern from the Custom Pattern drop-down panel, as shown in Figure 11-12.

If you don't see a pattern to your liking, click the panel pop-up menu at the bottom of the submenu and choose another preset library.

 Choose any other fill options you want to apply, such as Mode, Opacity, or Preserve Transparency.

> For details on these options, see the section "Filling and Outlining Selections," earlier in this chapter.

Click OK to fill the layer or selection with the chosen pattern.

FIGURE 11-12:
Fill your selection with one of the many
Elements preset patterns.

Creating Shapes of All Sorts

In this section, we leave the land of pixels and head into uncharted territory — Vectorville. Before we discuss the ins and outs of creating shapes, here's a little overview that explains the difference between pixels and vectors:

- >> Pixel images describe a shape in terms of a grid of pixels. When you increase the size of a pixel-based image, it loses quality and begins to look blocky, mushy, and otherwise nasty.
- >> Vectors describe a shape mathematically. The shapes comprise paths made up of lines, curves, and anchor points. Because vector shapes are math-based, you can resize them without any loss of quality whatsoever.

In Figure 11-13, you can see both types of images.

When you create a shape in Elements, you're creating a vector-based element. Shapes reside on a special kind of layer called, not surprisingly, a *shape layer*. Use shapes to create simple logos, web buttons, and other small spot illustrations.

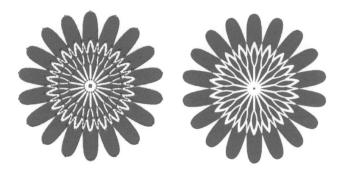

FIGURE 11-13: Elements images can be vector-based (left) or pixelbased (right).

Drawing a shape

Elements offers an assortment of shape tools for you to choose from. Follow these steps to draw a shape in your document:

1. Choose your desired shape tool from the Tools panel.

You can also press U to cycle through the shape tools. Here are the available tools:

- Rectangle and Ellipse: As with their Marquee counterparts, you can hold down the Shift key while dragging to produce a square or circle; select the From Center option to draw the shape from the center outward.
- Rounded Rectangle: This tool works like the regular Rectangle but with the addition of a radius value used to round off the corners of the rectangle.
- Polygon: This tool creates a polygon with a specified number of sides, from 3 to 100.
- Star: This tool creates a polygon or star with a specified number of sides/ vertices, from 3 to 100.
- **Line:** This tool draws a line with a width from 1 to 1,000 pixels. You can also add arrowheads at either end.
- Custom: Custom is the most varied shape tool. You have numerous preset custom shapes to choose from. As with any shape, hold down Shift to constrain proportions or select the From Center option to draw the shape from the center outward.
- In the Tool Options, click the down-pointing arrow to access Geometry options.

By default, the option is set to Unconstrained.

3. If you chose the Custom Shape tool in Step 1, click the Custom Shapes Preset picker down-pointing arrow to access the pop-up Shapes panel and choose your desired shape.

You can access more preset shape libraries via the pop-up menu at the top of the panel.

4. Choose your desired color from the Color drop-down list.

Click the color wheel icon in the bottom-right corner to access the Color Picker for additional color choices.

Choose a style from the Style picker drop-down panel.

To jazz up the shape with bevels and other fancy edges, choose a style from the panel. For more on styles, see Chapter 10.

Drag in the document to draw the shape you defined.

The shape appears in the image window on its own shape layer. Check out the Layers panel to see this phenomenon. Figure 11-14 shows our shape, a dove, from the Animals preset library.

FIGURE 11-14: Custom shapes run the gamut from animals to food.

Editing shapes

You can edit shapes that you create by using a variety of tools and techniques. Here's a list of the things you can do to modify your shapes:

- >> Select: Choose the Shape Selection tool to select one or more shapes in their layers. You can find this tool in the Tool Options along with the shapes tools.
- **>> Move:** Choose the Move tool (press V) to move the entire contents of the shape layer.
- >> Delete: Select a shape with the Shape Selection tool and press Delete to remove it.
- >> Transform Shape: Choose the Shape Selection tool and select your shape.

 Choose Image

 Transform Shape and choose your desired transformation.

- >> Change the color: Double-click the thumbnail of the shape layer on the Layers panel. This action transports you to the Color Picker, where you can choose a new color.
- >> Clone a shape: Hold down the Alt (Option on the Mac) key and move the shape with the Move tool.

To convert your vector-based shape into a pixel-based shape, click the Simplify button in the Tool Options or choose Layer \$\simplify\$ Simplify Layer. You can't edit a shape after you simplify it except to modify the pixels. But you can now apply filters to the layer. See Chapter 10 for more on fun with filters.

Although we spout on in this book about how a picture says a thousand words. we'd be terribly negligent if we didn't at least give a nod to the power of the written word as well. You may find that you never need to go near the type tools. That's fine. We won't be offended if you skip right past this chapter.

Then again, you may have an occasional need to add a caption, a headline, or maybe even a short paragraph to an image. Although it's by no means a wordprocessing or even page-layout program, Elements does give you ample tools for creating, editing, stylizing, and even distorting type.

Creating Type

You can apply basic text in Elements as either point or paragraph text. Here's a brief description of each mode:

>> Point: Use this most common mode if you want to enter only a few words. Select the Type tool, click in your image, and, well, type. The text appears while you type and continues to grow. In fact, it even continues past the boundary of your image! Point type is useful for short chunks of text, such as headlines, labels, logos, and headings for web pages.

Point type never wraps around to a new line. To wrap to the next line, you must press Enter (Return on a Mac).

>> Paragraph: Use this mode to enter longer chunks (or constrained blocks) of text on an image. Click and drag your type tool to create a text bounding box and then type. All the text is entered in this resizable bounding box. If a line of text is too long, Elements automatically wraps it around to the next line.

CHAPTER 11 Drawing, Painting, and Typing

Follow these steps to create point type:

- 1. Open the Photo Editor and choose Advanced mode.
- **2.** Open an image or create a new, blank Elements file by choosing File \Rightarrow New

 □ Blank File and clicking OK.
- 3. Select the Horizontal Type tool from the Tools panel.

You can also press T to cycle through the various type tools. Additionally, you can also select the Horizontal Type tool from the Tool Options. It looks like a capital letter T.

On the image, click where you want to insert your text.

Your cursor is called an I-beam. When you click, you make an insertion point.

A small, horizontal line about one-third of the way up the I-beam shows the baseline (the line on which the text sits) for horizontal type.

5. Specify your type options from the Tool Options.

All the options are described in detail in the section "Specifying Type Options," later in this chapter.

6. Type your text and press Enter (Return on a Mac) to begin a new line.

When you press Enter (or Return), you insert a hard return that doesn't move.

7. When you finish entering the text, click the Commit button (the blue check-mark icon) near your text.

If you want to bail out, click the Cancel button (the blue X icon).

You can also commit the type by pressing Enter on the numeric keypad or by clicking any other tool on the Tools panel. A new type layer with your text is created. Type layers appear on your Layers panel and are indicated by the Ticon.

To enter paragraph type, follow these steps:

- 1. Open the Photo Editor and choose Advanced mode.
- 2. Open an image or create a new, blank Elements file by choosing File ➪ New

 □ Blank File and clicking OK.
- 3. Select the Horizontal Type tool from the Tools panel or press T to cycle through the various type tools.

You can also select the Horizontal Type tool from the Tool Options.

- 4. On the image, insert and size the bounding box by using one of two methods:
 - Drag to create a bounding box close to your desired size. After you
 release the mouse button, you can drag any of the handles at the corners
 and sides of the box to resize it.
 - Hold down the Alt (Option on the Mac) key and click the image. The
 Paragraph Text Size dialog box appears. Enter the exact dimensions of
 your desired bounding box. When you click OK, your specified box
 appears, complete with handles for resizing later.
- Specify your type options from the Tool Options.

Options are described in detail in the following section.

6. Enter your text; to start a new paragraph, press Enter (Return on a Mac).

Each line wraps around to fit inside the bounding box, as shown in Figure 11-15.

If you type more text than can squeeze into the text box, an overflow icon (a box with a plus sign inside) appears. Resize the text box by dragging a bounding box handle.

 Click the Commit button (the blue check-mark icon) next to the text box or press Enter on the numeric keypad.

If you're not happy with the text, you can click the Cancel button (the blue X icon) and start over.

After you click Commit, Elements creates a new type layer.

Paragraph type wraps automatically without your assistance, so there's no need to enter a hard return as you type.

FIGURE 11-15:
Paragraph type
automatically
wraps to fit
within your
bounding box.

There is also a Vertical Type Tool for entering Asian characters. The remaining three tools are for creating type on a selection, shape, or *path* (which is a line, curved or straight, that doesn't appear in your actual image but that your text follows).

Specifying Type Options

When you're using a Type tool, the Tool Options box (found at the bottom of the workspace) includes several character and paragraph type settings, as shown in Figure 11–16. These options enable you to specify your type to your liking and pair it with your images.

FIGURE 11-16: Specify your type options, such as font family and size, before you type.

Here's an explanation of each available option in the Tool Options:

- >> Font Family: Select the font you want from the drop-down list. Elements provides a WYSIWYG (What You See Is What You Get) font menu. After each font name, the word Sample is rendered in the actual font no more selecting a font without knowing what it really looks like.
- >> Font Style: Some font families have additional styles, such as light or condensed. Only the styles available for a particular font appear in the list. This is also a WYSIWYG menu.
- >> Font Size: Choose your type size from the drop-down list or just type a size in the text box. Type size is most commonly measured in points (in which 72 points equals about 1 inch at a resolution of 72 ppi). You can switch to millimeters or pixels by choosing Edit → Preferences → Units & Rulers (on the Mac, choose Adobe Photoshop Elements Editor → Preferences → Units & Rulers).
- >> Leading: Leading (pronounced *LED-ding*) is the amount of space between the baselines of lines of type. A *baseline* is the imaginary line on which a line of type sits. You can choose Auto Leading or specify the amount of leading to apply. When you choose Auto Leading, Elements uses a value of 120 percent of your type point size. Therefore 10-point type gets 12 points of leading.

- Elements adds that extra 20 percent so that the bottoms of the lowest letters don't crash into the tops of the tallest letters on the next line.
- >> Tracking: This new setting adjusts the spacing between a group of letters.

 Negative amounts bring the letters closer together, whereas positive amounts space them farther apart.
- >> Color: Click the color swatch to select a color for your type from the Color Picker. You can also choose a color from the Swatches panel.
- >> Faux Bold: Use this option to create a fake bold style when a real bold style (which you'd choose under Font Style) doesn't exist. Be warned that, although the sky won't fall, applying faux styles can distort the proportions of a font. You should use fonts with real styles, and if they don't exist, oh, well.
- **Faux Italic:** This option creates a phony oblique style and carries the same warning as the Faux Bold option.
- >> Underline: This setting (obviously) underlines your type, like this.
- >> Strikethrough: Choose this option to apply a strikethrough style to your text.
- >> Text Alignment: These three options align your horizontal text on the left or right or in the center. If you happen to have vertical text, these options rotate 90 degrees clockwise and change into top, bottom, and center vertical settings.
- >> Style: Click this option to access a drop-down panel of preset layer styles that you can apply to your type. This option is accessible after you have committed your type. For more on this option and the Create Warped Text option (described in an upcoming bullet), see the section "Warping your type," later in this chapter.
- >> Change the Text Orientation: Select your type layer and then click this option to switch between vertical and horizontal type orientations.
- >> Create Warped Text: This fun option lets you distort type in more than a dozen ways.
- >> Anti-aliasing: Select this option to slightly smooth out the edges of your text. The Anti-aliasing option softens that edge by 1 pixel, as shown in Figure 11-17. For the most part, you want to keep this option turned on. The one occasion on which you may want it turned off is when you're creating small type to be displayed onscreen, such as on web pages. The soft edges can sometimes be tough to read.
- >> Text Overlay Templates: Click this option to open the Quote Graphic dialog box, where you can add text, graphics, and effects. See details on this option in the "Using Text Overlay Templates" section at the end of this chapter.

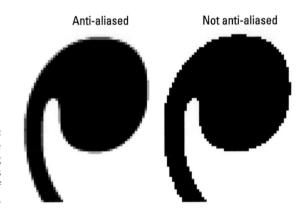

FIGURE 11-17:

The
Anti-aliasing
option softens
the edges of
your type.

You can apply type settings either before or after you enter your text.

If choosing all these options seems too tedious, you can use a Guided Edit called Add Text that makes adding stylized text to your images quick and simple.

Editing Text

To correct typos, add and delete type, or change any of the type options, simply follow these steps:

- Select the Type tool from the Tools panel.
- 2. Double-click within the text to automatically select the type layer. Note that triple-clicking selects all the text.
- 3. Make any changes to your text:
 - Change the font family, size, color, or other type option. If you want to change all the text, simply select that type layer on the Layers panel. To select only portions of the text, highlight the text by dragging across it with the I-beam of the Type tool. Then select your changes in the Tool Options; see the preceding section "Specifying Type Options" for details about your options for the Type tool.
 - Delete text. Highlight the text by dragging across it with the I-beam of the Type tool. Then press the Backspace key (Delete on the Mac).
 - Add text. Make an insertion point by clicking your I-beam within the line of text. Then type your new text.

Note: These editing steps apply to all types of text — point, paragraph, and path.

When you're done editing your text, click the Commit button (the blue check-mark icon).

You may also occasionally need to transform your text. To do so, make sure that the type layer is selected on the Layers panel. Then choose Image 中 Transform 中 Free Transform. Grab a handle on the bounding box and drag to rotate or scale. Press Ctrl (黑 on the Mac) and drag a handle to distort. When you're done, double-click inside the bounding box to commit the transformation, or click the Commit button (the blue check-mark icon). For more details on transformations, see Chapter 7.

Enhancing Type

Elements is capable of much more than just throwing a few black letters at the bottom of your image. And with a few clicks here and there, you can also warp, distort, enhance, and stylize your type. If you're not careful, your creative typography can outshine your image.

Adjusting type opacity

If you checked out Chapter 7 before reading this chapter, you know that *layers* are a digital version of the old analog transparency sheets. You can change element opacity on layers to let the underlying layer show through in varying degrees. This is also possible on a type layer. Figure 11–18 shows how varying the opacity percentage of your type layer makes more of the underlying layer show through. In Figure 11–18, the underlying layer is an image of water.

To change the opacity of a type layer, simply select the layer on the Layers panel, click the arrow to the right of the Opacity percentage, and drag the slider. You can also enter a value in the Opacity field. The lower the percentage, the less opaque the type (and the more the underlying layer shows through).

Applying filters to your type

One of the most interesting things you can do with type in Elements that you can't do in a word-processing or page-layout program is apply special effects, such as filters. You can make type look like it's on fire, underwater, or on the move — as shown in Figure 11-19, in which we applied a motion blur.

You can vary the opacity of type layers to allow the underlying layer to peek through.

Valeriy Lebedev/Shutterstock

Applying a motion blur to type can make it appear as fast as the car.

Luminescence/Shutterstock

The only caveat is that type has to be simplified (Layer ⇔ Simplify Layer) before a filter can be applied. Be sure to do all your text editing before you move to the filtering stage.

Applying the filter is as easy as selecting the simplified type layer on the Layers panel and choosing a filter from the Filter menu. For more on filters, see Chapter 10.

Painting your type with color and gradients

Changing the color of text is as easy as highlighting it and selecting a color from the Color Picker. But what if you want to do something a little less conventional, such as apply random brush strokes of paint across the type, as we did in the left image shown in Figure 11-20? It's really easier than it looks. Again, as with applying filters to text, the only criterion is that the type has to be simplified first. After that's done, select a color, grab the Brush tool with settings of your choice, and paint. In our example, we used the Granite Flow brush, found in the Special Effect Brushes presets. We used a diameter of 39, 15, and 6 pixels and just swiped our type a few times.

FIGURE 11-20: Bring your type to life with color (left) or a gradient (right).

You can also apply a gradient to your type. Here are the steps to follow after simplifying your type:

- 1. Select the text by either Ctrl+clicking (# +clicking on a Mac) the layer containing the text or locking the layer's transparency on the Layers panel.
- 2. Select the Gradient tool from the Tools panel.
- 3. In the Tool Options, click the down-pointing arrow next to the Gradient Picker to access the Gradient Picker panel.
- Choose your desired preset gradient.

5. Position your gradient cursor on the text where you want your gradient to start; drag to where you want your gradient to end.

Don't like the results? Drag again until you get the look you want. You can drag at any angle and to any length, even outside your type. In the right image shown in Figure 11-20, we used the copper gradient and just dragged from the top of the letters to the bottom. We also locked the transparent pixels on the layer to confine the gradient to just the type area.

Warping your type

If horizontal or vertical text is just way too regimented for you, try the Warp feature. The best part about the distortions you apply is that the text remains fully editable. This feature is fun and easy to use. Click the Create Warped Text button at the far right of the Tool Options. (It's the T with a curved line below it.) This action opens the Warp Text dialog box, where you find a vast array of distortions on the Style drop-down list with descriptive names such as Bulge, Inflate, and Squeeze.

After selecting a warp style, you can adjust the orientation, amount of bend, and degree of distortion by dragging the sliders. The Bend setting affects the amount of warp, and the Horizontal and Vertical Distortions apply perspective to that warp. Luckily, you can also view the results while you adjust. We could give you technical explanations of these adjustments, but the best way to see what they do is to just play with them. See Figure 11–21 to get a quick look at a few warp styles. The names speak for themselves.

squeezeme twistessister battle of the hulge overinflate

FIGURE 11-21:
Text remains
fully editable
after you apply
distortions
with the Warp
command.

You can also use the Transform command, such as scale and skew, to manipulate text. See Chapter 7 for details on transforming.

Using Text Overlay Templates

Click this option and use the following the steps to add text and graphics to your image.

- 1. With the Type tool selected, click the Text Overlay Templates button in the far right of the Tool Options.
- 2. In the Quote Graphic dialog box, you have various options to choose from:
 - Start from Scratch: This option enables you to choose a popular image size, such as for an Instagram post, letter size, or other option. Click OK and a blank template appears. In the Backgrounds panel on the right, choose a photo from your computer or Organizer or select a preset background. Add an optional border (choose color and size). You can also flip your image. Click the text box to change the placeholder text to your desired message. Specify your font, size, alignment, and other text attributes in the Styles panel. You can embellish your image with Shapes and Graphics from their respective panels. Simply find your shape or graphic and click to add. When you're done, click Save to name and save your file. Or click Done to return to the Editor.
 - Start with a Photo: If you have an image already open and want to add a
 text overlay, click this option. From there, follow the same steps as those
 for starting from scratch.
 - Choose from the various preset templates: Choose a preset and then
 choose your desired image size. From there, follow the same steps as
 those for starting from scratch or with a photo. Figure 11-22 shows a
 finished image.

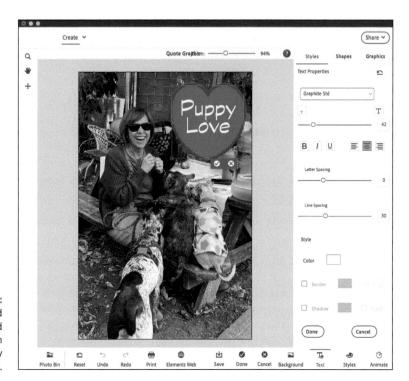

Easily add text and graphics with Text Overlay Templates.

Printing, Creating, and Sharing

IN THIS PART . . .

Manage color, use color profiles, and get your output to closely match what you see onscreen.

Print your pictures either at home or through an online service.

Share your pictures with family and friends on social media and online sharing services.

Display your photos in photo books, greeting cards, and slideshows.

- » Preparing files for printing
- » Working with printer profiles
- » Using the Print dialog box

Chapter 12 Getting It on Paper

erhaps the greatest challenge when using programs such as Photoshop Elements (and even the professionals who use its granddaddy, Adobe Photoshop) is getting what you see on your monitor to render a reasonable facsimile on a printed page. You can find all sorts of books on color printing — how to get color right, how to calibrate your equipment, and how to create and use color profiles — all for the purpose of getting a good match among your computer monitor, your printer, and the paper used to print your output. It's downright discouraging to spend a lot of time tweaking an image so that all the brilliant blue colors jump out on your computer monitor, only to find that all those blues turn to murky purples when the photo is printed.

In this chapter, we talk about options — many options — for setting print attributes for printing to your own color printer. If you need to, reread this chapter a few times just to be certain that you understand the process for printing goodquality images. A little time spent here will, we hope, save you some headaches down the road.

Getting Pictures Ready for Printing

The first step toward getting your photos to your desktop printer is to prepare each image for optimum output. You have several considerations when you're preparing files, including the ones in this list:

- >> Set resolution and size. In years past, better performance was obtained by downsampling images for desired print resolutions. Print drivers for just about all newer printers do a great job handling sampling for your output. As long as you have sufficient resolution for a quality print, leave the sampling to the print driver.
- Make all brightness and color corrections before printing. Make sure that your pictures appear their best before sending them to your printer. If you have your monitor properly calibrated, you should see a fair representation of what your pictures will look like before you print them. Chapter 5 covers corrections.
- >> Decide how color will be managed before you print. You can color-manage output to your printer in three ways, as we discuss in the following section. Know your printer's profiles and how to use them before you start to print your files. (See the next section, "Working with Color Printer Profiles," for more on understanding profiles.)
- >> Get your printer ready. When printing to desktop color printers, always be certain that your ink cartridges have ink and the nozzles are clean. Make sure you use the proper settings for paper and ink when you send a file to your printer. Be sure to review the manual that came with your printer so that you know how to perform all the steps required to make a quality print.

TIP

If you haven't used your printer for some time and the nozzles appear to be clogged, use the printer's utility over and over again and keep cleaning the nozzles. You may be able to resurrect a printer by running the cleaning operation 20 or more times. If you aren't successful, it's time to buy a new printer. Many of the newer printers today support ink tanks and have moved away from cartridges. If you have an old printer that uses ink cartridges, look at buying a new printer. Printers are relatively cheap, and those with ink tanks will cost you much less when it comes time to replace the inks.

WARNIN

Using any inks other than manufacturer-recommended inks can produce color problems. Each developer provides printer profiles specific for its recommended inks. With third-party inks, you don't have the advantage of using color profiles that have been tested by a printer manufacturer. If getting the most accurate color on your prints is important to you, use only those inks and papers recommended by your printer manufacturer.

Also, different papers require using different profiles. Use appropriate color profiles supplied by your printer developer for a given paper type. Use papers specifically recommended for your printer.

Working with Color Printer Profiles

The final leg in a color-managed workflow is to convert color from your color workspace profile to your printer's color profile. Basically, this conversion means that the colors you see on your monitor in your current workspace are accurately converted to the color that your printer can reproduce. To print accurate color, a color profile designed for your printer and the paper you use needs to be installed on your computer.

You can manage color in Photoshop Elements in three ways when it comes time to print your files:

- >> Printer Manages Colors: This method permits your desktop color printer to decide which profile to use when you print your photo. Your printer makes this decision according to the paper you select. If you choose Epson Premium Glossy Photo Paper, for example, your Epson printer chooses the profile that goes along with that particular paper. If you choose another paper, your printer chooses a different color profile. This method is all automatic, and color profile selection is made when you print your file.
 - Printers manage color quite well. If you're confused about what options to choose, let your printer manage the color and be done with it. More often than not, this choice produces good results.
- >> Photoshop Elements Manages Colors: When you make this choice, color management is taken out of the hands of your printer and is controlled by Elements. You must choose the color profile. If color profiles are installed by your printer, you can choose a color profile from the list of profiles that match your printer and the paper source.
 - If you choose to let Elements manage color and you don't have a color profile for your printer or the paper, choose sRGB for the profile. With desktop color printers, this profile works well as a default.
- >> No Color Management: You use this choice if you have a color profile embedded in one of your pictures. You'll probably rarely use this option. Unless you know how to embed profiles or receive files with embedded profiles from other users, don't make this choice in the Print dialog box. Because very few Elements users work with files with embedded profiles, we skip covering this method of printing your files.

Each of these three options requires you to decide how color is managed. You make choices (as we discuss later in this chapter when we walk you through the steps for printing) about whether to color–manage your output. These selections are unique to the Print dialog box and, more specifically, to the More Options dialog box for your individual printer.

Color profiles are also dependent on the ink being used, and refilling cartridges with generic ink can (in some cases) result in colors shifting. Similarly, if the nozzles aren't clean and delivering ink consistently, you may see strange results.

There are many different profiles, and quite a few for each printer. For profiles compatible with your printer, do an online search for profiles compatible with your printer and the paper you use.

Printing a photo with the printer managing color

Without going into all the settings you have to choose from in the Print and More Options dialog boxes, for now we look at printing a photo and letting the printer manage color.

All controls including print Picture Packages or Contact Sheets (Windows), use the Print dialog box from the Photo Editor. Color Management options offer you much better choices for managing color.

For the following example, we use an Epson printer. If you have a different printer, some of the dialog boxes and terms may be different. With a little careful examination of the Print dialog box, you can apply the following steps for any printer:

1. With a photo open in the Photo Editor, choose File ⇒ Print or press Ctrl+P (\mathbb{H}+P on the Mac).

The Print dialog box that opens contains all the settings you need to print a file, as shown in Figure 12-1.

Your settings may vary between the description and screens you see here and the settings for your printer.

Try to follow the process for selecting page attributes and color management to print photos to your printer.

2. In the Print dialog box on both Windows and the Mac, you make choices for orientation, paper type, paper size, and print quality, as shown in Figure 12-1 for the Mac.

For Mac users you'll find the Print dialog box changed from earlier versions of Photoshop Elements. The new Mac dialog now matches the same look and feel as the Windows Print dialog box.

Figure 12-1 shows options for an Epson L3250 printer. This dialog box is identical to the Print dialog box found on Windows.

- 3. Set the print attributes in the Print dialog box and click OK.
- 4. Click More Options at the bottom of the Elements Print dialog box.
- 5. Click Color Management in the More Options dialog box, as shown in Figure 12-2.
- 6. Choose your color management option.

This is where you can choose to let either your printer or Elements manage color. In many cases, unless you have special art papers or different paper types, you can choose to let the printer driver manage color.

- 7. Choose Printer Manages Color and click OK.
- 8. On the Mac, make your choices for the print attributes in the Print dialog box before printing.

When you click Print in the Elements Print dialog box, you arrive at the macOS Print dialog box. Where you see Layout, open the drop-down list and choose Print Settings. Here, you make choices for the paper type and quality.

9. Click Print.

The file prints with settings you make in the Page Setup dialog box (Windows) or Print dialog box (Mac).

Printing a photo with Elements managing color

If you want Elements to manage color, follow the same steps as you do for letting the printer manage color. When you arrive at the More Options and click Color Management, choose Photoshop Elements Manages Color. Then open the Printer Profile drop-down list and choose the profile recommended for your printer and the paper.

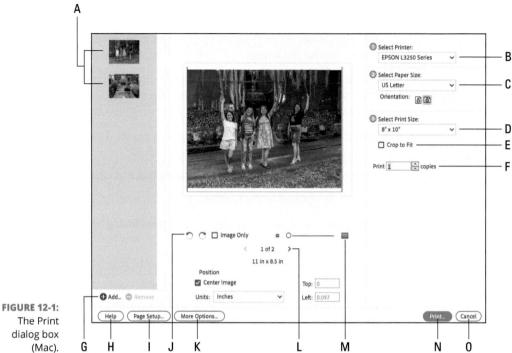

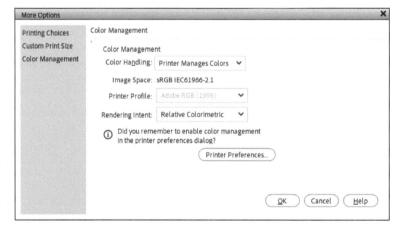

FIGURE 12-2: The More Options dialog box (Windows and Mac).

Printing a picture package or contact sheet

Elements offers two additional printing options that are available in different places on Windows and the Mac:

>> Picture Package: This option enables you to arrange one or more images on a page and print those images from a selection of standard-size prints.

>> Contact Sheet II: Choose this option to print samples of several images.

(Before digital photography, the contact sheet format was how photographers initially evaluated their shots.)

If you want to print a picture package or a contact sheet, you must print from the Organizer (Windows) or choose a command (Picture Package or Contact Sheet) from the File menu in the Photo Editor on the Mac, where these options are available.

All the steps for printing are basically the same, as outlined in the earlier section "Printing a photo with the printer managing color." The key difference is the Color Management options you see. The Color Management options are limited to choosing a Print Space (such as sRGB or Adobe RGB).

On a Windows computer, the Photo Editor offers better Color Management options. Always print your files from the Photo Editor unless you want to print a special print, such as a Picture Package, that requires you to print from the Organizer. Printing from the Photo Editor enables you to make use of all the Color Management options available in the More Options dialog box.

Getting Familiar with the Print Dialog Box

Because the Print dialog box options are identical in the Organizer and the Photo Editor in Windows (with the exception of color profile management), you find the same menus and buttons when you choose File Print from either the Organizer or Photo Editor. On the Mac, inasmuch as you can choose File Print in the Organizer, when you choose Print in the Organizer you are redirected to the Photo Editor where the printing occurs.

Using the Prints options

The following are the individual items you find in either dialog box (refer to Figure 12-1):

- (A) Image Thumbnails: When you select multiple images in the Organizer, all the selected images appear in a scrollable window on the left side of the dialog box.
- (B) Select Printer: Choose a target printer from the drop-down list.
- (C) Printer Settings (Windows only): Click this button to open properties unique to the selected printer.

- (D) Select Paper Size: Choose from print sizes that your printer supports. This list may change when you choose a different printer from the Select Printer drop-down list.
- (E) Crop to Fit: Select this check box to crop an image to fit the selected paper size.
- **(F) Print** _ **Copies of Each Image:** By default, one copy is printed. You can choose to print multiple copies by entering the number you want in the text box.
- (G) Add/Remove: Click + (plus sign) to add more files to the Picture Package and click (minus sign) to remove photos.
- (H) Help: Click Help to open online help.
- (I) Page Setup: Click this button to open the Page Setup dialog box.
- (J) Rotate: Click the rotate icons to rotate clockwise and counterclockwise. Only a single image can be rotated at a time.
- (K) More Options: Click More Options to open another dialog box that allows you to choose additional options.
- (L) Scroll Print Preview: Click the arrows to go through a print preview for all images in the list. Move the slider to zoom photos in the Print Preview.
- (M) Zoom: Move the slider to zoom in and out of a given image.
- (N) **Print:** Click Print after making all adjustments in the Print dialog box.
- (O) Cancel: Clicking Cancel dismisses the dialog box without sending a photo to the printer.

- » Understanding packaging and sharing options
- » Sending email attachments
- » Sharing Facebook cover and profile images
- » Creating files for web viewing

Chapter **13**Sharing Your Work

lements is a great packaging tool that can deploy your photos and projects for screen viewing — and not just on your computer monitor. You can edit photos or assemble creations that are exported for web viewing, and you can even prepare files to show on your television.

In Chapter 12, we cover the output requirements for printing files, which are much different from what you use for screen viewing. This chapter covers the options for web and screen viewing that get you started with the basics, including saving images for the web (or for screen viewing), as online slideshows, and for sharing files on social networks such as Facebook.

Using the Share Panel

You choose an option in the Share panel by clicking the Share button in either the Photo Editor or the Organizer. One of two options appear when you choose various menu commands in the Share panel:

- >> Some options lead you to more specific choices in the Share panel.
- Other choices open a window where you log in to an account for sharing photos. The choices for sharing photos with other services open windows for logging in to your account and proceeding through steps to prepare and upload images.

Figure 13–1 shows the Share panel as it appears in the Organizer (left) and in the Photo Editor (right). The Photo Editor Share panel has a more abbreviated set of options.

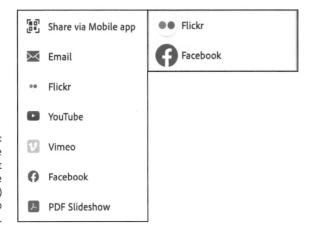

FIGURE 13-1:
The Share panel as it appears in the Organizer (left) and Photo Editor (right).

Options available in the Share panel are identical on both platforms. The full range of options for the Organizer's Share panel, as shown in Figure 13-1 on the left, include the following:

- NEW
- >> Share Via Mobile app: When you choose this option, a dialog box opens with a QR code. Scan the code with your mobile phone to download the Mobile app. When you download the file reported in the QR code, a version of Photoshop Elements for Mobile devices is downloaded to your cellphone. A word of caution when you download the app to your phone: If you don't have a single file selected, your entire catalog will be downloaded to your phone. The best way to download Photoshop Elements Mobile is to first double-click a photo in the Organizer and then scan the QR code.
- >> Email: See the next section, "Emailing photos."
- >> Flickr: Choose this option to share photos on the social media site Flickr.
- >> YouTube: If you have videos loaded in your Media Browser in the Organizer, use this menu choice to upload videos to your YouTube Channel.
- >> Vimeo: Vimeo is another site where you can create an account and upload videos.
- Facebook: Use this menu choice to upload photos and videos to your Facebook account.
- >> PDF Slideshow: Select photos in the Organizer or in an Album and use this menu choice to export the images to a PDF Slideshow.

In the sections ahead, we explore using the Share panel in the Organizer and making choices for preparing photos for sharing.

Emailing photos

Rather than save your file from Elements and then open your email client (such as Outlook or Apple Mail) and select the photo to attach to an email, you can use Elements to easily share photos via email with one click.

When you want to email a photo or a creation like some of those we talk about in Chapter 14, follow these steps:

- 1. In the Organizer, select the photos you want to email to a friend.
- 2. Open the Share panel and select Email Attachments.

The first time you try to email photos, Elements opens the Organizer Preferences panel and requires you to configure your email account. If your email account is already configured, you won't see the Preferences panel appear. Fill in the text boxes and click OK.

3. Select Convert Photos to JPEGs, choose a quality setting for the attachment, and click Next.

Drag the Quality slider and observe the file size noted at the bottom of the panel where you see Estimated Size, as shown in Figure 13-2.

(Optional) Add recipients.

The next panel provides settings for adding a message and adding recipients from an Address Book, as shown in Figure 13-3.

You can bypass adding recipients from your Address Book. If no recipients are listed in the Select Recipients panel, you can add recipient email addresses in the new message window in your email client. On the Mac, depending on the email client you use, you may have to manually add recipient addresses.

Click Next.

The photo(s) are first sampled to the output size. Wait a few minutes until Elements completes the sampling; then the photos are attached to a new email message in your default email client.

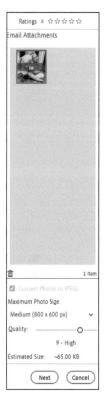

FIGURE 13-2: Set the Quality slider to a medium setting for faster uploads to your mail server.

Elements attaches the media to a new email message. You need to toggle to your email client in order to see the message and send the mail.

Review the To, Subject, and Attach fields to be certain the information is correct. Then click the Send button.

By default, Elements uses your primary email client application, which may or may not be the email program you use. You can change the default email client by pressing Ctrl+K (\mathbb{H}+K on the Mac) to open the Preferences dialog box when you're in the Organizer and then clicking Email in the left pane. From a drop-down list in the Sharing preferences, choose the email client application that you want Elements to use.

Elements supports using web-based email clients.

If you use Yahoo!, Gmail, or even another account, you can send your photos using your existing mail client. If you choose Other in the Email Preferences, you need to supply your SMTP Server and the Port number. If you need help with setting up the mail for other accounts not listed in the Email Preferences, contact your Internet Service Provider (ISP) for assistance.

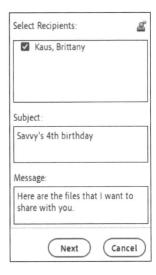

FIGURE 13-3: Add recipients from your Address Book.

Working with Adobe Premiere Elements

Several options in the Share and Create panels require that you use Adobe Premiere Elements. The items denoted as Burn Video DVD/BluRay, Online Video Sharing, and Mobile Phones and Players all require Adobe Premiere Elements.

If any of these items interest you, you can download a free trial of Adobe Premiere Elements and work with it for 30 days. If Premiere Elements is a tool you find worthwhile, you can purchase it from the Adobe Store. If you're perusing this book and have not yet purchased Elements 2025, you can purchase the Adobe Photoshop Elements 2025 and Adobe Premiere Elements 2025 bundle. Buying the bundle is much less expensive than buying the products separately.

For Adobe Premiere Elements trial versions, just click one of the options for video sharing in the Share panel, and you're prompted to download a trial version of Premiere Elements.

Sharing your photos on social networks

You have a variety of options for sharing photos and placing orders on a number of service networks. We don't have enough space in this book to cover every

service that Elements supports, so we walk through the more popular services (Flickr, Facebook, and Twitter) as examples for connecting with a service provider. If other services interest you, poke around and explore options for the services you use.

Experienced users of Elements will immediately notice that services such as Flickr have been promoted from options nested in the More Options drop-down list found in earlier versions of Elements to buttons shown in the Share panel.

Sharing photos on Facebook

Elements supports uploading photos to Facebook; however, you need to upload the photos from Adobe Elements (Beta). The upcoming section "Adobe Elements (Beta)" provides more details.

After a photo is uploaded, you see the photo on your Timeline (as shown in Figure 13-4) or in a photo collection.

Using other online services

After you become familiar with uploading photos to a service, you can easily follow similar steps to upload photos to any of the services that are supported by Elements. You first encounter the window to authorize an account, such as when using Facebook, Flickr, and Twitter. When setting up a new account, you can log in to the service and create the new account.

When you enter a site for sharing photos, printing photos, or creating items such as photo frames, follow the easy online steps that each service provides.

Adobe Elements (Beta)

Adobe Elements (Beta) was formerly known as Elements Web. This is a web service by Adobe that you can use for sharing a variety of content to various social media accounts. You can access the website by clicking the Elements Web icon in the Organizer on the Mac or the Elements Web icon in the Photo Editor on both Mac and Windows. When you arrive at the Adobe Elements (Beta) web page, you see a window like the one shown in Figure 13–5.

Click the Watch Video button to learn more about using the web app. Click the Try Now buttons to create photo collages, slideshows, peek-through overlays, fun pattern overlays, and a button for importing media on the web.

Making creations and sharing them from all the alternatives in Adobe Elements (Beta) is straightforward and self-explanatory. Poke around on this site and you'll quickly become familiar with creating some stunning media that you can share with friends and family.

A photo uploaded to a Facebook account.

Ted Padova (Book Author)

Adobe Elements (Beta) web page.

- » Understanding creations
- » Understanding common creation assembly
- » Creating Memories videos
- » Creating other projects, such as photo collages or photo calendars

Chapter **14**Making Creations

dobe Photoshop Elements offers you a number of creation tasks that you can share onscreen or in print. From both the Create and Share panels in the Panel Bin in the Organizer and Photo Editor, you have a number of menu choices for making creations designed for sharing.

In this chapter, we talk about creations designed for print and sharing. It's all here in Photoshop Elements, for both Windows and Mac users. If you're looking for how to create files for screen and web viewing, flip back to Chapter 13.

Checking Out the Create Panel

To see the creations available on the Create panel, as shown in Figure 14-1, click the Create tab above the Panel Bin. Like the Share panel we introduce in Chapter 13, the Create panel is available from either the Organizer or the Photo Editor. The Photo Editor doesn't support video creations; therefore, the Organizer offers you three additional items not available in the Photo Editor: Instant Movie, Video Story, and Video Collage.

The Create panel offers identical options in Windows and the Mac. You find options for creating slideshows, photo collages, quote graphics, photo prints, photo books, greeting cards, and photo calendars. In the Organizer, you find two additional options for creating video stories and video collages, as shown in Figure 14-1. For these two items, you need Adobe Premiere.

A marvelous feature in the Create panels is the ability to select photos and then easily upload them to the Fujifilm website. When you choose Prints & Gifts from either the Organizer or the Photo Editor, the Fujifilm Prints and Gifts home page opens, as shown in Figure 14-2.

	1	Greeting Card	(2)	Slideshow
	*	Highlight Reel	110	Photo Collage
1	*	Photo Book		Photo Reel
1		Photo Collage	r.	Quote Graphic
	~	Photo Prints		Photo Prints
-	74 74	Photo Reel	•	Photo Book
	<u>'</u>	Prints and Gifts	<u>•</u>	Greeting Card
1	Ť	Quote Graphic	<u>F</u>	Prints and Gifts
1	ė,	Slideshow		
		Video Collage		
_	_			

FIGURE 14-1:

The Create panel from the Organizer (left) and from the Photo Editor (right).

The Fujifilm home page.

You select a photo or several photos in the Organizer or Photo Editor and then choose this menu command to open a window. The window displays thumbnails of the selected photos and asks you to confirm the selection. Click Confirm, and the photos are uploaded to the Fujifilm website.

After the photos are uploaded, you find an array of choices for ordering photo prints or gift items. The gift items you can choose from include Mugs and Dinnerware, All Occasion Greeting Cards, and Device cases such as mobile phone cases. Click one of the items and a subgroup window displays choices you have for the group you selected, along with pricing for each item, as shown in Figure 14–3 after we clicked the Mugs and Dinnerware group. Select an item, add it to your cart, and place the order. The order process is similar to ordering items on Amazon.com.

FIGURE 14-3: Subgroups offer you several style choices and pricing information.

Keep in mind that you need to acquire the bundle of Photoshop Elements and Premiere Elements in order to use the video creation options.

The Video Collage creation offers you a means for creating a collage of video clips and still images to assemble your most memorable events. As with other video creations, you need to install Adobe Premiere Elements.

Note: When you open the Create panel in the Photo Editor, you won't see the options for video creations.

Grasping Creation-Assembly Basics

Creations such as photo books, greeting cards, photo calendars, and photo collages that you assemble from the Create panel (refer to Figure 14-1) are intended for output to either print or screen sharing.

Many creation options follow a similar set of steps to produce a file that is shared with other users or sent to an online printing service. In the Panel Bin, you can find all you need to make a new project by choosing layouts and producing a creation. Here are the common steps to follow when making a choice from the Create panel:

Select photos.

In the Organizer or in the Photo Bin in the Photo Editor, select the photos you want to use for your creation. Sort photos or use keyword tags (as we explain in Chapters 3 and 4) to simplify finding and selecting photos you want to use for a creation.

If you want to use photos from different folders, or when the images are spread around your hard drive, create an album, as we explain in Chapter 4. If you want to use the photos once for a creation, you can delete the album. Or you can keep the album around and use the same photos with several different creations.

2. Choose a menu item in the Create tab.

The photo(s) you selected are opening in the Photo Editor, and a wizard opens.

When you create a calendar, select 13 images. One image is used for the

calendar cover, and the remaining 12 images are used for each month.Select a size for the output in the left column.

In Figure 14-4, we selected to make a photo book, and the sizes are displayed in the left column.

4. Select a theme/layout.

Many of the creation options enable you to select a template. When you click a creation option on the Create panel, the panel changes to display choices for various themes, backgrounds, and borders. You make choices by clicking the theme or background. In Figure 14-4, you can see the Themes column for a photo book creation.

Most assets, such as themes, are not installed with your Photoshop Elements installation. When you select an asset such as a theme, it's downloaded from Adobe's website. A message window informs you that a download is in progress. Be patient and wait for the download to complete before moving on.

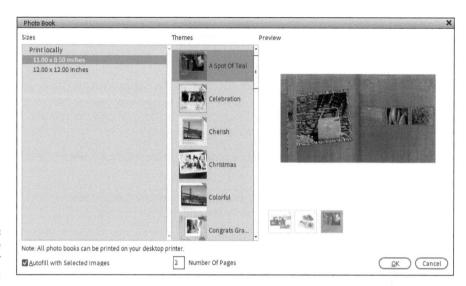

FIGURE 14-4: Select a theme for your creation.

Elements automatically creates the number of pages to accommodate the number of photos you selected in the Organizer or Photo Bin.

5. Select your options in the Create panel. Click OK.

The Create panel changes to a wizard and displays three icons at the bottom of the panel, as shown in Figure 14-5:

- Pages: Add or delete pages.
- Layouts: Choose a layout, as shown in Figure 14-6. You can click different layouts and view the results in the wizard.
- Graphics: Add artwork and text with the Graphics panel. Explore each item and choose options available for editing your creation.

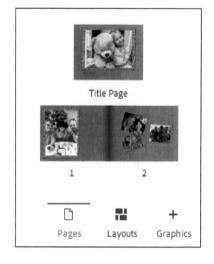

FIGURE 14-5: The Pages panel.

When you make a creation, you can determine the number of pages at the time you first choose a creation. Often, you forget about creating enough pages, or you find that you need more pages than originally anticipated. It can be downright frustrating if you need more pages but don't know how to add

the number you need. If you look closely at the top of the Pages panel, you find a Page icon. Click this icon to add more pages. To insert a page between two existing pages, click the first page in the sequence. Click the Page icon in the Pages panel, and the new pages are inserted after the selected page. To delete a page, select the page and click the Trash icon at the top of the Pages panel.

(Optional) Select options in the creation's Advanced mode.

Up to this point, you couldn't make any changes to your photos (other than sizing and rotating) because the wizard Interface is separate from the Organizer and Photo Editor.

Click the Advanced Mode button in the upper-left corner of the wizard, and you have access to the Photo Editor Tools panel. You can now make edits on any photos in the creation, as shown in Figure 14-7.

When you click Advanced Mode, the button name changes to Basic Mode. Click the Basic Mode button to return to the Create panel.

7. Click the output option at the bottom of the wizard:

- **Save:** Save the file as a Photoshop Elements Project. You can return to the project and edit it at a later time.
- Print: Before the output is generated, look over the preview of your creation. If you're using Advanced mode, click the Basic button at the top of the window and scroll through the pages to preview the creation.

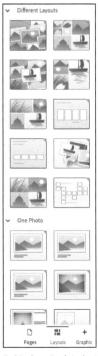

Ted Padova (Book Author)

FIGURE 14-6: The Layouts panel offers choices for many layouts.

Whether you want to create a photo book, a calendar, or any one of the other first five options in the Create panel, you follow the same steps.

When you make a creation that will ultimately be shared with other users or sent to an online service for printing, you *must* first select the photos you want in your creation. For example, when you create a photo book by clicking the Photo Book button on the Create panel, you first need to select photos.

The reason you must first select photos — in either the Organizer or Photo Bin — is that the creation process involves using a wizard to set the attributes for your creation. Elements must first know what photos you intend to use before it can open a wizard to walk you through the creation process.

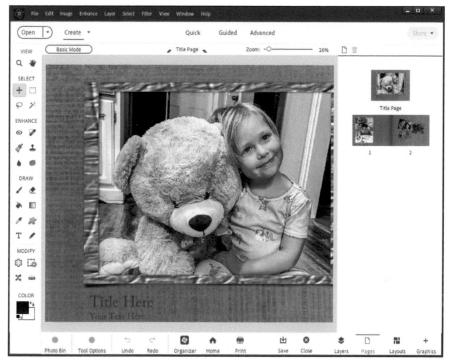

FIGURE 14-7:
Advanced
mode provides
you with the
Photo Editor
tools to edit
photos in your
creation before
saving or
printing.

Photo: Ted Padova

Creating a Quote Graphic

You begin with a photo open in the Photo Editor, select a photo in the Organizer, or start from scratch without selecting a photo. In the Create drop-down list that you open from either the Organizer or the Photo Editor, choose Quote Graphic.

The first panel opens, showing you the templates you can choose from. One option lets you start from scratch without using a template, as shown in Figure 14-8.

Click the template you want to use. The panel immediately changes to an assortment of fixed sizes and sharing destinations. For example, you can make an Instagram post, a Facebook Cover, a Twitter, or a Pinterest post. If you don't want to post to a social media site, you can choose from a number of different fixed sizes that you can open in the Photo Editor, as shown in Figure 14–9.

Click an option in the second panel, and you arrive at the Background/Effects panel. The default is the Background panel, where you can choose from a number of different background designs and colors. Click the Effects panel, and you can choose from a huge assortment of different kinds of effects.

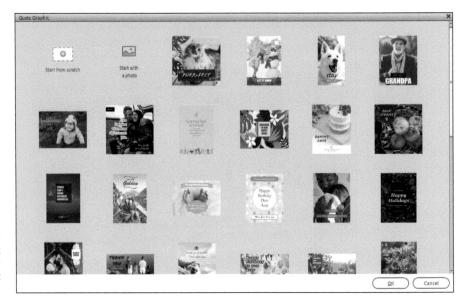

The first panel for the Quote Graphic creation.

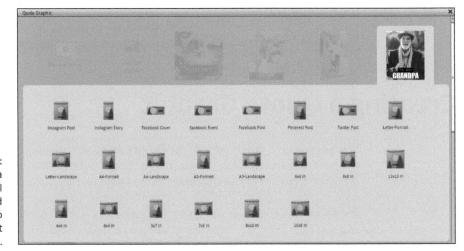

FIGURE 14-9: Choose from a variety of social media and common photo and document sizes.

The default photo appears in the panel, as shown in Figure 14-10. To replace the photo, open the Photo Bin in the Photo Editor and drag a photo to the document. When finished, click the Save button that appears at the bottom of the Background/Effects panels.

In Figure 14-11, you can see our final image after using the Beautiful Moments template.

FIGURE 14-10: The Background/ Effects panel.

Figure 14-11:
Final edited photo using the Quote Graphic creation.

Photo: Ted Padova

Creating a Memories Video

When you click the Slideshow menu command, you open the Slideshow Wizard. Click the Media button to add media to your slideshow. Click the Themes button to scroll through a number of different themes in the left panel, as shown in Figure 14-12.

FIGURE 14-12: Click a Theme to apply to the video.

The last button enables you to choose an audio track. You can choose from audio files loaded in the Organizer or click the + (plus sign) icon to add an audio file from your hard drive.

After making your selections, you're ready to export the file as a video slideshow. Open the Export menu in the top-right corner. You can choose to export your video directly to YouTube, Vimeo, a local disk, the cloud, or to Facebook. Choose an option and a dialog box opens, prompting you for a filename and a button to browse your hard drive (when saving to Local File). Locate the folder where you want to save the file and click OK. If you choose a social media option such as YouTube, Vimeo, or Facebook, a dialog box opens asking you to authorize the upload. Complete the authorization and the file is uploaded to the social media site.

To double-check your work, try to export the file to your hard drive and view it on your monitor before uploading the file to a social media site.

Creating a PDF Slideshow

In the Share panel, you have the PDF Slideshow option. When you select photos in the Organizer and choose this option, the Share panel opens and provides the same options as you find when using email (as described in Chapter 13). The only difference between this option and choosing to email your photos is that the selected images are saved as a PDF and then emailed to the recipients you select in the Share panel.

Making Additional Creations

Unfortunately, we don't have room in this book to cover each creation. Fortunately, many of the other creation types are intuitive and easy to master. To create instant videos, you need Adobe Premiere Elements. Other readily available items include photo books, greeting cards, photo stamps, calendars, and CD/DVDs that you burn (Windows only). For each creation type, Elements provides you with many editing options. Explore each of the creations available to you and consult the online Help file for steps you can follow.

그림은 발생님께서 가장이 그 이 나를 모르는데

The Part of Tens

IN THIS PART . . .

Find our top ten tips for the best Guided Edits, such as correcting skin tone, removing objects, and others that can make your photos look better than ever.

Discover great ideas for projects you can create for your home or work, such as flyers, posters, inventories, and more.

- » Correcting skin tones
- » Removing objects
- » Replacing backgrounds
- » Improving contrast
- » Resizing images

Chapter 15 The Ten Best Guided Edits

ith each release of Photoshop Elements, Adobe adds to the library of Guided Edits, which enable you to do complex tasks easily by following a series of steps. There are now almost 60 Guided Edits to choose from. Some of the edits are pure fun and whimsy, and you may use them every now and then. Others are more practical and designed to really help improve your photos. These are the ones that will become part of your regular toolkit to get your images looking their best. Here are ten of our favorites.

Correct Skin Tone

Occasionally, certain kinds of lighting can make the people in your portraits look a little green, yellow, magenta, or other color not normally associated with skin. The Correct Skin Tone Guided Edit easily fixes that problem. If you need more information on correcting skin tones, see the section "Adjusting skin tones," in Chapter 9.

Here are the steps to use this edit:

- 1. In Guided mode, choose File ➪ Open and select your image.
- 2. Under Basics, choose Correct Skin Tone.
- 3. Specify your view to be Before & After Horizontal or Before & After - Vertical.

This view gives you a side-by-side comparison of your image while editing.

- 4. Using the Skin Tone Selection eyedropper tool, click on a clear, evenly lit portion of the person's skin in the After image.
- 5. If you feel that you need to refine your results further, use the Tan, Blush, and Light sliders, as shown in Figure 15-1.

Note that the Light slider is pretty intense, so we recommend going easy on this adjustment.

- 6. After you're satisfied with the edit, click Next.
- 7. Elements now asks what you would like to do next. Select from:
 - **Save:** This option simply saves over your original image in the same location on your computer.
 - Save As: With this option, you now have the choice of saving your image to the cloud or to your computer. Click Continue, name the file, and click Save.
 - Continue Editing: In Quick or In Advanced: You can choose to continue editing the image in either Quick or Advanced mode.
 - **Print:** This option transports you to the Fujifilm Print & Gifts website and enables you to order prints, cards, and merchandise.
 - Share: Share your image to the Flickr website.
- 8. Click Done.

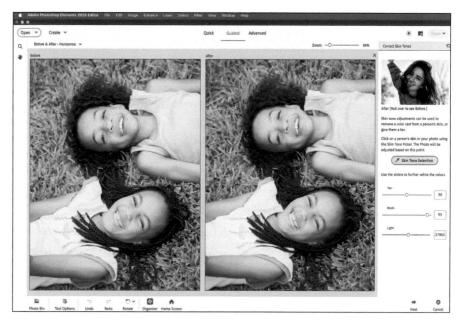

FIGURE 15-1: The Correct Skin Tone edit removes color casts from your people's skin.

Blend Images/Shutterstock

Sharpen

If you find that your image is a little soft or slightly blurry, you can apply a sharp-ening adjustment, which will increase the contrast between the pixels, giving the appearance that the focus is better. If you want more details on sharpening, be sure to check out the section "Sharpening for better focus," in Chapter 9.

Here are the steps to use this edit:

- 2. Under Basics, choose Sharpen.
- Specify your View to Before & After Horizontal or Before & After Vertical from the drop-down menu in the top-left corner (the default
 says "After Only").

This view gives you a side-by-side comparison of your image while editing.

4. Either click the Auto Fix button to have Elements analyze the image and automatically make the adjustment, or use the Sharpen slider to manually apply the edit.

Note that if your image is fairly soft to start with you may have to apply quite a bit of sharpening to see a noticeable result. The drawback to doing this sharpening is that the image may start to look a bit grainy.

- 5. After you're happy with the edit, click Next.
- 6. Elements now asks what you would like to do next. Select from:
 - Save: This option simply saves over your original image in the same location on your computer.
 - Save As: With this option, you now have the choice of saving your image to the cloud or to your computer. Click Continue, name the file, and click Save.
 - **Continue Editing: In Quick or In Advanced:** You can choose to continue editing the image in either Quick or Advanced mode.
 - **Print:** This option transports you to the Fujifilm Print & Gifts website and enables you to order prints, cards, and merchandise.
 - Share: Share your image to the Flickr website.
- 7. Click Done.

Object Removal

Sometimes you don't always have control over what you capture in your frame when taking a photo. Or maybe you're given a photo and asked to eliminate something from the image. The Object Removal Guided Edit is what you need to accomplish this task easily.

Follow these steps to remove an object:

- 1. In Guided mode, choose File \Rightarrow Open and select your image.
- 2. Under Basics, choose Object Removal.
- Specify your View to Before & After Horizontal or Before & After - Vertical.

This view gives you a side-by-side comparison of your image while editing.

4. In the After image, choose the Brush tool and brush over the object you want to eliminate. For more on each of these tools, check out Chapter 6, "Making and Modifying Selections."

We adjusted our Brush size to a medium-size diameter, and brushed over the brown horse.

- 5. If you need to add or subtract to fine-tune your selection, click the Add or Subtract buttons and brush over your desired areas.
- **6.** After you have adequately selected your object, click the Remove Object button.
- 7. If you see any visible seams, smudges, or other imperfections, use the Clone Stamp tool to fix these.

We used the Clone Stamp tool to repair a couple of spots. For further details on this tool, see the Chapter 8 section "Cloning with the Clone Stamp tool." As you can see in Figure 15-2, the brown horse is gone. It isn't perfect, and we would choose to edit it a bit more in Advanced mode, but it is a good start. Depending on your particular image and object, the Guided Edit could be all you need.

- f 8. When you're happy with the removal, click Next.
- 9. Elements now asks what you would like to do next. Select from:
 - Save: This option simply saves over your original image in the same location on your computer.
 - Save As: With this option, you now have the choice of saving your image to the cloud or to your computer. Click Continue, name the file, and click Save.
 - Continue Editing: In Quick or In Advanced: You can choose to continue editing the image in either Quick or Advanced mode.
 - Print: This option transports you to the Fujifilm Print & Gifts website and enables you to order prints, cards, and merchandise.
 - **Share:** Share your image to the Flickr website.
- 10. Click Done.

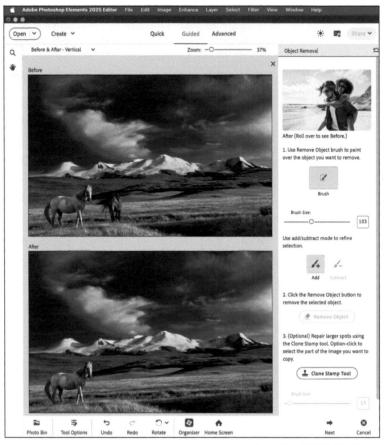

Remove objects for your desired composition.

Dmitry Pichugin/Adobe Stock Photos

Perfect Portrait

The Perfect Portrait Guided Edit is a kind of one-stop shop for enhancing your portraits. You can do most of these enhancements using the tools and techniques in Advanced mode, and if you want more control over the results, that may be where you will end up. But for those who want their enhancing to be quick and easy, Perfect Portrait is the place to be.

Follow these steps to remove an object:

- 1. In Guided mode, choose File

 Open and choose your image.
- 2. Under Special Edits, choose Perfect Portrait.

3. Specify your View to Before & After – Horizontal or Before & After - Vertical.

This view gives you a side-by-side comparison of your image while editing.

- 4. Click the Smooth Skin button. Elements applies a smoothing effect. If the effect is too strong, dial it back with the Strength ramp.
- Click the Increase Contrast button to do just that (increase the contrast).

We recommend avoiding this edit because it does not give you enough control as to how you want to increase the contrast, plus it's a little heavy-handed. If your portrait needs a contrast adjustment, you are better off doing it in Quick or Advanced mode and using the Levels or Color Curves adjustment.

- Fine-tune your portrait's face by applying the following.
 - Features: This option enables you to adjust a person's facial features, such as by enlarging eyes, tilting the head, and so on. For more on this feature, see Chapter 9.
 - Remove Blemishes: This option uses the Spot Healing Brush to eliminate blemishes, wrinkles, and so on. Click areas of the face that need healing. For more info on the Spot Healing Brush, see the section "Zeroing in with the Spot Healing Brush," in Chapter 8.

If you want to increase the diameter of your brush for this tool and the others, click the right bracket key. To decrease the diameter, click the left bracket key.

- Whiten Teeth: Click or brush over any teeth that need whitening.
- Open Closed Eyes: This option opens the Open Closed Eyes dialog box. Open another photo that can be used a source image for the replacement of your closed eyes, or you can try one of the sample images.
- Brighten Eyes: Click or brush over the eyes to brighten them.
- Darken Eyebrows: Brush over the eyebrows to darken them.
- 7. Click Add Glow if you want to add a glow effect to the portrait.

Clicking on this option transports you into another window, the Filter Gallery, and into the Diffuse Glow filter settings. Specify your options and click OK.

8. If you want to slim down your subject, click the Slim Down option.

Unfortunately, this option really doesn't give you any settings to control how slim you want your subject. We recommend skipping this option and using the Liquify filter in Quick or Advanced mode instead. For more on using Liquify, see "Distorting with the Liquify filter," in Chapter 10.

- 9. After you're happy with the removal, click Next.
- 10. Elements now asks what you would like to do next. Select from:
 - Save: This option simply saves over your original image in the same location on your computer.
 - Save As: With this option, you now have the choice of saving your image to the cloud or to your computer. Click Continue, name the file, and click Save.
 - Continue Editing: In Quick or In Advanced: You can choose to continue editing the image in either Quick or Advanced mode.
 - **Print:** This option transports you to the Fujifilm Print & Gifts website and enables you to order prints, cards, and merchandise.
 - Share: Share your image to the Flickr website.

11. Click Done.

In addition to humans, your pet can also receive a makeover with the Perfect Pet Guided Edit. With this edit, you can remove dirt, spots, and even a collar and leash! Fix the lighting and color, add an effect, and your pet is ready for showing off on social media.

Replace Background

Sometimes you want to pluck your subject out and put it into another scene. Other times, you want to leave your subject where it is and bring a different scene into the background. This Guided Edit enables you to do the latter.

Follow these steps to remove an object:

- 1. In Guided mode, choose File ⇔ Open and select your photo.
- 2. Under Special Edits, choose Replace Background.
- Specify your View to Before & After Horizontal or Before & After - Vertical.

This view gives you a side- by-side comparison of your image while editing.

4. Click the Select Subject button (Elements automatically detects and selects your subject) or use the Auto Selection, Quick Selection, or Brush tools. To add to or delete from your initial selection, use the Refine Selection Brush tool. For details on these selection tools, see Chapter 6.

We chose the Select Subject button because we had good contrast between our subject and the background. If you don't get good results with this automatic selection method, try one of the other selection tools.

5. Choose a new background by

- Importing a photo: We wanted a nicer-looking body of water, so we imported another image
- Choosing None: This option deletes the background and leaves a transparent background.
- Choosing Color: Click within the color field or color ramp in the Color Picker and click OK
- Selecting a photo from Adobe Stock: Enter a name for your desired image, such as water, and select an image from the search results. Click License for Free.
- Choosing a Preset: Click your choice from a set of preset backgrounds.
 Note that you have nine backgrounds to choose from.

- 7. If you have too much of the original background around the edges of your subject, use the Refine Edge Brush (Subtract) to brush it away. If you have inadvertently deleted part of your subject, use the same tool (Add) to brush it back in.
- 8. If your subject and its new background don't really match well in terms of lighting and looks a tad fake, click the Auto Match Color Tone option.

Our swan (see Figure 15-3, top) was a bit too bright, but when we clicked the Auto Match Color Tone option, it made our swan too dark, so we chose Edit 🖒 Undo to undo the adjustment.

- 9. If you like your composite, click Next.
- 10. Elements now asks what you would like to do next. Select from:
 - Save: This option simply saves over your original image in the same location on your computer.
 - Save As: With this option, you now have the choice of saving your image to the cloud or to your computer. Click Continue, name the file, and click Save.

- Continue Editing: In Quick or In Advanced: You can choose to continue editing the image in either Quick or Advanced mode. Because the Auto Match Color Tone option didn't work for us, we took our swan into Advanced mode and darkened it a bit using the Levels adjustment. You can see the final result in Figure 15-3 (bottom).
- Print: This option transports you to the Fujifilm Print & Gifts website and enables you to order prints, cards, and merchandise.
- Share: Share your image to the Flickr website.

11. Click Done.

FIGURE 15-3: Swap out your original background with a new one.

Denis Kuvaey/Shutterstock and Source: pixel2013/Plxabay

Remove a Color Cast

If your image has too much green, magenta, or other color, it's probably suffering from what is referred to as a color cast. Sometimes it is caused by the lighting; other times it can be an old photo whose green or magenta ink has faded. You can remove this unwanted color by using the Remove a Color Cast Guided Edit.

Here's how to use this edit:

- 1. In Guided mode, choose File \Leftrightarrow Open and choose your image.
- 2. Under Color, choose Remove A Color Cast.
- 3. Specify your View to Before & After Horizontal or Before & After Vertical.

This view gives you a side-by-side comparison of your image while editing.

4. Click the Color Cast Selection button.

With the eyedropper, click a portion of the image that should be the "truest" gray, black, or white. A word of warning: Selecting this portion may take several attempts. We had to click around several times before we got the results we wanted (see Figure 15-4). We were successful by clicking the center of the left tree trunk in front of our tea house.

- 5. Click Next.
- 6. Elements now asks what you would like to do next. Select from:
 - Save: This option simply saves over your original image in the same location on your computer.
 - Save As: With this option, you now have the choice of saving your image to the cloud or to your computer. Click Continue, name the file, and click Save.
 - Continue Editing: In Quick or In Advanced: You can choose to continue editing the image in either Quick or Advanced mode.
 - Print: This option transports you to the Fujifilm Print & Gifts website and enables you to order prints, cards, and merchandise.
 - Share: Share your image to the Flickr website.
- 7. Click Done.

FIGURE 15-4: Eliminate color casts from your images.

Levels

Adjusting the contrast in your image is a fix that you will find yourself doing quite often. Although you have several ways to make this fix, one of the best is to use Levels. It is a bit more complex than some of the automatic ways of contrast adjustment in Elements, but this Guided Edit walks you through the process. For more details on levels, see "Pinpointing proper contrast with Levels," in Chapter 9.

Here's the lowdown on using the Levels Guided Edit:

- 1. In Guided mode, choose File ➪ Open and select your photo.
- 2. Under Basics, choose Levels.
- Specify your View to Before & After Horizontal or Before & After - Vertical.

This view gives you a side-by-side comparison of your image while editing.

4. Click the Create Levels Adjustment button.

The New Layer dialog box appears. Name your layer and click OK.

In the Levels dialog box that appears, adjust your shadows (black slider), midtones (gray slider), and highlights (white slider).

The easiest way to get started with the adjustment is to drag your shadows slider to the right, to the beginning of the histogram (the graph that represents your tonal range). Then drag your highlights slider to the left, to the beginning

of the histogram, as shown in Figure 15-5. If you feel that your midtones also need an adjustment, drag the midtone slider to the right to make the midtones darker and to the left to make them brighter. It isn't uncommon to not have to adjust the midtones after the shadows and highlights have been adjusted. Our Taipei shop cat looks so much better.

- 6. Click OK.
- 7. Click Next.
- 8. Elements now asks you what you would like to do next. Select from:
 - **Save:** This option simply saves over your original image in the same location on your computer.
 - Save As: With this option, you now have the choice of saving your image
 to the cloud or to your computer. Click Continue, name the file, and
 click Save.
 - Continue Editing: In Quick or In Advanced: You can choose to continue editing the image in either Quick or Advanced mode.
 - Print: This option transports you to the Fujifilm Print & Gifts website and enables you to order prints, cards, and merchandise.
 - Share: Share your image to the Flickr or Twitter websites.
- Click Done.

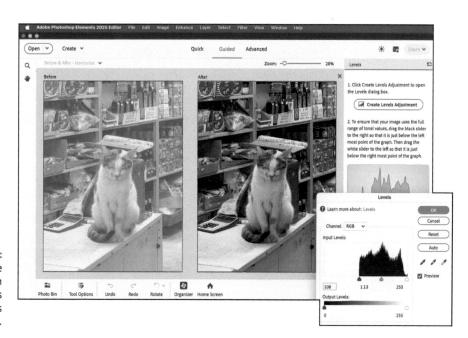

FIGURE 15-5:
Adjust the contrast in your images with the Levels Guided Edit.

Resize Your Photo

We realize that resizing your photo may not be the most interesting edit you want to make, but it is very important. Here's why, in a nutshell. Images need to be sized for their specific purpose. Preparing an image for a screen (a website or social media post) or print will require different pixel dimensions for them to display or print properly and with good quality.

Here are the steps to resize your image:

- 1. In Guided mode, choose File

 Open and select your image.
- 2. Under Basics, choose Resize Your Photo.
- **3.** Specify your View to Before & After Horizontal or Before & After Vertical.

 This view gives you a side-by-side comparison of your image while editing.
- 4. Select an output option: either Web or Print.
- 5. Select a size option.

For the Web output option, choose from Long Edge, Short Edge, Width & Height, or File Size. For Long Edge or Short Edge options, the height or width is automatically adjusted to keep the aspect ratio. We wanted to resize our image for a Facebook poster, so it is recommended to use a width of 1200 pixels. For the Print output option, choose from Long Edge, Short Edge, Width & Height, or standard print dimensions in inches.

- **6.** Depending on the size you specified, you will be asked to Apply or to Preview and adjust the crop window as needed.
- 7. Click the blue check mark after you're satisfied with your image.
- 8. Click Next.
- 9. Elements now asks you what you would like to do next. Select from:
 - **Save:** This option simply saves over your original image in the same location on your computer.
 - Save As: With this option, you now have the choice of saving your image to the cloud or to your computer. Click Continue, name the file, and click Save.
 - Continue Editing: In Quick or In Advanced: You can choose to continue editing the image in either Quick or Advanced mode.
 - **Print:** This option transports you to the Fujifilm Print & Gifts website and enables you to order prints cards and merchandise.
 - Share: Share your image to the Flickr website.
- 10. Click Done.

Recompose

If you're like us, you may have sometimes wished that you would have taken a vertical or square photo instead of a horizontal one. Cropping it wouldn't work because you would be slicing off an important part of the image. This particular Guided Edit can be a lifesaver in that instance. The Recompose Guided Edit enables you to resize your image without sacrificing your vital content.

Here are the steps to recomposing your photo:

- 1. In Guided mode, choose File ⇔ Open and choose your photo.
- 2. Under Special Edits, choose Recompose.
- Specify your View to Before & After Horizontal or Before & After - Vertical.

This view gives you a side-by-side comparison of your image while editing.

4. You can start with the Recompose-Simple option. In the After image, drag the handles on the sides or corners to resize your image.

Make sure to pay attention to both your main subjects and especially to the space between the subjects. If all is okay, you are good to go and can go to Step 6. If your results are less than desirable, go to Step 5 to Recompose with finer details.

5. If Step 4 didn't work, take the Protect brush and brush over any vital content that you want to keep or protect. We protected both men in our image. You can then brush over any content you want to remove with the Remove brush. In the After image, drag the handles on the sides or corners to resize your image, as shown in Figure 15-6.

Note that if you need to clean up your protected or removed areas, use the appropriate Eraser brush. You can adjust Brush Size diameter with the slider.

- If you want to use a preset size to resize your image, select it from the Preset drop-down menu.
- Click the blue check mark when you're satisfied with your image.
- 8. Click Next.
- 9. Elements now asks you what you would like to do next. Select from:
 - Save: This option simply saves over your original image in the same location on your computer.
 - Save As: With this option, you now have the choice of saving your image to the cloud or to your computer. Click Continue, name the file, and click Save.

- Continue Editing: In Quick or In Advanced: You can choose to continue editing the image in either Quick or Advanced mode.
- **Print:** This option transports you to the Fujifilm Print & Gifts website and enables you to order prints, cards, and merchandise.
- Share: Share your image to the Flickr website.

10. Click Done.

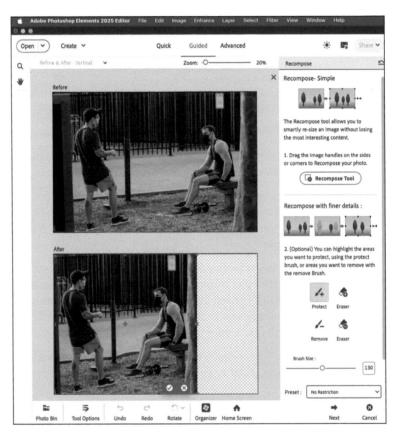

FIGURE 15-6:
Resize
your image
without losing
important
content.

Kate Trifo/Pexels.com

Depending on how much you resize your image, you may have to do some retouching, especially in between your subjects. We had to do just that with our final image (refer to Figure 15–6). Use the Clone Stamp tool and Spot Healing Brush tool to eliminate these imperfections. For further details on these two tools, see these sections in Chapter 8: "Cloning with the Clone Stamp tool" and "Zeroing in with the Spot Healing Brush."

Move & Scale Object

Occasionally you wish that the subject of your photo were bigger, smaller, or in a different location within the frame (see Figure 15–7). Although seamlessly changing any of those aspects sounds difficult, with the Move & Scale Object Guided Edit, each one is amazingly easy.

FIGURE 15-7: Move and scale your subject seamlessly.

Abassaka/Getty Images

Here are the steps to resize as well as move (if you want) your image:

- 2. Under Basics, choose Move & Scale Object.

3. Specify your View to Before & After – Horizontal or Before & After – Vertical.

This view gives you a side-by-side comparison of your image while editing.

- 4. Select your subject with either the Auto Selection or Quick Selection tools. If you choose the Quick Selection tool, you can adjust the Brush Size diameter.
- If you need to add or subtract to fine-tune your selection, click the Add or Subtract buttons and brush over your desired areas.

Note that the Brush Size diameter slider works for this tool as well.

- **6.** Move or duplicate your selected subject by dragging it to your desired location. If you want to also scale your subject, drag a corner handle.
- 7. Click the blue check mark after you're satisfied with your image.
- 8. Retouch any seams or flaws around your subject, if needed, using the Spot Healing Brush (smaller flaws) or the Clone Stamp tool (larger flaws) and you can use both. You can adjust the Brush Size diameter to better eliminate the flaw.

For further details on these two tools, see the Chapter 8 sections "Cloning with the Clone Stamp tool" and "Zeroing in with the Spot Healing Brush."

- 9. Click Next.
- 10. Elements now asks you what you would like to do next. Select from:
 - **Save:** This option simply saves over your original image in the same location on your computer.
 - Save As: With this option, you now have the choice of saving your image to the cloud or to your computer. Click Continue, name the file, and click Save.
 - Continue Editing: In Quick or In Advanced: You can choose to continue editing the image in either Quick or Advanced mode.
 - **Print:** This option transports you to the Fujifilm Print & Gifts website and enables you to order prints, cards, and merchandise.
 - Share: Share your image to the Flickr website.

11. Click Done.

Two more of our favorite Guided Edits are covered in detail in Chapter 10, in the section "Using Photomerge." Photomerge Scene Cleaner enables you to eliminate objects like cars and passersby from multiple shots to get a "clean" image. Combine Photos lets you easily extract one image and composite it into another.

- » Advertising in flyers and online auctions
- » Going big with posters
- » Creating a household inventory or project documentation
- » Working with blogs

Chapter **16**Ten (or So) More Project Ideas

ven though Elements already gives you a wide array of creations to make — from photo books to greeting cards to slideshows — you can easily do even more with the program. In this chapter, you find ideas for using your inventory of digital images to make your life more productive, more organized, and more fun. This chapter just scratches the surface. Before you know it, your photos will be a part of every aspect of your life, from your clothing to the art on your walls.

Screen Savers

If you have two or more photos you want to use, you can create a screen saver in Windows or macOS. Follow these steps in Windows:

- 1. Copy the photos you want to see in your screen saver to a new folder.
- 2. Right-click anywhere on the desktop and select Personalize.
- Click Lock Screen in the Settings window and scroll down to the Screen Saver Settings.

- 4. In the Screen Saver Settings window, select Photos in the drop-down menu.
- Click Settings.
- **6.** Click Browse and navigate to the folder you created in Step 1 and select the photos.
- 7. Select a slideshow speed from the drop-down menu.

Optionally, check Shuffle to randomize the photo order.

- 8. Click Save.
- 9. Click the Preview button to test your screen saver.
- Click the arrows to specify the amount of time before your screen saver displays.
- 11. Click OK.

Mac users can create custom screen savers even more easily:

- >> Choose System Settings from the Apple menu.
- >> Click Screen Saver from the menu on the left.
- >> Choose your desired screen saver design from the thumbnails. Select whether you want the screen saver to also be your wallpaper and show on all Spaces (if you have multiple monitors). Then click Lock Screen Settings and specify when your screen saver begins and becomes inactive.
- >> Click the Close icon in the top-left corner.

Flyers, Ads, and Online Auctions

Whether you're selling puppies or advertising an open house, adding a photo to an ad or flyer really helps to drive home your message. Here are the abbreviated steps to quickly create an ad or a flyer:

- 1. In Advanced mode, choose File → New → Blank File.
- 2. In the New dialog box, enter your specs and then click OK.

Enter the final dimensions and resolution for your desired output. If you want to print your ad or flyer on your desktop printer or at a service bureau, a good guideline for resolution is 300 pixels per inch (ppi). Leave the color mode as RGB and the Background Contents as White.

To fill your background with color, choose Edit ightharpoonup Fill Layer and then choose Color from the Use pop-up menu. Choose your desired color in the Color Picker and then click OK.

3. Open your photos and then drag and drop them onto your new canvas with the Move tool.

Each image is on a separate layer.

Choose Window ➡ Images ➡ Cascade or Tile to view all your canvases at the same time.

4. Select the Type tool, click the canvas, add your desired text, and then position your type with the Move tool.

If you want to add a bevel or drop shadow to your type, select your Type layer and, in the Styles panel (choose Window \hookrightarrow Styles or click the Styles icon in the bottom-right corner), choose Drop Shadows or Bevels from the Styles dropdown menu at the top of the panel. Double-click the shadow or bevel of your choice. We chose a Simple Inner bevel and a Soft Edge shadow.

5. When you're done, choose File ➪ Save.

Choose whether to save your image to the cloud or on your computer and click Continue.

6. Name your file, choose Photoshop (.psd) from the Format drop-down list, and make sure that the Layers and ICC Profile (Embed Color Profile on the Mac) check boxes are selected. Select the Use Lower Case Extension (Windows only) option.

If you're taking your document to a copy shop, save your document as a Photoshop PDF (.pdf) file.

- (Optional) To save a copy of your ad or flyer in the Organizer, select the Include in the Elements Organizer check box.
- 8. Click Save.

Clothes, Hats, and More

Buy plain, colored T-shirts at your local discount store or plain aprons and tote bags at a craft or fabric store. Then buy special transfer paper at your office supply, big-box, or computer store. Print your photos on the transfer paper (be sure to flip the images horizontally first) and iron the print onto the fabric. When you're done, you have a personalized gift for very little cash.

Posters

You can get posters and large prints at many copy shops and at online vendors such as VistaPrint and GotPrint. Call and talk to a knowledgeable rep so that you know exactly how to prepare your file. Here are a few questions to ask:

- >> What file format and resolution should the file be?
- >> What print sizes do you offer?
- >> Do you provide mounting and lamination services?

Note that online companies such as Shutterfly and CafePress will print your image on everything from cellphone cases to drinkware to beach towels.

Household and Business Inventories

Shoot pictures of your items. In the Organizer, select the image and choose Edit \hookrightarrow Add Caption to include makes, models, purchase dates, and dollar values of each piece. Then create a single PDF document from those multiple files by creating a slideshow. Chapter 14 explains how to create the slideshow PDF. After the PDF is finished, you can upload it to cloud storage site or save it to an external drive that's stored somewhere else (in a safe deposit box or other secure location). This is great for providing documentation for insurance claims.

Project Documentation

If you're taking a class or workshop, take your camera to class (if the instructor doesn't mind). Documenting the positions or steps of that new yoga, pottery, or gardening class can help you practice or re-create it on your own. Import your desired photos into the Organizer and create notes on each step of the project in the caption area. When you're done, output the images to a PDF slideshow. For details on creating PDF slideshows, see Chapter 14.

School Reports and Projects

Have to write a paper on the habits of the lemurs of Madagascar? Trek down to your local zoo and have a photo shoot. Create a simple collage of lemurs eating, sleeping, and doing the other things that lemurs do. You can use the Photo Collage command on the Create panel, or create a custom collage by making selections (see Chapter 6) and dragging and dropping them onto a blank canvas.

Blogs

Creating a simple blog is a great way to share not only your latest and greatest photos but also recent news about family and friends. Some of the most popular free blogging platforms are http://www.blogger.com/, www.squarespace.com, www.wix.com (all website creators with blogging capabilities), www.wordpress.com, and www.medium.com.

For info on how to share to social media sites like Twitter and Facebook, see Chapter 13.

Wait — There's More

Before you start taking your photos to the next dimension, consider a few extra ideas: Make fun place cards for dinner party guests; create your own business cards or letterhead; design your own bookmarks, bookplates, and notepads; or label storage boxes with photos of their contents. Check out www.pinterest.com and other sites for a slew of projects to do with photos.

Index

Α	Adobe Partner Services, 29
	Adobe Portrait, 90
Actions menu (Photo Bin), 23	Adobe Premier Elements, 300
Actions panel, 20	Adobe RGB color workspace, 295
Add Event button (Organizer), 35	Adobe Standard, 90
Add Location button (Organizer), 35	Adobe Stock images, 24-26
Add Noise filter, 203	Adobe Vivid, 90
adding	ads, 336–337
color to Color Swatches panel, 258	Advanced dialog box, 41
files from folders/removable media, 39–40	Airbrush button, 263
images	albums
to albums, 51–54	adding images to, 51–54
to Organizer, 38–43	creating, 51–53
layer masks, 133	editing, 53–54
people in Media Browser, 54–56	searching by, 66
to selections, 110	Albums tab (Organizer), 35
shadows, 240-244	aligning submenu, 140
Adjust Color for Skin Tone command, 197–198	Amount command, 127
Adjust Facial Features command/dialog box, 214	Angle (Raw Editor), 78
Adjust Sharpness command, 208–209	Angle option, 233, 263
adjusting	anti-aliasing, 101, 260–261, 262
appearance of Color Swatches panel, 259	Anti-aliasing option, 279, 280
background color, 258	Application Updates, 29
clarity, 202–219	applying
color, 187–202	effects, 237–240
color temperature, 200–201	filters
facial features, 214	about, 226–227, 233–234, 281–283
lighting, 182–187	to type, 281–283
noise, 86–87	Marquee options, 100–102
selections, 109–111	preset gradients, 269–272
skin tones, 197–198, 317–319	preset patterns, 271–272
Tolerances setting in Magic Wand tool, 106–107	styles, 241–242
type opacity, 281	arranging submenu, 140
Adjustment layers, 133, 219–222	artifacts, removing, 203–204
Adjustments icon, 164	Aspect drop-down list, 101–102
Adjustments panel, 20	Aspect Ratio (Raw Editor), 78
Adobe Camera Raw profiles, 90	attributes, of Camera Raw images, 75–76
Adobe Color, 90	auctions, online, 336–337
Adobe Firefly (website), 26	Auto Color Correction command, 157–158
Adobe Landscape, 90	Auto Contrast command, 157
Adobe Monochrome, 90	Auto Curate (Organizer), 35

Auto Haze Removal command, 157	Brightness/Contrast command, 184
Auto Levels command, 156–157	Browse dialog box, 41
Auto Red Eye Fix command, 159–160, 163	brush dynamics, 263
Auto Selection tool, 115–117	Brush Preset Picker panel, 264
Auto Sharpen command, 158–159	Brush tool, 211-212, 262-264
Auto Smart Fix tool, 154–155	Burn tool, 174–175
Auto Smart Tone tool, 155–156	business inventories, 338
Auto/B&W (Basic panel), 82	
Average filter, 204	C
	_
D	Calibration panel (Raw Editor), 87
В	Camera Data Readout (Raw Editor), 78
background color, 256, 258	Camera Raw Editor
Background Eraser tool, 123–125	about, 73
backgrounds	Basic panel, 81–84
converting to layers, 130–131	Calibration panel, 87
replacing, 324–326	changing image defaults, 93
backing up	components, 77–81
catalogs, 60–61	Detail panel, 85–87
photos/files, 60-61	filmstrips, 87-89
backlit, 183	launching, 73–74
Basic panel (Raw Editor), 81–84	opening
Before/After (Q) (Raw Editor), 80	images in, 76–77
bevel shadow, 241	non-raw images in, 92
bit depths, 75–76	panels, 81–87
Bitmap mode, 226	profiles, 89–92
Blacks (Basic panel), 84	XML files and preferences, 93–96
blend modes	Camera Raw files
about, 244	about, 73–74
darken, 245, 246	attributes, 75–76
fill color and, 267	opening images in Camera Raw Editor, 76-77
general, 245	Cancel (Raw Editor), 80
HSL, 249	Catalog Info (Organizer), 36
inverter, 245	Catalog Manager, 58–59
Lighten, 245, 247	cataloging files, 57–61
Bloat (B) tool, 230	catalogs
blogs, 339	backing up, 60–61
Blur filter, 204	working with, 59-60
Blur More filter, 204	Change Object Color command, 193–194
Blur tool, 177-178, 204	Change Object Color feature, 1
blurring commands, 204–207	Change the Text orientation option, 279
borders, creating, 267–268	Change Views (Raw Editor), 79-80
bounding box, 140	ChatBot, 1
brightness	Cheat Sheet (website), 4
monitor, 290	checkerboard square icon, 133
for printing, 290	circle cursor, 256
	55

circles, creating, 100 Color Picker, 256-257 Clarity (Basic panel), 84 Color Swatches panel, 20, 257-259 clarity, adjusting, 202-219 color temperature, adjusting, 200-201 Classic tab, 164 Colorize Photo dialog box, 211-212 Clipboard, 139 colorizing photos, 211-212 Clone Stamp tool, 164-166 Combine Photos feature, 253-254 cloning, 164-166 about, 2 Close button (image window), 13 Comic filter, 234-235 clothes, printing on, 337 commands color Adjust Color for Skin Tone, 197-198 Adjust Color for Skin Tone command, 197-198 Adjust Facial Features, 214 adjusting Adjust Sharpness, 208-209 about, 187-202 Amount, 127 skin tones, 197-198 Auto Color Correction, 157-158 changing with Change Object Color command, 193–194 Auto Contrast, 157 choosing, 255-260 Auto Haze Removal, 157 color casts, 188-189 Auto Levels, 156-157 Color Picker, 256-257 Auto Red Eye Fix, 159-160, 163 Color Swatches panel, 257-259 Auto Sharpen, 158-159 correcting with Color Curves, 195-196 blurring, 204-207 Defringe command, 198-199 Brightness/Contrast, 184 defringing layers, 198-199 Change Object Color, 193-194 eliminating Contrast, 127 about, 190-191 Copy Merged, 137 haze, 199-200 Decontaminate Colors, 127 Evedropper tool, 259-260 Defringe, 198-199 Hue/Saturation command, 189-190 Deselect, 125-126 Impressionist Brush, 264-265 Feather, 127 mapping, 201-202 Fill, 266-268 Paint Bucket tool, 268-269 Free Transform, 140-141 preset, 258 Get Files from Folders, 38 for printing, 290 Hue/Saturation, 189-190, 211-212 Remove Color Cast command, 188-189 Layer via Copy, 138 Remove Color command, 190-191 Layer via Cut, 138 Replace Color command, 191-193 Levels, 185-187 switching between, 191-193 Output, 127 type and, 283-284 Photo Filter, 200-201 Color blend mode, 249 Photomerge Panorama, 250-252 Color Burn blend mode, 246 Radius, 126 color casts, removing, 188-189, 327-328 Remove Color, 190-191 Color Curves, 195-196 Remove Color Cast, 188-189 Color Dodge blend mode, 247 Replace Color, 191-193 color mode, 13 Select All, 125-126 color noise reduction, 87 Shadows/Highlights, 183-184 Color option, 279 Shift Edge, 127

commands (continued)	shapes, 272–275
Smart Radius, 126	slideshows, 63–64
Smooth, 126	squares, 100
Straighten, 151	creations
Stroke, 267–268	about, 303, 313
Transform, 140–141, 285	assembly basics, 306–309
Unsharp Mask, 207–208	Create panel, 303–305
contact sheet, 294–295	Memories video, 312
Contact Sheet option, 292	PDF slideshows, 313
Content-Aware Move tool, 172–173	Quote Graphics, 309–311
context menus, 2	Crop Adjustments (Raw Editor), 79
contextual menus, 15	Crop & Rotate (Raw Editor), 78–79
contrast	Crop tool, 146–148
about, 86	cropping images, 145–151
Basic panel, 83	current selected layer (image window), 14
Levels command, 185–187	current tool (image window), 14
sharpening and, 203	Custom tool, 273
Contrast command, 127	Custom Workspace panel, 21
controlling editing environment, 26-31	
Convert and save images (Raw Editor), 78	D
Convert to Black and White dialog box, 191	D
Cookie Cutter tool, 120–122	Darken blend mode, 245, 246
Copy Merged command, 137	darkening, 174–175
copying and pasting styles, 242	Darker Color blend mode, 246
Correct Camera Distortion filter, 232–233	date, searching by, 66
correcting color with Color Curves, 195-196	Decontaminate Colors command, 127
corrective filters, 227	defining selections, 97–98
Country/Region Selection, 29	Defringe command, 198–199
Create Keyword Tag dialog box, 48–49	defringing layers, 198–199
Create panel, 8, 10, 303–305	deleting
Create Warped Text option, 279	layers, 134
Create/Share (Organizer), 35	styles, 242
Create/Share panel, 21	Depth (Raw Editor), 80
creating	Depth Blur filter, 204
Adjustment layers, 133	Depth of Field filter, 2
albums, 51–53	Deselect command, 125–126
circles, 100	Despeckle filter, 203
elliptical selections, 98–102	destructive filters, 227
Favorites list, 91–92	Detail panel (Raw Editor), 85–87
image views, 21-23	Difference blend mode, 249
layers, 132–133, 136–138	Display & Cursors preferences, 28
Memories video, 312	DNG Converter, 75
PDF slideshow, 313	DNG File Handling (Preferences dialog box), 9-
Quote Graphics, 309-311	docked position, 9
rectangular selections, 98-102	document dimensions (image window), 14

Document Information Pop-up Menu (Photo Editor),	Eraser tools, 122–125
9, 10	events, searching by, 66
document profile (image window), 14	Events tab (Organizer), 34
document sizes (image window), 14	Exclusion blend mode, 249
documentation, project, 338	Exposure (Basic panel), 83
Dodge tool, 174–175	Eyedropper tool, 259-260
Done (Raw Editor), 80	
Double Exposure, 239	_
downloading images with Elements Downloader, 40–42	F
dragging and dropping layers, 139	Facebook, sharing photos on, 301
drawing shapes, 273–274	Fade option (Brush), 263
drop shadow, 241	Faux Bold option, 279
duplicates, searching, 68-69	Faux Italic option, 279
duplicating layers, 133, 138	Favorites list, creating, 91–92
dust, removing, 203-204	Favorites panel, 21
Dust & Scratches filter, 203	Feather command, 127
	feathering, 101
-	features, new, 1–2
E	Features buttons
Edge Extension Scale, 233	Organizer, 35
Edit (Raw Editor), 78	Photo Editor, 8, 10
editing	file formats, 142
about, 7	File tabs (Photo Editor), 9, 10
albums, 53–54	Filename (image window), 13
controlling environment for, 26–31	filenames, viewing, 23
in Quick mode, 160–164	files
shapes, 274–275	adding from folders/removable media, 39–40
style settings, 242	backing up, 60–61
text, 280-281	cataloging, 57–61
workflow for, 18-24	sidecar, 96
editing window. See Filter Gallery	Fill command, 266–268
Editor button (Organizer), 36	fill layers, 133
effects, applying, 237–240	filling selections, 266–268
Effects icon, 164	filmstrips, 87–89
Effects panel, 19	1 100 100 100 100 100 100 100 100 100 1
efficiency (image window), 14	Filter Gallery, 227, 228–229
elements, moving, 217–219	Filter menu, 226
Elements Downloader, downloading images with, 40–42	filtering media, 62
Elements Organizer, 2	filters
Elements Web (Organizer), 36	about, 225–226
Ellipse tool, 273	Add Noise, 203
Elliptical Marquee tool, 99–100	adjusting color temperature with photo, 200–201
elliptical selections, creating, 98–102	applying
emailing photos, 299–300	about, 226–227, 233–234, 281–283
Equalize mapper, 201	to type, 281–283
Erase Refinements tool, 127	Average, 204
LI doe Neillielliello tool, 127	Blur. 204

filters (continued)	Font Style option, 278
Blur More, 204	foreground color, 256
Comic, 234–235	Frames icon, 164
Correct Camera Distortion, 232–233	Free Transform command, 140–141
corrective, 227	freeform selections, 102–106
Depth Blur, 204	
Despeckle, 203	C
destructive, 227	G
Dust & Scratches, 203	Gaussian Blur filter, 204–205
Filter Gallery, 228–229	General area (Preferences dialog box), 94
Gaussian Blur, 204–205	general blend modes, 245
Graphic, 235–236	General preferences, 28
Graphic Novel, 235–236	General tab (Preferences dialog box), 27
Lens Blur, 205	Get Files from Folders command, 38
Liquify, 229–231	Get Photos and Videos from Files and Folders dialog box, 39
Median, 203	Getting Media dialog box, 43
Motion Blur, 205	Gradient Map mapper, 202
multistep, 227	gradients
one-step, 227	preset, 269–272
Pen and Ink, 236–237	type and, 283–284
Radial Blur, 205	Graphic filter, 235–236
Reduce Noise, 203–204	Graphics natel, 20, 243–244
Smart Blur, 205	Guided Edits, 23–24, 26, 317–334
Surface Blur, 205	Guides & Grid preferences, 28
Filters panel, 19, 226	Guides & Grid preferences, 26
Find by Details (Metadata) dialog box, 67-68	
flattening layers, 141–143	Н
Flickr, 301	Hand tool, 79, 127, 233
Flip Horizontal (Raw Editor), 79	hard drive, organizing photos/media on, 37–38
Flip Vertical (Raw Editor), 79	Hard Light blend mode, 248
floating windows, 13	Hard Mix blend mode, 248
flow rate, 180	Hardness option (Brush), 263
Fluorescent Chalk effect, 237–238	hats, printing on, 337
flyers, 336-337	haze, eliminating, 199–200
focus, improving with sharpening, 207–209	Haze Removal dialog box, 199–200
focusing, 178–179	Healing Brush tool, 167–168
folders	Height (H), 102
adding files from, 39–40	Help (Raw Editor), 79
importing photos from, 42-43	Hide Panel button (Organizer), 35
searching by, 66	hiding
Folders tab (Organizer), 35	layers, 132
Folders view (Organizer), 35	styles, 242
Font Family option, 278	Highlight clipping warning (Raw Editor), 78
Font Size option, 278	Highlights (Basic panel), 83

Histogram	searching for, 65–69
Basic panel, 82	sharpening, 85–87, 319–320
Raw Editor, 78	straightening, 145–151
Histogram panel, 21	viewing in Memories, 63-64
history, searching by, 66	imperfections, fixing with tools, 164-180
History panel, 21	Import (Organizer), 35
Home Screen (Photo Editor), 10	Import panel (Media Browser), 44-45
Home Screen button (Organizer), 36	importing photos from folders, 42-43
Horizontal Perspective, 233	Impressionist Brush, 264–265
household inventories, 338	Indexed Color mode, 226
HSL blend modes, 249	Info panel, 21
Hub. <i>See</i> Home screen	Information box (image window), 13
Hue blend mode, 249	inner shadow, 241
Hue Jitter option (Brush), 263	Instant Fix button, 36
Hue/Saturation command/dialog box, 189–190, 211–212	interpolation, 233
	intersecting selections, 110
ı	inversing selections, 126
I	Invert mapper, 202
icons, explained, 3	inverter blend modes, 245
lmage Thumbnails (Raw Editor), 80	
image window	V
Photo Editor, 11–15	K
Raw Editor, 80	keyboard collisions, 110–111
mages	Keyboard shortcuts (Preferences dialog box), 95
adding to albums, 51–54	keywords, searching by, 66
Adobe Stock, 24–26	
backing up, 60–61	L
Camera Raw, 75–76	Lagra to als
changing defaults, 93	Lasso tools
colorizing, 211–212	creating freeform selections with, 102–106
creating views for, 21–23	selecting with, 102–106
cropping, 145–151	launching
downloading with Elements Downloader, 40–42	Camera Raw Editor, 73–74
emailing, 299–300	Catalog Manager, 58
importing from folders, 42–43	Preferences dialog box, 26–27
moving, 217	Preset Manager dialog box, 30–31
opening in Camera Raw Editor, 76–77	layer masks, adding, 133
organizing	Layer menu, 134–135
groups of with tags, 47–50	Layer via Copy command, 138
on hard drive, 37–38	Layer via Cut command, 138
pixel, 272	layers
preparing for printing, 290–291	about, 129–130
rating with stars, 50–51	converting backgrounds to, 130–131
recomposing, 151–153, 331–332	creating, 132–133, 136–138
resizing, 330	defringing, 198-199

layers (continued)	M
deleting, 134	Magic Eraser tool, 125
dragging and dropping, 139	Magic Wand tool, 106–109
duplicating, 133, 138	Magnetic Lasso tool, 105
fill, 133	Magnification box (image window), 13
flattening, 141–143	mapping colors, 201–202
Layer menu, 134–135	Marquee options, applying, 100–102
Layer via Copy command, 138	Mask mode, 112
Layer via Cut command, 138	masking, 86
Layers panel, 131–134	media. <i>See also</i> images
linking, 133, 140	filtering, 62
locking, 133–134	organizing on hard drive, 37–38
merging, 141–143	searching by type of, 66
moving content of, 139–140	Media Browser
rearranging, 133	adding people in, 54–56
renaming, 133	navigating, 44–45
Select menu, 134, 136	Organizer, 36
transforming, 140–141	Media Filter buttons (Organizer), 34
Layers panel, 19, 131–134	Media tab (Organizer), 34
Layout (Photo Editor), 9, 10	Media Windows (Photo Editor), 10
Leading option, 278–279	Median filter, 203
lens barrel, 232	Memories, viewing photos in, 63–64
Lens Blur filter, 205	Memories video, 312
Levels command, 185–187	Menu bar
Levels Guided Edit, 328–329	Organizer, 34
libraries, preset, 30–31	Photo Editor, 7–8
Lighten blend modes, 245, 247	menus, contextual, 15. See also specific menus
lightening, 174–175	merging layers, 141–143
Lighter Color blend mode, 247	metadata, searching, 66–68
lighting	modes. See also specific modes
adjusting, 182–187	color, 13
blend modes for, 245	Photo Editor, 8, 10
Brightness/Contrast command, 184	moiré pattern, 204–205
Levels command, 185–187	More button (Home screen), 20-21
Shadows/Highlights command, 183–184	More image settings (Raw Editor), 79
Line tool, 273	More menu (Photo Editor), 10
Linear Burn blend mode, 246	More Options dialog box, 292
Linear Dodge blend mode, 247	Motion Blur filter, 205
Linear Light blend mode, 248	Move & Scale Guided Edit, 333-334
linking layers, 133, 140	Move tool, 139–140, 141
Liquify filter, 229–231	moving
List view (Media Browser), 44	layer content, 139–140
loading swatches, 258–259	objects, 333–334
locking layers, 133–134	Moving Elements feature, 217–219
Luminosity blend mode, 249	Moving Overlays feature, 214–216

Moving Photos feature, 217	components of, 34–37
Multiply blend mode, 246	finding images, 57-69
multistep filters, 227	navigating Media Browser, 44–45
	organizing
N	groups of images with tags, 47–50
	media on hard drive, 37–38
navigating	Photo Editor, 10
Media Browser, 44–45	rating images with stars, 50–51
Preferences dialog box, 26–27	setting preferences, 45–46
Navigator panel, 21	viewing images, 57–69
New icon, 3	Orientation (Preferences dialog box), 95
noise	Output command, 127
adjusting, 86–87	Overlay blend mode, 248
removing, 203–204	overlays, moving, 214–216
non-destructive editing, 75	
•	P
0	Paint Bucket tool, 268–269
Object Removal Guided Edit, 172	Panel Bin
objects	Photo Editor, 8, 10
moving, 333–334	Raw Editor, 79
removing, 320–322	panels
scaling, 333–334	about, 19–21
objects, searching, 69	Camera Raw Editor, 81–87
one-step auto fixes, 154–160	Photo Editor, 10
one-step filters, 227	Preferences dialog box, 95
online auctions, 336–337	path, 278
opacity, type, 281	patterns, applying preset, 271–272
Open (Raw Editor), 80	PDF slideshow, 313
Open Closed Eyes feature/dialog box, 209-211	Pen and Ink filter, 236–237
Open dialog box, 11	Pencil tool, 260–262
Open menu (Photo Editor), 8, 10	people
Open Preferences (Raw Editor), 78	adding in Media Browser, 54–56
opening	searching by, 66
Catalog Manager, 58	People tab (Organizer), 34
images in Camera Raw Editor, 76–77	Perfect Portrait Guided Edit, 322–324
non-raw images in Camera Raw Editor, 92	performance
Preset Manager dialog box, 30–31	improving for catalogs, 60
Organizer	preferences for, 28
about, 33, 83	Perspective Crop tool, 148–150
adding	Photo Bin
images to, 38-43	Actions menu, 23
images to albums, 51–54	using, 21–23
people in Media Browser, 54–56	Photo Bin/Tool Options (Photo Editor), 9, 10

Photo Editor	pictures
about, 7	adding to albums, 51–54
Color Management options in, 292	backing up, 60–61
components of, 7–21	Camera Raw, 75–76
contextual menus, 15	changing defaults, 93
image window, 11–15	colorizing, 211–212
modes, 10	creating views for, 21–23
panels, 19–21	cropping, 145–151
selecting	downloading with Elements Downloader, 40-42
from Tool Options, 17–18	emailing, 299–300
tools, 15–17	importing from folders, 42-43
Photo Filter command, 200–201	moving, 217
Photomerge feature	opening in Camera Raw Editor, 76–77
about, 250	organizing
Photomerge Panorama command, 250–252	groups of with tags, 47–50
Photomerge Panorama command, 250–252	on hard drive, 37–38
Photomerge Scene Cleaner, 250	pixel, 272
photos	preparing for printing, 290–291
adding to albums, 51–54	rating with stars, 50–51
backing up, 60–61	recomposing, 151-153, 331-332
Camera Raw, 75–76	resizing, 330
changing defaults, 93	searching for, 65–69
colorizing, 211–212	sharpening, 85-87, 319-320
creating views for, 21–23	straightening, 145–151
cropping, 145–151	viewing in Memories, 63-64
downloading with Elements Downloader, 40–42	Pin Light blend mode, 248
emailing, 299–300	pixel images, 272
importing from folders, 42-43	pixel-based shapes, 275
moving, 217	places, searching by, 66
opening in Camera Raw Editor, 76–77	Places tab (Organizer), 34
organizing	plug-ins. See filters
groups of with tags, 47-50	Plug-Ins preferences, 29
on hard drive, 37–38	Polygon tool, 273
pixel, 272	Polygonal Lasso tool, 105–106
preparing for printing, 290–291	Portable Document Format (PDF), 142
rating with stars, 50–51	Posterize mapper, 202
recomposing, 151-153, 331-332	posters, 338
resizing, 330	preferences
searching for, 65–69	setting for Organizer, 45–46
sharpening, 85-87, 319-320	XML files, 93–96
straightening, 145–151	Preferences dialog box, 26-27, 93-95
viewing in Memories, 63-64	Preferences pane3, 28–29
Photoshop file format (.psd), 142	preset colors, 258
Picture Package option, 294	preset gradients, applying, 269–272

preset libraries, 30–31	Refine Selection Brush, 118–120
Preset Manager dialog box, 30–31	refining edges of selections, 126–127
preset patterns, applying, 271–272	Remember icon, 3
Print dialog box, 292–293, 295–296	removable media, adding files from, 39–40
printer color profiles, 291–295	Remove Color Cast command, 188–189
printing	Remove Color command, 190–191
about, 289	Remove tool, 16, 170–172
preparing pictures for, 290–291	about, 2
Print dialog box, 292–293, 295–296	removing
printer color profiles, 291–295	artifacts, 203–204
Profile (Basic panel), 83	color, 190–191
profiles	color casts, 188–189, 327–328
Adobe Camera Raw, 90	dust, 203–204
Camera Raw Editor, 89–92	haze, 199–200
managing, 91	noise, 203–204
program defaults, changing, 93–95	objects, 320–322
project ideas, 335–339	scratches, 203–204
Pucker (P) tool, 230	renaming layers, 133
1 delice (1) 1001, 250	Replace Color command, 191–193
_	Replace Color dialog box, 191–193
Q	replacing
Quick Actions, 2	backgrounds, 324–326
Quick mode, editing in, 160-164	swatches, 259
Quick Selection tool, 113–115	repositioning, 172–173
Quote Graphics, 309–311	resizing
	image window, 13
D	photos, 330
R	resolution, for printing, 290
Radial Blur filter, 205	retouching, 167–168
radius, 85	Rotate (Photo Editor), 9, 10
Radius command, 126	Rotate Left (L) (Raw Editor), 78
Ratings (Organizer), 35	Rotate Right (R) (Raw Editor), 78
rating(s)	Rounded Rectangle tool, 273
images with stars, 50–51	Roundness option (Brush), 263
searching by, 66	Rule of Thirds, 147
Raw Editor. See Camera Raw Editor	Nate of Tillias, 147
rearranging layers, 133	_
recomposing images, 151–153, 331–332	S
Rectangle tool, 273	Saturation (Basic panel), 84
Rectangular Marquee tool, 98–99	Saturation blend mode, 249
rectangular selections, creating, 98–102	Save options, 95–96
Red Eye Removal tool (Raw Editor), 79	Saving Files preferences, 28
Reduce Noise filter, 203–204	saving swatches, 258
Refine Edge option, 126–127	scaling
Refine Edge tool, 102	objects, 333–334
Refine Radius tool, 127	styles, 243

Scatter option (Brush), 263	Select menu, 125–127
school reports/project, 339	Selection Brush, 111–113
Scratch Disks, 28, 29	square, 100
scratch sizes (image window), 14	stroking, 267–268
scratches, removing, 203–204	of subjects, 117–118
Screen blend mode, 247	subtracting from, 110
screen savers, 335–336	Shadow clipping warning (Raw Editor), 78
scroll bars (image window), 13	Shadows (Basic panel), 83–84
Search button (Organizer), 34, 65	shadows, adding, 240-244
searching	Shadows/Highlights command, 183–184
duplicates, 68–69	shapes
by history, 66	creating, 272–275
metadata, 66–68	drawing, 273–274
objects, 69	Share button (Organizer), 35
for photos, 65-69	Share menu (Photo Editor), 8, 10
similarities, 68–69	Share panel
Select All command, 125–126	about, 297–298
Select menu, 125-127, 134, 136	Adobe Premier Elements, 300
selecting	emailing photos, 299–300
color, 255–260	sharing on social networks, 300-302
with Lasso tool, 102–106	sharing
layers, 131–132	Share panel, 297–302
subjects, 117–118	on social networks, 300–302
from Tool Options, 17–18	Sharpen tool, 178-179
tools, 15–17	sharpening
selection border, cropping with, 150	contrast and, 203
Selection Brush, 111–113	images, 85–87, 319–320
selections	improving focus using, 207-209
adding to, 110	Shift and Alt (Option on the Mac), 100
Auto Selection tool, 115–117	Shift Edge command, 127
circle, 100	Show Grid option, 233
Cookie Cutter tool, 120–122	sidecar files, 96
creating	similarities, searching, 68-69
elliptical, 98–102	size, for printing, 290
rectangular, 98–102	skin smoothing, 213-214
defining, 97–98	skin tones, adjusting, 197–198, 317–319
Eraser tools, 122–125	Slideshow button (Organizer), 36
filling, 266-268	slideshows
freeform, 102–106	creating, 63–64
intersecting, 110	PDF, 313
inversing, 126	Smart Blur filter, 205
modifying, 109–111	Smart Brush tools, 219–222
Quick Selection tool, 113–115	Smart Radius command, 126
Refine Selection Brush, 118–120	Smart tags, searching by, 66
refining edges of, 126–127	Smooth command, 126

Smooth Skin feature/dialog box, 213-214	Text Alignment option, 279
smoothing skin, 213–214	text overlay templates, 285–286
smoothness, 87	Text Overlay Templates option, 279
Smudge tool, 175–177	Textures icon, 164
social networks, sharing on, 300–302	3-D cube icon, 257
Soft Light blend mode, 248	Threshold mapper, 202
softening, 177–178	timing (image window), 14
Sort By drop-down list (Organizer), 34	Tint (Basic panel), 83
Spacing option (Brush), 263	Tip icon, 3
Sponge tool, 179–180	Toggle between current settings and defaults (Raw
Spot Healing Brush/Healing Brush, 163, 169–170	Editor), 80
squares, creating, 100	Toggle full screen mode (Raw Editor), 78
Star tool, 273	Tolerance setting (Magic Wand tool), 106–107
Stars (Raw Editor), 80	Tool Options, 17–18, 278–280
stars, rating images with, 50–51	tools
Straighten menu commands, 151	Auto Selection, 115–117
Straighten tool, 78, 150–151	Auto Smart Fix, 154–155
straightening images, 145–151	Auto Smart Tone, 155–156
Strikethrough option, 279	Background Eraser, 123–125
Stroke command, 267–268	Bloat (B), 230
stroking selections, 267–268	Blur, 177–178, 204–207
Style option, 279	Brush, 211-212, 262-264
styles	Burn, 174–175
applying, 241–242	Clone Stamp, 164–166
working with, 242–243	Content-Aware Move, 172–173
Styles panel, 19	Cookie Cutter, 120–122
subjects, selecting, 117–118	Crop, 146–148
submenus, arranging, 140	current, 14
subtracting, from selections, 110	Custom, 273
Surface Blur filter, 205	Dodge, 174–175
swatches	Ellipse, 273
loading, 258–259	Elliptical Marquee, 99–100
replacing, 259	Eraser, 122–125
saving, 258	Eyedropper, 259–260
	Healing Brush, 167–168
_	Lasso, 102–106
T	Line, 273
Tagged Image File Format (TIFF), 142	Magic Eraser, 125
tags, organizing groups of images with, 47–50	Magic Wand, 106–109
Tags panel, 36, 47–50	Magnetic Lasso, 105
Technical Stuff icon, 3	Move, 139–140, 141
teeth, whitening, 163	Paint Bucket, 268–269
Temperature (Basic panel), 83	Pencil, 260–262
text. See also type	Perspective Crop, 148–150
editing, 280–281	Polygon, 273
transforming, 281	Polygonal Lasso, 105–106

tools (continued)	Undo/Redo (Photo Editor), 9, 10
Pucker (P), 230	Undo/Rotate button (Organizer), 35
Quick Selection, 113–115	Units & Rulers preferences, 28
Rectangle, 273	Unsharp Mask command, 207–208
Rectangular Marquee, 98–99	
Refine Edge, 102	M
Remove, 170-172	V
Rounded Rectangle, 273	vector-based shapes, 275
selecting, 15–17	vectors, 272
Sharpen, 178–179	Vertical Perspective, 233
Smart Brush, 219–222	Vibrance (Basic panel), 84
Smudge, 175–177	View menu (Organizer), 62
Sponge, 179–180	View Mode, 126
Star, 273	views
Straighten, 150–151	creating for images, 21–23
Twirl Clockwise (R), 230	switching between, 62
Twirl Counterclockwise (L), 230	Vignette, 232
Warp (W), 230	Vivid Light blend mode, 248
Tools panel (Photo Editor), 9, 10, 15–17	
Tracking option, 279	W
Transform command, 140–141, 285	
transforming	Warning icon, 3
layers, 140–141	Warp (W) tool, 230
text, 281	warping type, 284–285
Transparency preferences, 28	websites
Tree view (Media Browser), 45	Adobe Firefly, 26
troubleshooting corrupted catalogs, 60	Cheat Sheet, 4
Twirl Clockwise (R) tool, 230	White Balance (Basic panel), 83
Twirl Counterclockwise (L) tool, 230	whitening teeth, 163
Twitter, 301	Whites (Basic panel), 84
type	Width (W), 102
about, 278	windows, 13
adjusting opacity, 281	
applying filters to, 281–283	X
color and, 283–284	
editing text, 280–281	XML files, 93–96
gradients and, 283–284	
specifying options for, 278–280	Z
warping, 284–285	Zoom and Pan (Preferences dialog box), 95
Type preferences, 29	Zoom button (Organizer), 36
-NE-E- and anisani ma	Zoom options (Raw Editor), 79
	Zoom tool, 79, 127, 233
U	

Underline option, 279 undocking windows, 13

About the Authors

Barbara Obermeier: Barbara is the principal of Obermeier Design, a graphic design studio in Ventura, California. She is the author of the *Photoshop All-in-One For Dummies* series and has contributed as author or coauthor on more than 30 books on Adobe Photoshop, Adobe Photoshop Elements, Adobe Illustrator, Microsoft PowerPoint, and digital photography for John Wiley & Sons, Inc., Peachpit Press, and Adobe Press. She is currently the Chair of the Visual Arts Department at California Lutheran University in Thousand Oaks, California.

Ted Padova: Ted is semi-retired; he still writes and teaches some photo classes. He has written more than 70 computer books on subjects such as Adobe Photoshop, Adobe Photoshop Elements, Adobe Acrobat, Adobe Illustrator, and Adobe InDesign.

Authors' Acknowledgments

We would like to thank our excellent project editor, Susan Christophersen, who kept us on track throughout the development of this work; Hanna Sytsma, our Senior Editorial Editor who coordinated all editing, reviewing, and kept us on course throughout the project; Steve Hayes, our executive editor; Doug Sahlin, technical editing wizard, who made what we wrote sound better; and all the dedicated production staff at Wiley.

Barbara Obermeier: A special thanks to Ted Padova, my coauthor and friend, who always reminds me there is still a 1 in 53 million chance that we can win the lottery.

Ted Padova: First and foremost, I'd like to thank Barbara Obermeier for asking me to join her in this journey on exploring Photoshop Elements — now in our 18th collaboration on this project. Also, special thanks to Bernadette Baro, Dina Lopez, Camille Sedar, and Cindy De Vera for modeling. A very special thank you to my lovely niece Courtany Jensen for her photo contribution.

Publisher's Acknowledgments

Executive Editor: Steve Hayes

Project Manager and Copy Editor:

Susan Christophersen

Technical Editor: Doug Sahlin

Production Editor: Tamilmani Varadharaj

Cover Image:

© iacomino FRiMAGES/Shutterstock